DAK'ART

DAK'ART

The Biennale of Dakar and the Making of Contemporary African Art

Edited by
Ugochukwu-Smooth C. Nzewi and Thomas Fillitz

Routledge
Taylor & Francis Group

LONDON AND NEW YORK

This edition published 2021
by Routledge
2 Park Square, Milton Park, Abingdon, Oxon, OX14 4RN

and by Routledge
52 Vanderbilt Avenue, New York, NY 10017

Routledge is an imprint of the Taylor & Francis Group, an informa business

British Library Cataloguing-in-Publication Data
A catalogue record for this book is available from the British Library

Library of Congress Cataloging-in-Publication Data
A catalog record has been requested for this book

ISBN: 978-1-350-10649-9 (hbk)
ISBN: 978-1-003-08515-7 (ebk)

Typeset in Minion Pro
by RefineCatch Limited, Bungay, Suffolk

For legal purposes the Acknowledgements on p. xiv constitute an extension
of this copyright page.

Cover design: Tjaša Krivec
Cover image © Rhema Chachage.

CONTENTS

LIST OF ILLUSTRATIONS

CONTRIBUTORS

Eva Barois De Caevel is an independent curator, writer and editor. Her areas of interest are feminism, post-colonial studies, the body and sexuality, critique of Western-centred art history and thus the renewal of writing and critical speech. She is assistant curator for RAW Material Company and coordinator of RAW Académie (Senegal), and editor and consultant for the Institute for Human Activities (Congo, Netherlands, Belgium). She is one of the founders of the international collective of curators Cartel de Kunst, Paris. In 2014, she was awarded the ICI Independent Vision Curatorial Award 2014. In 2016, she was co-curator with Koyo Kouoh of *Still (the) Barbarians*, EVA International, Ireland's Biennial in Limerick. In 2018, she was guest curator of the edition of LagosPhoto Festival, Lagos. Among her texts in exhibition catalogues and specialized journals: with Els Roelandt (eds) (2017), *Cercle d'Art des Travailleurs de Plantation Congolaise. Congolese Plantation Workers Art League*. New York: Sternberg Press.

Viyé Diba is visual artist and professor at the École Nationale des Arts du Sénégal. Besides his training as artist at Institut National des Arts, Dakar, and École pilote internationale d'art et de recherche of Villa Arson, Nice, France, he also studied urban geography at Université de Nice, France. Since 1989 he has been president of the Association Nationale des Artistes Plasticiens du Sénégal (ANAPS), and was a member of the Dak'Art's *Conseil scientifique* in 1996, 2000 and 2004, and later of the Biennale's *Comité d'orientation* in 2008, 2010 and 2012. At Dak'Art 2018, he curated the exhibition *La Brèche* (The Breach) in the Senegalese Pavilion. In 2018, he was also curator of the inaugural exhibition on contemporary arts at the Musée des Civilisations Noires, Dakar (MCN). He has received several national and international decorations, including the Chevalier de l'Ordre du Mérite Sénégalais, and was awarded the Biennale's *Grand Prix Léopolod Sédar Senghor* in 1998. Among his participation in major exhibitions are: The Johannesburg Biennale (1995 and 1997); *Container 96 – Art across Oceans*, Copenhagen (1996); *Grafolies* – La Biennale d'Abidjan (1993). His artworks are in the collections of the Smithsonian National Museum of African Art, Washington DC, Brooklyn Museum, New York, and Fowler Museum, University of California Los Angeles, among others. A monograph on Viyé Diba: The Huchard, Ousmane Sow, (1994), *Viyé Diba: Plasticien de l'environnement*, Dakar: Sépia.

Thomas Fillitz is retired professor of social and cultural anthropology, University of Vienna. He was visiting professor at various universities in Europe, in particular in 2008 at Université Lumière Lyon–2, and in 2011 at Université Paris Descartes–Sorbonne. From 2003 to 2009 he was external examiner in the Department of

Anthropology, National University of Ireland, Maynooth, and from 2007 to 2013 he was secretary of the European Association of Social Anthropologists (EASA). He has conducted field research in Northern Nigeria, Côte d'Ivoire, Benin and Senegal. He has carried out research on contemporary art in Africa with special focus on West Africa since the early 1990s, and has conducted fieldwork on the Biennale of Dakar since 2008. Among his publications are: with Paul van der Grijp (2018), *An Anthropology of Contemporary Art*, London: Bloomsbury Academic; (2018) 'Art and Anthropology: Different Practices and Common Fields of Intersection', *FIELD – A Journal of Socially Engaged Art Criticism*, 11. Available online: http:// field-journal.com/issue-11/art-and-anthropology-different-practices-and-common-fields-of-intersection.

Joanna Grabski is director of the School of Art and professor of art history at the Herberger Institute for Design and the Arts, Arizona State University, USA. She has conducted research in Dakar since 1998 and has published extensively on art institutions, artistic livelihoods, market spaces, public art, fashion and street life, the Dak'Art Biennale of Contemporary Art, visuality and creativity, urban memory, and interpretations of the built environment. Among her honours and awards are the Art Journal Award and the Millard Meiss Publication Award from the College Art Association. Her current research focuses on art schools and art world globalization. Documentary film on Dakar's storied Colobane Market as a site for transforming used objects: (2013), *Market Imaginary*, Bloomington, Indiana: Indiana University Press. Among her publications are: (2017), *Art World City: The Creative Economy of Artists and Urban Life in Dakar*, Bloomington, Indiana: Indiana University Press; with Carol Magee (2013), *African Art, Interviews, Narratives: Bodies of Knowledge at Work*, Bloomington, Indiana: Indiana University Press.

Koyo Kouoh is executive director and chief curator of Zeitz Museum of Contemporary Art Africa, Cape Town, South Africa. Founding artistic director of the Dakar-based RAW Material Company, she is a seasoned and well-respected art world professional who has curated in Africa and internationally. She was involved with the Dak'Art Biennale in a consulting capacity from 2000 to 2004. She co-curated *Les Rencontres de la Photographie Africaine* in Bamako (2001 and 2003) and curated the 37th EVA International, Ireland's Biennial in Limerick (2016). She served as the inaugural curator of 1:54 FORUM, the educational programme of 1: 54 Contemporary African Art Fair, and for five years helped to establish the fair's reputation. She served in an advisory role for documenta 12 (2007), 13 (2012) and 14 (2017), and in 2003 was a member of the Golden Lion Jury of the 50th Venice Biennale. Among her publications are: (ed.), (2013), *Word!Word!Word! Issa Samb and the Undecipherable Form*, Berlin: Sternberg Press; (ed.), (2012), *Chronicle of a Revolt: Photographs of a Season of Protest*, exhibition catalogue, Dakar: RAW Material Company.

Massamba Mbaye is an art critic, exhibition curator and historian of theories of communication. He received a diploma in strategic marketing, and researched on

cybernetic and subjective aesthetics. He is lecturer at Université Cheikh Anta Diop de Dakar and Université Virtuelle du Sénégal. Member of the Association Internationale des Critiques d'Art (AICA), he is currently director general of a media and communication group. He is honorary president of the Association de la Presse Culturelle du Sénégal and associate curator at Dakar's RAW Material Company, where he organizes the platform on aesthetics *Vox Artis*. Since 2006, he has been a member of the *Comité d'orientation* of the Biennale of Dakar, and as such the person responsible for communication. He has been curating exhibitions since 1995, in particular with Migrations Culturelles aquitaine afriques (MC2a), Bordeaux. For Dak'Art 2014, he curated the exhibition *Diversité Culturelle* at Musée Théodore Monod. He regularly curates exhibitions for Galerie Kemboury, Dakar. Among his publications are: with Abdou Sylla and Sidy Seck (2009), *Une passion en couleurs: Art contemporain au Sénégal: Collection de Abdoulaye Diop et de Fatoumata Sow*, Dakar: Imprimerie du Midi; an article in Yacouba Konaté (ed.), (2013), *Art et bestiaire chez quelques artistes du Sénégal et d'Afrique du Sud (Etude sur Ousmane Sow, Soly Cissé, Mamady Seydi et Andries Botha)*, Aix-en-Provence: Collection Blachère.

El Hadji Malick Ndiaye studied art history at Université de Rennes, France, and holds a diploma of the Institut National du Patrimoine, Paris. Former post-doctoral researcher at the Laboratoire d'Excellence Création, Arts et Patrimoines (Labex CAP) and the Centre de Recherches sur les Arts et le Langage (EHESS/CNRS), he is currently researcher at Université Cheikh Anta Diop de Dakar, curator of Musée Théodore Monod d'art africain and secretary general of ICOM-Senegal. He teaches art history and cultural patrimony at Université Cheikh Anta Diop. He was member of the *comité d'orientation* of Dak'Art 2018, and directed the commission for the forum *Rencontres–échanges*. He has been appointed artistic director of the Biennale of Dakar 2020. His research focuses on modern and contemporary art and global history, cultural politics, and museums in Africa. Among his publications are: (2016), 'Le commissaire et l'objet d'art. Les expositions transnationales comme espaces de recherche sur la mondialisation', *Proteus-Cahiers des théories de l'art, 10*: 31–9; (2009), 'Iba Ndiaye (1928–2008): Comment interpréter la modernité avec un pinceau?', Part 1, *Ethiopiques, 83*: 227–46; (2010), 'Iba Ndiaye (1928–2008): Comment interpréter la modernité avec un pinceau?', Part 2, *Ethiopiques, 84*: 389–98.

Ugochukwu-Smooth C. Nzewi is an artist, art historian, and the Steven and Lisa Tananbaum Curator in the Department of Painting and Sculpture at the Museum of Modern Art, New York. Previously, he served as the curator of African art at the Cleveland Museum of Art, Cleveland, Ohio, and Dartmouth College's Hood Museum of Art, New Hampshire, USA. He has co-curated major international exhibitions including Dak'Art 2014, and in 2016–17 served on the curatorial team of the eleventh Shanghai Biennale. He has lectured and given talks at academic institutions and museums around the world. His writing has appeared in important academic journals and art magazines. As an artist, Nzewi has participated in major

artists' residencies and workshops. He has exhibited internationally and is represented in public and private collections including the Smithsonian National Museum of African Art, Washington DC, and Newark Museum, Newark, USA. His recent publications include: (2019), *Emeka Ogboh: Lagos Soundscapes,* Bielefeld: Kerber Verlag; (2020), *Second Careers: Two Tributaries in African Art,* exhibition catalogue, Cleveland: The Cleveland Museum of Art.

Iolanda Pensa is an art critic and senior researcher. She is head of the research area 'Culture and Territory' at the Laboratory of Visual Culture of SUPSI University of Applied Sciences and Arts of Southern Switzerland. Previously she was founder and board member of the iStrike Foundation in Rotterdam and scientific director at lettera27 Foundation (now Moleskine Foundation) for the project WikiAfrica. Her research focuses on systems of knowledge production and distribution, on the impact of cultural institutions, public art and biennials, and on Wikipedia and open licences. She has accomplished field research in particular in Dakar (following the Biennale of Contemporary African Art since 1998) and in Douala (following the work of Doual'art since 2003). Selected publications include: (ed.), (2017), *Public art in Africa: Art et transformations urbaines à Douala/Art and Urban Transformations in Douala,* Geneva: MetisPresses; (2006), 'Les biennales et la géographie: Les biennales de Venise, du Caire et de Dakar', in *Créations Artistiques Contemporaines en Pays d'Islam: des Arts en Tension,* Jocelyne Dakhlia (ed.), 573–88, Paris: Kimé éditions.

Sylvain Sankalé trained as a lawyer. Besides his career as lawyer and consultant, he is a collector of traditional and contemporary African art, has developed important activities as art critic and is a member of the Association Internationale des Critiques d'Art (AICA). He is lecturer at the Institut Supérieur des Arts et des Cultures (ISAC), at the Faculty of Law, Université Cheikh Anta Diop de Dakar, and teaches in other countries including Hungary and Côte d'Ivoire. He is a founding member of the Fondation Charles Donwahi pour l'art contemporain, Abidjan, and was its first secretary general in 2008. He was president of the *Conseil scientifique* of Dak'Art 2000, member of the *Comité de sélection* of Dak'Art 2010, and curator of several exhibitions of Dak'Art–In and Off. Commissioned by the state of Senegal and international sponsors, he has undertaken several studies on the restructuring of the Biennale of Dakar. Among his publications are: (ed.), (2008), 'Afrique une et multiple!/Africa One and Multiple!', Secrétariat Général, 42–7, exhibition catalogue, Dakar: Biennale de l'art africain contemporain; (2005), 'Some magical sparks in many trivialities?', Special Issue *Arts Visuels: L'Afrique s'installe/Visual Arts: Africa turns to installations,* Ousseynou Wade (ed.), *Afrik'arts,* 2: 50–4.

ACKNOWLEDGEMENTS

Since the 1990s, the Biennale of Contemporary African Art reinserted Africa into global cultural discourse and has since cemented its presence in the international calendar of major art events. In the absence of the platform provided by Dak'Art, our paths, perhaps, may not have crossed and the seed for this volume would not have been planted. In 2008, we began independent studies of the Biennale of Dakar as a graduate student of art history at Emory University, Atlanta, and as a professor of anthropology at University of Vienna.

Ugochukwu-Smooth Nzewi became interested in the Biennale of Dakar for his PhD project at Emory University under the supervision of Emerita Professor Sidney Littlefield Kasfir. Nzewi is grateful to Emory University's Graduate School and Art History Department, the Smithsonian Institution's graduate and pre-doctoral fellowships, TIAA-CREF Ruth Simms Hamilton Research Fellowship for the African Diaspora, for supporting his research in Dakar and Paris. He is also indebted to the late Senegalese artist Ndary Lo for his friendship and support during years of research on Dak'Art.

Thomas Fillitz had been working on contemporary African art, and specifically with artists in Côte d'Ivoire and Benin. In Vienna he became close friends with the late Senegalese modernist Amadou Sow. They had many conversations about modern and contemporary art in Senegal, about the teachings of Pierre Lods, and Amadou sparked Thomas's interest to begin to conduct research on the Biennale of Dakar. Memories of Ndary Lo and Amadou Sow thus accompany Ugochukwu-Smooth and Thomas's work on this volume.

We met for the first time in Dakar in May during the Biennale in 2012, and in August the same year in Vienna, during which we discussed our approaches, topics, and data that we have collected. We soon realized our mutual deep passion for the Biennale of Dakar. In late spring of 2017, Ugochukwu-Smooth contacted Thomas to suggest that we co-edit a volume on the Biennale of Dakar, and Thomas responded with enthusiasm. During summer 2017, we exchanged many ideas about this volume on Dak'Art, about possible topics, who should be invited to contribute, etc. From the outset it was clear to us that positions from Dakar had to be represented as well, personalities from the local art world who collaborated closely in one way or another with the Biennale. After first contacts via email, we were happy to meet our colleagues during Dak'Art 2018. All of them were excited about this project, and welcomed it – for which we are grateful to them. In several personal and group conversations we further sharpened the profile of the book.

It is the first comprehensive volume on Dak'Art and includes the voices of scholars and some of the principal actors who have been involved in the Biennale since its inception. We are sincerely indebted to our colleagues for accepting our

humble invitation and for contributing essays that provide different perspectives on the biennale. The present volume is the outcome of reflections and experiences of colleagues and friends from Dakar and other regions of the world, and with different professional backgrounds. The editors are confident that these multiple perspectives provide the complex image of the Biennale of Dakar and that one can experience this mega-event in all its facets during a real visit. We were delighted to collaborate with our contributors to produce these insights into the Biennale of Dakar, and we would like to thank all of them for their commitment to and trust in this project. We regret that some personalities we had approached, such as Ousseynou Wade, could not contribute to this volume eventually. We moreover thank the anonymous reviewers for their invaluable comments.

We thank Elissa Watters, research and curatorial fellow at Yale University Art Gallery, for her invaluable work as editorial assistant. Finally, we would like to express our gratitude to Bloomsbury Publishers, especially Miriam Cantwell, erstwhile commissioning editor, and Lucy Carroll, assistant editor, whose deep enthusiasm for the project from the outset sustained its completion. Our thanks also go to the publisher's co-editing team for its expert editorial work.

Ugochukwu-Smooth C. Nzewi and Thomas Fillitz
New York and Vienna, July 2019

NOTES ON TEXTS

- The chapters 1.2 by Massamba Mbaye, 1.3 by Viyé Diba, 2.2 by El Hadji Malick Ndiyae, and 2.4 by Sylvain Sankalé were delivered in French. Thomas Fillitz produced a first translation from French into English; Elissa Watters, Yale University, and Ugochukwu-Smooth C. Nzewi provided an edited version.
- The original French manuscript titles are:
- Chapter 2: *L'histoire de l'art moderne et contemporaine du Sénégal: Du courant négriste aux logiques de la société ouverte*, Massamba Mbaye.
- Chapter 3: *Les « Lointains enfants » de l'ouverture de Senghor prennent date*, Viyé Diba.
- Chapter 5: *Les Rencontres–échanges: une histoire intellectuelle de la biennale de Dakar*, El Hadji Malick Ndiaye.
- Chapter 7: *La Biennale de Dakar et l'État du Sénégal*, Sylvain Sankalé.
- Chapter 8 by Koyo Kouoh and Eva Barois De Caevel is based on Kouoh's evaluation report, *Proposition de Réforme de la Biennale de Dakar* (2014), which she was commissioned to produce following the Biennale's eleventh edition in 2014.
- All other chapters are original contributions of the authors to the present volume.

INTRODUCTION

Ugochukwu-Smooth C. Nzewi and Thomas Fillitz

The Biennale of Dakar, Dak'Art, was created in 1989 by the government of Senegal to promote the latest examples of contemporary art in Africa. Framed as a pan-African biennial and exhibiting the works of African and African diaspora artists, Dak'Art is organized every two years in Dakar, Senegal, a country that since independence in 1960 has considered arts and culture as key to national development. Since the 1990s, Dak'Art has served as an important nexus between the African and international art worlds. Dak'Art's emergence in 1989 was dictated by a confluence of social, political and economic factors. Apart from Senegal's policy of cultural diplomacy, the liberalization of Senegal's economy in the 1980s was an important factor. The new economic order shifted emphasis from the Keynesian model, which posited the state as the engine of development, to the neoliberal logic of lean government and the so-called free market through economic deregulation and privatization (see Gersovitz and Waterbury 1987).

This shift, which was widespread among African countries in the 1980s, ushered in the indirect control of developing economies by Western-based multilateral institutions and multinational corporations. Unlike the 1960s and 1970s, when pan-Africanism was, notionally at least, intrinsically woven into the fabric of governance in newly independent African countries, it disappeared or was paid only lip service in the corridors of power for most of the 1980s. There were no longer political leaders who understood the uses of pan-Africanism as a philosophical bedrock for the construction of national cultures. The effect of the economic shift was profoundly felt by Senegalese artists and the entire cultural sector. It disrupted a state system that had supported and provided subventions for artists while acquiring the bulk of their works. At the same time, the new economic climate helped create a new form of cultural patronage that led artists to begin to look beyond the state for support. Dak'Art emerged from a convergence of factors: the desire by Senegalese artists to engage the outside world; the return of cultural pan-Africanism as anchor for international solidarity, as was the case during the early postcolonial period in Senegal (this point was made in no uncertain terms during the historic *Art Against Apartheid* (see Nzewi, Chapter 1)); and revalorization of Senegal's policy of cultural diplomacy.

Dak'Art's emergence and growth in the 1990s coincided with the expansion of the international art world beyond the Western hemisphere. A key indicator of this expansion was the proliferation of art biennials. From fewer than thirty in 1990, biennials have grown to over 155 in a space of twenty years, according to the Biennial Foundation. This upsurge brought about a more heterogeneous, complex and global sense of contemporary art. Arjun Appadurai's theory of 'imagined worlds' describes the global flow of cultural capital between the centre and the periphery (1996: 33–5). Art biennials fit into this idea of 'imagined worlds'. As global exhibitions, they bring together works of art from different geographical regions and convene a global audience. Yet, they vary in scope and mission, and not all assemble artists of diverse ethnicities and geographical backgrounds. Dak'Art is an example of a geographically and ethnically delimited venue.

Before the creation of Dak'Art, the structure of the international art world largely excluded non-Western artists and black artists in the West. Dak'Art was created specifically to address this problem by focusing on artists of African descent. It articulated an alternative framework for the reception of contemporary art from Africa, a vision of making and seeing biennials as global exhibitions but from a regional perspective – a vision that might be described as pan-African internationalism (Nzewi 2013). Although more African artists now exhibit alongside their contemporaries in Africa and elsewhere and on an equal footing, Dak'Art has continued to focus only on art and artists of Africa and the diaspora as a strategy of visibility in a heavily saturated global biennial system.

What makes Dak'Art noteworthy is that it is a trailblazer in the promotion of African and African diaspora artists, an orientation that has become the norm for the number of art biennials that have since emerged in Africa, such as Rencontres de Bamako–Biennale Africaine de la Photographie (Bamako, Mali), Lubumbashi Biennale (Democratic Republic of Congo), and the defunct Afrika Heritage Biennale (Enugu and Lagos, Nigeria). In spite of the pervading pan-African consciousness of these biennials, there are differences. For example, while the Rencontres de Bamako (otherwise known as the Bamako Biennale) is similar to Dak'Art in its focus on African and African diaspora artists, there are two major differences between the two. These concern sponsorship and scope. The Bamako Biennale is co-organized and co-sponsored by the Ministry of Culture of Mali and Culturesfrance (the French government organ responsible for promoting French culture in the world) and represents France's contemporary cultural relations with its former colonies in Africa (Bajorek and Haney 2009). Since its inception in 1994, the Bamako Biennale has focused on new trends in African photography, and most recently has expanded to included video and film. Unlike Dak'Art, it does not exhibit other art forms.

The emancipatory vision embedded in postcolonial criticisms has shaped the political agendas of biennials such as Dak'Art. This vision is considered as the postcolonial turn in the international art world (Smith 2009). According to Terry Smith, the postcolonial turn is a world cultural change that allowed for increased dialogue between 'local and internationalist values', especially in art circuits from around 1989 (ibid.: 151–67). Further, it also marks the emergence of a plethora of

art, 'shaped by local, national, anticolonial, independent, globalization, anti-globalization values (those of diversity, identity and critiques)' (ibid.: 7). As the art historian and curator Yacouba Konaté suggests, Dak'Art began the process by which the vanquished takes it upon himself to recount, rewrite or produce history from the loser's perspective and then gain a sense of the victor's authority and character (Konaté 2010: 108). Dak'Art's politics of presence also take into account the aspirations of the local art community in Senegal to be connected to international cultural flows on their own terms. It fulfils the Senegalese state's desire to continue to promote culture as intrinsic to the nation's development agenda. Dak'Art's cultural vision is both global and local. Dak'Art's physical site is Dakar, but its reach is global, given its focus on African and African diaspora (both the recent and older diaspora).

Dak'Art in Scholarly Publications

Scholars from various disciplines – such as philosophy of aesthetics, art history, visual culture studies, or anthropology – have researched the Biennale of Dakar. There are two published monographs so far (Konaté 2009, Rodatus 2015), two unpublished PhD theses (Pensa 2011, Nzewi 2013), book chapters (Grabski 2017, Diop 2018), numerous journal articles (e.g. Fillitz 2016) and some MA theses (e.g. Mauchan 2009). In the following we shall focus and briefly present the monographs, the PhD theses, and the chapters of Grabski and Diop.

Valentin Mudimbe (2009) introduces Konaté's book on the Biennale of Dakar with the words: 'And then came this book. It is African, and it is in dialogue' (ibid.: 7).[1] Yacouba Konaté's *La Biennale de Dakar* (2009) is to date the most important publication on the Biennale of Dakar. Philosopher of aesthetics in Abidjan, internationally renowned art critic and curator, Konaté was appointed to different functions and tasks of Dak'Art. He was a member of the selection committee in 1998, was invited to curate the exhibition *Africa* within the spaces of the *Expositions individuelles* in 2004, and participated at several forums of debate *Rencontres-échanges*. Most importantly, Konaté was appointed general curator of the seventh edition in 2006, and conceptualized the *Exposition internationale* as *Agreements, Allusions and Misunderstandings*.

Konaté himself connects his leading questions to an intercultural dialogue with Adorno and researches 'how the need for a large-scale cultural manifestation like the Biennale of Dakar elaborates a form of art for masses, while resisting self-deception, and standardization' (2009: 16).[2] For the author, there is no doubt that Dak'Art is the flagship event of contemporary visual arts in Africa (ibid.: 17). The investigation, however, concerns how the Biennale created itself through its own history, and thereby became itself a motor for history and of creativity – for artists who create to participate in it, and as institution that participates in the general history of the global biennials network (ibid.).

Konaté sees the global proliferation of art biennials from the 1990s on in connection to the fall of the Berlin Wall and the implosion of socialist states (1989),

and explains the birth of biennials in Africa in relation to the end of Apartheid (1994), and more so the one of mono-party systems and their concomitant replacement by political pluralisms. 'The time of the biennials therefore is ... the one of an overall exigency of freedoms' (ibid.).[3] In line with such a relationality between art and politics, Konaté studies the Biennale of Dakar in the framework of a theory of art history that is conceived as a sociopolitical field and operates at the levels of pan-Africanism, internationalism and contemporaneity (ibid.: 18–19).

The relationship between these three levels is not without tensions and frictions, although a fundamentally African mega-art event is an exciting objective, as Konaté experiences with the curatorship of the 2006 edition. The author views in particular the opening of the Biennale to Africa's diaspora as putting in motion the notion of Africanity, which has important impacts on artistic practices, and within the Biennale on the selection of artists and their artworks: new art forms such as installation, video, multi-media, or performances emerge (ibid.: 66). The author elaborates on these tensions, which start by 2000. At this fourth edition, Simon Njami's presentation of Bili Bidjocka raises protests, as the artist proposes an art project – an imaginary journey through the city of Dakar (ibid.: 69–70). Other artists' works or curators' selections and exhibitions (e.g. Bruno Cora in 2002) follow with massive critiques of local artists and art world professionals. All these critical voices merge in a very specific, local view of the Biennale's task, and of what contemporary art is: 'Under the umbrella of contemporary art, Dak'Art has not to open its doors without moderation nor discernment to "whatsoever". The œuvres on display have to be foremost artworks, that is creations' (ibid.: 73–4).[4]

Indeed, the author explains the history of the Biennale by reflecting on these paramount concepts of pan-Africanism, contemporaneity and internationalism in the embedment of art in the sociopolitical field. By doing so, Konaté outlines organizational structures of the institution, such as selection committees, their criteria, and some of their debates. His presentation of the Biennale of Dakar fuses in the discussion of the seventh edition for which he endorses the conceptual and concrete responsibilities.

With a deeply occidental gaze, Verena Rodatus undertakes a quite different reading of Konaté's three levels – pan-Africanism, internationalism and contemporaneity – in her volume *Postkoloniale Positionen?* (*Postcolonial Positions?*, 2015), the publication of her doctoral thesis. The author looks at Dak'Art as art historian, and her research question concerns the political identity dilemma she detects, insofar as the Biennale focuses on contemporary and African art, being at the same time similar (contemporary and international) and specific (African). Rodatus asks about the roles of origin, migration and international fame for the selection, and whether the Western concept of the biennial is relevant for the presentation of African artistic production (ibid.: 16). To these ends, the young researcher visited the Biennale of 2006.

The author's approach, however, is a study from the vantage of the international, Western-dominated art field, that is, from occidental art history combined with gender and postcolonial theory. In the main Chapter 4, the author takes the reader along a tour through the *Exposition internationale*, picks out artworks and discusses

them on the basis of ideas and concepts from occidental intellectual and cultural traditions. Above all, Rodatus critiques the exhibition as an ahistorical approach to art creations of Africa and its diaspora, and thereby sees a reinsertion of the European early twentieth-century Primitivism discourse, which operated with the colonialist stereotype of a homogeneous Africa existing out of history (ibid.: 183). It is noteworthy that, as general curator, Yacouba Konaté had precisely chosen *Agreements, Allusions and Misunderstandings* as the title of the *Exposition internationale* (2006).

Iolanda Pensa's thesis of Dak'Art is the result of twelve years' research in the field (2011: 7). In this study, the Biennale is presented as a cultural node which stretches into the system of contemporary art in relation to the art market and the cultural politics (ibid.: 7). Pensa questions how market and politics appear when looked at from Dak'Art. The author emphasizes the importance of networks for the cultural institution – of artists, art world professionals, media, politicians, funding agencies, etc. – as it concerns the Biennale's connections to people, institutions and territories.

Hence, the researcher dedicates Chapter 3 to the history of the Biennale. This discussion is well embedded in (a) an anticipated consideration of the global biennials system, and African biennials in particular; and (b) topics of art in Africa, and specifically the notion of contemporary African art. Of major interest is Pensa's hypothesis that the Biennale of Dakar is 'a project of cooperation and of development. First, it is a project, because, as of its new orientation of 1996, the Biennale is structured in "objectives, activities, and measurable results", and this new structure has an evident effect on its functioning' (ibid: 9).[5] The author conceives this hypothesis in respect to the state's decree for the Biennale: it has to have an impact on the professionalization of artistic practices, of art world professionals (e.g. art critics), of dealers of contemporary African art (ibid.). The call for a general public will be a critique that confronts the Secretariat General during the various editions.

Pensa pinpoints an important fact in the state's control of Dak'Art, another aspect that supports the idea of the Biennale as a development project: in defining the Biennale's orientation on contemporary African art, the state does not specifically focus on the artworks and their quality. 'The project insists on the economic development, which includes as well the formations and participation of local communities' (ibid.: 241).[6] This is, she concludes, an important aspect for the institution to attract funding agencies which usually are not identified with artistic and cultural projects.

Regarding the impact of the Biennale, Pensa's conclusion is more sobering than that of Grabski (2017) or Diop (2018): 'Dak'Art did not create new works, she did not invent innovative ways of exhibiting ... she did not facilitate the emergence of active and stable institutions in Dakar' (Pensa 2011: 126).[7] However, the author also enumerates a number of strengths, among which she lists as achievement the contribution to the career of artists and of involved curators in Africa above all (ibid.: 127).

In his 2013 dissertation, Ugochukwu-Smooth Nzewi argues that the significance of Dak'Art as an international platform for contemporary art is rooted in its

geopolitical commitments. The Biennale deploys pan-Africanism as a mobilizing tool for the promotion of African art and artists, an approach that highlights neoliberal multiculturalism of the international art world since the 1990s. For Dak'Art, it helps that it distinguishes it from older or well-resourced biennials. Issues associated with location and capital highlight the unequal distribution of global capitalism, which structures power and cultural relations between regional blocs and between the local and the global (see Elkins et al. 2010: 85–96). Dak'Art's regional focus and lack of financial strength narrow its influence. It cannot compete for international attention with many biennials in Europe and emerging centres in Asia. Its regional emphasis is thus a cultural politics of visibilty, a ploy that helps it carve out a space for itself in the global circuit of biennials as non-Western, postcolonial and pan-African.

Nzewi considers how Dak'Art's cultural politics aligns it with biennials with pronounced ideological focus such as the Bienal de La Habana, which was established in 1984 as a platform for mostly non-Western artists from Africa, Asia and Latin America based on a postcolonial discourse of 'Thirdworldism'(Rojas-Sotelo 2009). Although Nzewi contends that Dak'Art's regional postcolonial perspective appears to borrow a leaf from the Bienal de La Habana, he traces its model of internationalism to early pan-African congresses and festivals in the mid-twentieth century. They include the International Congress of African Culture [Salisbury (now Harare), 1962], the *First World Festival of Negro Arts* (Dakar, 1966), the *First Pan-African Festival* (Algiers, 1969) and the *Second World Festival of Black and African Arts* (Lagos, 1977), all which were organized during the 1960s and 1970s, a period of intense cultural nationalism and decolonization. The festivals provided not only the setting for the celebration of black and African cultures, but also served as a reminder of black peoples' resilience over racism and colonialism. Beyond celebrating global cultures, the historical significance of these earlier events lies in their representation of alternative internationalism and modernism through their exhibitions of modern black and African art. The festivals thus laid the groundwork for what Nzewi refers to as pan-African internationalism. However, Nzewi also points out a crucial difference between Dak'Art and its illustrious forebears. Unlike the early pan-African events, Dak'Art's pan-African internationalism is outward-looking. Dak'Art is more concerned with enabling African artists to gain a foothold in the mainstream of the international art world. It is therefore a departure from the early pan-African events, which aimed for a global cultural exchange strictly on the basis of racial and geographical solidarity.

Joanna Grabski (2017) looks at the Biennale of Dakar in the chapter 'Mapping the Dak'Art Biennale in Dakar' within her encompassing book on the Dakar art world (ibid.: 57–94). As Diop (2018), Grabski acknowledges the importance of the Biennale 'to Dakar's art scene, its city, and an increasingly populated global landscape of biennales' (ibid.: 57). The author subdivides her description of Dak'Art under three topics: (a) a focus on the two spaces of the Biennale, the official 'In' and the informal 'Off'; (b) Dakar as a contact zone; (c) the Biennale as a discursive space (ibid.: 57–8).

Grabski highlights the importance of Dak'Art–Off. This huge quantity of exhibitions, scattered all over the city, is significant for Dakar. These Off activities 'are articulations of the art world city's ongoing dynamics as much as they are platforms to participate in the larger Biennale' (ibid.: 61). The author further pinpoints a fundamental aspect for a visitor: if one wants to learn about artistic practices in Dakar, these are visible in the Off spaces. As a pan-African Biennale, Grabski connects Dak'Art-In to two other mega-events in Francophone West Africa, to the African film biennial (FESPACO) in Ouagadougou, Burkina Faso, and the Biennale of African photography (Rencontres de Bamako) in Bamako, Mali. Main cultural-ideological metaphors for Dakar are 'port of entry' to the continent, and the city as 'a centuries-old crossroads' (ibid.: 70). Considering the selection of Dakar for a Biennale of visual arts, Senghor's *Premier Festival Mondial des Arts Nègres* (1966) too needs to be mentioned.

As a contact zone, Grabski elaborates on the Biennale's structures, the secretary general, its two committees, of organization and of selection. In doing so, the author draws important connections between these personalities and their professional and geographical backgrounds for the international visibility of the cultural institution. With the third framework, the Biennale as a discursive space, Joanna Grabski expands on the catalogues of the *Exposition internationale* and acknowledges an 'increased intellectual framing' (ibid.: 85). Internationally renowned scholars such as Salah Hassan or Simon Njami are 'mapping Africa within multiple discourses of local and global relevance' (ibid.). In line with these amendments of the catalogue, the author briefly presents the forum *Rencontres-échanges* where major subjects are debated during the Biennale's first week. The Biennale as discursive space is also the section in which Grabski discusses several artworks and attempts to show their local, regional, transnational and global interconnections. Indeed, these different scales of cultural spaces are a major concern of the author, insofar as they correspond to diverse fields of knowledge traditions: 'In Dakar's art world city and in the global landscape of biennales, Dak'Art represents a mediating platform among several geopolitical locations and spatial scales' (ibid.: 94).

Babacar Mbay Diop approaches the Biennale as a specialist in the philosophy of aesthetics. In his revised *Critique de la notion d'art africain* (2018), he deals with the cultural institution in the chapter 'La Biennale de Dakar: Attracteur culturel et vitrine des artistes africains' (ibid.: 243–67). The author was Secretary General of the Biennale for a short period of twenty-one months, and responsible for the eleventh edition of 2014 (ibid.: 244). Diop dedicates the larger parts of his outline of the Biennale to the core venue, the *Exposition internationale*, and the various other exhibitions. Here and there, the author mentions important personalities for the organization of an edition and members of the selection committees; sometimes he clearly refers to some artists. The reader thus gets an impression of the Biennale's multifarious search to include different art trends, as with the *Salon du design* (until 2008), or with the homage to a renowned Senegalese *sous-verre* artist, Gora Mbengue, in 2002. For Diop, the edition of 2004 is remarkable given that the *Exposition internationale* is inclusive for multiple art media; besides painting

there are photography, installation, performance, video, and interactive media arts (ibid.: 250). Up to the twelfth edition of 2016, the author highlights for each edition what he considers as most interesting, and mentions those artists who impressed him.

In an overall perspective, Diop asserts that the Biennale of Dakar is a mandatory site of transit for any African artist who wants to be known on the continent, and this is its principal task (ibid.: 263). With his review of the past editions, the author, however, invites the reader to follow him in questioning the Biennale's present African definition: 'the exigency today is to get out of an "Africanity" which could be necessary at its beginning, but which requires to be exceeded nowadays' (ibid.: 244).[8] The author indeed picks up this subject again at the end of his historical apercu, and argues for an opening of the Biennale to the artists of the world while privileging the African artists: 'this would be a much more interesting encounter for the melting of cultures' (ibid.: 265).[9] According to Diop, Dak'Art has become the principal cultural node for contemporary African artists, and a place of radiation of the state of Senegal (ibid.: 267).

The Present Volume

Two Theoretical Frames

For the theoretical conceptualization of the Biennale of Dakar we may retain the following aspects from the existing literature on this institution: in respect to art forms, the connections between their pan-African, international and contemporary dimensions, which also may be considered within multiple scales (local, transnational, international, global), the view of the mega-event as a contact zone and discursive field, and the interconnection of the art world with the sociopolitical field.

General biennial research largely focuses on the mega-event, the curatorial concepts, the invited artists and their artworks or artistic projects, and the impact on the construction of a contemporary art canon at a global scale. *Biennials and Beyond: Exhibitions that Made Art History: 1962–2002* (2013), a volume edited by Bruce Altshuler, presents so-called canonical exhibitions and relates them to art historical narratives – their impact at a global or national scale for contemporary art. Charles Green and Anthony Gardner (2016) speak in respect of this exhibition format of 'landmark survey shows of international contemporary art' (ibid.: 3) and conceptualize the canonization of contemporary art in connection with these formats, which 'have come, since the early 1990s, to define contemporary art' (ibid.). Of course, scholars nowadays agree that the investigation of a particular biennial requires a diachronic perspective, and to combine this with an examination of processes of biennial foundations all around the globe.

As already presented, from times incipient the Biennale of Dakar is stuck within politics of the state of Senegal and cultural visions of a generation of Senegalese artists (see Nzewi, Chapter 1, and Diba, Chapter 3). Historically, the state insists

on its political will to found the Biennale; it provides its structure (the General Secretariat) and ensures financially the organization of each edition, and thereby its cyclical cluster. For the state, the Biennale is above all an image of its cultural politics. The artists claim the idea of the international biennial, to have presented it by 1986 to President Abdou Diouf, and to have intensively lobbied for it until its institutionalization in 1992. For these artists, the Biennale is imagined as a challenge for their artistic practices, for the development of the local art world, and as an appropriate tool for raising the visibility of their art creations on a global scale.

The task of theorizing the role of the Biennale of Dakar thus incites us to formulate two conceptual approaches: (a) we consider it as a cultural institution in Georgina Born's (2010) terms and methodological implications; and (b) we discuss this institution as a 'field-configuring event' (Lampel and Meyer 2008).

Born's conceptualization of the notion of cultural institution stems from her research on two leading cultural institutions: the computer music institute IRCAM of Centre Georges Pompidou in Paris, and the BBC's cultural broadcasting in London (Born 2010). 'Cultural institutions constitute a social microcosm through which is accomplished not only the cultural production at stake, but which embodies metonymically the aesthetic discourses and controversies that surround any creative practice' (Born 2010: 191).

Further, Born views five key themes to be investigated: aesthetics and cultural objects; the place of institutions; agency and subjectivity; questions of history, temporality and change; and problems of value and judgements (ibid.: 172). As a cultural institution the Biennale of Dakar requires the examination of the following topics: the history of the institution and the history of Senegalese contemporary art; selections of artworks and aesthetic discourses; the impact of the structure of the Biennale on creativity and its objectives; the cultural institution as node of cultural encounters and as stretching out to other art institutions and art worlds. Furthermore, inscribed within a dynamic of anchoring and opening the Biennale is analysed in relation to the local art world, transnational institutions, and to the global biennials network (or circuit) – in other words, what is its local role regarding artistic practices, and art-related discourses and negotiations? Secondly, as a pan-Africanist conceived internationalism, each edition encourages to reflect upon the meaning of contemporary African art – by means of the selection of artists, their artworks and art projects, and also in respect to the forum of art debates *Rencontres–échanges*, which primarily focuses on African art criticism and art markets. Thirdly, in its relationship to the global discursive field, the Biennale needs to articulate its ambitions to be acknowledged as renowned mega-event by way of reformulating with each edition its uniqueness among this present-day multitude of similar exhibition formats.

The concept 'field-configuring event' (Lampel and Meyer 2008) was elaborated in management studies and economics specifically for the investigation of trade fairs. In anthropology, Hege Høyer Leivestad and Anette Nyqvist (2017) and Brian Moeran and Jesper Strandgaard Pedersen (2011) propose to apply it to the examination of mega-events at large, such art fairs, biennials, professional

conferences, fashion weeks, or festivals. Field-configuring events are 'settings in which people from diverse organizations and with diverse purposes assemble periodically ... to announce new products, develop industry standards, construct social networks, recognize accomplishments, share and interpret information and transact business' (Lampel and Meyer 2008: 1026). Regarding art biennials, one clarification is required: as the artistic director Simon Njami stressed at a press conference during the 2016 edition, biennials are primarily not marketplaces. Instead of economic valuation, the question is about their cultural validation by means of a biennial exhibition. Sales of artworks or the funding of artistic projects may be post-biennial returns of an artist's selection; here the inquiry rather is about a biennial's influence on the canonization of contemporary art and the orientation of art discourses within local, transnational and global fields.

Joseph Lampel and Alan Meyer conceive six characteristics for field-configuring events (2008: 1027), which we shall present in the following in relationship to the Biennale of Dakar. First, Dak'Art assembles individuals of diverse professional, organizational and geographical backgrounds. Dakar clearly positions itself as a node where artists, art professionals from different art worlds and art markets, and an art-interested public meet. Closely connected to this first characteristic are those enumerated as the third one, the Biennale as a site of (unstructured) opportunities for face-to-face social interactions, and number five for information exchange and collective sense-making. These characteristics comply with the state's cultural politics of creating Dakar as a major cultural node in Africa, and in the objective to contribute to the development of artistic practices and the professionalization of art criticism and the art market. These characteristics further meet the artistic intentions in relation to the Biennale, to exchange with peers, art world professionals, collectors and visitors.

Hence, the Biennale appears as a field of condensation of various knowledges (see Nyqvist et al. 2017: 13–14). It encompasses knowledges as experiences of regionally different sociopolitical worlds, of art discourses from diverse and multiple art worlds, artistic techniques, of the medium of pictures and the knowledge artworks are generating, or the knowledge curators are activating with their exhibition. Dominic Power and Johan Jansson (2008) emphasize as another aspect of such a site the 'multiple overlapping spaces' (ibid.: 424). Here we may consider the different exhibitions and the forum *Rencontres–échanges* of the official Biennale, and the innumerable activities that are under the umbrella of Dak'Art–Off (see Grabski, Chapter 10). Interests, motivations, orientations regarding art forms, their trends and specializations play a major role in the fashioning of these heterogeneous fields of the Biennale.

Originally, Lampel and Meyer (2008: 1027) mention duration as the second characteristic. The Biennale lasts for a month, from early May to early June, and most of its international visitors join in during the first two weeks. Time also relates to the cyclical dimension; the Biennale takes place biannually. These aspects are most important to embed the cultural institution within the wider global biennials network, and to be included in the yearly biennials calendar as published by the Biennial Foundation. Thereby, art world professionals, collectors and art-

interested individuals may travel from one biennial to the other, and plan and organize these voyages accordingly. This cyclical cluster (Power and Jansson 2008: 423) also has repercussions on organizational activities of the Biennale of Dakar, and on the curators' (artistic director's) comprehension of dominant art forms, etc.

Corresponding to characteristic number four, the Biennale includes ceremonial and dramaturgical activities. The grand opening ceremony at Grand Théâtre National is the political act at the Biennale. It unfolds around the president of the Republic of Senegal, with ministers, ambassadors, influential personalities of Senegal's political, economic and cultural fields, international biennial visitors, etc. It is a ritual performance in which the president of the organizational committee addresses the state's president regarding the Biennale's art-related achievements and needs (budget, legal status), and the latter's response highlights the major decisions of his government regarding cultural politics, in particular their benefits for the Biennale and Senegal's artists. This act ends with the award of the Biennale's prizes, above all the *Grand Prix du Chef de l'État*. The artistic ritual follows in the afternoon with the inauguration of the core exhibition, the *Exposition internationale*. This occurs quite informally, without any talks, music performances, or praise singers. The curatorial team, or the artistic director, guide the minister of culture and his entourage through the exhibition, in between artists, art world professionals and a large audience.

The sixth and final characteristic relates to the reputation the Biennale generates. By state decree (see Sankalé, Chapter 7) the Biennale has the mandate to promote contemporary African art, and specifically the work of Senegalese artists. Though formulated as a cultural-political goal, this aspect depends on many factors that are part of international art worlds connections. It is a matter of the validation of an artwork as contemporary African art, the result of decisions and negotiations in Dakar's art world, transnationally in other African art worlds. Further, an encompassing validation of contemporary African art is dependent on its position within the global canon of contemporary art. Hence, the status of the Biennale within the global biennials network is at stake, that is, its overall performance, the international fame of the specialists who select and invite artists and conceive the exhibitions, and those who decide on the awarding of prizes at each edition.

The concept 'cultural institution' orients the study of the Biennale more to art-related aspects in their intersection with the mandates of cultural politics. Considering the objective of its uniqueness, the local horizon turns the investigation to the formation and development of the institution; in a transnational perspective, it focuses on the condensation of Dak'Art's spatial connections in Africa and its diaspora; at a global level, the concept involves a view of Dak'Art within the global biennials network. Complementing, however, this strive for uniqueness with the possibilities of international-continental interconnectedness, future potentials of collaboration – instead of competition – could convey a further meaning to the openness of Senegal's cultural dualism of *enracinement et ouverture* (rootedness and openness). The concept 'field-configuring event' complements the former, and the investigation has to demonstrate how, in which way, and for which fields the Biennale of Dakar is field-configuring (see Nyqvist et al. 2017: 7).

Multiple Voices and the Structure of the Volume

The Biennale as a space of encounter of people with different sociocultural and geographical backgrounds is emblematic for the conceptualization of this volume. Authors from diverse places and regions, from various disciplines and professions mingle to shed light on different aspects of the Biennale and Dakar's art world. Some have researched the Biennale, others had functions related to the organization of the Biennale, or were commissioned to formulate reports on an edition's achievements.

Several authors were members of the organizational committee: the artist and curator Viyé Diba (1996, 1998, 2000, 2004, 2008, 2010, 2012), the art critic and curator Massamba Mbaye (2006, 2008, 2010, 2012, 2016, 2018), the art historian El Hadji Malick Ndiaye (2018), and the art critic and curator Sylvain Sankalé (2000). Two contributors were members of curatorial teams (selection committees): Sylvain Sankalé in 2000 and 2010, and Ugochukwu-Smooth Nzewi for the eleventh edition of 2014. For the same edition, Massamba Mbaye curated the exhibition *Diversité Culturelle* at Musée Théodore Monod. In 2018, Sylvain Sankalé co-curated Fondation Dapper's retrospective of renowned sculptor Ndary Lo in a side-wing of Ancien Palais de Justice, while Viyé Diba was curator of the exhibition *La Brèche* (the breach), the Senegalese Pavilion, in 2018. For this same thirteenth edition, El Hadji Malick Ndiaye conceptualized the forum *Rencontres–échanges*. The Senegalese government further commissioned in 2008 Sylvain Sankalé to write a report on the Biennale's performance, and in 2014 independent curator and founder of RAW Material Company, Koyo Kouoh. Finally, Joanna Grabski, Iolanda Pensa, Ugochukwu-Smooth Nzewi and Thomas Fillitz have extensively researched Dakar's art world and the Biennale, though from different disciplinary vantages: from art history (Grabski and Nzewi), and from visual culture and anthropology (Pensa, Fillitz).

Hence, all contributors to this volume on the Biennale of Dakar are specialists in the field, and they contribute with distinctive viewpoints, thereby relying on particular regional and disciplinary knowledge traditions. This also becomes apparent in the writing styles. They stretch from essays (e.g. Diba), via report style (e.g. Kouoh and De Caevel), to scholarly articles (e.g. Grabski, Ndiaye). We believe that this mixture of expertise, of professional traditions, and writing styles on the grounds of diverse geographical backgrounds contributes to the liveliness and complexity of the discussion of Biennale of Dakar, both as a localized cultural institution and as a field-configuring mega-event within international and global interconnections.

The volume is structured in three parts according to different scales of cultural fields. Part 1 – *Historical Perspectives* considers historical perspectives of the Biennale within the Dakar art world. Part 2 – *The Biennale of Contemporary African Art* focuses exclusively on Dak'Art, deploys organizational aspects, other overlapping spaces, and expands to future structures of the Biennale. Part 3 – *Contemporary African Art at Dak'Art* stretches considerations of the Biennale's performance within the network of African art worlds. Finally, the epilogue

reflects knowledge generated by the research of Dak'Art in contrast to the wider field of global biennial studies.

Ugochukwu-Smooth Nzewi starts with the examination of the history and foundation of the Biennale of Dakar and considers how it has served as an important link between the African and the international mainstream art worlds since the 1990s. His chapter describes the respective historical events, immediate sociopolitical and economic factors, local and foreign catalysts, which may have inspired or which led to the creation and subsequent consolidation of the Dak'Art Biennale as the preeminent large-scale international contemporary art event in Africa. For example, it considers the various roles played by state and non-state actors, especially local artists, as a critical stakeholder in the creation of the Biennale. Nzewi suggests that Dak'Art is a clear manifestation of Senegal's longstanding policy of cultural diplomacy, instituted during the administration of Léopold Sédar Senghor, the country's first president, and continued by successive presidents since then to promote international relations and to position Senegal as a leading cultural hub globally. The chapter situates Dak'Art within a constellation of postcolonial discourses within which it outlines its geopolitical focus, understood as pan-African internationalism. Exploring the early iterations of the Biennale – first as an event that was meant to oscillate between literary and visual arts in 1990; second as an international biennial with a universalist vision in the mode of the Biennale di Venezia in 1992; and finally, its reinvention as a pan-African biennale, its institutional identity since then – Nzewi considers Dak'Art as the more recent and a consistent example of twentieth-century black politics of cultural visibility and viability. Its geopolitical focus enables it to maintain a distinct and easily recognizable identity within the capacious field of art biennials.

Instead of a history of modern and contemporary art in Senegal, Massamba Mbaye takes the entanglement of politics, economy and art as line of reflection. The author structures his historical account along Senghor's dialectics of *enracinement et ouverture* (rootedness and openness), and chooses as historical periodization the presidencies from Léopold Sédar Senghor to Macky Sall. Mbaye argues that Senghor as a poet-president clearly set the standards for the state's cultural activities, and all decisions and cultural politics of Abdou Diouf, Abdoulaye Wade and Macky Sall need to be analysed from this vantage point. Although the economic crisis of the early 1980s, and the first structural adjustment programme, deviated the state's interests and activities regarding arts and culture, Abdou Diouf relaunched cultural projects during the 1980s and 1990s, and specifically founded in 1989 the Biennale of Dakar. Grand cultural projects were then on the agenda of Abdoulaye Wade, and raised a certain nostalgia for Senghor's epoch. In contrast, his successor, Macky Sall only progressively integrated culture and art into his political orientations. His initiatives may be considered as gradual reappropriations of cultural matters for Senegal's international politics. Whatsoever, Macky Sall will highly improve the Biennale's budget.

Part 1 ends with a prominent artist's considerations of artistic concerns in Senegal from a historical perspective. Viyé Diba thereby reflects the artistic endeavours in relation to the state and their insertion into society. He furthermore

extends his discussion into a transnational dimension of this field. The author's starting points are, on the one hand, the artists of his generation who began to detach themselves from Senghor's squeezing embrace and dogma. On the other, Diba points to artistic reflections and practices that search for personal, self-conscious solutions, against the innumerable voices from the Other, the former colonialist. The foundation of Dakar's art school and the birth of the École de Dakar movement characterize the first conceptual context, otherwise described as rootedness (*enracinement*). Nevertheless, the author stresses that the generation of the artists who were open to other influences, confluences, and ideas (*ouverture*), was already there in the 1970s in the Village des Arts. The artist also highlights the maturity of the artists in the early 1980s: endangered by economic recession, they envision and develop their freedom of expression without any state interference. With the broadly elaborated historical narrative, Viyé Diba explicitly rejects any suggestion that artistic practices and their artworks could be copies of currents of occidental art history. He instead demonstrates their striving for new means of expression, styles, the medium as support of the image, and materials. For the author, the Biennale of Dakar is a culmination of their endeavours in the fields of (fine) arts. It is a platform they consciously envisioned, and had been working for since the mid-1980s.

In the first chapter of Part 2, Ugochukwu-Smooth Nzewi and Thomas Fillitz investigate the central structures of the Biennale's artistic performance. After its reinvention as *Biennale de l'art africain contemporain*, new structures were implemented, such as the *Conseil scientifique/Comité d'orientation* (organization committee), the selection committee, and the application procedures for artists. In particular, the interplay between selection committee, secretary general and president of the *Comité d'orientation* appears paramount for the Biennale's success. The authors argue that the periodic restructuring of the selection committee – the subject of the first section of this chapter – constitutes earnest reflections to improve the Biennale's exhibitions in its embedment into the global biennials circuit. Dak'Art is not just another art festival, another large-scale exhibition. For the Biennale secretariat, the constitution of the Biennale of Contemporary African Art in 1993 is the inception of a process of conceptualizing this particular biennial form in relation to the local art world, to those on the African continent, and to the global biennial network.

El Hadji Malick Ndiaye focuses on another space of the Biennale, the forum *Rencontres–échanges* (Encounters and Exchanges). This platform of debate was explicitly introduced with the second edition in 1996, and since then has been a fundamental element of the Biennale's performance. Ndiaye asks about the influence the talks, round tables and discussions had and have on selections of artworks in the Biennale's exhibitions, and on the practices of Senegal's artists. In doing so, the author connects Senegal's history of art with cultural politics. Ndiaye examines structural reforms and new scientific orientations within the Biennale, then analyses discursive regimes around central subjects of art criticism and markets of contemporary art. In his last section, the author argues for a new conceptualization of aesthetics as a consequence of *Exposition internationale* at

the thirteenth Biennale edition (2018), and which future trajectories are being opened.

Fillitz shifts the focus on Dak'Art and its public. The author argues that another aspect of the uniqueness of such a mega-event is how it concentrates an audience in its sites at a certain time, and who these social agents are. Whereas terms like public, or audience, may insinuate such entities as homogeneous, their huge heterogeneity rather is at stake: artists, art world professionals, market agents, collectors, art amateurs, and many other criteria (age, education, financial capacities). An often applied strategy is the subdivision of a biennial's audience into international and local, and a subsequent argument is the lack of local public. Fillitz studies different meanings this latter notion may take. In the state's discourse it refers to citizenry, claims the mandate to the Biennale to improve this segment. For local artists and many art world professionals, the same notion is understood as an improvement of art world members, hence also of new buyers of art. The author, however, projects the idea of a particular audience of the Biennale that is conceived beyond this divide, and would emphasize both the institution's uniqueness as well as its interconnectedness with other continental art institutions, ensuing another perspective of Dakar as major cultural node.

The chapters of Sylvain Sankalé (7) and Koyo Kouoh and Eva Barois De Caevel (8) are deeply connected to former evaluation reports the authors were commissioned to compile. Their chapters therefore are not only studies of what is given, or what has evolved in whatever direction during the various editions. More so, they both in contrasting ways deal with future organizational perspectives and necessary reforms of the Biennale of Dakar. Sylvain Sankalé analyses what he views so far as strengths and weaknesses of the cultural institution. If the Biennale intends to maintain its objective of being the principal vector of contemporary African art for the world, and an exceptional space for the encounter and exchange of artists and art world professionals, such adaptations in many fields are more than necessary. Sankalé, however, not only argues in respect of the artistic dimension of the Biennale. From the beginning, he combines the latter with state requirements for its cultural politics, to celebrate internationally the Biennale for the radiance of Senegal's cultural will. The author argues that reforms not only strive to elevate Dak'Art to the level of similar, internationally most appreciated biennials, but can also be viewed in scope of an adequate affirmation of Senegal's artistic capacities and of their symbolic valorization. Being as well a renowned lawyer, Sankalé fuses all the specific reforms into the crucial question of the legal status of the Biennale.

Koyo Kouoh and Eva Barois De Caevel start precisely with the problem of the legal status – the Biennale being affiliated to the state – and recall that basically all evaluation reports encourage an autonomous institution. Kouoh and De Caevel too view reforms as mandatory; according to the authors, the Biennale is at present at a crossroad where it is at risk of losing its aura and international prestige. Most interestingly, Kouoh and De Caevel argue for a fundamental reorientation of the Biennale. If it had been defined as mega-event for contemporary African art in 1993, now the authors claim the need for an intensified openness to favour the pan-African spirit of sharing and exchanging. They list a number of approaches

and recommendations that will help secure the long-term future of the Biennale within the global context without losing its unique institutional identity.

Ugochukwu-Smooth Nzewi opens the discussions of the subject of Part 3, Dak'Art's global reflection of contemporary art while focusing on its African dimensions. In his chapter, Nzewi analyses a broad range of artworks exhibited at Dak'Art from 1992 to 2018. He addresses the period from 1992 to 1996, the first phase of the Biennale, as the conservative period where it exhibited mostly paintings, sculptures and mixed-media, all of which bore the formal outlines of postcolonial modernism. This formative period in the history of the Biennale was when it struggled with its institutional identity and the advancement of a contemporary African art that was both international and transnational in scope. From 1998, Dak'Art began to take into account emerging trends in international art and to showcase an expanded range of art forms including performance, photography, video and conceptual art. This development suggests the waning of tropes that valorized cultural nationalism such as mask icons, geometric forms, stylized human forms, etc., hallmarks of modernist preoccupations in African art. With an increased awareness of cultural globalization, Dak'Art began to offer a context of understanding the zeitgeist of contemporary African art and the elaboration of artistic contemporaneity. The chapter suggests that while the Biennale provides an important avenue to encounter recent trends in African art, it does not provide a complete picture of what is created within and outside Africa under the rubric of contemporary African art.

Joanna Grabski's chapter reflects the reciprocal impacts between the official Dak'Art–In sites and Dak'Art–Off. If Off exhibitions were previously considered as secondary destinations of the Biennale of Dakar, the author asserts that, at present, the Off events are what makes the Biennale a collectively mobilized urban project. Besides the interconnections between the In and the Off, the chapter further elaborates the relationship of the Off exhibitions to Dakar's art world city. Grabski specifically argues that the embedment of Dak'Art–Off within Dakar's art world activities characterizes the Biennale's uniqueness within the global biennials network.

Iolanda Pensa undertakes a comparative study of Dak'Art and SUD–Salon Urbain de Douala, a triennial event dedicated to public art by the cultural association Doual'art, Cameroon. With the comparison, Pensa highlights some of the elements that characterize the two events as field-configuring, such as the different relationship with the city and the territory and the discordant strategy in the selection of the artists and in the production of the artworks. Due to the close relationship to the immediate environment, the city of Douala, a clear impact on artistic practices can be observed for SUD–Salon Urbain de Douala, whereas the author sees the Biennale as operating in a wider field by virtue of its official invitations and the welcome of a large number of art professionals. In addition, Pensa further recognizes a certain social quality in informal and non-organized realms of Dak'Art when artists are still waiting for the arrival of their works, others are searching the markets for hard-to-find materials, and participants unfamiliar with the city are looking for advice, and subsequently to engage in new exchanges.

In the epilogue, Fillitz and Nzewi describe Dak'Art's position within the global biennials network, a continuing preoccupation of the Biennale's artistic discourses, specifically in relation to strategies of centre–periphery constructions, and to critiques of global canon productions. Indeed, its foundation as a mega-event of contemporary African art occurred some years after the founding of the Bienal de La Habana in 1984 as a biennial dedicated to the so-called 'Third World', the two iterations of the Johannesburg Biennial, in 1995 and 1997, and before the exponential growth in the number of biennials on an unprecedented global scale. In connection with global biennial studies – either models for describing the history of the foundation and proliferation of this exhibition form, or problems that are seen in conjunction with this worldwide multitude of cultural institutions – the authors present the peculiar narration of Dak'Art by means of which it asserts its uniqueness within the global biennials network, a self-positioning that has nothing to do with those global discourses that structure biennials according to centre–periphery hierarchies. And regarding global art canon productions, the recent iterations of the Biennale of Dakar manifestly prove that the reflection of globalism of contemporary art deals with aesthetics of interweaving in the creation of contemporary African art.

Part I

HISTORICAL PERSPECTIVES

Chapter 1

THE FOUNDATION AND HISTORY OF THE BIENNALE OF DAKAR

Ugochukwu-Smooth C. Nzewi

Dakar will be hosting the Biennale of Arts and Literature from December 10–18, 1990. This regular event will enable men of culture on this continent and in other countries to meet and communicate and to share fascinating experiences of creating and recreating. Dakar will thus offer our peoples one of those moments of fraternity when civilization creates, thinks about what it is, and prepares to go forth and conquer the future.

—Diouf in Sylla 1998: 148

President Abdou Diouf chose an august occasion in October 1989 during the annual national *Salon* organized by Association Nationale des Artistes Plasticiens Sénégalais (ANAPS, National Association of Senegalese Visual Artists) to formally announce the creation of Dak'Art. The symbolism of the occasion, which traditionally served as an outlet for the state to collect new works for the national collection, is hard to miss. At the international level, the art world was going through a momentous shift, occasioned by the formal the end of the Cold War and the rising tide of neoliberal globalization. The ground-breaking *Magiciens de la Terre* exhibition (18 May–14 October 1989), which featured a number of African artists (including Senegalese Seni Awa Camara) who gained international fame subsequently, opened at the Centre Georges Pompidou and the Grande Halle de la Villette, initially to subdued attention, to challenge the invisibility and denial of contemporaneity of non-Western art and artists in the international mainstream. Diouf's announcement on 7 October, a week before *Magiciens de la Terre* officially closed in Paris, cannot be any more coincidental and/or auspicious. It is more likely that Diouf may not have been aware of the event in Paris that would shift the understanding of contemporary art in a global context in the incoming decades. In any case, in announcing the creation of the Biennale of Dakar, President Diouf was prescient about the shape of things to come.

As the opening epigraph suggests, President Diouf's choice words – fraternity, representation, international relations – capture some of the values that art biennials claim they stand for. Addressing men/women of culture in Africa and

beyond to rally together suggests that he had something more historic in mind. President Diouf echoed lofty sentiments expressed by black luminaries at different historical moments during the twentieth century to challenge black and African sociopolitical and economic dehumanization and exploitation and cultural conditions of anonymity on the international stage. For example, he recalls the stirring communiqué drafted by the venerable pan-Africanist W. E. B. DuBois at the end of the first pan-African Congress in London in 1900, addressed to the 'Nations of the World':

> In the metropolis of the modern world, in this the closing year of the nineteenth century, there has been assembled a congress of men and women of African blood, to deliberate solemnly upon the present situation and outlook of the darker races of mankind. The problem of the twentieth century is the problem of the color-line, the question as to how far differences of race – which show themselves chiefly in the color of the skin and the texture of the hair – will hereafter be made the basis of denying to over half the world the right of sharing to their utmost ability the opportunities and privileges of modern civilization.
>
> DuBois in Langley 1979: 738–9

DuBois was one of the forty black leaders from the United States, the Caribbean, Europe and Africa who convened in London in 1900 for the first pan-African Congress to address the abject situation of black people dealing with the yoke of racism and colonialism and inserting that situation into global consciousness (Hooker 1974; Sherwood 2011). However, the more direct and pertinent example to President Diouf's speech is Alioune Diop's inaugural editorial for *Présence Africaine* in 1947. The Senegalese philosopher, social entrepreneur and founder of the journal *Présence Africaine*, Diop charged 'all contributors of good will (White, Yellow or Black), who might be able to help define African originality and hasten its introduction into the modern world' (Diop 1947: 8–9). He was responding to the unfolding modern cultural ferment and situating Africa within a global conversation in which it had hitherto been sidelined.[1] President Diouf was therefore revamping the old ideological quest for black and African global relevance that dates to the early decades of the twentieth century, but now under a postcolonial climate and with a new framework.

This chapter explores the motivations, as well as the sociopolitical, economic and cultural conditions in Dakar and elsewhere that may have spurred the emergence of Dak'Art as a major international exhibition with its specific brand of cultural politics. As such, it considers the conflation of actors, events, ideological and intellectual perspectives (historical and contemporary) that catalysed Dak'Art either directly or indirectly. This would include President Diouf in his constitutionally assigned role as the benefactor and protector of arts and culture; the art community in Senegal, of which visual artists were a major stakeholder; and Senegal's longstanding policy on cultural diplomacy instituted by the country's first President Léopold Sédar Senghor. The chapter also considers the legacy

of black cultural politics of visibility enunciated at different historic moments during the twentieth century that, arguably, found a renewed impetus in what scholars refer to as the postcolonial turn, which intersected with the globalization of the international art world at around the period of Dak'Art's creation in 1989 and its formative period in the 1990s (McCarthy and Dimitriadis 2000; Smith 2011).

History and Context

The origin of the Dak'Art Biennale is a contested narrative. It is not clear whose original idea it was. Amadou Lamine Sall, who, as the foundational secretary general, supervised the maiden and second iterations of the Dak'Art in 1990 and 1992, credits Moustapha Ka, Senegal's Minister of Culture in the late 1980s and early 1990s, as the mastermind.[2] Sall's position must be prefixed in that Minister Ka served at the pleasure of President Diouf and would have been implementing a decision reached by the Diouf administration. In many interviews and discussions with a cross-section of the art community and scholars of Senegalese art during my research time in Dakar between 2008 and 2018, the general consensus is that the art community was instrumental to the creation of Dak'Art.[3] The conventional narrative is that Senegalese artists were engaged in a sustained campaign throughout the 1980s for an international arts event on the scale of the *Premier Festival Mondial des Arts Nègres* (First World Festival of Negro Arts) that the state organized in 1966. The event placed the country on the global cultural map and represented the high point of Senegal's cultural diplomacy in the early postcolonial period.

Yet this general narrative, that situates the artists' community as original initiator of Dak'Art, must be weighed against the fact that the inaugural Biennale in 1990 focused on literature and not visual art. Dak'Art's first Secretary General, Amadou Lamine Sall, an acclaimed poet, insists that Dak'Art must be seen as part of the trajectory of grandiose cultural events initiated and executed by the government of Senegal since independence to burnish the country's image internationally. In other words, the Biennale reaffirms that cultural diplomacy has always been part and parcel of the enunciation of national development since the country's independence in 1960. From inception, Dak'Art was set up as an elaboration of Senegal's cultural policy agenda.

After gaining political independence from France in 1960, successive Senegalese governments considered culture to be a key aspect of national planning, social development and economic prosperity. The tone was set by Léopold Sédar Senghor. As the first president of independent Senegal, Senghor defined culture as the foundation on which national development and economic growth rests. His promotion of culture was part of a development aesthetic which encompassed his political, economic and social agendas (Ebong 1991: 198). *Négritude* was the ideological foundation of Senghor's cultural policy (Markovitz 1969: 68–71). A modernist movement, it insisted on the recuperation and deployment of assumed

African cultural roots as a basis for modern literature, philosophy and visual arts. Critics of *Négritude* have long viewed it as an essentializing racial ideology which romanticized Africa. Its sympathizers acknowledge the historical situation that gave rise to the movement.

Caught between Europe's cultural turmoil and post-war anxieties, and the 'borrowed personality'[4] imposed on them by the French cultural policy of assimilation, Senghor from colonial Senegal, Aimé Césaire from colonial Martinique and Léon Gotran-Damas from colonial French Guyana, who later founded the *Négritude* movement, felt a deep sense of anxiety and isolation from the mainstream French society. The colonized subjects were expected to adopt French customs and cultures, and were, at least in theory, granted the rights of French citizens. By imitating French ways and discarding native or ancestral cultural values, black students and intellectuals adopted a borrowed personality that consigned them to an interstitial space in which they were no longer natives nor fully French (Diouf 1998). The colonial policy of assimilation was introduced in the late nineteenth century to expand French cultures to the colonies with the intention of making black Frenchmen out of colonial subjects. *Négritude* thus arose from their desire to overcome self-rejection by consciously returning to assumed cultural roots.[5] In that sense, it was a response to French colonialism and thus decidedly anti-colonial and self-empowering.

When Senghor became the president of the newly independent Senegal in 1960, he transformed *Négritude* into a functional state ideology and the bedrock of his modernization agenda. The concept gave rise to an intensive and extensive development of modern culture in Senegal in the 1960s and 1970s. In his multiple roles as president, cultural broker and art patron par excellence, he was committed to using the public space to articulate a postcolonial modern culture that reinforced the social fabric. This new culture recalled the cultural past yet took full account of changes in the cultural present. Senghor's cultural policy was framed as the dialectical concept of *enracinement* (rootedness) and *ouverture* (openness) (M'Bengue 1973). The culmination of Senghor's cultural diplomacy in the first decade of independence was the successful staging of *Premier Festival Mondial des Arts Nègres* (First World Festival of Negro Arts) in Dakar, in April 1966, which celebrated black cultural achievements and fortitude after many centuries of adversity.

The idea of a pan-African festival in Africa emerged initially at the mid-century landmark Congress of Black Writers and Artists in Paris in 1956 and in Rome in 1959. Convened by the Senegalese writer and philosopher Alioune Diop using the platform of the journal *Présence Africaine*, the two congresses were staged to galvanize black solidarity and to promote cultural internationalism and modernism in anticipation of the end of colonialism and the critical necessity of decolonization. While recognizing that black people were not the only victims of racism and colonialism, Diop believed that a black cultural renaissance would help to counter racial prejudices and lead to global peace and mutual understanding among the world's different races (Diop 1956: 3–6). The outline for the First World Festival of

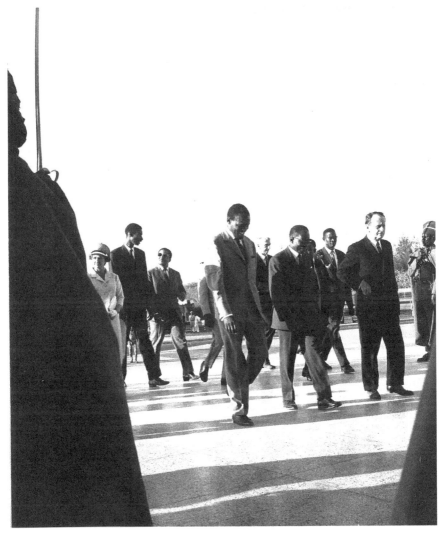

Figure 1.1 President Léopold Sédar Senghor and André Malraux arriving at the Musée Dynamique, *Festival Mondial des Arts Nègres*, Dakar 1966. Photographer as yet unidentified. Courtesy PANAFEST Archive, Musée du Quai Branly–Jacques Chirac.

Negro Arts was sketched in Paris and solidified in Rome. The festival was to become a symbol of 'the links between political liberties and cultural liberties' (Musée du Quai Branly 2010). Its exhibition of global modern black art titled *Tendances et Confrontations* can be rightly seen as the precursor of Dak'Art [Nzewi 2013; Underwood 2019. (For more on Senghor's presidency, see Chapter 2 of this volume)].

Figure 1.2 Installation view of *Tendances et Confrontations* (*Tendencies and Confrontations*) exhibition, *Festival Mondial des Arts Nègres*, Dakar 1966. Photo © Roland Kaehr. Courtesy PANAFEST Archive, Musée du Quai Branly–Jacques Chirac.

The Road to Dak'Art: The 1980s and the Structural Adjustment Programmes

When Senegal's economy began to falter in the mid-1970s, attention shifted from culture to more pressing economic demands. The cumulative effect of the decline in earnings from export and increased external borrowing wore Senegalese economy thin and led to the retirement of Senghor from the presidency. He handed over to his protégé Abdou Diouf, a trained economist and technocrat, in 1981. Senegal's economic woes made it amenable to the reform package proposed by multilateral financial institutions, such as the International Monetary Fund (IMF) and the World Bank (Chowdhry and Beeman 1994). Diouf's government shifted Senegal's economy from social welfarism to economic liberalism in the bid to implement the reform package designed by the World Bank and IMF.[6] The movement towards free markets and away from state intervention was known as the structural adjustment programmes (SAP; Easterly 2005). The reforms initiated by President Diouf provided only limited support for arts and cultural institutions.

The historian Mamadou Diouf points out that under President Diouf's reform programmes, 'technocrats equated cultural events with money' (Diouf in Snipes 1998: 72–3). While arguing that it was not only money that was required to promote cultural events, Diouf states that artistic events were no longer important 'because culture was no longer a part of daily life as it was during the Senghor years' (ibid.). During this period, many cultural associations emerged to exploit

new forms of financial capital associated with liberalization. The growing number of private galleries, foreign cultural centres and international opportunities provided artists with alternative sources of income. The reduction in state-led cultural programmes was offset in part by foreign cultural centres, especially the French Cultural Centre, but also the Goethe Institute, the Dutch Embassy, the Swiss Cultural Centre and the United States Information Service (USIS – now defunct; Harney 2004: 226–30). However, they did not effectively offset the sort of patronage formerly provided by the state during Senghor's era.

The liberalization of the economy in the 1980s altered government relations with both foreign and local interest groups, of which the artists' community was one. As government support for national art exhibitions waned, artists met the challenge by becoming more entrepreneurial. The annual *Salon National des Artistes Plasticiens*, which served traditionally as the channel through which the state collected works for the national collection, faced limited funding. The organization of the *Salon* was taken over by Association Nationale des Artistes Plasticiens Sénégalais (ANAPS, National Association of Senegalese Visual Artists), an artists' cooperative begun in 1984 which emerged from the ashes of defunct Artistes Plasticiens du Sénégal (ARPLASEN, Visual Artists of Senegal), the state-funded artists' organization created in 1975. Unlike the old ARPLASEN, ANAPS was independent of the state. From 1986 on, the annual national *Salons* were organized by ANAPS, which expanded the national *Salon*'s sphere of influence to include public lectures and studio meetings as a way of returning Senegalese art to the public (El Hadji Sy in Huchard 1989: 76).

In 1986, ANAPS organized *Art contre l'Apartheid* (Art Against Apartheid) at the Musée Dynamique (Huchard 2010: 405–12). It was the second annual exhibition of the newly reconstituted artists' association. Weaned off the patronage of the state, unlike its predecessor the defunct ARPLASEN, ANAPS had begun to organize its own exhibitions and to explore themes of its own choosing, some focused on social events and quotidian experience, others politically motivated such as *Art Against Apartheid*.[7] The struggle to liberate South Africa was understood around the continent as a fight against the last bastion of colonialism and racism in Africa.

Art contre l'Apartheid may have been inspired by *Artists Against Apartheid*, organized by the Paris-based 'Artists of the World against Apartheid' with the support of the United Nations Special Committee Against Apartheid to mobilize international awareness for the liberation struggles in South Africa under Apartheid. Featuring eighty leading artists from all over the world, the exhibition opened in Paris in 1983 and subsequently travelled to Spain, the Netherlands, United States, the Caribbean and Japan, during that decade.[8] *Art contre l'Apartheid* portrayed solidarity closer to home, given that *Artists Against Apartheid* was never held in continental Africa, and was a demonstration of the aspiration of Senegalese artists to be part of a broader international conversation.

While delivering the opening speech in his capacity as the president of ANAPS at the exhibition, the artist El Hadji Sy paid homage to President Diouf as the protector of arts and letters in Senegal, but also addressed the government's failure

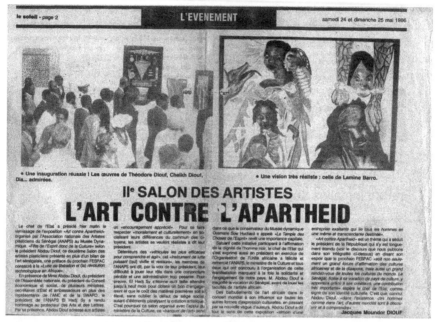

Figure 1.3 Le Soleil (review), Art Against Apartheid, Musée Dynamique, Dakar, 23 May–23 June 1986. Courtesy Weltkulturen Museum, Frankfurt/Main; Archive El Hadji Sy.

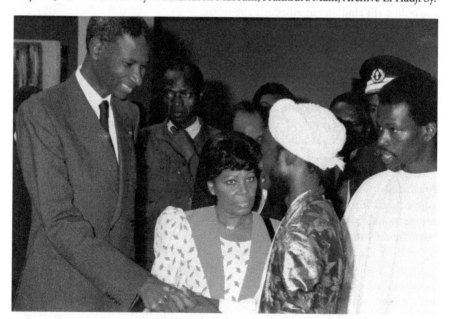

Figure 1.4 From left to right: President Abdou Diouf, Mme Elisabeth Diouf, Babacar Sedikh Traoré Diop and El Hadji Sy at the exhibition *Art Against Apartheid*, Musée Dynamique, Dakar, 23 May 1986. Courtesy Weltkulturen Museum, Frankfurt/Main; Archive El Hadji Sy.

to implement Senegal's cultural policy as it is required by the constitution. Sy pointed out that in spite of the fact that the state reduced its budget for cultural activities to 1 per cent of the total budget, it still found it hard to implement the budget (Huchard, ibid). This situation, he claimed, had left artists demoralized and unable to fulfil their role as cultural ambassadors for Senegal. In essence, he was calling out the government for paying lip service to arts and that it was dismantling the structures for cultural development instituted by his predecessor, Léopold Sédar Senghor.

An obviously chastised Diouf praised the creative output of Senegalese artists and their astuteness in organizing an exhibition that addressed a worthy cause (Diouf 1995: 236). While acknowledging the constraints inflicted on Senegal's fragile economy, the result of the deep spending cuts as stipulated in the structural adjustment programme, he reiterated that culture was a binding imperative of the state. Culture, as Diouf pointed out, represents an original contribution of any people, and Senegal's cultural policy reflects Senegal's cultural authenticity. The state, 'as a matter of priority . . . is duty-bound in setting up functional infrastructures able to implement [its cultural] policy' (ibid.). President Diouf was once again restating the centrality of arts and culture to the national development of Senegal.

Coincidentally, the exhibition was organized during President Diouf's chairmanship of the Organization of African Unity (OAU, now the African Union), the premier pan-African institution. In addition to performing a kind of critique of Diouf's government failing in its constitutional role to arts and culture, the exhibition also drew attention to the disappearance of pan-African discourse from government business, as was the case under the previous administration. Arguably, *Art contre l'Apartheid* laid the groundwork for Dak'Art to emerge, as artists used the occasion to remind the government of its cultural policy. In addition, the exhibition reflected the collective will of artists to address an issue of cultural, political and ideological significance in the spirit of pan-Africanism. This display of a united front would outline their subsequent determined pursuit of a biennial. Unsurprisingly, the decision to create an international art event was communicated to artists at a colloquium organized under the aegis of OAU in 1989 (Sylla 1998). Diouf reconfirmed his decision at the award ceremony of the annual Grand Prize of Arts and Letters on 6 August 1989 (Diouf in Konaté 2010: 115).

The Making of a Pan-African Biennale

The year 1989 was a pivotal one in Senegal. President Diouf's government had emerged from the worst part of the country's economic crisis in the 1980s. The government had completed the second phase of the structural adjustment programme and there was relative economic stability to undertake cultural projects again. Diouf's regime was ready to listen to the concerns of artists (Konaté, ibid). In partnership with artists, the government created a new artists' village on the old site of a Chinese construction company in the Yoff suburb of Dakar. As public-supported cultural activities resumed, the state once again adopted the

policy of *enracinement* and *ouverture* as the framework for Senegal's participation in local and international exhibitions. In the 1990 celebration of the bicentennial anniversary of the French Revolution in France, Senegal contributed a state-organized exhibition at La Grande Arche de la Fraternité in Paris (Niane 1989). The exhibition, *Art sur vie: Art contemporain du Sénégal* (Art on Life: Contemporary Art of Senegal) was modelled on the 1974 travelling exhibition, *Art sénégalais d'aujourd hui* (Senegalese Art Today).[9] The exhibition followed the formal announcement by President Diouf in October 1989 of the government's intent to establish a festival of literature and visual arts, from which Dak'Art subsequently emerged, and in hindsight, his biggest cultural accomplishment and legacy.

The centralizing objectives of Dak'Art as enunciated in 1990 were: to promote national development and cultural diplomacy; create a space of dialogue between Africa and the rest of the world; promote creativity and literary and artistic developments; intensify inter-African cultural exchanges and integration; elaborate the cultural dimensions of development; implement sub-regional and regional strategies for the creation, financing and profitability of creative and cultural industries in Africa; and lastly, encourage cultural cooperation that would lead to a better protection and distribution of African cultural property (Diouf 1990: 3). Moustapha Ka, then Minister of Culture, suggested that Dak'Art seek to provide the context and venue for the assessment of artistic and cultural development in Africa (Ka 1990: 5). This intention underlined the configuration of Dak'Art 1990 as a contact zone for cultural experts in Africa, political and economic leaders, government officials and foreign interlocutors to meet and offer proposals and policies on contemporary culture of Africa.

The maiden edition of Dak'Art titled *Rendez-vous des Lettres* was a literary festival that included a parade by elementary and secondary school students and the national band, theatre performances, the screening of African films, literary presentations, music concerts, art exhibitions, and the main event, which was a colloquium on the theme *Aires Culturelles et Création Littéraire en Afrique* (Cultural Areas and Literary Creation in Africa). The colloquium aimed to raise questions on the relationship between culture and literature, and to facilitate a dialogue on African cultural cooperation and collective development as critical to economic prosperity in Africa. Although the focus was literature, Dak'Art 1990 included two art exhibitions, at the Galerie Nationale (National Gallery), Dakar, which included about 100 artworks from the state collection, and artists' open studios at the new Village des Arts, situated close to the highway leading to Léopold Sédar Senghor International Airport (Sylla 149). Even the presence of former President Senghor, who had come from Verson, in the Normandy region of France, to which he had retired after leaving power, failed to draw significant international attention. This led the state to reevaluate the idea of alternating the Biennale between literary art and visual arts. Consequently, the state decided to convert literary Dak'Art to an annual national *Salon* of literature and letters.[10]

Dak'Art 1992, however, was the first real attempt to address the concerns of Senegalese artists for an international artistic exchange. It was framed as a venue

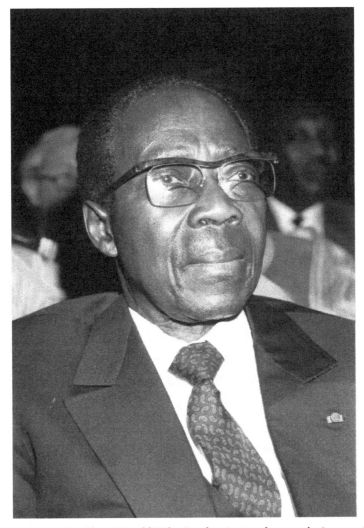

Figure 1.5 Former President Léopold Sédar Senghor in attendance at the inaugural Dak'Art Biennale in 1990. Courtesy of Secrétariat Général de la Biennale de l'art africain contemporain.

of encounters between African and international artists, and as a space for cultural dialogue among civilizations. According to Minister Ka, Dak'Art 1992 was expected to serve as, among other things, the venue for the meeting of cultures, a space of dialogue among civilizations, the celebration of the resuscitated École de Dakar, modern African art, black art, and world art (Ka 1992: 2). In his speech at the opening ceremony at Daniel Sorano Theatre on 14 December 1992, President Diouf described Dak'Art as the successor to the First World Festival of 1966, and dedicated the Biennale to the memory of his predecessor Senghor:

We want to tell him that the *École de Dakar*, this Dakar which gave birth to the famous Black encounter of 1966, carries his stamp at the end of the day. It is the synthesis of traditional and modern creativities, this mixing of forms and themes which make each brushstroke a declaration of the universality of art … contemporary art has the same spiritual, moral, and aesthetic value as our traditional art. It deserves the same respect, the same admiration, and also deserves to reach the same heights.

<div align="right">Diouf 1992: 10</div>

Diouf's attempt to connect Dak'Art to the First World Festival suggests continuity in Senegal's cultural policy. Simultaneously, it reflected an inchoate articulation of Dak'Art's geopolitical ambition (Nzewi 2012: 34–40). Pan-Africanism at Dak'Art 1992 was, at best, rhetorical, asserted only in the speeches, such as those by President Diouf and Minister Ka. There was nothing in the activities that reflected pan-African solidarity.

Despite its theme of *Arts et Regards croisés sur l'Afrique* (*Perspectives on Art in Africa*), Dak'Art 1992's official exhibition lacked a curatorial focus and the display of work was incoherent and mediocre (Zaya 1993). Art historian Clémentine Deliss, who was a member of the Biennale's jury in 1992, outlined the major weaknesses in a review, writing that the organizers deferred too much to Western

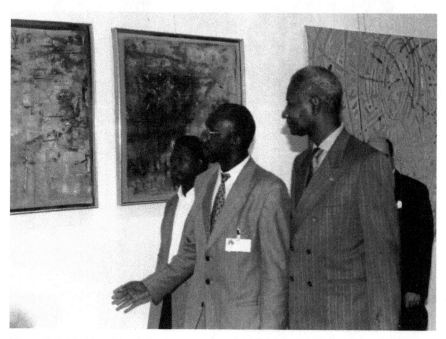

Figure 1.6 President Diouf viewing a section of the International Selection of Dak'Art 1992 at the IFAN Museum, Dakar, December 1992. Courtesy of Secrétariat Général de la Biennale de l'art africain contemporain.

(French, in this context) cultural brokers who, among other things, resisted any attempt to challenge their authority on the content and shape of the Biennale (1993: 18, 20, 23, 84–5). She also suggested that they relied too much on French expertise and a so-called international art circuit built on a Eurocentric foundation.[11] In fact, the exhibition catalogue was published by the French magazine *Cimaise*. Deliss argued that the organizers were more interested in courting Western validation, which prevented them from really developing a pan-African focus for the Biennale.[12]

The process of addressing the ambiguous articulation of Dak'Art's agenda and the numerous organizational and curatorial challenges that plagued Dak'Art 1992 began in earnest at the Biennale's conclusion. Sall was relieved of his position as secretary general of Dak'Art. Coura Ba Thiam, who replaced Moustapha Ka as the Minister of Culture, accused Sall of lacking professional and organizational competence. According to Sall, he was not replaced but resigned of his own volition because he could not work with Minister Thiam.[13] Thiam was keen to implement the recommendations of the European Union uncritically. Sall said that he walked away from the position because he could not accept the evaluation by Isabelle Bosman and her committee from the EU, who recommended that Dak'Art be transformed into a biennale of visual art.[14] Sall stated that he was annoyed that Europe wanted to dictate the nature of the biennale because the EU was bearing the larger percentage of the total cost of Dak'Art.[15] His annoyance could have stemmed from his literary background as a writer and poet, and also from the extent to which he was important to the development of the biennale. Certainly, Sall would have had misgivings concerning the idea of focusing Dak'Art solely on visual arts.

Yet Sall was neither an administrator nor an expert on contemporary art. He was replaced by Rémi Sagna, who trained as a cultural administrator and had bureaucratic experience. He was also the choice of Senegalese artists who wanted to reclaim for themselves an art biennial. Artists had also begun to lobby Minister Thiam to refocus the biennial exclusively on visual art.[16] In June 1993 the Ministry of Culture and the Dak'Art Secretariat organized a week-long evaluation panel sponsored by the European Union to address the issues and criticisms that had arisen at Dak'Art 1990 and 1992.[17] The panel included local artists such as Viyé Diba and Ousmane Sow, art historians such as Abdou Sylla, along with European experts, including Isabelle Bosman of the EU. The major issue discussed was the direction Dak'Art was to take: would it remain an international biennale or shift its focus to a geopolitical context?[18] It was already agreed that alternating the biennale between literary and visual arts was no longer feasible. It was also noted that African and African diaspora artists had little visibility at the international level. Thus, the decision was made to transform Dak'Art into a pan-African biennale totally dedicated to contemporary African art.

In clearly outlining a new direction for Dak'Art, the evaluation panel expected that the Biennale would become the foremost international venue for contemporary African art and artists. With the new pan-African identity, Dak'Art would distinguish itself from other biennials that had more financial strength and international recognition. While announcing the reinvention of Dak'Art in

October of 1993, Minister Thiam introduced changes in the Biennale's organizational structure of Dak'Art (see Fillitz, Chapter 6). Dak'Art did not take place in 1994 due to the reorganization. Rémi Sagna had just resumed his appointment as secretary general and needed the time to seek funding support from the government and potential local and international collaborators.[19] The Biennale was postponed to 1995. When Dak'Art could not hold it then due to lingering financial and organizational problems, it was moved once more, to 1996.[20] In late 1995, Coura Ba Thiam was replaced as Minister of Culture by Abdoulaye Elimane Kane, who fixed a substantive date. According to Rémi Sagna, Kane was the minister who truly empowered the Dak'Art Secretariat. He left financial, artistic and logistic responsibilities to the organizers, and only stepped in when his oversight was required.[21]

On 9 May 1996, Dak'Art became formally known as the Biennale of Contemporary African Art at the opening ceremony of Dak'Art 1996, held in the Daniel Sorano Theatre. In his opening speech, President Diouf once again made references to the First World Festival of 1966 as the main inspiration of Dak'Art (Diouf 1996: 4). Coincidentally, it was also the thirtieth anniversary of the Dakar festival, which, as Diouf pointed out, called for celebration. It has been a standard feature at every Dak'Art Biennale since the inaugural edition to reaffirm its connection to the Dakar festival in official speeches.[22] Dak'Art 1996 was no different in that respect, but the Biennale's reinvented identity in 1996 added legitimacy to this connection.

There were other important developments at Dak'Art 1996 which strengthened its new focus as a pan-African biennial. It became a longer and more elaborate event, moving from one week to two weeks, and would become a month-long event in succeeding iterations. The only exception was in 1998, when Dak'Art lasted for a miserly one week because of legislative elections. For as long as the Biennale lasted, its art exhibitions and ancillary activities in nooks and crannies of Dakar re-mapped Dakar as a pan-African city.

Conclusion

Dak'Art 1996 was pivotal in that it began a new chapter for Dak'Art as a pan-African biennial and has remained so ever since, although successive iterations, especially in 2016 and 2018, have sought a more expansive articulation of pan-African internationalism by including artists who are not necessarily African-born or part of the African diaspora. Yet, its reinvention as a pan-African biennale (as its official mantra suggests) captured the emancipatory vision that undergirded the proliferation of art biennales globally in the 1990s. Scholars have defined this vision as the postcolonial turn that allowed for increased dialogue between 'local and internationalist values', especially in art circuits, and the emergence of a plethora of art 'shaped by local, national, anticolonial, independent, globalization, anti-globalization values (those of diversity, identity, and critiques), from around 1989' (Smith 2009: 151–67).

Dak'Art was established to help revive Senegal's reputation as a cultural hub in Africa and reinject art into the country's cultural diplomacy and as a centrepiece of national development agenda. Its significance as an international platform for contemporary art is rooted in its geopolitical commitments, of which pan-Africanism is a mobilizing tool. As I have demonstrated, the genealogy of the Biennale's pan-African internationalism stretches back to epochal events throughout the twentieth century that insisted on the visibility of black people and the viability of their cultures and arts. This will include the Congress of Black Writers and Artists in Paris and Rome in mid-century and the significant *First World Festival of Negro Arts*. It can be argued that these historical events conceptually provided a fodder of inspiration for the reimagination of Dak'Art Biennale in 1996 in that quest to advance a global Africa-centred vision of international contemporary art. It also helped that the international art world was undergoing seismic shift in the 1990s from its West-centrism to a more global purview that enabled Dak'Art to secure an inimitable place as a pan-African biennale. Finally, to echo art historian Vittoria Martini (2010), Dak'Art is an 'archetypal biennale' whose specificity reveals a rich and unique history (ibid.: 12).

Acknowledgements

This chapter draws from my unpublished PhD dissertation titled *The Dak'Art Biennial in the Making of Contemporary African Art, 1992–Present* (2014, Emory University). I am especially indebted to Emory University's Graduate School and Art History Department, Smithsonian National Museum of African Art and the TIAA-CREF Ruth Simms Hamilton Research Fellowship for generously supporting my doctoral research in Senegal, Britain, Nigeria, France and Germany between 2008 and 2013.

Chapter 2

A Politico-Economic History of Modern and Contemporary Art in Senegal: From *Négritude* to the Logics of the Open Society

Massamba Mbaye

Introduction

From the first years of Senegal's independence in 1960 on, President Léopold Sédar Senghor institutionalized a comprehensive cultural apparatus that was congruent with his position on the philosophy of *Négritude*, which he helped formulate and pioneer. Being politician, art theorist and cultural visionary all at the same time, Senghor initiated and implemented cultural-political acts that structured durable artistic practices and strongly impacted all modern and contemporary Senegalese fine art production.

By putting the philosophy into practice, Senghor gave *Négritude* a practical mould. For Senghor, fostering appreciation for black civilization was part of the logic of valorization that underlay his cultural goals. Hence, his conceptualizations of *Négritude* reached beyond the strict field of the visual arts. In order to educate Senegalese elites in his philosophical beliefs, Senghor strived to align the cornerstones of national education with his theories. Indeed, the young Senegalese Republic developed institutions that valorized culture. The School of Dakar, for example, one of the first of such institutions, was born. Senghor further promoted state sponsorship to cultivate these new institutions that rose out of this theory of *Négritude*.

This chapter examines the history of modern art in Senegal from the vantage of major institutional paradigms, beginning with Senghor's presidency, when the most significant acts related to culture and arts were implemented. These institutions played a central role in the formation of modern Senegalese visual art, as the first post-independence generations of visual artists expressed themselves either in accordance with the institutionalized canons or in counter-position to them. These two overarching artistic positions explain the broad trajectories of creative dynamics in Senegalese visual arts, even though, on an individual level, artistic practices embody all nuances of creative freedom.

On the fundaments of Senghor's political achievements in the field of culture and art, the chapter presents, on the one hand, the persisting political impulses after Senghor's retirement from presidency, and, on the other, the points of departure from his visions. Seen within its politico-economic context, the history of modern and contemporary art in Senegal after Senghor is complicated. Within its artistic context, this history raises the question of how institutional frameworks have enabled the conditions or counter-conditions for artistic expression. In the first part of this chapter, I ask about the major contextual givens that sparked well-known visual reactions in Senegal between 1960 and 1980.[1]

The second part of the chapter will consider the rupture and drastic diminution of state-sponsored activities during the period between 1980 and 2000. Abdou Diouf, former President of Senegal (1981–2000), rose to power during an economic crisis. Senegal was in deficit and was, therefore, obliged to adopt the structural adjustment programmes dictated by the institutions of Bretton Woods. These new politico-economic circumstances caused the state to curtail its support of the cultural sector in Senegal.

The third part of the chapter addresses the grand projects and nostalgia for major events of the Senghorian period during the presidency of Abdoulaye Wade (2000–2012). Broadly speaking, Wade's visions and ideas reconnect with the projects undertaken during the years that immediately followed Senegal's independence, under Senghor's leadership. Furthermore, a certain logic of the state's detachment from culture under President Diouf prevailed until the end of Wade's presidency in 2012 and continues to this day. During these years, which saw the first liberal governance in Senegal, the state's cultural initiatives did not fully take the Senegalese artists' perspectives into account.

The fourth part of the chapter focuses on ongoing activities that characterize the cultural activities of sitting President Macky Sall (2012–present). At the beginning of his presidency, Sall did not systematically address culture and the arts. However, the Biennale of Dakar has consequently received government support. Furthermore, other actions supporting artists have been launched under Sall, including policies concerning copyright and social security matters.

The final section considers events and artistic achievements that lie beyond state sponsorship and are important in the history of modern and contemporary art in Senegal. The focus is on alternative trajectories that artists developed in the aftermath of 1980, their strivings for autonomy, and their attempts to better insert themselves in international art markets.

Senghor's Cultural Fundamentals

Senghor explained his concept of *Négritude* in a speech on 26 September 1966 at the University of Montreal: 'It is a rare gift of emotion, an existential and unitary ontology that provides all of the strategies for valorizing black civilization.'[2] It also legitimates the battle for the recovery and the affirmation of black personality. In 1969, Senghor spoke of his blackness as a valuable and empowering physical trait

and weapon: 'My *Négritude* is a trowel in my hand, a spear in my fist' (Senghor 1969: 265).[3] Inscribed in a logic of positive affirmation for black people who have suffered centuries of all kinds of exploitation, *Négritude* is the political drive to reclaim and obtain independence. It also enables black people to enter the universal. Senghor's concept of the *civilisation de l'Universel* (civilization of the Universal) is composed of all human civilizations combined (Senghor 1977). It is a space of encounter between all of humanity.

It is noteworthy that Senghor makes a distinction between the *civilisation de l'Universel* and the *civilisation universelle* (universal civilization). Whereas the latter erases all singularity, the former is built on respect for difference and, consequently, for cultural diversity. It does not aim to impose uniformity or a Eurocentric paradigm. The civilization of the Universal is characteristic of twentieth-century humanism and is, according to Senghor, at the *rendez-vous du donner et du recevoir* (crossroad of giving and receiving) (Senghor 1964: 17). *Négritude* operates on Senghor's presupposition that culture is at the same time rooting and uprooting, and opening (*enracinement et ouverture*).

According to Senghor, black people do not need to be afraid of their past. In the making of contemporaneity, there are possible correspondences between Africa and the Occident. For both, the creation of works of art is one of the indicators of a dignified society. Artistic production proves that a society includes individuals who are capable of self-reflection and aesthetic appreciation. Truly, black art is what black people contribute to the civilization of the Universal. Senghor described this capacity in his own terms: 'the Jewish people have brought the message of the Bible, the Arab people, the message of the Qur'an. As for us, black people, the message of Black art' (Senghor cited in Aziza 1980: 284).[4]

These ideas are the foundation of the elaborate Senghorian cultural apparatus. They are, moreover, a consequence of the ambition of African leaders to anchor the nation states with an educational system that should not conceal traits of a people or any preferred forms of expression.

The Foundation of the École de Dakar in the 1960s

For Senghor, culture was an important diplomatic tool. It is increasingly easy to discern a coherent plan that has its first basis in education. Artistic education, specifically, dates from the colonial period. Dakar has had a conservatory since 1948. At the moment of independence of the Fédération du Mali in 1958–9, the Conservatory of Dakar was transformed into the Maison des Arts du Mali and placed at Théâtre du Palais.[5] Within this structure, the first fine arts education programmes started. With the dissolution of the Fédération du Mali in November 1960, the Maison des Arts du Mali became the École des Arts du Sénégal and was transferred to Corniche Ouest, a site that house the museum of black–African civilizations.

The two first teachers were Iba Ndiaye and Papa Ibra Tall. Iba Ndiaye returned to Senegal from France in 1959 and founded and directed the section Arts Plastiques (Fine Arts) at the École des Arts du Sénégal. Papa Ibra Tall returned from France a year later and founded the other section, *Recherches plastiques*

nègres (Black Fine Arts Research). In 1964, this section would host the studio for tapestry, which prefigured the Manufacture des arts décoratifs (Sylla 1998: 85).[6]

Born in Saint-Louis in 1928 and died in Paris in 2008, Iba Ndiaye was one of the pioneers of modern African art. He studied at the École Nationale Supérieure des Beaux Arts in Paris in 1949. In 1966 – several years after his return to Senegal – Ndiaye had his first solo exhibition. For Iba Ndiaye, to paint means to pick up from reminiscence and to draw on personal and cultural memory. One of his most significant accomplishments, for example, was a series on the *Tabaski*, in Senegal a major feast of Islamic tradition. His interest lies, further, in landscapes, elaborates around the theme of the jazz, and evokes African mystic beliefs. In as much as the artist inscribes himself within his African universe, he considers himself as a painter *tout court* so as to avoid the reductive stereotypes of 'Africanness'. Most importantly, Ndiaye was intransigent about his views on art education, insisting on classical academy training.

> For him, it was shocking to reduce the black creator to spontaneity, to instinct and fantasy, dispensing him from any form of reflection. History had already established that pictorial techniques existed and that they could be learned. And with their mastery one could render in colours and forms all that populates our physical and mental universe.
>
> Mbaye 2009[7]

Conversely, Papa Ibra Tall advocated for spontaneity in art-making. Tall was born in Tivouane in 1935 and died in Dakar in 2015. He trained at École Spéciale d'Architecture and the Beaux Arts in Paris in 1955. During his time in Paris, he spent time in pan-African intellectual circles and illustrated several books by Alioune Diop, the editor of *Présence Africaine*. On the occasion of the Congress of Black Writers and Artists in Rome in 1959, he organized an exhibition of black artists living in Europe. Tall also participated in other major cultural events, including the eighth Biennale of São Paulo (1965), the *Premier Festival Mondial des Arts Nègres* (1966), the *Premier Festival Panafricain d'Alger* (1969), the first *Salon des artistes plasticiens sénégalais* at the Musée Dynamique de Dakar (1973), and several conferences, such as *Art Nègre et Civilisation de l'Universel*, which was held on the occasion of Picasso's exhibition at the Musée Dynamique de Dakar (1972), and the World Congress of the International Society of Education Through Art, Adelaide (1978). For many years, Tall was director of the Manufactures des arts décoratifs in Thiès. His tapestry *Le Grand Magal de Touba* was gifted by Senegal to the United Nations. Like Ndiaye, Tall was also inspired by jazz, and the local scenes of Senegal was a consistent subject.

Pierre Jacques André Lods joined this body of precursors of art education in 1960. Previously, Lods had been involved in the French colonial army and, subsequently, became a professor of mathematics and a painter. Senghor heard about Lods' teaching methods on the occasion of an exhibition in Paris in 1957 at the Institut national pédagogique, and decided to include him in his cultural politics of fine arts (Senghor 1989: 19). Lods truly made a name for himself during

the second Congress of Black Writers and Artists in Rome in 1959, when he introduced his teaching methods of the Poto-Poto workshop that he had founded and directed in Brazzaville in 1951. Lods' belief in the creative spontaneity of the black artist coincided with Senghor's views. Hence, Pierre Lods joined the section *Recherches plastiques nègres* of École des Arts du Sénégal as Papa Ibra Tall's assistant. Lods was also responsible for the foundation of the first academy of fine arts of Central Africa in 1950.

These three masters – Iba Ndiaye, Papa Ibra Tall and Pierre Lods – provided the foundation for what in the future would become known as the École de Dakar. To be precise, in speaking of the École de Dakar one must differentiate between the art school proper and the so-labelled art movement, which was predominantly shaped by the research into black arts directed by Tall and Lods. Indeed, Senghor's theories on black art were applied to black art as defined by the latter. Ndiaye's section Arts Plastiques took another route, and its programme followed a rigorous, classical academic formation that culminated in the awarding of diplomas. In contrast, the section *Recherches plastiques nègres* was a free academy.

Art and State Sponsorship

When Dakar's art school was founded in 1960, everything suggested that President Senghor already had in mind the grand mega-event that had been in development since independence: the *Festival Mondial des Art Nègres*. The year before the festival, Senghor had visited the École des Arts. There, he was introduced to the artworks of Ibou Diouf. These works of art convinced the president that Senegalese visual artists would do well at the festival.

The mega-event took place from 30 March to 24 April 1966 in Dakar and Gorée Island. It aimed to make Senegal an exclusive site of black culture. In the Festival's international exhibition of modern African art at the Ancien Palais de Justice, *Tendances et confrontations, les arts contemporains* (Trends and confrontations, the contemporary arts) curated by Ndiaye, visitors from across the world could appreciate the talent of several artists of the standing of grand masters, as André Malraux, France's Minister of Culture at the time, affirmed with enthusiasm. Senghor himself reported: 'André Malraux, who inaugurated the exhibition with me, remarked on this occasion, "You have seven or eight painters of international distinction here who in no way fall short of the world's best"' (Senghor 1989: 19).

The *Festival Mondial des Arts Nègres*, however, was not unique among Senghor's initiatives. He launched the building of a museum of modern art, the Musée Dynamique. He also set in motion the organization of exhibitions of several European masters, including Marc Chagall (March 1971), Picasso (April 1972), Pierre Soulages (November 1974), Alfred Manessier (1976), and other artists of international renown, such as Iba Ndiaye (1977).

As a matter of fact, Senghor established state sponsorship in all cultural domains. Under the direction of President Senghor, art centres including the Conservatoire national de musique, de danse, et d'art dramatique and the École d'architecture et d'urbanisme were built. Administrative institutions were

established, as were mechanisms for financing cultural initiatives. In this context, the law of the 1 per cent, which concerns the private patrimony of the state, needs mention. This law, no. 68-02 of 4 January 1968, addresses the decoration of public buildings: if the costs of a construction project (public or private) exceed twenty million francs CFA (€30,489 or US$34,050), 1 per cent must be spent on the ornamentation of the building.

In the Ambiguous Track of Senghor

Senghor left the presidency of his own volition in 1980. His successor, Abdou Diouf was President until 2000. Diouf, who was educated in the Senghorian tradition, aimed to inscribe himself into the established tradition, as Abdou Sylla describes:

> The tradition of state sponsorship initiated by Senghor was not interrupted or abandoned by his successor; on the contrary, besides the maintenance of traditional forms, this sponsorship was diversified with new initiatives and was intensified thanks to the search for and exploitation of new frontiers and bulwarks.
>
> Hence, from 1982 on, President Abdou Diouf commissioned the elaboration of a national cultural Charter, whose conception benefitted from the collaboration of all relevant national competencies. After several years of work, this commission submitted its conclusions in 1989 . . .
>
> This Charter inspires, while integrating the two initial axes, the cultural politics that had been applied since then.
>
> Sylla 1997[8]

The national cultural charter became a document of reference for Senegalese cultural politics. It was defined as a cultural response to any form of alienation. Furthermore, it constituted the thresholds for social inclusion by means of culture, and it represented a guide of values and norms to be taken into account in the modern education system.

Under Diouf's governance, the Galerie Nationale was founded in 1983. This centre for art exhibitions had 700 square metres of display space. In 1990, the general commissariat for the realization of the Memorial of Gorée was established. This architectural structure would become a multifunctional site and house the International Centre of the Memory of the Victims of Slavery. It centres on the memory of Gorée, an island in the bay of Dakar that was an important point of the triangular transatlantic slave trade. The international architectural contest for the Gorée Memorial fell under the purview of UNESCO and the Union Internationale des architectes (UIA). In September 1997, the Italian Ottavio di Blasi was declared winner of this competition.

Interestingly, the Memorial of Gorée was created at the same time as the Biennale of Dakar and the Grand Prizes of the President of the Republic for the Arts and Letters, all of which were presidential initiatives to promote culture and

the visual arts. The site of the memorial is also a space of artistic expressions regarding the memory of slavery and of visions of Africa. The Biennale of Dakar and grand prizes awarded to visual artists were conceived as avenues that would help valorize and validate contemporary African artistic practices.

Abdou Diouf came to power in a context of economic crisis, and the country – facing a heavy treasury deficit – was forced to follow literally the austerity politics prescribed by the institutions of Bretton Woods (Seck 1998). While culture was, at the time, the centrepiece of Senegalese politics, it lost state investment. As Abdou Sylla rightly states:

> Parallel to the drastic reduction of budgets and the financing capacities of the state, a reorientation of cultural politics operated from 1990 on. Starting in 1992, this reorientation translated into the organization of the Days of Partnership during the Biennale of Dakar. Its major objectives were, among other things, to search for new possible sources for financing cultural projects and to encourage artists to initiate projects of cultural industries.
>
> Sylla 1997[9]

According to Sylla, the Minister of Culture, Abdoulaye Elimane Kane, who was appointed in May 1995, confirmed this search for alternative paths:

> The present Minister of Culture ... perceived, it seems, the importance and the stakes of the new dynamics; and, taking into consideration the major constraints of the State, he redefined, in an interview to *Sud-Quotidien* (nos 706 and 707 of 16 and 17 August 1995) in a realistic manner the axes of the new cultural politics of the State: reaffirmation and anchorage in the original foundations of the country's cultural politics (*enracinement et ouverture*), encouragement and support for artistic and cultural creativity and innovation, restructuration of certain institutions, privatization of others, search for the financing of cultural and artistic projects, creation of a Foundation for the Development of Cultural Industries (FODIC), establishment of the Project of Support to the Cultural Initiatives (PSIC) in partnership with the European Union and with an initial financing of 300 millions of francs CFA, etc.
>
> ibid.[10]

Notwithstanding, although culture continued to figure in state politics and policies, the era of extensive state patronage had ended as a result of the drastic reduction of resources reserved exclusively for culture. This change did not occur without some 'grinding of teeth'. We were passing from the era of cultural favour under Senghor to a 'period of disenchantment', to use the term of Amadou Lamine Sall. According to Amadou Gueye Ndiaye, another cultural actor:

> Civil servants in raw wood gradually replaced the creators. The Senegalese cultural landscape began to take on a green-grey hue; then it fossilized, because

of a lack of fertilizers. Culture, in the conceptual meaning of the word, was transformed into 'leisurization of culture'.

Tchédji 2010[11]

Under Diouf, the Musée Dynamique was transferred to the Ministry of Justice, and from 1988, the building was transformed into the Supreme Court. Initially, this assignment seemed to be temporary. However, the president repeatedly underlined this situation. He also re-emphasized it during his inaugural speech of the third *Salon des artistes plasticiens* at the Galerie Nationale in 1988: 'The assignment, which is entirely provisional, when all is said and done, of the Musée Dynamique to the Supreme Court will have no negative repercussions' (Diouf 1988: 3).[12] Diouf was also responsible for the violent clearance of the Village des Arts in 1983. Artists protested for several weeks at nearby Corniche Ouest with their materials and objects.

Artists had to wait until 1998, when the president allocated a new Village des Arts of Dakar, inaugurated on 23 April that year. The site of this village, which continues to function to this day in the same location, is the former camp of Chinese workers who constructed the football stadium, Stade Léopold Sédar Senghor. Once completed, the new art space included an administrative building, eight buildings housing studios, an art gallery – Galerie L.S. Senghor, a cafeteria/restaurant, a space for youth, a library, and sanitary facilities. In their meeting between 1 and 4 July 1998, the first commission for the attribution of spaces established a list of forty artists who would be awarded studios. The keys were handed over on 16 July. Ten women artists were selected: Fatim Mbengue, Anne Marie Diam, Djamilatou Bikami, Félicité Codjo, Racky Diankha, Rokhaya Kamara, Seynabou Sakho, Ndèye Daro Diagne, Beti Weber and Sylvie Gérard. Among the thirty male artists were: Ibou Diouf, Séa Diallo, Boubacar Camara, Cheikh Niass, El Hadji Sy, Moussa Diop Sambalaye, Guibril André Diop, Mamadou Seya Ndiaye and Louis Bassène.

As already mentioned, the Biennale of Dakar was born under the presidency of Abdou Diouf. The state of Senegal founded the Biennale in 1989 with a first edition dedicated to literature in 1990. The event was focused on international contemporary art in 1992, and its definitive dedication to contemporary African art was decided in 1993, with its first edition in 1996. This decision manifested the desire of the state of Senegal to promote contemporary African art and to present Dakar as space of encounter for these creations.

This Biennale was a good opportunity for local fine artists who had been literally left to themselves in these times of economic crises. They found new modes of expression through their contact with trends in international contemporary art. These interactions with global trends not only helped Senegalese artists to develop their own personal artistic styles and practices but also enabled them to access new opportunities beyond the established structures of the state. In the absence of state support and resources to purchase conventional art materials, some artists turned to their environment for alternative materials. Above all, the Biennale of Dakar contributed to the validation of African artistic practices.

Wade and his Grand Works

From 2000 on, the Biennale of Dakar continued to serve the promotion of Senegalese artistic creation under the presidency of Abdoulaye Wade. Wade defined himself a liberal politician, and he was such in the realm of the arts. The President conceived of 'seven marvels' that would be realized in a grand cultural park located in the centre of Dakar and covering ten hectares. The 'marvels' would include the Grand National Theatre, the School of Arts, the School of Architecture, the National Archives, the House of Music, the National Library and the Musée des Civilisations Noires (MCN). During Wade's governance only the Grand National Theatre was accomplished, and it was inaugurated on 15 April 2011. It housed the opening ceremonies of the Biennale of Dakar in 2012, 2014 and 2018.

Wade also launched and realized the *Monument de la Renaissance Africaine* and inaugurated it on 3 April 2010. It was erected on one of the Mamelles hills, Cap Vert, in Dakar's district Ouakam. With a height of 52 metres, it is Africa's largest sculpture. Considering the hill's height, *Renaissance Africaine* overhangs Dakar at 152 metres. The monument represents a young family – father, wife and child – emerging out of an extinct volcano and facing the Atlantic Ocean. It symbolizes the cultural renaissance of an Africa that has suffered from three centuries of obscurantism and misery. This œuvre was copyrighted under the name of President Wade and became the object of serious controversy when internationally renowned sculptor Ousmane Sow claimed its authorship.[13] Regardless, *Renaissance Africaine* belongs today to the cultural map of Senegal.

During this period also falls the founding of the *3ème Festival Mondial des Arts Nègres* (FESMAN), which bears historical continuity with the famous *First World Festival of Negro Arts*, held in Dakar and Gorée Island in 1966, and the subsequent one in Lagos in 1977. Wade's FESMAN took place from 10 to 31 December 2010 in Dakar and Saint-Louis; Brazil was the guest of honour. Three large exhibitions on Africa and the African diaspora were scheduled. *Modernités et Résistances/Aux Souffles du Monde* (Modernities and Resistance/At the Breaths of the World) was dedicated to the visual arts. *Images, Imageries, Imaginaires* (Images, Imageries, Imaginaries) showed photography. Finally, for design there was *Création conceptualisée et Création intuitive* (Conceptualized Creativity and Intuitive Creativity). Curated by Florence Alexis, the exhibition of visual arts included seventy artists.

After the festival, President Wade claimed that the event has no price and presents a return on investment in his speech to the Senegalese nation on 31 December 2010:

> What we just experienced has no price, but it is legitimate to ask about the fallouts. Let's talk about them. Tens of billions of revenues distributed to artists, their orchestras, their dancers and their collaborators, to intellectuals who received per diems, to hotels and their providers, to numerous enterprises that realized the villages and carried out the renovations of the spectacle halls, to enterprises with thousands of workers of all categories, carpenters, masons,

labourers, scrap metal merchants, exhibition designers, transporters, restaurant owners and, lastly, merchants of food commodities, of meat and vegetables, chicken suppliers, all to supply 6,000 persons during the course of three weeks!

Faye 2010[14]

This accountability translates a line of strength in the discourse on the arts of Abdoulaye Wade. Beyond the paradigm of cultural valorization, it promotes above all the monetization of artistic products. The promotion of cultural industries was a constant throughout Wade's presidency. While the grand projects undertaken under his leadership were large-scale actions in the artistic realm, their approach seems oriented towards the commercialization of the arts – a realism that was, on the whole, understandable, even if it did not embrace all the problems regarding cultural matters that are not fundamentally oriented towards material needs. Indeed, Wade's activities and speeches always had an ambivalence that sometimes relegated culture to the realm of accessories. His last official address to the Senegalese nation on the occasion of New Year's Day 2012 was revealing. He did not mention culture in the larger trajectories of this accounting discourse. He spoke of infrastructures, transport, energy and agriculture, breeding, fishing, the mines, the crafts, the environment, tourism and social matters. Before addressing electoral issues, however, Wade touched on cultural matters. He announced the construction of three of his seven marvels: the complex library-archives, the museum of contemporary art, and the Musée des Civilisations Noires. He also discussed a project that involved protecting the coast of Gorée Island against erosion (DakarActu 2012).

A relatively continuous discourse on cultural industries was typical during Wade's presidency. This discourse derived from ideas of the epoch of the affirmation of culture, both pre- and postcolonial, and focused on grand projects that would bring Senegal international recognition. Nonetheless, Wade did not establish a structured proposal that would develop culture's entrepreneurial identity and allow it to remain in liberal logics. In addition, one has to recognize that the important cultural constructions are focusing on the new generations with significant revenue.

From 2012 On

The care of cultural matters was not systematically addressed in the first discourses of President Macky Sall, who took office in March 2012. In the 167-page *Plan Sénégal émergent* (Plan for an Emerging Senegal) that Sall endorsed in 2013 – a new long-term policy framework with a horizon of 2035 – culture is mentioned in only a few lines:

In the cultural domain, the aim is to valorize the potentialities and to stimulate the creativity and the talent of artists in order to increase the volume and the quality of cultural and artistic production. To these ends, to promote the high-

performing creative industries and to better distribute the cultural products nationally and internationally, infrastructures and cultural platforms will be realized in order to accompany the development of the sector. Concerning the required means, emphasis must be put on: the improvement of access to loans for the bearers of cultural projects, the promotion of artistic formation, the strengthening of the involvement of private agents in cultural promotion, and the promotion of the status of artists, of their intellectual and artistic property rights, and the fight against piracy.

<div align="right">

ibid.[15]

</div>

In this framework, culture seems to be complementary; it should be more structured. However, it does not indicate an aversion of the state to culture, but rather suggests a certain historical continuity with previous governmental orientations to the cultural sector. Macky Sall noted this on the occasion of the inauguration of the Musée des Civilisations Noires in 2018:

This moment is historical. It partakes of these landmarks which, while connecting us to the past, resist the usury of time, improve with their age and project us into a future by keeping our feet firm on the foundation that is our history. *Enracinement and ouverture* (rooting and openness), President Senghor would say. The act we are passing today is not an isolated singularity in its time and in its context. It is inscribed in the continuity of history.

The Musée des Civilisations Noires joins, in fact, a dynamic of long course; a dynamic of confluences and symphonies between Africans and Afro-descendants who are united in the affirmation of their values of culture and civilization.

<div align="right">

Gouvernement République du Sénégal 2018[16]

</div>

Indeed, a museum of black civilizations is an old Senghorian idea that was never realized during his governance. Abdoulaye Wade revitalized this vision and transformed it into a concrete project. Macky Sall inaugurated the cultural institution. The Musée des Civilisations Noires is a public institution with its own patrimony and financial autonomy. Its objective is the valorization of the patrimony of black civilizations in the spirit of *enracinement et ouverture* (rootedness and openness). It is likely to welcome cultural witnesses of black civilizations as well as of the world, following the principles of the civilization of the Universal.

During Sall's presidency, the Biennale of Dakar has also been maintained and consolidated, with the state of Senegal covering 75 per cent of the Biennale's budget. For the past few editions of the Biennale, the president raised government support first to 500 million francs CFA (€762,300 or US$851,252) and then to one billion francs CFA (€1,524,600 or US$1,702,504) in 2018. This support is the result of a directive initiated by the president of the republic during the *Conseil des Ministres* (Council of Ministers) of 28 February 2018. Furthermore, after the Biennale of 2016, the decision was made to allocate the Ancien Palais de Justice to contemporary African art.

The year 2017 was declared the year of culture, and in his discourse on the eve of the national day of independence, President Sall listed recent cultural initiatives:

In support the our cultural patrimony, the government has acquiesced important efforts regarding: the rehabilitation of religious buildings and sites of memory; the creation of the *Sénégalaise* for writers' copyrights, and connected related rights; the contribution to the *Mutuelle nationale* for national health insurance for cultural agents, under the title of the Universal Health Coverage;

The doubling of the budget of the Biennale of contemporary African art, henceforth raised to 500 million francs CFA; the renovation of the Ancien Palais de Justice and its transformation into the Palais des Arts; and shortly, the imminent launching of the construction sites of the École Nationale des Arts et Métier de la Culture, and of the Bibliothèque nationale.

 Gouvernement République du Sénégal 2017[17]

Under President Sall, the state has attempted to revalorize the cultural sector not only by increasing contributions to the Biennale of Dakar, but also by increasing funding allocated to creativity and the creative industries from 2.8 billion francs CFA (€4,268,488 or US$4,767,012) in 2013 to over 5.5 billion francs CFA (€8,384,530 or US$9,363,774). Furthermore, state support of the cinematographic and audio-visual industry has raised between one and two billion francs CFA, and the Grand Prize of the President of the Republic for Arts and Letters, initially fixed at ten million francs CFA, has risen to twenty million francs CFA (€30,490 or US$34,050). In addition, another fund has been established to promote urban cultures, and, specifically, to encourage cultural projects by creative young people in the sector. Its budget has already risen from three hundred million to six hundred million francs CFA (€914,676 or US$1,021,503).

In his inaugural speech, President Sall underlined his ambition to do more, 'because culture, which bears remarkable identity and reflects the soul of the population, has no price'. Many important initiatives demonstrate a gradual reappropriation of cultural matters within the emergent potential of Senegal. It is, however, a late reappropriation that should be affirmed, as culture should structure the emergent perspectives.

Beyond the State's Paradigms

Senegalese modern art emerged during the 1960s. Nonetheless, it is necessary to note the influence of Abbé David Boilat, the subject of the ongoing research of Senegalese critique Sylvain Sankalé. Boilat was born in Saint-Louis in April 1814 to a French father and 'signare'[18] mother who originated from the same city, the former colonial capital. In 1853, Boilat published his *Esquisses sénégalaises*, which proposed some kind of geographic, ethnographic and historical assessments of Senegal between 1817 and 1853. Sketches that are authentic pieces of art illustrate

this publication. In this respect, Boilat is a precursor of modern art in Senegal, especially because he subtly addressed issues of emancipation in his work.

> The work of Boilat does not limit itself to the edification of this scholarly compilation, and, consequently, to a static description of Senegal at a moment in its history. Throughout this volume, in fact, the author is preoccupied with situating observed facts in relation to the country's evolution.
>
> Mouralis 1995: 835[19]

This precursory work was later followed by artistic productions, thanks to the environment fostered by Senghor, which gave birth to two talented individuals: Iba Ndiaye and Papa Ibra Tall. These two led the first generations of artists who were celebrated through various events, such as the *Premier Festival Mondial des Arts Nègres*, which introduced Ibou Diouf to an international public. Diouf graduated out of the section *Recherches plastiques nègres* of the École de Dakar and won the poster competition of the *Premier Festival Mondial des Arts Nègres* in 1966. He subsequently became a figurehead in contemporary Senegalese art, and his artworks toured the world, going on display in Paris (1967 and 1974), Montreal (1967), Mexico City (1968), São Paolo (1969) and Algiers (1969). For the Summit of Francophone Countries held in Paris in 1991, Diouf worked with Senegalese artists Babacar Lô, Khalifa Guèye, Fodé Camara and Cheikh Niass to make a monumental œuvre of 400 square metres at the Palais de Chaillot.

Also significant in the development of modern Senegalese art was the exhibition *Art sénégalais d'aujourd'hui*, which took place in 1974 at Grand Palais in Paris. This exhibition was a major platform for many Senegalese artists, including Amadou Bâ, Amadou Seck, Modou Niang, Papa Ibra Tall, Bocar Pathé Diongue, Gora Mbengue and Ousmane Faye. The artistic expressions of modern Senegalese artists were predominantly pictorial, but there was also a school of sculpture that developed around André Seck, whom Senghor convinced to return to Senegal from Belgium. Seck opened the sculpture branch at the École des Arts. Later, Guibril André Diop, Tafsir Momar Guèye and Moustapha Dimé, among others, emerged as ambassadors of contemporary sculpture, despite the obstacles posed by Islam. In some regions of the country, wooden sculpture is forbidden, as it is considered idolatrous. Historian Abdoualye Bathily affirms that Islam had a negative impact on traditional African heritage (see Snipe 1998: 90).

This did not impede sculptor Ousmane Sow, who was born in Dakar in 1935 and practised art for decades, from attaining fame in the global art world. Some – wrongly – have nicknamed him the 'African Rodin'. His international reputation was sealed by his exhibition at the Passerelle des Arts in Paris in 1999, and in 2013 he was appointed a member of the Académie Française. Ousmane Sow's art resists classification, as he traverses, in his own unique way, a wide range of contemporary Senegalese artistic practice.

El Hadji Sy embraced artistic practice as singular, personal expression, treading on canvases with his feet in order to give his body presence in his work. He exhibited in 1979 at Galerie 39 of the Centre Culturel Français in Dakar, thus

opening this space to young Senegalese creations of the time, such as the work of Guibril André Diop – an outstanding sculptor who experimented with the linearity of iron. Issa Samb, called Joe Ouakam, also strongly influenced this period by proposing alternative means of mixing artistic approaches through the group Laboratoire Agit'Art and series of international workshops Tenq.

Another collective, Huit Facettes-Interaction, gained renown in 1996. This group aimed to foster artistic practices in rural environments, particularly in Hamdallaye Samba Mbaye and Joal. The work of the artists involved, including Abdoulaye N'Doye, El Hadji Sy, Fodé Camara, Cheikh Niass, Jean Marie Bruce, Mor Lisa Bâ and Amadou Kane Sy, was exhibited in 2002 at documenta 11 in Kassel, Germany, curated by Okwui Enwezor.

From the first generation to the present one, numerous Senegalese artists have distinguished themselves nationally. Of these, only a few have attained international fame. Examples from the younger generation include Soly Cissé, Ndary Lo and young photographer Omar Victor Diop, who proposes a new approach to an artistic practice that finds precedent in earlier pioneers such as Mama and Salla Casset. *Sous-verre* painting, which has its own tradition and generation of artists who revolutionized this mode of pictorial expression in the modern era, such as Germaine Anta Gueye, Séa Diallo and Serigne Ndiaye, also presents a distinct branch within Senegalese art.

Following the role of Senghor, artists have progressively developed alternative trajectories since 1980, when state sponsorship of art and culture diminished. Senegalese artists, however, understand the stakes of being autonomous and seizing the opportunities of a global art market that uses digital connections as channels of valorization.

Conclusion

This chapter deliberately follows four periods of Senegalese history as defined by the four presidencies since the country's independence. It begins when a poet becomes president and establishes cultural interest in Senegal, which, in turn, structures certain political choices. The objective of this chapter is to explore the different cultural initiatives executed under successive presidents since Senegal's independence in 1960. This approach allows us to discern a line of continuity with Senghor's approach and initiatives before the challenging economic climate caused its decline in the 1980s. During the 2000s, there was a resurgence in government support for the cultural sector, as economic constraints did not prevent liberal President Abdoulaye Wade from launching substantial cultural projects. These projects revitalized visions of the first years following independence, notably with the cultural park and the works on the Musée des Civilisations Noires (MCN). Critics generally agree that Wade's presidency was marked by some nostalgia for Senghor's epoch. Wade engaged in politics with pan-Africanist ideas that aligned closely with Senghor's *Négritude*, but with a liberal nuance, as opposed to Senghor's African socialism.

Macky Sall, the liberal but less radical president who succeeded Wade, progressively integrated culture into his framework. Under Sall, culture has increasingly been recognized as a powerful political tool for bringing international attention to Senegal. Senghor understood this from the beginning. From his state as Maecenas of the arts, Senegal passes to 'lesser state' *vis-à-vis* the arts, while continuing to support artistic initiatives, as exemplified by the Biennale of Dakar, which was (and still is) an incubator of contemporary African art.

Since the difficult conditions of the early 1980s, Senegalese artists have searched systematically to diversify their opportunities and connect themselves to international endeavours – both of which the Biennale of Dakar facilitates. It seems that artists are increasingly becoming citizens of the world, open to any practical trends, be it in the domain of artistic practices or managerial capacities. This opening will enrich artistic production, which is currently dependent on both local and international art markets. The latter is increasingly offering better opportunities for Senegalese visual artists.

This chapter has shown how the state's paradigms explain the diverse historical situations for artistic creation. These political fields do not necessarily contradict the diversity of artistic practices. Rather, they enable artists to position themselves either within or outside the system. This permanent tension becomes more complex with the opening of the international art market, which has roots in the *Premier Festival Mondial des Arts Nègres* (1966) and subsequent touring exhibitions of modern Senegalese art. These events raised the international visibility of Senegalese artists. The subsequent disengagement of the state allowed artists to engage in autonomous initiatives and create new axes of cooperation with galleries and various other art institutions. It is not an easy task to trace in detail the various activities of artists and their multiple exhibitions and sales in diverse art centres of the globe. It is, however, a reality that Senegalese artists circulate globally wherever there are collections of contemporary African art.

Chapter 3

THE 'DISTANCING CHILDREN' FROM SENGHOR'S OPENNESS TAKE A STANCE

Viyé Diba

Introduction

I don't situate myself in a particular African problematic/paradigm. For me, there isn't such a thing as an African art, or a Senegalese art. My problem isn't to try to be an African, I am one. The 'African soul' is in me and I don't need to wear it on my sleeve, to make an obsession of it.

—Diba in Harney 1996: 42

My statement – which Elizabeth Harney takes up from Ousmane Sow Huchard's monograph on me (1994: 27) – expresses the sentiments of my generation of artists and our alleged distancing from the ideologies and policies of Léopold Sédar Senghor, the first president of Senegal (1960–80). This distancing began with the 1968 Dakar student rebellion and union. The protesters considered the politics of the newly independent nation reactionary and, specifically, challenged Senegal's neo-colonialist relationship to the former colonial metropolis. By confronting the conservatism that prevailed under Senghor's presidency, the protesters facilitated the emergence of leftist sensibilities.

This is the theoretical framework. Despite such an opinion, doubt is not permitted. Africa, as Rabelais used to say, always contributes with something new to humanity. Nowadays, more than in the past, this adage is best illustrated with the contemporary arts of the Black continent. Today, the world is again at a turning point; the ideologies that govern the world are showing their limits. Humanity has become prisoner of its own projection. One interrogates, and the world searches for future solutions. The question of identity is at the heart of our political system. Liberalism murmurs on the contrary, called protectionism, when the interests of its creators are threatened. The authors of the doctrine of 'free movement' impose their vision on the rest of the world. The results are, sometimes, disastrous. In 2018, there were more than 3,000 deaths in the Mediterranean. Many were young Africans trying to find refuge in Europe. But current European policies treat the Other as a menace and create barriers obstructing entry. The oppositional views of

liberalist French President Emmanuel Macron and neo-nationalist Italian Deputy
Prime Minister Matteo Salvini with regards to immigration, including from Africa,
have contributed to the humanitarian crisis that persists as immigrants continue
to try to cross the Mediterranean. Yet this and other challenges that confront Africa
present opportunities to learn and better ourselves and our communities by
enriching our personal consciences, bolstering solidarity across the African
continent and nurturing our personal, communal and national identities.

The anxiety, injustices and rejection of the Other that Africans face are among
the preoccupations that contemporary African artists address with their respective
tools and media. Contemporary artists of the African continent and diaspora have
their own interpretations of the situation, depending on where they live. The
richness of subjects with which they grapple reflects these differences in perspective.
As French Renaissance writer and humanist François Rabelais said, Africa
continually brings something new to humanity. Today more than ever, this adage
manifests itself in contemporary African art.

The difficulties of the Africans call for behaviours of solution. The infatuation
of the most prestigious sites of artistic creation today (biennials, contemporary art
fairs, museums, galleries, journals, private collections) with contemporary African
art illustrates the quality of our artistic practices and the pertinence of our
preoccupations. To be ourselves and embody the world is our creed. We use all
modes of artistic expression. Aesthetic relevance is our means, and the Biennale
of Dakar is our starting point – it legitimizes our venture.

The Openness Of Senghor

In 1959, Senegal began to foster an environment conducive to intellectual,
philosophical, economical, artistic and cultural reflections. Under President
Senghor, who was elected just after Senegal gained independence in 1960, the
country further developed its academic and cultural environment and pursued
important initiatives. The concepts of *enracinement et ouverture* (rootedness and
openness), *civilisation de l'Universel* (civilization of the Universal), *rendez-vous du
donner et du recevoir* (crossroad of giving and receiving), etc., drove these initiatives.
While the 1960s were marked by an inclination towards creating and documenting
history that culminated in the *Premier Festival Mondial des Arts Nègres* (First
World Festival of Black Arts) in 1966, the following decade was characterized by
cosmopolitan awareness or openness.

The École de Dakar (School of Dakar) – as André Malraux[1] called it – was the
centre of artistic creation during this period. Three artists were the most influential:
Papa Ibra Tall, Iba Ndiaye and Pierre Lods. The primary stylistic characteristics
were the frontality of the design and usage of geometric motifs, purity of line,
reference to traditional sculpture, and warm colours (black and white, and earth
tones). Ibou Diouf was the leader of the School. On 1 January 1972, the Senegalese
authorities founded the Institut National des Arts du Sénégal (INA) as a
continuation of the École des Arts de la Fédération du Mali (1959) and the École

des Arts du Sénégal (1960). The INA became the pedagogical laboratory of internationalism. Visual artists, musicians, architects and playwrights cohabited the same pedagogical space. Strong figures such as playwrights Douta Seck and Abdoulaye Farba Sarr, ceramist André Seck, musician Abderrahmane Diop, and visual artists Silmon Faye and Mamadou Gay made their students proud. These individuals made the INA a centre of excellence. The diversity of the aesthetic trends fostered an environment favourable to plurality and cosmopolitanism. Teachers, for the most part (the majority were expatriates, such as Paolo Paolucci, master of pencil drawing), taught technical skills at a level on par with that of the Western academy. The classic artistic disciplines, as well as art history and anthropology, were taught. Aware of the high stakes of the Institute, the criteria for student admission were raised. The world was already within our reach.

At the time, Pierre Lods' studio of *Recherches Plastiques Nègres* (Research in Black Fine Arts) at the Institut National des Arts du Sénégal resisted the new situation. Our generation – the 'second generation' – witnessed this intellectual and artistic movement. The period was characterized by major conferences on humanistic inquiries as well as exhibitions of Senegalese art abroad. The internationalist vision of the new generation crystallized at the Musée Dynamique (Dynamic Museum), an art space established in 1966 that supported the development of a local contemporary art scene and knowledge of local artistic and cultural patrimony. Its influential exhibitions of masters of modern and contemporary Western art, including Pablo Picasso (1972), Friedensreich Hundertwasser (1973), Pierre Soulages (1974) and Alfred Manessier (1976), strongly influenced artists in Senegal.

Senegal is at a crossroad. We were the privileged witnesses of this artistic and intellectual development. We were already out in the world and are agents of great ideas that agitate it. In 1978, graduates of the INA occupied the former military camp Lat Dior at Avenue Peytavin with the protective support of Pierre Lods. They held artistic performances, incorporating the visual arts, theatre, cinematography and music, and experimented with all media. At this event, called the Village des Arts, art exhibitions, cultural conferences and political debates flourished. No themes, ideas or formats were forbidden. The event's proximity to the INA, as well as to coastal neighbourhoods, facilitated the development of the relationship between the participating artists and others in the arts and the general population. The Village became inescapable in the city of Dakar, until political authorities closed it in 1983, following a performance that contained controversial political content.

The Birth of the Biennale

The Generation of Openness

The position of Senegal under Senghor was enviable, as the first conception of contemporary African art in Senegal was born with the École de Dakar. The state

passed several laws that favoured artists: in 1967 (immediately following the *Premier Festival Mondial des Arts Nègres* of 1966), a decree regarding artistic patrimony; in 1968, the law of the 1 per cent (intended, in part, to build a system of public art education); and in 1978, a decree that provided financial support and social stability for artists and more broadly invested in the development of culture, as well as a law regarding architecture in Senegal. The goal of these decrees and laws was to establish a collection of national art and to create better working conditions for Senegalese civil servants, especially since these artistic œuvres had previously been under the domains of different administrations.

The election of President Abdou Diouf in 1980 marked a distinct change of course regarding state affairs. Artists lost almost everything as a result of the structural adjustment programme that came into effect under the injunction of the institutions of Bretton Woods, including the World Bank and the International Monetary Fund. Culture was no longer one of the priorities of the Senegalese authorities. The expulsion of the artists from the Village des Arts in 1983 has clearly announced the trend, and its immediate consequences were the loss of any state support and of an adequate work environment, and organizational frailty. Under these circumstances there were two possible outcomes: to organize oneself or to disappear.

The first step was to revitalize the Association Nationale des Artistes Plasticiens du Sénégal (ANAPS). The ANAPS took over the *Salon National des Artistes Plasticiens* in 1985, creating the conditions for an organizational reset.[2] With this endeavour, artists saw a renewed focus on the image of the lost Village des Arts, and with the exhibition *Art contre l'Apartheid* (1986), held in support of the liberation struggle in South Africa, they re-established both their contact with the state and their engagement with politics.

Artists integrated questions of international current events into their work. Under the ANAPS's leadership, the *Salon* was dedicated to the reconciliation between the state and the artistic community. It offered President Abdou Diouf his first public appearance after the critical outcome of heated presidential elections. Art became again the site of national reconciliation. Artists became politically engaged, regaining their sense of purpose and rebuilding the position they once held under former President Senghor – even those who had previously rejected any political engagement. The *Salon* was, therefore, ready for renewal, and the generation of post-'68 artists felt in full possession of its artistic and organizational capacities. There was no longer any official political doctrine.

This generation of artists was grappling with the problems of the world and the state of culture and art in order to approach the country's political leaders, who had begun to entertain the ideas of these 'dreamers'. At the occasion of this inauguration, ANAPS's president, Viyé Diba, introduced the idea of a biennial event that would provide a space where encounters between Senegalese artists and other world-renowned artists could take place. The visual artists took a stance. The word 'art' signified 'visual art'. Theatre and cinema were marginalized because of their financial dependence on the state, which did not have the means to support such 'budget-consuming' sectors. Literature, too, suffered from ongoing de-

Senghorization, and dance struggled to free itself from populism. Music, on the other hand – especially hip hop, which was just emerging – was able to flourish by refashioning itself as one of the new media arts.

At this time, the environment was favourable for these artists because the state was not concerned with creativity and intellectual ideas, as had been the case under Senghor. There was no longer an official cultural doctrine. The influence of the Village des Arts began to take effect. All of the current artistic styles that occupied the world were represented (Fauvism, Cubism, Surrealism, Expressionism, Minimalism), as well as the leaders of the old École de Dakar. Classic art formats and media were strongly present, but they were rendered in a local expression. The plurality of artistic formats, media and styles only strengthened the arts in Senegal. To echo Chinese Communist Party Chairman Mao Zedong, 'letting a hundred flowers bloom and a hundred schools of thought contend' promotes the flourishing of the arts.

Nonetheless, a group of artists, including Moustapha Dimé, Viyé Diba and Serigne Mbaye Camara, dedicated itself to exploring new formats within a new discourse.

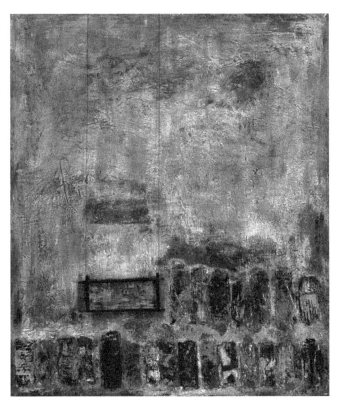

Figure 3.1 Viyé Diba, *Pesanteur des Silhouettes*, 1991, acrylic on canvas. Courtesy of Bassam Chaitou Collection and the artist. Photo credit: Haidar Chams and Bassam Chaitou.

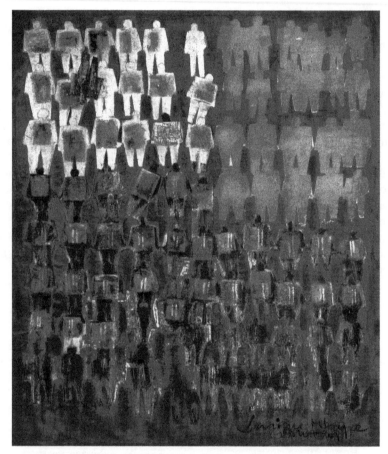

Figure 3.2 Serigne Mbaye Camara, *Peuples*, 1989, acrylic and collage on canvas.
Courtesy of Bassam Chaitou Collection and the artist. Photo credit: Haidar Chams and
Bassam Chaitou.

Dakar-born artist Ousmane Sow made a striking appearance on the
international stage with his larger-than-life sculptures, which first showed at the
Centre Culturel Français de Dakar in 1987. The inclusion of Seni Awa Camara's
clay sculptures in the exhibition *Magiciens de la Terre*, held at the Centre Georges
Pompidou in Paris in 1989, similarly gained the Bignona-based artist international
attention. The interdisciplinary collective Laboratoire Agit'Art, established by
visual artist Issa Samb, filmmaker Djibril Diop Mambéty, painter El Hadji Sy and
playwright Youssoupha Dione, continued the pursuit of new, politically charged
artistic formats and objects. The replacement of expatriate teachers formerly at the
INA with local ones who adhered to a pedagogy of recuperation also explained
this renewal in the field of Senegalese art. As a result of all these happenings,
Senegal became part of the global art world.

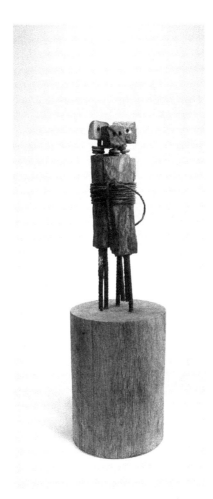

Figure 3.3 Serigne Mbaye Camara, *Adolescence*, 1998, wood and iron. Courtesy of Bassam Chaitou Collection and the artist. Photo credit: Haidar Chams and Bassam Chaitou.

The International Context

The rising power of the socialists in France marked a fundamental shift in the real internationalization of art. Their project *L'État culturel en débat* (the cultural state under debate), undertaken 1981–95, and the strong personality of Minister of Culture Jack Lang are particularly noteworthy. State politics during the bipartisanship of left and right parties was a driving force for the countries of the Third World whose economies were dominated by Western powers. The structural adjustment programme was ideologically rooted in the fact that these countries were, for the most part, tied to the former colonial metropolises because of political monetary pressures.

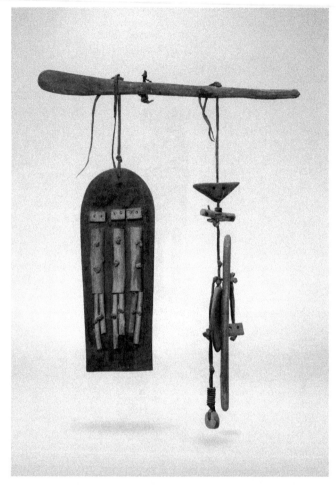

Figure 3.4 Serigne Mbaye Camara, *Tablette Talibé*, 2000, wood and leather. Courtesy of Bassam Chaitou Collection and the artist. Photo credit: Haidar Chams and Bassam Chaitou.

In the early 1980s, France's President François Mitterrand initiated a cultural politics of resistance to Anglo-Saxon (mostly US American) domination by means of the audio-visual. The control of the 'image' was at stake. Its mutation into cultural diversity provoked the United States' withdrawal from UNESCO in 1984. Amadou Mahar M'Bow, a Dakar-born Senegalese educator who served as general director of UNESCO from 1974 to 1987, bore the consequences of the conflict over transnational control of the audio-visual field.[3] In this confrontation the African representatives appeared as naïf actors, given that their audio-visual production was nearly non-existent – we recall the concept '*cinéma calebasse*' (calabash cinema). Hypocrisy was at its height. France demarcated its cultural

territory by protecting its patrimony, while the African countries were stripped of any political means for cultural development. This field was rapidly occupied by state-run NGOs, such as Afrique en Création.

The end of the Cold War brought about a new political environment in which the East and West began to work together. New diplomatic, commercial and cultural exchanges took shape. Like in the real world, art searched for an escape, a new order. The 1989 exhibition *Magiciens de la Terre* seemed to anticipate the birth of this order – a less Western hegemonic hold on the world. It predicted Senghor's vision of a civilization of the Universal that was deeply rooted in multiculturalism. 'We must enrich ourselves with our mutual differences,' wrote Senghor, paraphrasing French writer Paul Valéry. New paradigms start to be considered for a definition of aesthetics.

The Local Context, Artistic Preoccupations, and New Aesthetics

The great political preoccupations of the 1970s, their economic consequences and the ensuing rural exodus, and the absence of viable economic perspectives encouraged the progressive emergence of an economy of survival dominated by the informal sector. New residents in the urban environment, who arrived without any qualifications, took any job. Everything was recuperated, sold, and resold; cities transformed, co-constituted by changing conditions and reality. They became sites of anonymity and of conflict of a different nature. The poetics that characterized the era of Senghor were replaced by violent clashes. Our cities paid the price of these urban disorders, largely because of the ongoing inaccessibility of the political opposition to the state media. Walls became the preferred supports of social and political communication. The materials and objects of the progressive development of this world of consumption became witnesses to these changes. The textile industry bore the first consequences with the import of frippery ('second-hand'). Everywhere, entire sections of local economies suffered.

These political, social and economic circumstances were the basis of the pedagogical commerce of the École Nationale des Arts, and its teacher-artists occupied a privileged position in this new local world. The same was true for certain artists who were very attentive to these ongoing changes. These artists clearly expressed their distance from the artistic environment that immediately followed Senegal's independence. In this way, the third artistic path forward was born. The focus on everyday life and the new social relations in our cities legitimized these artists' practices.

Weaning off artists from institutions and the resulting renewal and diversification of the aesthetic discourse defined this movement. In addition, since Senghor's passing in 2001, artists have digested world currents better. New materials have enriched artistic practices, the artists' proximity to the social environment is highlighted in their aesthetic expression, spirituality and politics have been at the centre of their concerns. The *Salon National des artistes* of 1989, which announced the advent of the Biennale of Dakar, marked both the end of a long process and the start of a new orientation. Perceptible changes in the world

could be felt. The idea of multiculturalism was present early on, thanks to Senghor. In reality, nothing new under the sun – Senegal is the world. Malraux was not wrong when he told Senghor that he held in his fragile hands the destiny of a whole continent – in fact, he held the destiny of the whole world. Senghor had transgressed the frontiers of Senegal, of Africa, to unite the whole world.

Besides the surprise guests such as Ousmane Sow and Seni Awa Camara, Serigne Ndiaye and Anta Germaine Gueye, among others, revitalized the *fixé sous-verre* (painting under glass) technique and desacralized glass. Through the work of Boubacar Touré Mandemory, Djibril Sy, Mamadou Touré Behan, Pap Ba and Bouna Médoune Seye, among others, photography became accepted as a form of art and gained interest among Senegalese artists. Art brut confronted art savant. This contingent of artists began to emerge not only in Senegal but also in other parts of the continent, while some lived and worked outside of Africa. Later, magazines such as *Revue Noire*[4] began to report on these new artistic directions. This magazine in particular acted as a platform for the different artistic initiatives across the continent. It sufficiently fostered and institutionalized a large field of artistic practice further advanced by the initiators of the Biennale. The foundation of this artistic scenario, however, was economic. The art of the poor (*récuperation*) established itself, and the artistic materials, as well as the artistic discourses, demonstrated these economic entanglements.

Impact on African Art

The evolution of the historical situation roughly traced here and its culminating point (the Biennale) are, unsurprisingly, inscribed in an art historical logic. The Biennale's artistic content is in no way a mere copy of Western currents. The presence of new materials and objects of everyday life do not allude to any previous art movements. The artists have taken to task the dramatic consequences of this colonial economy that exploited and destroyed the land, causing a rural exodus. A newly dominant economy of survival of the informal and a rising political awareness characterize this new art. Any presupposition of imitation of the Other (i.e. the West) is far from the artists' intentions. Arguably, their central focus on materiality or spirituality is orginal. The Dak'Art Biennale has become the requisite rite of passage for all black artists. Its aim – as it has been since its first occurrence in 1990 – is universalist. Its African specificity results from the nature of its financing, two-thirds of which comes from development agencies whose missions are to make visible African artists who are nearly absent from the world stage.

The Biennale of Dakar and *Magiciens de la Terre* share the same temporal space. The latter has become the site of legitimation of all these reflections. In 1991, the exhibition *Africa Explores – 20th Century African Art*, curated by Susan Vogel at the New Museum in New York, expanded the artistic field to objects of urban popular creativity. These initiatives opened the doors for subsequent projects that have given African artists further international visibility and recognition. For example, at the innovative 1996 show *Container 96 – Art across Oceans*, several African artists contributed to the 'village' of containers constructed in Copenhagen's

port with materials that evoked their homelands through both visuals and smells. The travelling exhibition *The Short Century – Independence and Liberation Movements in Africa 1945–1994* (Munich, Berlin, Chicago and New York, 2001–2), curated by Okwui Enwezor, was a major survey of African art during the rise of liberation movements and new cultural identities across the continent. This landmark exhibition demonstrated the immense contributions of African artists to universal debates and universal aesthetics. The 2004–7 travelling exhibition or *Africa Remix: Contemporary Art of a Continent* (Düsseldorf 2004, London and Paris 2005, Tokyo 2006, Johannesburg 2007), curated by Simon Njami, was another historical breakthrough in that it enabled the circulation of contemporary works created within the past decade by over seventy artists from twenty-three African countries, making it, at the time, the largest exhibition of contemporary African art ever shown in Europe.

The Biennale of Dakar has similarly included many national and international representatives in the academic world, in the media, or in artistic events, all of whom have contributed to the promotion of the continent through the work of curators such as Okwui Enwezor, Simon Njami, Salah Hassen, Olù Oguibe, Yacouba Konaté, and many others. For visual artists, the Biennale is the ultimate site *par excellence* of pilgrimage and the launching pad for conquering the world. High-quality scholarly debates within the forum *Rencontres-échanges* complement the exhibition programmes of the various editions of the Biennale (see Chapter 5). Distinguished African artists are courted for future projects. During the month of the Biennale, Africa is on the global cultural map. The artists exhibited take a stance and speak to the world, and the world hears them.

The Biennale of Dakar has become the mandatory site of transit for all black artists, such as Mohamed Kacimi (Morocco) or Pascal Marthine Tayou (Cameroon). Its perspective is universalist, as conceived for its first edition of 1992. Its African specificity has developed out of the nature of its funding, two-thirds being covered by development agencies. The latter's main ambition is the visibility of African artists, who are nearly absent from the world stage. From an aesthetic point of view, the decade of the 1990s was dominated by this new materiality punctuated by objects and their social and spiritual meanings. The works of art that were awarded the Biennale's *Grand Prix du Chef de l'État*, including Moustapha Dimé's *La Femme nue* (1992), Abdoulayé Konaté's *Hommage aux chasseurs du Mandé* (1996), or Viyé Diba's *Choses au mur* (1998), illustrate these trajectories. All of these awarded artists have analytical and critical perspectives on their immediate environments.

Nonetheless, these artistic practices were not undisputed. Renowned Senegalese artist Papa Ibra Tall, for example, railed against the notion of recuperation and installation art, declaring that the West wanted to transform Africans into the vultures of the world. Similarly hesitant about the trends in contemporary African art, in 1996, the Senegalese Minister of Culture Abdoulaye Elimane Kane asked Ousmane Sow Huchard, then president of the Scientific Committee of the Biennale, whether Pascal Marthine Tayou's installation *Émotion fécale*, shown at the gallery of the German Goethe Institute, was art. These two opinions illustrate ruptures

with an older generation of African artists, the pioneer class of modernists, state officials, and with local populations. The inability of these different groups to understand the new preoccupations of contemporary artists is still a problem today. These artists reflect economic realities. The turn of the twenty-first century was marked by the appropriation of new artistic supports and the opening of artistic practices to a diversity of modes of expression. The award-winning works of art indicate that installation art has taken the lead. New media are emerging and are, currently, predominantly presented by expatriates. Painting and sculpture still appear, but they are losing importance.

The Biennale, however, should both foster an environment favourable to the production of contemporary artistic knowledge and create the infrastructure to support a real art market and a politics of art education.

Conclusion

Africa's presence on the international art stage is affirmed and reinforced through the Biennale of Dakar. Even if its budget is negligible, the regularity of its editions gives it credibility. This has nothing to do with its audience or with the creativity, the self-denial, or the imagination of its organizers, directors and experts. The Biennale has convinced the global art world. It is the largest cultural event on the African continent and is the barometer of the creativity of African artists. Its weakness is its low impact on African populations. Yet these populations should find in the Biennale the conditions of their success. Politicians, experts and artists are called upon to answer questions regarding the quality of life, the education system, and the strategic orientation of the black continent as it faces globalization.

Part II

DAK'ART – THE BIENNALE OF CONTEMPORARY
AFRICAN ART

Chapter 4

SELECTION COMMITTEES, SELECTION PROCESSES AND APPLICATION PROCEDURES

Ugochukwu-Smooth C. Nzewi and Thomas Fillitz

Introduction

The reinvention of the Biennale of Dakar as *Biennale de l'art africain contemporain* was not only with regard to the formulation of an art-related objective, or the creation of fundamental structures to reach this objective by complying with international standards. The General Secretariat was conceived as the structure of the Biennale in late 1993, relatively independent from the Ministry of Culture, and the *Conseil scientifique* was established in 1994 (Konaté 2009: 53). Structural characteristics comprised the selection committee and the application procedures for artists. Local reflections engaged concretely with the local conceptualization of the meaning of a biennial format as a 'field-configuring event' (see Introduction), rather than a mega-event viewed as a festival of arts. Research on biennials has identified the particularity of this format in different ways: the biennial may be a 'critical site of experimentation in exhibition-making', a space for 'utopian possibility' a cultural institution 'for grappling with such issues as politics … globalization, and postcolonialism in art-making and -showing today' (Filipovic et al. 2010: 13). For Green and Gardner (2016) the biennials' 'mix of artists and art from diverse cultures and places has ensured that vital intercultural dialogues have emerged' (ibid.: 3).

In this sense, the 1992 Biennale of international art was also a failure because it adapted the model of Venice with low financial capacities, without critical curatorial interventions, and without theorizing the Biennale's embedment within the global biennials' networks. Ousmane Sow Huchard (2010) recalls two other factors. First, the committee of evaluation was well acquainted with the single, unrepeated event of modern African arts, *Grafolies*, in Abidjan (1993) (ibid.: 529). This meant that, at that time, the field for constituting a cyclical space of contemporary African art was thus far not occupied. Second, while preparations for Dak'Art 1996 were underway, the second secretary general, Rémi Sagna and Huchard,[1] as president of the *Conseil scientifique* (1996 and 1998) (ibid.: 529–30), were aware of the failure of the first Johannesburg Biennial in 1995, for prioritizing

its international focus and insufficiently relating to local constellations (Green and Gardner 2016: 156–7).

The secretary general, the *Conseil scientifique*, the selection committee, as well as selection procedures based on applications by dossier constituted the structural core of the Biennale. Rémi Sagna and Ousmane Sow Huchard were the driving forces of the time, and Dak'Art 1996 the testing ground for the newly established structure.

The *Conseil scientifique*, renamed the *Comité d'orientation* (orientation committee) from 2006, is responsible for formulating the main aspects of the organization of the Biennale: financial matters, the number of artists and artworks, the orientation of the central *Exposition internationale*, the subjects and curators of the *Expositions individuelles*, the *Salon du design*, the sites of all official exhibitions, the supervision of the different technical fields – such as the production of the catalogue, the invitation of artists and guests. Above all, in consultation with the secretary general, the orientation committee appoints the members of the selection committee.

Members of the *Conseil scientifique* are nominated by ministerial order. In 1996, it was constituted of twenty-two persons, a similar number in 2006, fifteen in 2014 and 2018, plus the secretary general. All of them are Senegalese personalities, functionaries, private sector workers, artists, gallerists, art world professionals or scholars. The turnover is low: for instance, artist Viyé Diba was a member in 2004, 2008 and 2012, artist/art critic Alioune Badiane in 2004, 2006, 2008 and 2012, gallerist Thérèse Tupin Diatta in 2006, 2008, 2010 and 2012 and the committee's president in 2014.

Indeed, as several interlocutors state, after the formative years the work of the *Conseil scientifique/Comité d'orientation* suffered from the diversity of intentions due to its professional heterogeneity, as well as from the lack of availability and disposability of members who are occupied full-time with their profession. Most important is the committee's president, who interacts with the secretary general and the selection committee. Formally, this paramount position becomes evident during the Biennale's official inauguration ceremony, as the president of this committee addresses the president of the republic, the invited guests of honour and the accredited public. As already mentioned, Ousmane Sow Huchard played a prominent role during the 1996 and 1998 editions and in the restructuring and initial readjustments of the Biennale. In 2000, the lawyer/collector/art critic/curator Sylvain Sankalé succeeded him. In 2002, magistrate Marie-José Crespin was elected the committee's president, and in 2004 and 2006 Victor-Emmanuel Cabrita, poet and director of the Cours Sainte-Marie de Hann, the most important educational centre of West Africa. Gérard Sénac, director general of Eiffage Sénégal and major art sponsor, picked up the baton for the editions of 2008, 2010 and 2012, followed in 2014 by Thérèse Tupin Diatta, director of Galerie Kemboury, and in 2016 and 2018 Baïdy Agne, president of the National Council of Employers and art collector.

Notwithstanding constraints related to the status of the Biennale of Dakar as a cultural institution under the Ministry of Culture, and various critiques concerning the appointment of personalities or the choice of artists and artworks for the

Exposition internationale, we argue that the Biennale is continuously aiming to develop as a specific global field of artistic encounter and exchange and to increase the challenges for curators and artists. As such, these changes are not simple adjustments or mere reactions to local critiques, but activities of continuously conceptualizing and re-conceptualizing the event's format, standards and framework.

In this chapter we examine the changes in the selection committees and selection processes, and their implications not only for artists and their artworks, or for curatorial teams, but above all for the structure of the Biennale. The first section outlines characteristics of the selection committees, and how they are restructured all along the Biennale's cycle. The second section consists of an account about processes, interactions and debates that surrounded Dak'Art 2014 by Ugochukwu-Smooth Nzewi, who was co-curator of that edition. The third and final section reflects these changes in the structure of the selection committees and selection processes within the frame of theoretical issues related to biennial research. This examination leads into considering the re-positioning of the Biennale of Dakar as a global mega-art event while still being the Biennale of Contemporary African Art within the global biennials network.

Structural Properties

From the outset of Dak'Art, the selection committee was composed of people with different cultural interests and some without curatorial backgrounds. In 1992, it included Samir Sobhy (former representative of UNICEF in Dakar), Mamadou Niang (professor of fine arts, Senegal), François Belorgey (former director of French Cultural Centre, Dakar), His Excellency Hector Alberto Flores (former ambassador of Argentina to Senegal), Thomas Hodges (former director of the American Cultural Center, Dakar), Marie-Laure Croiziers de Lacvivier (cultural entrepreneur and collector of African art), Rémi Sagna (former director of the National Library Senegal and subsequently the second secretary general of the Biennale) and Kalidou Sy (former director of the National School of Fine Arts, Dakar). The process of selecting artists was done in consultation with foreign embassies, national ministries of culture, foreign cultural centres and embassies in Dakar.

While announcing the reinvention of Dak'Art in October 1993, Minister Thiam introduced changes in its organizational structure. The new structure consisted of the general secretariat, scientific committee, technical committee and international selection committee. The general secretariat took over the overall administrative responsibility for organizing the Biennale from the Ministry of Culture and Communication, although it remained under the supervision of the ministry. The secretariat was overseen by a secretary general, who is a government bureaucrat, and complemented by staff drawn from the Ministry of Culture. The second component, the scientific committee (at times referred to as the orientation committee), was tasked with making decisions concerning the general direction of

the Biennale at each iteration, such as themes, exhibition venues, budget and sponsorship, exhibition catalogue, and other ancillary activities (lectures and workshops, etc.). This organizational structure has remained in force with slight adjustments and changes in personnel in succeeding editions of Dak'Art.

The orientation committee serves as a liaison with the secretary general to manage the Biennale events. It includes important Senegalese artists, cultural journalists, art critics, curators, art historians, art collectors, distinguished academicians, gallery owners, cultural administrators and government officials, mostly based in Dakar, appointed by the minister of culture in consultation with the secretary general. Over several Dak'Art editions, the orientation committee has included Viyé Diba (artist), Ousmane Sow (artist), Issa Samb (artist), Mauro Petroni (artist), Aïssa Dione (artist and gallerist), Abdou Sylla (art critic and art historian) Ousmane Sow Huchard (museologist), Sylvain Sankalé (art patron and collector), Marie-José Crespin (magistrate) and Massamba Mbaye (art journalist).

The creation of the international selection committee (which in some editions doubled as the jury for the prize awards) was an important development that has helped to connect Dak'Art to the mainstream art world and brought about more professionalism in the selection of artists and in the curation of Dak'Art from 1996 onward. Over the years, it has included leading artists, curators, critics and art historians such as Achille Bonito Oliva (curator of the 45th Biennale di Venezia in 1993), David Elliott (former president of the international committee of ICOM for Museums of Modern and Contemporary Art), Meskerem Assegued (founder of Zoma Art Museum, Addis Ababa, Ethiopia), Thomas Boutoux (art critic and independent curator), Gerald Matt (art historian and former director of the Kunsthalle, Vienna), El Anatsui (artist), Ablade Glover (artist) and Marilyn Martin (former director of the Iziko South African National Gallery).

Whether selection committee, general curator, or artistic director, the secretary general proposes the candidate(s) to the minister of culture, who then proceeds to nomination. The secretary general and the president of the orientation committee are also part of the selection processes. So far, there has been one exception to the nomination procedure when in 2008 the minister appointed Maguèye Kassé, professor of German literature at Université Cheikh Anta Diop (UCAD), as general curator without consulting the secretary general or the president of the orientation committee (see Kouoh and De Caevel, Chapter 8; Eyene 2008). In particular, the entity of a selection committee with a selection process based on applications from a dossier of artists is a characteristic of the Biennale of Dakar. Furthermore, there was no overall title or subject for the Biennale until the edition of 2006. Ery Camara (2002), who was president of the selection committee in 2002, highlights precisely these aspects of Dak'Art:

> This distinctive feature makes this Biennial quite different specially at its selection stage from such other events resulting from invitations sent by one or several organizers and presenting a selection more closely connected to a thematic speech or to another subject.
>
> ibid.: 17

Secretary General Sagna defends these structural decisions for creating the possibility for more viewpoints in the selection process and a balanced choice with better opportunities for less-established artists (personal communication to Fillitz; see also Sagna in Vincent 2007: 135). Further, as the decree of the Senegalese government clearly formulated the central objective of the Biennale as the promotion of contemporary African art (see Sankalé, Chapter 7), there seemed no real necessity for a thematic focus of the *Exposition internationale* in the 1990s, the task being rather to grapple with the latest achievements of contemporary African art. Nonetheless, Sagna insists in conversation that the Biennale had to deal with local circumstances while coping with international standards in order to position Dak'Art within the global biennials network.

Regarding the Biennale's development of the selection committee structures, four different strategies can be identified: a) from 1996 to 2000: large committees, combining African, European, North American and Asian art world professionals; b) 2006 and 2008: African general curators who invite their curatorial team; c) 2010 to 2014: small selection committees, exclusively African experts; d) 2016 and 2018: one artistic director with African origins who invites international curators for other exhibition projects.

(a) 1996 to 2000: Large committees: For the first three editions, the Biennale opted for rather large selection committees. Excluding the secretary general and president of the *Conseil scientifique*, there were eleven nominations in 1996, fourteen in both 1998 and 2000. Half of the members were from Africa, the other half from Europe, North America and/or Asia, and their professions were related to arts. For example, this is the committee of 1998 (Biennale of Dakar 1998: n.p.): 1) from Africa: Ali Louati (director of Maison des Arts, Tunisia), Yacouba Konaté (professor of philosophy, art critic and curator, Côte d'Ivoire), Linda Givon (gallerist, South Africa), Edem Kodjo (collector, Togo), Ousmane Sow (artist, Senegal), Alioune Badiane (artist and director of the École Nationale des Arts, Senegal); 2) from Europe and North America: the president of the committee Achille Bonito Oliva (art critic and curator, Italy), Mary Jane Jacob (curator, United States.), Alfons Hug (curator and cultural worker, Germany), Danièle Giraudy (chief curator of patrimony of twentieth century, France), Dominique Fontaine (exhibition and programme coordinator at Canadian Museum of Civilizations, Canada), Lucien Billinelli (gallerist, Belgium), Chantal Ponbriand (director of art magazine, Canada), Diana Porfirio (textile designer, Belgium).

Another striking feature of the selection committee until 2004 was the nomination of well-known personalities from international art worlds as its president: Achille Bonito Oliva in 1998, David Elliott in 2000, Ery Camara in 2002 and Sara Diamond in 2004.

(b) 2006 and 2008: African general curator scheme: The edition of 1998 was also the one where the Biennale considered reducing the preponderance of Senegalese artists and artworks within the official exhibitions (Sagna in Pensa 2011: 89). Huchard's report also highlighted the lack of internationally renowned African

artists and suggested considering the possibility of issuing invitations (ibid.: 91). Dissatisfaction with the committee nominations and procedures reached its peak with the edition of 2000. The selection sparked angry reactions among Dakar's artists and art world professionals, when the president of the selection committee, David Elliott, declared the end of painting and the age of installation art (see below). Hence, with the leadership of new Secretary General Ousseynou Wade[2] and new President of the *Conseil scientifique* Marie-José Crespin, the Biennale's structures and strategies were reconsidered in 2002, with a smaller committee and commissioning its members with the curatorial tasks for different exhibitions.

The real rupture and reconceptualization of Dak'Art's characteristics occured in the realm of the 2006 edition. Through an open call, the Biennale searched for an African general curator and appointed Yacouba Konaté. He was entitled to constitute his own curatorial team, following specializations which enabled a 'balanced representation of the various areas of the continent' (Wade 2006: 17): for West Africa, Olabisi Silva from Nigeria; for Senegal, Youma Fall from Senegal; for Southern Africa, Barbara Murray from Zimbabwe; for Central Africa, Célestin Badibanga ne Mwine from DR Congo; for North Africa, Abdellah Karroum from Morocco; for European diasporas, Marie-Louise Syring from Germany; and for diasporas of the Americas, Amy Horshack from the United States. Furthermore, besides selecting from applications, the curatorial team was allowed to invite several artists to the *Exposition internationale*, or to propose artists to be considered for selection by the team – another important innovation (Konaté 2009: 59). Finally, Dak'Art 2006 was given an overall subject: *Africa – Agreements, Allusions and Misunderstandings*. Konaté highlights the advantage of a theme insofar as it constitutes a frame for the artist's creativity: s/he is encouraged to research, and to reflect her/his environment (Konaté 2009: 106). From an overall perspective, Secretary General Ousseynou Wade noted with satisfaction that 'The Biennial of Contemporary African Art has now adopted a new approach that helps to widen the options within a more coherent global artistic project' (Wade 2006: 17).

The experiment with a general curator who invited his associate curators was a one-off. The new prestige project dear to President Abdoulaye Wade, the *3ème Festival Mondial des Arts Nègres* (FESMAN), would heavily influence the organization and performance of the edition of 2008. In February of the same year, uncertainty surrounded the eighth Biennale of Contemporary African Art. The budget for the mega-event was allocated much later than ever before, and moreover was heavily reduced by a rumoured 30 per cent (see also Pensa 2011: 108). The minister of culture installed the general curator on his own initiative, and four African experts were paired with three European peers. The eighth Biennale of Dakar was a disappointment, money went missing, and everything was done under huge time pressure. FESMAN, nonetheless, did not take place that year.

(c) 2010 to 2014: Small selection committees, African Experts: The internationally renowned non-African president of the selection committee was passé, the African general curator with his curatorial team scheme did not last. For 2010, 2012 and 2014, the Biennale formed a small selection committee with exclusively African

experts. In 2010 the *3ème Festival Mondial des Arts Nègres* was a serious threat to the Biennale. Informally, Dakar art world specialists speculated that the state had cut up to 50 per cent of its financial allocation. What was certain was that for the first time the European Union did not fund the Biennale. In a conversation with Fillitz, the EU ambassador confirmed that the Biennale did not apply for financial support, and thus could not be considered. This year, indeed, FESMAN had absolute priority for President Wade, and finally this festival could be realized (see Mbaye, Chapter 2).

The policy of deliberately inviting a few artists became standard. A member of the 2010 selection committee repeatedly asserts that the *Comité d'orientation*, represented by its president, Gérard Sénac, encouraged them to also propose artists of their choice for selection. In 2012, each of the three curators could name two artists to be included in the show (Naidoo 2012: 22). In 2014, the *Comité d'orientation* agreed with the selection committee upon twenty artists who could be invited by the curatorial team. Henceforth, the Biennale of Dakar relied on a double structure for selection: first, the usual application procedure by dossier; and second, the invitation without application. Even so, some of Dakar's artists were concerned about the rise of a two-class system: the exclusive invitation for a few artists, and the general procedure for the vast majority. Finally, the curatorial teams of 2012 and 2014 broke again with the principle of geo-cultural distribution of selection tasks among curators.

The edition of 2012 was the last Biennale for Secretary General Ousseynou Wade. Babacar Mbaye Diop, professor of philosophy of aesthetics at Université Cheikh Anta Diop (UCAD), was appointed new Secretary General, and gallery director Thérèse Tupin Diatta became president of the *Comité d'orientation*. Diop would stay for twenty-one months (Diop 2018: 244). In conversation he described the two major trajectories of his function: administratively, he was commissioned officially to prepare a new legal status of the Biennale as a foundation (see Sankalé, Chapter 7), and on the artistic level his vision was to free the mega-event from its African frame, and to position Dak'Art as a global biennial (Diop 2018).

(d) 2016 and 2018: The artistic director scheme with African origins: After Babacar Mbaye Diop's resignation, Mahmadou Rassoul Seydi was appointed in 2016, and was succeeded by Marième Bâ in 2018. However, the president of the *Comité d'orientation* for both editions was Baïdy Agne, the president of the National Council of Employers. With the edition of 2016, another rupture occured which pushed the general curator system towards the star-curator model (Green and Gardner 2016: 19–47). Internationally renowned curator Simon Njami was appointed *directeur artistique* (artistic director) with responsibility for all official exhibitions of the Biennale and exclusive decisions about artists and artworks to be displayed in the *Exposition internationale* and the overall structure of the exhibition. Taking the Biennale's theme as his guideline, he adapted the selection procedure to this objective: invited artists dominated, complemented by a choice from general applicants. Njami further extended invitations to international curators and their

respective exhibition projects. Njami was nominated artistic director once again for the edition of 2018, and with the strong support of Baïdy Agne he continued on the route he had embarked on.

Dak'Art 2014 in Context

Historical/Conceptual Backdrop

Dak'Art 2014's orientation committee was chaired by the gallerist Thérèse Tupin Diatta. Members included the art historian Abdou Sylla, who has served repeatedly on the committee, Mahmadou Rassoul Seydi (then director of the National Festival of Arts and Cultures and Secretary General of Dak'Art 2015–16), Zoulou Mbaye (painter), Aliou Ndiaye (art critic), Alioune Diop (cultural journalist), Hamady Bocum (director of the National Heritage Commission), Alioune Badiane (artist and former director of École Nationale des Arts, Senegal) and Babacar Mbaye Diop (former secretary general of Dak'Art 2013–15), who served as rapporteur. In May 2013, Secretary General Diop and the orientation committee formally announced the selection of Elise Atangana, Abdelkader Damani and Ugochukwu-Smooth Nzewi as co-curators of the eleventh Dak'Art Biennale, repeating a curatorial collegiate model that the Biennale took in 2010 and 2012. For the three co-curators, Dak'Art 2014 was an opportunity to revitalize the Biennale, which arguably hit a major milestone in 2006, declined in 2008 and suffered significant damage to its reputation in 2010.

Before delving into Dak'Art 2014, it is worth exploring briefly Dak'Art 2006 and 2010 editions, arguably the highest and lowest moments in the Biennale's history and which served as critical conceptual frames of reference for the co-curators of Dak'Art 2014. Dak'Art 2006 was the most expansive and representative in terms of art genres, demographics and national spread. The official exhibition included the works of one hundred artists, and displayed more works of art than any of its predecessors or successors. For the first time in Dak'Art's history, a 'general curator' was formally appointed and empowered to select a curatorial team and adopt a curatorial focus devoid of administrative interference.[3] There was a call for curatorial proposals by the orientation committee, and the Abidjan-based curator and philosopher Yacouba Konaté's proposal was selected. Having curated sections of Dak'Art in 1998 and 2004, and having been a member of several evaluation panels since 1996, Konaté had an intimate knowledge of the Biennale.

This knowledge proved useful for Konaté in surmounting the bureaucracy at Dak'Art's Secretariat and the Ministry of Culture, as well as in engaging local power and cultural brokers (personal communication with Nzewi on 13 May 2012). He was reasonably successful in getting the Ministry of Culture to release funds for Dak'Art on schedule, which was a major achievement.[4] Konaté was able to assemble and mobilize an eight-member curatorial team (including himself) to travel around the continent and in Europe and North America to meet artists in their locales. Some of the artists were selected on the basis of this direct contact.

Others were chosen on the basis of submitted portfolios, which is Dak'Art's traditional selection process. This dual approach, according to Konaté, enabled the curators to include works of interesting artists who would not have followed the established procedure for submitting portfolios.

Dak'Art 2010 was a difficult moment in the history of the Biennale. It was hampered by President Abdoulaye Wade's shifting interests. Although Dak'Art was established by Diouf, the twelve years of Wade's presidency from 2000 to 2012 were a crucial period of consolidation of Dak'Art. However, in the second half of his presidency following Dak'Art 2006, Wade's cultural interests had begun to shift to high-visibility prestige projects that bore his imprint. The most outstanding of these projects that competed with Dak'Art, and those which elicited the most public attention, were the *Monument Renaissance Africaine* and the *3ème Festival Mondial des Arts Nègres* (otherwise known as FESMAN).

The two projects were formally unveiled in 2010 to coincide with the fiftieth anniversary of Senegal's independence. As a result, Dak'Art in 2010 was almost cancelled. In the estimation of local artists, FESMAN was a colossal diversion of funds that should have been used to strengthen Dak'Art. This view was reinforced by the lack of proper organization of the visual art section of FESMAN.[5] According to Sylvain Sankalé, co-curator of Dak'Art 2010, although funding was secured at the last minute from the Ministry of Culture, the budget was smaller than usual (personal communication with Nzewi, 20 and 30 April 2012). The European Union, the largest contributor to Dak'Art, also pulled out in 2010. The official position was that the disengagement was based on Senegal's failure to implement recommendations by the EU to improve Dak'Art's administrative capacity and to begin the process of making it independent of the Ministry of Culture. Dak'Art's status as a state-led initiative makes it practically impossible for it to be independent. In addition, the administrative staff are employees of the Ministry of Culture and do not have much power to implement recommendations unless sanctioned by the government. Conversely, rumours held that the Biennale's administration did not formally apply to the European Union in respect of Dak'Art 2010. Overall, financial uncertainties have always plagued the organization of Dak'Art events, but the situation was particularly precarious in 2010. The Biennale's ninth edition was drastically scaled down. Out of the 400 artists' portfolios that were reviewed by the five-member jury (Marilyn Martin, South Africa; Sylvain Sankalé, Senegal; Kunle Filani, Nigeria; Marème Malong Samb, Cameroon; and Rachida Triki, Algeria), who also served as the curators of Dak'Art 2010, only twenty-five artists were selected on the advice of the orientation committee.

Dak'Art 2012 was overshadowed by former President Wade's final attempt to subvert democracy and hold on to power and his subsequent defeat by President Macky Sall. This period in Senegal's political history was defined by intense political activism and grassroot mobilization. Although the political climate made the Biennale a low-key event in 2012, yet Dak'Art 2012 was more effective than the preceding one. The co-curators Christine Eyene, Nadira Laggoune and Riason Naidoo, who also constituted the selection committee, emphasized younger or lesser-known artists, returning the Biennale to its mission of providing a platform

to launch the careers of emerging artists. In 2014, it was clear to Atangana, Damani and Nzewi that Dak'Art was indeed in need of revitalization. The success of Dak'Art 2006 was a significant reference point. The 2014 edition was thus an opportunity to return the Biennale to global art world's consciousness, at least in the minds of the curatorial team.

Producing the Common

Dak'Art 2014 did not have an external international selection committee; instead, it comprised the curators. This situation was not novel; Dak'Art 2002, 2006, 2010 and 2012 curators doubled as the selection committee and the jury for the award of art prizes. Following the 26 May, 2013 announcement of the co-curators of the eleventh Dak'Art Biennale, Atagana, Damani and Nzewi were respectively charged with African diaspora, North Africa and sub-Saharan Africa by the Dak'Art administration. In November 2013, the three-man curatorial team visited Dakar, meeting in person for the first time and with Secretary General Diop and the orientation committee members. This initial site visit in Dakar was to review the application of over 700 artists who submitted their portfolios, identify potential exhibition spaces, and deliberate on a curatorial vision for the 2014 edition.

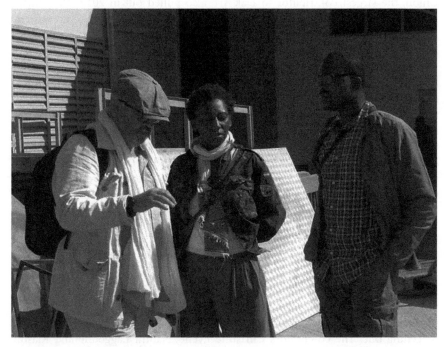

Figure 4.1 Abdelkader Damani, Elise Atangana, Ugochukwu-Smooth C. Nzewi (left to right), co-curators of Dak'Art 2014. Photo credit: Ugochukwu-Smooth C. Nzewi.

During that first meeting the co-curators elected to work collaboratively. What informed this decision, in part, was that with Dak'Art, the country of Senegal was offering a selfless service to Africa and the diaspora. Thus, the spirit of pan-African solidarity that the Biennale represents demanded collective action. The other reason was that artists from across Africa and beyond applied for participation by submitting their portfolios and it would have been impractical to organize these submissions under the three rubrics of the curatorial appointment. Working collaboratively was therefore logical and more effective. This desire and decision to work together would inform Dak'Art 2014's general theme of *Producing the Common*.

For the co-curators, *Producing the Common* offered an Africa-centred vision of globalization drawing upon Edouard Glissant's *Mondialité* (one world in relation), a concept that echoes the Senghorian civilization of the Universal (see Mbaye, Chapter 2). It was important to consider the role a biennial located in Africa can play in addressing our common humanity in line with Dak'Art's rich history and raison d'être. With *Producing the Common*, the co-curators made the conscious decision not to attach 'Africa' to the theme as a cultural or political signifier, as had been the case in preceding iterations of the Biennale. The theme also guided the

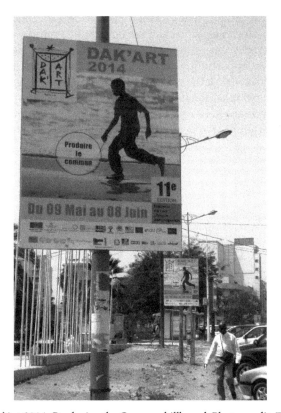

Figure 4.2 Dak'Art 2014: *Producing the Common* billboard. Photo credit: Thomas Fillitz.

selection of artists during the portfolio review process. *Producing the Common* served as the Biennale's general theme as well as the theme of the *Exposition internationale*. 'Cabinet of Curiosity', later retitled *Anonymous*, was a corollary to the *Producing the Common* theme.

With *Anonymous*, the co-curators had two goals in mind. First, to revisit the invention of African art as a global commodity and discourse, tracing back to its humble origins in Western *Wunderkammern*, the ethnographic aura that once surrounded it vis-à-vis the late nineteenth into the twentieth centuries' discourse of unknown (African) artists, and the rise of modern and contemporary African art from mid-century to the present. Second, *Anonymous* was employed as a trope by the co-curators to offer a critique of established versus emerging artists; star artists versus unknown artists; national versus transnational/international. The *Anonymous* exhibition offered a level playing field for all the artists regardless of their art world status and nationality. All the works in the display had no tombstone information, thus making it impossible to identify them by the names of the artists who created them.

To complement the number of artists selected via the application process, each curator invited eight artists of their choice. The co-curators made a collective decision not to select or invite artists who had previously participated in Dak'Art because it undercut the Biennale's mission of providing a venue for discovering new artists and serving as a platform for introducing emerging or unknown artists into the international scene. At the same time, the repeated exposure of some of these artists reduces opportunities for other artists who have yet to find a platform of exposure and goes against the Biennial's objective of launching new talents. This point was raised by Senegalese artist Viyé Diba, a member of Dak'Art 2006's orientation committee. Referring to Dak'Art 2006's selection process, Diba wondered why certain works were included, based on what he referred to as 'the

Figure 4.3 *Anonymous* exhibition, Dak'Art 2014, 9 May–8 June 2014. Photo credit: Ugochukwu-Smooth C. Nzewi.

unexamined reputation of the artist' (2006). Questioning the hybrid approach of Dak'Art 2006's artists' selection, Diba argues that such a process can be less transparent and allows curators to give preferential treatment to artists from their own networks (ibid.).

Diba's position was clearly on the co-curators' minds, especially what he describes as the hybrid approach of shortlisting artists through their submitted portfolios and complementing the choices with the curators' invitations. From a personal perspective, the hybrid model presents the best approach in the selection of artists for Dak'Art exhibitions. It allows the Biennale to maintain a level playing field for both established and emerging artists, which selection by submitted portfolios provides, but also guards against the exclusion of artists whose works and presence have the potential of enriching the Biennale. The portfolio method does have its limitations as well. Artists who are photo-savvy can put together very impressive portfolios. In many instances, the photos were not a true representation of the original works when they were received by the Biennale. This came up in Nzewi's interviews with several past curators of Dak'Art, including Yacouba Konaté, Marilyn Martin, Christine Eyene and N'Goné Fall.

All the same, the hybrid approach proved effective in 2014, especially with the co-curators' decision to focus on artists who would be exhibiting for the first time. Between them, the three co-curators invited twenty-four African and African diaspora artists who were bona fide art world stars, had had long careers without concomitant recognition, or were on the path to mainstream success. They included Julie Meheretu (Ethiopia/United States), John Akomfrah (Britain/Ghana), Wangechi Mutu (Kenya/United States), Radcliffe Bailey (United States), Simone Leigh (United States), Tam Joseph (Britain), Kader Attia (Algeria/France),

Figure 4.4 Emeka Ogboh, *Song of the Germans*, multi-channel sound installation, *All the World's Futures*, Biennale di Venezia 2015. Courtesy of the artist and Ugochukwu-Smooth C. Nzewi.

Dris Ouadahi (Algeria) and Candice Breitz (South Africa). In addition to privileging the invitation of female artists, the curators paid close attention to countries that had had marginal or no presence at Dak'Art, such as Malawi and Somalia. Consequentially, Dak'Art 2014 artists John Akomfrah, Emeka Ogboh (Nigeria), Nidhal Chamekh (Tunisia), Wangechi Mutu, Samson Kambalu (Malawi) and Massinissa Selmani (Algeria) were included in the Biennale di Venezia 2015's *All the World's Futures*, curated by Okwui Enwezor.

Yet the challenge of making art biennials in a short space of time – Dak'Art 2014 is a case in point – is that it does not afford enough time to contemplate, develop and implement robust and far-reaching curatorial vision as the co-curators would have hoped for. In addition, assembling individuals with no previous history of working together at short notice and leaving them less time to gel can compromise the outcome of the Biennale. Also, the recurring problems that have been enumerated by Sylvain Sankalé, Koyo Kouoh and Eva Barois De Caevel (see Chapters 7 and 8) were a stumbling block. In 2014, the co-curators had to contend with a laissez-faire disposition by the Dak'Art management in discharging its duty. For example, on several occasions, the co-curators combined their curatorial duty and administrative work such as arranging flight tickets and airport pick-ups for artists and checking them into their hotels, as well as visiting the airport storage facilities frequently in search of artists' works. These were logistical matters that should have been taken care of by the Biennale staff who were assigned those roles. The curatorial team also contended with unnecessary interference with their curatorial vision. One major instance is the *Anonymous* exhibition, a gesture to the colonial legacy of the invention of African art as part of world art, but which the Dak'Art administration rejected, forcing the co-curators to come up with a new, and perhaps better, title. Fortunately, Dak'Art 2014 had other successes with the quality of participating artists and artworks, the

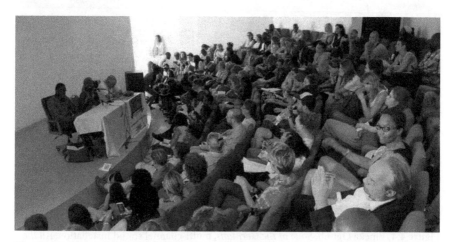

Figure 4.5 Press conference, Dak'Art 2014, 6 May 2014. Courtesy of Ugochukwu-Smooth C. Nzewi.

Rencontres–échanges conference, the participation of international visitors who came to Dakar in large numbers during the month-long event, and an impressive international reception.

Re-making the Format of Dak'Art

One may wonder about the reasons for developing these strategies of selection. Are they consequences of thinking the Biennale's position within the global biennials network? Are they reactions to the critiques each edition is subjected to? One can assert that choices of artists and artworks never reach unanimity, but over the Biennale's cycle there are some major lines of dissatisfaction: a) the dominance of European/North American criteria for contemporary art, and the concomitant neglect of contemporary African art discourses; b) the presence of Senegalese artists in the *Exposition internationale*; and c) the equal representation of artists from all African regions.

The significant incorporation of non-African experts in the selection committee was a continuous, major source of discontent. Regarding Dak'Art 98, art critic Katya García-Antón comments in this respect about 'the spectre of colonialism' (1998: 87), whereas Konaté (2009) notes for all these editions that non-African art world professionals present with the support of some African specialists 'their version of contemporary art in Africa' (ibid.: 88). In personal conversations, several artists angrily stated that many of these non-African experts were not acquainted with the history of modern and contemporary African art, but were well paid and generously hosted by the Biennale. Ousmane Sow Huchard likes to recall his intervention in 1998, when Achille Bonito Oliva suddenly wanted a last-minute reassessment of the already finalized selections, as he was worrying about his international reputation (personal communication; see also Konaté 2009: 88–9).

However, the appointment of an internationally highly renowned curator is a widely held practice for creating visibility within the global biennials network. Biennial research actually recognizes that such globally acting curators relay each other in the artistic direction of major mega-art events. By 2000, this had produced a global biennials circuit with 'few celebrated artistic directors' (Smith 2012: 18–19).

Due to their activities within international art spaces (e.g. biennials), such curators are closely involved in global discourses of contemporary art, and these are specifically different from local and regional ones (Buchholz 2016: 41). Indeed, inviting such renowned European and North American curators onto selection committees, and appointing them as their presidents, corresponds to a conscious appropriation of these competencies for the benefit of the Biennale. This is another aspect of the strategy that was practised for five editions in the early days of Dak'Art and was introduced in a new constellation with the artistic direction of Simon Njami.

As it were, the search for adequate selection expertise and mechanisms is connected to selection criteria that are embedded within tensions between currents of global art discourses, currents of modern and contemporary African art, and

stereotyped imaginations of contemporary African art. Elliott's major emphasis on installation art (Dak'Art 2000) is in line with contemporary art trends promoted on the global scale, although it should be remembered that installation art had been present at the time in African art worlds as well. The selection criteria for Dak'Art 2004 related rather to imaginations, as the committee asked itself: 'Could the art speak to a pan-African audience? Would international audiences engage with the artists' works?' (Diamond 2004: 15), finally asserting that this *Exposition internationale* 'is alight with intellectual, emotional and spiritual reflections of contemporary African experience' (ibid.). In other words, the committee wanted artworks that corresponded to engagements with the respective local environment, to contemporary African art trends, and expressed a (stereotypical) 'Africanness'. For Dak'Art 2006, Konaté recalls the Minister's request: '*s'il vous plait, faites-nous une biennale africaine!*' (please make us an African Biennale) (Konaté 2009: 61), to which he replied: '*Mme le Ministre, vous ne serez pas déçue*' (Madam Minister, you will not be disappointed) (ibid.). The general curator and his team decided that their choice would consist of one-quarter landmark artists (historically important), one-quarter young artists (who were never previously selected for the Biennale), and one-half confirmed artists (ibid.: 104).

There was an interesting dialogue in 2010 during the selection committee's panel at the forum *Rencontres–échanges*. Sankalé carefully explained the criteria and procedures, then emphasized that all five members had agreed to choose according to personal taste, and to leave art historical and theoretical discourses aside. The quality of the artwork was the central target, reflections about its African or European/North American dimensions or its classification should be avoided as this constituted partitioning (personal communication to Fillitz). Marilyn Martin, at this time director of the Iziko South African National Gallery, Cape Town, confirmed that they had such debates, but the five members realized one thing: they were speaking in different art languages.

Many participants felt this to be a provocation. Yet, these positions make clear in a radical way the fundamental aspects of selection processes: any inclusion or exclusion is an external value judgement, as Groys argues in *Art Power* (2008). Martin's insight into the diversity of art languages, even if restricted to African art worlds, refers to how academic discourses produce differences, that is, hierarchies, among artistic creations, while Sankalé's insistence on 'personal taste' highlights 'absolute subjectivity' – as he further circumscribed taste. Both are differently argued value judgements, but the selection each of these procedures entails is 'the effect of pressure exercised by external forces and powers' (ibid.: 13). Hence, as radical as was the 2010 selection committee's decision to exclusively consider young artists who had never been shown at the *Exposition internationale* – a consequent interpretation of the topic 'Perspective' of Dak'Art's 2010 subject *Retrospective[6] and Perspectives* – basing this decision on personal taste is equally radical and uncovers a central aspect of all aesthetic judgement. It creates difference in the form of hierarchies.

Indeed, the selection committee of Dak'Art 2012 articulated the problem in a different way. As curator Nadira Laggoune-Aklouche (2012) explained, the three

curators strove to create a 'picture as representative as possible of what is happening on the continent, of artists coming from the most prolific countries or from countries where one goes rarely, and which art is equally rarely exhibited' (ibid.: 18–19). For Christine Eyene (2012), curator in the same committee, 'the issue of not making a "Western-style" selection was raised' (ibid.: 14). Thereafter the committee took the orientation not to reject 'works whose aesthetics is specific to Africa. In other words, find the right balance of vernacular contemporary visual language' (ibid.). Their peer, Riason Naidoo (2012) gives insight into the criteria-related topics they discussed:

> whether new work by established artists previously selected at Dak'Art should be considered; whether we should be profiling works by younger artists who had never shown at Dak'Art before – or both. And whether our choices are confident enough to select artists even if their work does not correspond to international trends and western criteria?
>
> ibid.: 22–3

The exclusive appointment in 2014 of African curators, or curators with African origin, contributed to eliminate imaginations of an Africanness, while the contrast between global contemporary art trends and African ones not only diminished, but rather moved closer to a global perspectivism. The subject matter of the editions of 2014, 2016 and 2018 facilitated this orientation, as these topics took centre stage in choices of artists and artworks, and applications were complemented by invitations. Furthermore, the concept of the format for the Biennale of Dakar was explicitly shaped. It is not an art institution that relies on fostering a permanent art collection, it is not a site for visualizing the art history of a city, a region or a continent. Simon Njami (2016) clearly formulated the format for Dak'Art 2016 as 'a place of experimentation and discovery, thus necessarily free of the certitudes that dominate reason and reasoning' (ibid.: 38).

Experimentation without the constraints of an art collection also influences the selection of artists. Beyond complying with Dak'Art's regulation of having either citizenship of an African state or African origins, there are no restrictions. Whether an artwork is well inscribed within a local art world, whether it relates to an African complex of contemporary art, or whether it fits into global discourses of contemporary art – for Njami the question is the quality of the work of art and its relationship to the subject. Key notions of the artistic director are experimentation, freedom of creation, re-enchanting the world, and desire (ibid.).

Outlook

This chapter has discussed the central structure of the Biennale's artistic performance. Considering the Biennale's cycle, the interplay between selection committee, secretary general and president of the *Comité d'orientation* appears paramount. We argue that the periodic restructuring of the selection committee,

as outlined in the first section, is not simply readjustment, as former Secretaries General Rémi Sagna and Ousseynou Wade have mentioned in conversation with each of us. We view them as earnest reflections to improve the Biennale's exhibitions in its embedment into the global biennials circuit. Dak'Art is not just another art festival, another large-scale exhibition. For the Biennale Secretariat, the constitution of the Biennale of Contemporary African Art in 1993 was the inception of a process of conceptualizing this particular biennial format in relation to the local art world, to those on the African continent, and to the global biennial network.

Of course, we need to recognize critiques of selections, such as the committee's lack of knowledge of the history of modern and contemporary African art, the preferential treatment of an art medium (installation), the influence of good-looking portfolios due to the artists' access to the latest technologies, or the favouritism towards artists from certain countries. These arguments had an influence on rethinking the selection criteria. Decisions, nonetheless, go well beyond such individual opinions about value judgements of selection committees. The choice of prominent international curators as presidents of these committees are clear strategic signs for placing the Biennale within the global network, and the criterion of African origin or citizenship for committee members expresses the desire for an African perspective against the hegemony of Europe and North American discourses. Further, the introduction of a general curator (2006, 2008) and the more recent implementation of an internationally highly renowned artistic director (2016, 2018) reflect these distinct aims and the possibilities of institutionalizing them.

In the second section, Nzewi presented his own experiences as co-curator of Dak'Art 2014. Although the committees' independence regarding selection criteria and decision making was highlighted by secretaries general and presidents of the *Comité d'orientation* in conversation during our respective researches, Nzewi shows that they had to react to previous Biennale editions' performances, and that there were certain frameworks and constraints to which they had to respond in one way or another. Although the members of the selection committee should be committed to a geo-political structuring of the selection process, they had to reject this prerogative, and instead implemented another, more appropriate procedure. Further, Nzewi mentions time constraints for the selection and invitation of artists. There was no opportunity for the curatorial team to travel around Africa and beyond to solicit works of art, as was the case for Dak'Art 2006. Instead, they relied on the applicants' portfolios and the artists they knew about beforehand. If Dak'Art is meant as a venue to discover and launch the careers of artists, it holds therefore that curators should travel to find new talents rather than recycling the same names. In addition, the process of travelling and meeting artists might have spurred Dak'Art 2014's curator to develop a stronger theme or to think differently about the edition. Instead they relied on their imagination and preconceived ideas. Another major constraint was the inability of the Dak'Art administration to provide logistic and administrative support as and when required for the curatorial team, artists and invited guests. In addition, the Biennale's management in the

person of the secretary general tended to interfere with the curatorial process of selection and conception of exhibitions.

The final section complements the argument thus far presented insofar as it outlines major approaches of selection committees to the Biennale's overall objective of promoting contemporary African art and specifically the work of contemporary Senegalese artists. It is noteworthy that the decision for exclusively African curators for the *Exposition internationale* is accompanied by a reflection of these art experts about the meanings and implications of such an orientation – to be neither 'Western-style' nor responding to imaginaries of an 'Africanness'. These latest constellations of the selection agenda demonstrate the orientation the Biennale of Dakar has taken through its cycles. Artistically, it is far beyond what Jeannine Tang (2011) mistakenly denotes as a national enterprise, where 'curating the region may substitute regional loyalties for internationalism' (ibid.: 78, 80). The Biennale of Dakar is global in several perspectives: first, it deals with the diverse art worlds of the continent; second, it reaches out to include artists from Africa's diasporas, that is, artists who are working in multiple art worlds around the globe; and third, its curators participate in very diverse art discourses. Henceforth, the Biennale of Dakar can neither be conceived as a national field of contemporary art, nor as a regional, Francophone West African institution, nor as a bounded continental entity – but as one African art world. The challenge now is to be the Biennale for contemporary African art within the global biennials network, and to unfold its local, regional and global locations. In this regard, the editions of 2014, 2016 and 2018 have well prepared the future's visions and trajectories.

Chapter 5

ENCOUNTERS AND EXCHANGES: AN INTELLECTUAL HISTORY OF THE BIENNALE OF DAKAR

El Hadji Malick Ndiaye

Introduction

The visibility of artists is constructed through the strategic and enduring interaction between the hazards of the art market, the support of cultural structures (museums, galleries, art centres, etc.), the periodicity of mega-art events (biennials, festivals, etc.), and the unpredictable behaviour of the gatekeepers of art [curators, critics, etc. (Aka 2014)]. An exhibition therefore is important as a site of visibility, whereas the critical art discourse contributes to the reflection of the development of artistic practices. If this discourse takes place within the framework of a biennial, a double reading is articulated, insofar as the event itself is a factor that is structuring history. On one hand, it encompasses positions which mark all the more the space of enunciation, as they reach a real historical depth in a world dominated by power relations. On the other, these discourses interpret a discursive reflexivity which shows the capacity of the biennial to reflect itself within the global art cartography.

The Biennale of Dakar (Dak'Art) has benefited from a frame of reflection which permitted to represent itself, to accompany in an epistemic procedure the ongoing artistic creation on the continent, and to situate this latter in the time of the world. Dak'Art reflects the creative artistic process and changes of forms within political, social, economic and religious contexts. This discourse unfolds in the forum *Rencontres–échanges* (Encounters and exchanges). All through the various editions of Dak'Art its trajectory is woven according to the preoccupations of agents to write art history from Africa's own perspective. If one conceives this forum as a barometer of a history of ideas, then one needs to raise several questions. How did the *Rencontres–échanges* accompany the development of artistic politics, the evolution of iconography and the diversification of art's media? Which are the discursive regimes of the Biennale as well as its successive representations? In what way is the Biennale a space which repositions the continent's history of art against the obsolescence of the old critical representations?

This chapter reviews the trajectory of the *Rencontres–échanges* in a double perspective. First, this will be done in relation to the art worlds on national and

global scales, and second, by following the evolution of the concept of contemporary African art. The diversity of ideas inherent in the Biennale requires a historical approach. With such an approach, the examination of this forum of the Biennale may connect the history of art and cultural politics. To these ends, my analysis consists of three sections. First, the historical context of the emergence of the *Rencontres–échanges* will be explored. It moves between structural reforms and new scientific orientations of the Biennale, which is conceived in the mould of the *Premier Festival Mondial des Arts Nègres* (First World Festival of Black Arts; 1966). Second, the cyclical discursive regimes of this forum will be considered – that is, the changing topics of art criticism and the art market which characterize these regimes. The third section will investigate how the thirteenth edition of the Biennale of Dakar (2018) was an important milestone of a new historical conscience for future trajectories.

The Biennale of Dakar (1990–92): A Pan-African Encounter in the Wake of 'Mega-Events'

The overall scope of large art manifestations may be seen in the fact that they solve the problem of antinomies – that is, of dualistic and ambiguous phenomena where the modern and the non-modern, the national and the non-national, the local and the non-local mingle (Roche 2000: 8). The model of Dak'Art is moulded according to the ambivalence of two mega-events: the Biennale di Venezia and the *Premier Festival Mondial des Arts Nègres*.

The World Festival of Black Arts reactivated the cultural traditions of the continent in order to transplant them on a time axis of periodical continuity. As it combined past and future, this festival displayed African cultures from their most dynamic perspective. It was thus a historical adjuvant at a time in which a bipolar century dictated an occidental cultural hegemony, dominated since 1895 by the Biennale di Venezia. This '*championnat international des arts*' [international art championship (Descargues cited in Malbert 2006)], the emblematic figure of the global artistic scene, mirrored the political and diplomatic divergences of the planet. Mirror of the art market, focal point of art criticism and rendezvous of the art jet-set, this mammoth remains a mastodon of the artistic ecology. Nevertheless, from the 1990s onwards, artists of the African continent struggled against these bourgeois conventions and the ensuing imposition of a distorted art history of this biennial to reach visibility in an ephemeral and sporadic manner.[1]

In Senegal, the creation of a biennial was urgent in the aftermath of Senghor's providence-state which was assured until 1980. Multiple are the reasons for the foundation of the Biennale of Dakar, but the 'principal motivation of Dak'Art rested on the will of the government of Senegal to bring back to life the cultural prestige of the World Festival of Black Arts of Dakar, thus to make of the Senegalese capital a cultural nodal point in contemporaneity' (Diadji 2003: 76).[2] For sure, the birth of the Biennale of Dakar expresses a fascination and a nostalgia of political and cultural agents for this mega-event of 1966. 'Hence, its specificity is connected

to the endogenous exigency, in contrast for instance to the Biennale of Bamako, which was born out of French political reason' (Sagna and Fall 2006: 43).[3]

In 1990, the Biennale of Dakar started as a multidisciplinary event (arts and letters) around the theme *Regards croisés sur l'Afrique* (Perspectives on Art in Africa). Centred on Africa but very open to the world, the model of this edition strangely recalled the ambience of the large pan-African encounters, even in the spaces of critical reflection. The reports of the editions of 1990 and 1992 admit that the first international conferences of the Biennale appeared like experiences that reconnected with the first and second Congress of Black Writers and Artists (Paris 1956, Rome 1959). These two international conferences constituted a platform for the circulation of concepts and analytical categories, one required to provide the African intelligentsia with the elements of a concerted politics of cultural development. 'In this context, the international seminars … often lead to the formulation of propositions and recommendations which are marked by the seal of local expertise, in a context of openness to constructive ideas from elsewhere' (Ministère de la culture, n.d.: 5).[4] The forum of the Biennale of 1992, with the title *Art contemporain africain: permanences et mutations* (contemporary African art: permanence and mutations)[5] is a revealing example. It was structured according to three axes relating to economic stakes, popular creativity, and art criticism in Africa. The overall objectives were, first, to evaluate the criteria of appreciation of African artistic production, and, second, to discuss the contours, forms and contents of a specific African art criticism. The space of critical reflection, however, was fragmented as another format was organized besides the forum, the *Journées du Partenariat* (days of partnerships). This latter consisted in introductory talks, works of experts, and the presentation of projects in search of partnerships. 'The overall report of the three days of international seminars dresses a global appraisal of the itinerary of African art since the times of the World Festival of Black Arts of 1966 and its place in the world' (Secrétariat de la Biennale, n.d.: 3).[6]

The strong identification with the 1966 festival had led the Biennale of 1992 to focus on international expertise, to the detriment of African specialists. Their minor involvement in the conferences was widely pointed out. The participation of some African experts from Ghana, South Africa, Gambia, Cameroon or Côte d'Ivoire should have contributed to dissolving this reproach – the latter, however, resided and worked mostly in Europe or the United States. 'The identification of the grand majority of participants, all categories, passed via the bias of occidental networks. At the research of African artists, the Biennale selected those of the diaspora already integrated into these networks. It sent out the largest number of invitations to occidental critics and art dealers' (Bosman 1992: 30).[7] The malaise in respect of this event, which was organized in partnership with the North, has to be viewed in the context of a time when Africa was attempting to define a particular contemporary aesthetic with references that were encroaching from all sides.

Following the Biennale of 1992, several joint actions were undertaken in order to revise its model and frame of reference. An international seminar of evaluation was organized to reappraise the Biennale's structure, and the European Commission published a separate evaluation report. Regarding the forum of seminars, the

report recommended a focus on the art markets and encounters with gallerists, and prescribed an orientation towards presentations which privilege dialogue and which are susceptible to launch debates 'between artists and specialists, on the life of artists and their artistic practices, as well as regarding mechanisms and strategies for penetrating markets' (Huchard and Badiane, n.d.: 11).[8] In the spirit of these reforms, the term *'colloque'* (seminar, conference) was no longer to be used. From 1996 on, the new terminology was *Comité technique 'Rencontres–échanges'* (Technical committee 'encounters–exchanges').[9]

Rencontres–Échanges (1996–2016): Spaces of Critique and Discursive Regimes

Art criticism and the art market are the two subjects that permanently dominate the forum *Rencontres–échanges* of the Biennale of Dakar. For Senegalese art critic Iba Ndiaye Diadji, this preoccupation stems 'from the ambition of the Scientific committee of Dak'Art to better position the arts of Africa in the present debate on artistic contemporaneity, and to transform Dakar into a stronghold in the global market of fine arts' (Diadji 2003: 80).[10] It is important to emphasize that matters relative to the market by and large have accompanied the endeavours for an autonomous status of the Biennale. Indeed, in 1996 the topic of the forum was *La création artistique africaine et le marché international de l'art* (the African artistic creation and the international art market). Major themes of the conference were critical analyses of the artist's alienation by the art market, how demands of countries of the North impact on the formatting of cultural products, as well as the resulting stylistic trends. Hence, the presence of tenacious critique was considered vital as a shield against the dehumanization of artistic forms, as some critics perceived these artistic developments.

Tensions between the choice of materials with which to inscribe the world and the nature of the symbols which create their meaning characterized the existential ambiguity of the artistic expression during these first editions of Dak'Art. Whereas artists strove to define their artistic personality in respect of their interrogation of the world during the 1990s, foreign journalists and art critics viewed the search for authenticity as the forum's central artistic issue. Iba Ndiaye Diadji, for instance, recalls the stupefaction of the audience – foreign journalists and visitors – when he presented the artist Iba Ndiaye as not being an African painter (Diadji 2002: 9–10). In these spaces of art critique, the relationship with the artistic African creation was beginning to break out into two trajectories – authenticity and globalism – both, however, being transcended by the artistic practices. Indeed, artists had already been working in artistic languages that were no longer suppressed by the hegemony of the painting medium and its referents. While Senegalese artists such as Moustapha Dimé (1952–98) had practised installation art in the early 1980s, this technique was validated with the Biennale edition of 1996, when several works of installation art were selected and the *Grand Prix du Chef de l'État* was awarded to the installation by Abdoulaye Konaté from Mali, *Hommage aux chasseurs du mandé* (1994; see Sylla 1998: 61).

In 1998, the forum centred on *Management de l'art africain contemporain* (Management of contemporary African art). The conference debates demonstrated the wide gaps within ideas of contemporary African art: whereas art critics such as Iba Ndiaye Diadji wanted to consider its singularity, this same conceptualization would not be sustained by the public. The majority of the latter estimated that 'African art had to account solely to the relentless laws of the global art market' (Diadji 2002: 10).[11] It seemed as if the complex ambivalence of the artists was the exclusive theme of art criticism, since it legitimized the sustainability of the Biennale within the global biennial system. This viewpoint intensified with the edition of 2000, which fused design and textile creativity in a *Salon international du design africain*, while the *Salon de l'éducation* disappeared. The topic of the *Rencontres–échanges* focused on *L'art africain contemporain: courants, styles et creation à l'aube du 3ème millénaire* (contemporary African art: currents, styles and creation on the eve of the third millennium). Indeed, the beginning of the new millennium introduced challenges to the artists, with a scientific turn in the art selected. This topic supplemented questions of identity of the stylistic sign, a paradigm that was transgressed in the 1990s with installation art. Now, the introduction of the virtual called for a redefinition of the real, which was aligned around a new interaction between creator and spectator.

The impact of information and communication technologies in the arts was intensified during the following Biennale editions, and interconnected with subjects of globalization and the artists' identity. Thus, the 2002 forum of debates focused on *Créations contemporaines et nouvelles identités* (contemporary creations and new identities). The Biennale thereby introduced the forum of digital arts following the suspension of the *Salon sous-verre* and the Marché des Arts Plastiques Africains (MAPA; market of African fine arts).

With artistic supports centred on the digital, the place of the artist in the global art market, as well as the nature of materials for artistic practice in times of globalization, evolved respectively. Indeed, 'during the four last editions of Dak'Art (2000, 2002, 2004, 2006), installation works, videos and ICT are by far in the majority: in 2004 they are sixty-five out of ninety-one; in 2006, they are forty-four out of 122 works in total' (Sylla 2008).[12] As a consequence, the expansion of the digital as art medium was interrogated as a threat to African creativity. Such questionings demonstrated contrasting lines of reflection between the spaces of art criticism and the structural transformations of artistic practices on the continent. This trend was particularly accentuated in the Biennale of 2004, which dealt with *L'Art contemporain africain à l'épreuve de la mondialisation: problèmes, enjeux, perspectives* (contemporary African art confronted by globalization: problems, challenges, perspectives). The emergence of a new aesthetics called for a considerable revision of the criteria of appreciation, and, in tandem, a professionalization of art criticism in Africa. As Aminata Diaw Cissé observes:

> The receptivity of a new aesthetic carried by performances and installations, by the use of the digital suggests the availability of an audience knowledgeable about these new modalities in the African visual art. If to be in our days is to be

digitised, then the learning of this technology and the appropriation of the possibilities it offers prove to be an imperative both for the creators and the audience. Even if artistic production is personal, it nevertheless has a space-time anchorage which always locates it in a given culture. The digital gap which further marginalises Africa is not definitive as the resumption of historical initiative on both the individual and the collective plans remains the salvatory way.

<div align="right">Cissé 2004: 173</div>

Following these considerations, the reception of artworks was thus discussed in light of the desire to stabilize the concept of contemporary African art, while the frame of analysis was the notion of globalization. The ambition was to define aesthetic categories that should be applied to the new modes of creativity, preconditions to evaluate how artists and their artworks insert themselves in the global circuit of ideas, and how they negotiate their role in the world. It is obvious to note that the discussions about a definition of African art, those connected to its authenticity or to its alienation, have dissipated over the years. Within this framework, the heritage of the modern seems to progressively cede the space to the contemporary, insofar as the École de Dakar loosens its hold on Senegalese contemporary artists. At this level,

the problem of the contemporary imposes itself from time to time as large exhibitions like the biennale of Dakar or the one of Johannesburg emerge. There is a contiguity of fact between contemporary art and the biennale as specific form of exhibition. The biennale as instance and institution is an element of the system of contemporary art with the acting community of gallery directors, museum curators, critics, curators.

<div align="right">Konaté 2009: 88[13]</div>

Nonetheless, the contemporary articulates a new approach to pan-Africanism that the Biennale's editions of 2006, 2008 and 2010 redefined from the vantage of its exhibitions: *Africa: Agreements, Allusions and Misunderstandings* (2006), *Africa: Mirror?* (2008), and *Retrospective and Perspectives* (2010). Undoubtedly, the pan-Africanist dimension was anchored in the intentionality of the Biennale's birth, and it never left the spirit of the Biennale of Dakar. How to negotiate a contemporaneity within the continuity of a historical conscience whose seeds have given birth to Dak'Art? Hence, the new lively discourse of the *Rencontres-échanges* is the celebration of urban culture. Indeed, this latter is in line with the emergence of a new artistic language of cultural actors that Mamadou Diouf defines as third-generation artists: 'Their aesthetic commitment traces them at the same time as it borrows the patterns of urban culture produced by daily life. They thus neglect the nation and its political concerns' (Diouf 2012: 166). This dynamic between the city and the social was pursued in the editions of 2012 (*Contemporary Creation and Social Dynamics*) and 2014 (*Producing the Common*).

The forum of this eleventh edition (2014) touched in a transversal way various subjects related to the theme of 'the professions of the arts'. Seven round tables were programmed over four consecutive days with the following sub-topics: exhibition curatorship for contemporary art, the art critic, the art historian, the artist and the gallerist, institutions of contemporary art: fairs, auction houses, museums, biennials ... art dealers, buyers, collectors, Maecenas. In collaboration with the magazine AFRKADAA, a final round table was organized on the subject of contemporary art magazines (Biennale of Dakar 2014: 14).

The construction of a space of art criticism which would reflect the contemporary has been an ongoing, growing intention of the Secretariat General of the Biennale of Dakar. Within this environment the scholarly conference of the 2016 edition was *Symbioses*. It focused on the subject of re-enchantment and was well anchored in the thought of Léopold Sédar Senghor. The premises of the *Conseil Economique, Social et Environnemental* (Economic, Social and Environmental Council) hosted the forum. With the invited curators taking centre stage, the conference dealt with 'the idea of re-enchantment and of the renaissance of an aesthetics of contemporary African art which is conscious of its missions as translator of a dynamic Africa in mutation, and as a bridge towards other ways of seeing and thinking the world' (Biennale of Dakar 2016: 23).[14]

'L'heure Rouge' (2018) and the Transformation of the Normative Intellectual Frames

For the editions of 2016 and 2018, for the first time in the history of the Biennale of Dakar the same artistic director, Simon Njami, was appointed twice. These two editions enshrined the question of contemporary art within successive expressions of two major representatives of *Négritude*. The edition of 2016 dealt with *Réenchantement: La Cité dans le Jour Bleu* (Reenchantments: The City in the Blue Daylight) and related to a poem of Léopold Sédar Senghor, whereas the title of the 2018 edition – *L'heure Rouge: une nouvelle Humanité* (The Red Hour: a new Humanity) – recalled a theatre play of Aimé Césaire (*Et les chiens se taisaient*, 1958) and refers to the time of accomplishment. This reference to time as a metaphor for the epoch of Africa's new prominence led to several horizons of reflection and action. The hour of accomplishment (2018) heralded a new era in which the individual rethinks their relationship to the Other and considers ways to rearticulate their presence in the world.

> To renegotiate our place in the world, however, passes via the revision of the concepts which govern us. Even so, the stakes of the time are profoundly anchored in the artistic reflection and contemporary art. What does this thinking of our quotidian relationships with globalism teach us, as it is fashioned by the flux of ideas, the circulation of cultural goods, and the frenzy networks of interactive and interdependent agents?
>
> Ndiaye 2018: 284[15]

Starting with this question, the theme of the forum focused on *Arts contemporains africains et transformations des cadres intellectuels normatifs* (contemporary African arts and transformations of the normative intellectual frames).[16] If the terms of the debate were already well rooted in the recurrent subjects of the Biennale, the method of raising the questions changed profoundly. Foremost, the topics related to art criticism were merged within the writing of history, insofar as the shaping of the latter has to pass via an interrogation of categories of reflection and analysis. Furthermore, this intellectual work can only be approached while reflecting the aesthetic within the global framework of a social history of artistic practices. This allows the association of cultural history with intellectual history. The scope thus is to study the African cultural mutations within a global field. Furthermore, debates took the opportunity to connect the problems of the market with the architecture of public politics. If it is true that a market for contemporary art cannot be decreed, it is equally certain that its emergence can only be realized with the considerable contribution of most favourable cultural politics. This latter has to produce the necessary conditions to encourage the market agents (auction houses, art dealers, collectors, etc.). The objective is the amelioration of the institutional environment of contemporary African arts, by updating the elements of the art market, the status of the artist and the new supports of valorization of contemporary African arts.

Several innovations were implemented during the 2018 Biennale. As a centre of thought production, the Université Cheikh Anta Diop of Dakar hosted the inaugural lecture given by Simon Gikandi, Princeton University, on the subject of *arts et savoirs* (arts and knowledge). Entitled *Art and African Thinking*, Gikandi presented his talk in the presence of the rector of the university, Mamadou Diouf acted as moderator and Souleymane Bachir Diagne was the discussant. Three preliminary conferences were scheduled each morning at Musée Théodore Monod d'art africain de l'IFAN Ch. A. Diop, the main centre for the forum *Rencontres–échanges*. The reflections and debates revolved around three topics: Arts and History, Arts and Institutions, and Arts and Finances. Systematically, all talks had follow-up workshops focusing on seven subjects:[17] cartographies of knowledge; writing history by means of the exhibition; the creative work as production of knowledge; public politics and autonomy of cultures; intellectual property and status of the artist; finance, lobbying and strategies for art markets in Africa; prospective new supports of valorization of contemporary African arts.

The diffusion of these exchanges was instantaneous, as streaming through social media was assured, thereby enabling academic ideas to be disseminated beyond the circle of initiates. The 2018 edition of the Biennale included several challenges around the subject of strengthening Dakar's place in the dispositive of reflecting artistic creativity. It clearly intended to pick up the initiative in the fields of arts and culture in Africa, and to position the city of Dakar as international centre of reflection in the domain of contemporary arts of the African continent. In the future, art criticism is adjunct to the capacity of giving birth to an aesthetic, to renew it, or to reveal its different trajectories.

Conclusion

For its two first editions (1990 and 1992), the Biennale of Dakar perpetuated the spirit of the *Premier Festival Mondial des Arts Nègres* (1966). As a platform for discussion, the grand pan-African Congresses of Black Writers and Artists in Paris (1956) and Rome (1959) inspired the forum *Rencontres–échanges*. Whereas the Biennale of 1992 reserved only minimal space for African art critics, the successive editions strove to acknowledge African expertise in this field. Conceived from a pan-African perspective, the art market and art criticism have been perennially the two standing axes. They are, however, closely interwoven with the diversity of approaches that has accompanied the changes in the exhibited artistic productions.

Since the *Rencontres–échanges* of 1996, whose subject was *La création artistique africaine et le marché international de l'art* (the artistic African creation and the international art market), the Biennale of Dakar has not ceased to reflect itself within the contradiction of the two poles of art criticism and the art market. If *Management de l'art africain contemporain* (management of contemporary African art, 1998) was an opportunity to rethink the structure that should govern the creative process on the continent, *L'Art africain contemporain: courants, styles et création à l'aube du 3ème millénaire* (contemporary African art: currents, styles and creation on the eve of the third millennium, 2000) introduced the scientific turn in art. It progressed to interpellating questions about African creativity and globalization with the editions of 2002, *Création contemporaine et nouvelles identités* (contemporary creations and new identities) and 2004, *L'Art contemporain africain à l'épreuve de la mondialisation: problèmes, enjeux et perspectives* (contemporary African art at the test of globalization: problems, stakes and perspectives). Further, the topic of the contemporary, which seemed increasingly on the artistic agenda, was connected to new interrogations about pan-Africanism with Dak'Art 2006 (*Africa: Agreements, Allusions and Misunderstandings*), Dak'Art 2008 (*Africa: Mirror?*) and Dak'Art 2010 (*Dak'Art 1990–2010: Retrospective and Perspectives*). The combination of the strong heritage of preceding editions and the evolution of artistic techniques and materials justified the focus on new establishments of relations to the world, of inhabiting the city, and of African creativity. These themes were reflected in the editions of 2012, *Création contemporaine et dynamique sociale* (contemporary creation and social dynamics) and 2014, *Les métiers des arts visuels* (the professions of visual arts). Finally, the editions of 2016, *Symbioses* and 2018, *Arts contemporains africains et transformations des cadres intellectuels et normatifs* (contemporary African arts and transformations of the normative intellectual frames) honoured the pan-African spirit that founded the Biennale of Dakar, by paying tribute to Léopold Sédar Senghor and Aimé Césaire. Nonetheless, Dak'Art 2018 demonstrated how theoretical reflections on the writing of history and public politics may constitute new approaches to the two central preoccupations of the Biennale's forum: art criticism and the art market.

In a country where the history of modern art is traditionally dominated by the omnipotence of painting, the developments of installation art (from 1980 on) and multimedia art (from 2000 on) have nourished intense discussions regarding the

blossoming of African artistic productions and their inscriptions in an urban contemporaneity of the twenty-first century. The history of the forum *Rencontres-échanges* demonstrates how the contemporary recovers the pan-African spirit, ever renewed in the debates, while it orients itself progressively to concerns related to the writing of the history of art of Africa. One can thus assert that the forum *Rencontres-échanges* defines its identity through the global mutations that result from the flow of ideas and cultural goods. Its importance is anchored in the connections between artistic practices and the elaboration of scholarly knowledge about arts and public politics, which are reconciled with new ways of living with creativity and of governing it.

Chapter 6

DAK'ART AND THE PRODUCTION OF ITS PUBLIC

Thomas Fillitz

Introduction

'Ah, it's Biennale time! I was already wondering when you would arrive!' This exclamation has become a kind of ritual formulation each time I arrive a few days ahead of the Biennale's opening at my beloved hotel in Dakar's city centre – a welcome expressed at the reception desk, by the barkeeper, or the room cleaners ... When I started my ethnographic research on the Biennale of Dakar in February 2008, I also asked people around in the city whether they knew about the Biennale, and I was struck by how many of them knew it, and told me how proud they were that this mega-event takes place in Dakar. I repeated such conversations during Biennale editions, and further asked interlocutors whether they knew what is actually shown at the official exhibition sites. Their answer was simple: 'art' – nothing more. Yes, they know that the president of the republic is inaugurating the Biennale, they see dancing groups in colourful dresses who are performing in front of the cultural institutions (either Théâtre Sorano, or Grand Théâtre National), they watch official limousines delivering ambassadors and other important personalities, they realize there is a heavy police presence, traffic jams, etc. But none of them would visit any official exhibit of the Biennale, or get more information on the event, or question the reason why so many people fly in for the city's biennial extravaganza.

As Yacouba Konaté (2009) states, the *Dakarois* have heard of the Biennale, they know about it, but by and large none of them visits any of the exhibitions (ibid.: 76). Truly, the question of Dak'Art's public is an ongoing subject – a work for the General Secretariat, a matter of critique from state officials, artists, and many local art world professionals. Former Secretary General Ousseynou Wade repeatedly told me that the Biennale was severely critiqued for the absence of a local general public. His predecessor, Rémi Sagna also emphasizes that this topic is one of the great challenges (Sagna in Vincent 2007: 134). Again for the thirteenth edition of 2018, Secretary General Marième Bâ set the widening of the audience as an objective in the Biennale's press release (Ba 2018: 7).

Simon Sheikh (2010) defines this problem as 'lack of local sedimentation' (ibid.: 157), a reproach often used by governments for questioning the meaning of a

biennial as a cultural institution of national interest. A dramatic example is the Johannesburg Biennale, which was liquidated during its second edition in 1997. Although the work of general curator Okwui Enwezor and his team was highly esteemed internationally, the biennial suffered locally a 'miserable lack of public support' (Budney 1998: 89). Hence, the Johannesburg City Council took social, political and artistic critiques and protests as reason to close the mega-event without entering into dialogue with supporters.

This chapter examines Dak'Art's production of the public within the framework of Lampel and Meyer's (2008) concept of 'field-configuring event'. Regarding the Biennale's objectives, the decree of the state of Senegal clearly emphasizes the promotion of Senegalese and African artists, the improvement of African art world professionals, as well as the elevation of Dakar to become the African capital for arts (see Sankalé, Chapter 7).[1] This investigation of the public reflects in particular how artists, curators, art specialists, and an art public with highly different geographical backgrounds are brought together in face-to-face interactions. Thus, the subject is how the Biennale actively structures its audiences, as another aspect of the production of its uniqueness and importance within international art worlds networks, and above all, the global biennials network.

In the first part of the chapter, I discuss how information about the Biennale's public could be collected. In an overall consideration, audience research of mega-events is methodologically a difficult task, due to different locations and a large public that often is reluctant to answer some questions. The task is even more difficult when entrance is free, with no record of entrance-counting tickets. Should one count the number of visitors as individuals, or the number of visits, and what information does such research provide? Are there other tools for collecting information on visitors? The first part reflects on these questions, and presents results of a survey the Biennale undertook in 2008, as well as those of an orientation survey I undertook together with students of my seminar at the University of Vienna in 2010. The Biennale's insistence on accreditation appears as another mechanism for data collection. Finally, it describes the large-scale survey of 2018, conceived and realized by Senegal's Agence Nationale de la Statistique et de la Démographie (ANSD).

The second part uses data from the Biennale's survey of 2008 and our orientation survey of 2010. The central theme is the claim to attract a general public to the Biennale's main venue, the *Exposition internationale*. While by 2008 I could observe an overall satisfaction with the international audience, the lack of a local, general public is an equally long-standing topic. This part examines what is meant in discourses about this general public – the notion having a different meaning for state representatives than for members of the Dakar art world. The topic further expands to reflect on the relationship between prestigious sites for art and people from popular neighbourhoods, as well as on the impact of artworks created in far-distance places and the particular audience this might involve. This last point shifts the investigation of the public to the potential of the Biennale of Dakar in producing a public that connects this mega-event to other major art institutions in Africa, thus complementing the permanent search for uniqueness

in the global biennials network with an intensified regional, continental interconnectedness.

The Public of Dak'Art

Research

Most importantly, all official venues of the Biennale of Dakar are free for everyone. Access to these exhibition sites is without any hindrance; there are security controls, but only at the main venue, the *Exposition internationale*. There are no obvious tools for counting visitors. I simply observed guardians with a manual counting tool during the last editions (2016, 2018). As welcome such a policy of open visits is, the lack of any reliable counting mechanism unfortunately does not allow precise information about the number of visitors.[2]

A tool for collecting certain information is the Biennale's request for accreditation for anybody wishing to visit the mega-event. According to the Biennale, VIPs, journalists and general visitors need to get an accreditation if they wish to participate in inaugurations, receptions, or to take pictures, to film, etc. Applicants are required to provide information about their profession, where they live and work, how often they participated at Biennale's editions, their gender, date of birth, etc. Indeed, accreditation may be considered as a useful tool for collecting information on participants, whether international or local. These data, however, do not seem to be exploited systematically. The Biennale's website contains details about international prestigious participations for 2012 from Biennale di Venezia, Dubai Art Fair, La Biennale de Lyon, Festival Videobrasil de São Paolo, Centre Georges Pompidou, Tate Modern, Newark Museum, National Gallery of Nigeria, Royal Ontario Museum, etc.

Even so, accreditation is also only partial. In practice, accreditation badges were mandatory only at the grand opening ceremonies at Théâtre Sorano or Grand Théâtre National. Whether local or foreign, many visitors I have met so far, for instance, did not care about accreditation, as they would not be attending what they considered political events within the Biennale, such as the grand opening ceremony. These badges, nevertheless, may be of help in other official situations: a friend reported to me that her badge was accepted instead of an identity card for getting on the ferry to Gorée Island in May 2018.

Since the Biennale's birth until the edition of 2018, there have been only two visitor surveys of the Biennale. The first was in 2008, organized by the Biennale itself, and the other in 2018, conceived and realized by the Agence Nationale de la Statistique et de la Démographie (ANSD). As former Secretary General Ousseynou Wade ascertains, the survey of 2008 was just a small one, and not comparable to the scientific one which was undertaken in 2018. During my visit with a group of students from the University of Vienna in late May 2008, we saw at each site several young people who were sitting at a small table with questionnaires in front of them. We agreed with pleasure to provide information to the various questions.

Youma Fall (2009) presented the results of this survey in a talk she gave at the University of Erfurth, Germany, on 1 December 2009. She structures them according to two categories at large: (a) official participants, and (b) the larger audience (*autres publics*). The first category consists largely of invited personalities: sponsors, journalists, international art world professionals and art amateurs, as well as those artists whose artworks have been selected (see below). Under 'larger audience', Fall lists artists who exhibited in the OFF – 140 international and 312 Senegalese, 230 international collectors and art amateurs (Africa, Europe) and fifty-two art amateurs from Dakar, 690 international art professionals (Africa, Europe, United States, Asia) and 133 from Senegal, 520 tourists visiting Senegal (Europe, United States), 1,400 from schools and universities in and around Dakar. Highly revealing for the present purpose is the listing of the category 'local public' as insignificant (ibid.: 4).

On these grounds, Fall conceives eight larger network categories which she connects to specific objectives (ibid.: 5). Some examples: the network of international artistic festivals and biennials is related to the innovation of the organizational system, the one for artists focuses on the creation of secondary events, the network art worlds conforms to the production of art criticism and art theory, schools and universities to the education of youth, press and media to the diffusion and media marketing, and institutional partnerships to the diversification of sponsorship and autonomy of the institution (ibid.). On the one hand, Fall thereby confirms that the Biennale fulfils important objectives. On the other, she interprets the data as highlighting the perennial international dimension of Dak'Art's public, whereas the insignificance of a local audience demonstrates that contemporary visual arts have so far not rooted in the African environment. '[T]he two dimensional artwork and conceptual art have difficulties to impose themselves among the local African population. This may be traced back to the long tradition of sculptures and masks' (ibid.).[3]

So far, no specific data on the personalities of visitors are accessible to me regarding the survey of 2018. The Ministry of Culture and Communication (2018) informs in an official declaration (2018) that its objective is the measurement and quantification of the impact of the Biennale of Dakar, as well as the mega-event's indirect economic returns (ibid.). In fact, I was interviewed for this survey during a session of the forum *Rencontres–échanges* at Musée de l'IFAN. I remarked that the questionnaire was strongly structured around financial topics: prices of the aircraft ticket, of the hotel in Dakar, how much one would spend for restaurants and cafés, for commodities (souvenirs), etc. According to the president of the orientation committee, Baïdy Agne, this survey confirms that the Biennale of 2018 produced an (indirect) return on the state's financial investments, generating 2.28 billion francs CFA (€3.47 million, US$3.88 million; Birane 2018).

During my visit to the Biennale in 2010, I conducted a small survey together with a group of students from my department. Starting on the second day after the opening, the survey was carried out over four days[4] at the international exhibition at Musée Théodore Monod, and over two hours in the morning. We excluded employees of the Biennale, members of its committees and jury, and officially

invited personalities. We had elaborated a questionnaire to get some image of who the visitors of the Biennale are, what is their age, their education, their interests in the Biennale and biennials at large, etc. From the beginning, we conceived this research as a qualitative orientation: a total of 105 questionnaires were analysed from forty-seven Senegalese visitors, four persons from other countries of the African continent, and forty-four from other regions of the world.[5]

This rather small orientation survey shows that visitors are young: those aged between 18 and 35 dominate (60 per cent), followed by the age group 36–45 (25 per cent). Regarding education, visitors have at least an A-level, or a professional training. However, university absolvents constitute a clear and vast majority, with nearly 90 per cent. There are quasi-balanced responses to the interest in Dak'Art, either in contemporary art in general, or specifically in contemporary African art. Although we had conceived this differentiation in the questionnaire, we nevertheless were astonished that many interlocutors insisted on their specific interest in contemporary African art, and their disinterest in global contemporary art. Further, two-thirds of our interlocutors clearly stated that they would not visit another biennial; this was true for both Senegalese and international interviewees.[6] African interviewees were by and large living and working in Senegal, with an impressive concentration on Grand Dakar. Only four came from other countries of the continent: one from Togo, two from Tunisia, and one from Cameroon. International visitors we interviewed were living and working in Martinique, Guadeloupe, France, United States, Switzerland, Germany, Belgium, Canada, Italy, Spain and Canary Islands, and The Netherlands.

Generalizing our findings on the visitors of Dak'Art: they are rather young; all are educated; they all share an interest in contemporary art, half of them in African artistic practices, and two-thirds of them are specifically interested in this Biennale and no other. Senegalese visitors are largely living and working in Grand Dakar, and all of them have professions related to art: artists, art teachers in school, students in (history of) art, etc. Finally, extremely few visitors come from other regions of the continent – or at least we could not interact with more of them.

Of course, our limited research does not allow scholarly serious quantitative interpretations. For some aspects, I nonetheless found parallels with some general data from a visitors' survey of documenta 11 (Kassel, 2002): visitors are mostly of an age between 20 and 39, a third of them are academics, a little more than 1 per cent are skilled workers, and only 7 per cent of Kassel's population visited the event (Ketteritzsch 2007).[7]

Dak'Art's Invitation and Educational Strategies

Since 1996 the Biennale has followed a policy of inviting official participants, artists and international art world professionals, and gallerists. The Biennale takes charge of their travel, accommodation and local transport during the first week. According to Konaté, this strategy amounted to 30 per cent of the Biennale's overall budget (Konaté 2009: 79). Indeed, as the survey of 2008 makes apparent, the differentiation between official participants and larger audience corresponds for

artists and art world professionals to whether their travel and accommodation is covered by the institution or not. Fall observes that by now most of the visiting art world professionals cover their own expenses (Fall 2009: 4). The regulations for the edition of 2018 mentions in article 16 that the organizers decide exclusively about invitations, and in article 17 that only accommodation of official guests, their local transport between the various sites and their meals are fully covered (Règlement intérieur 2017).

On the basis of these invitation policies, one can observe intensive interactions between local and international artists and art world professionals. Artists, for instance, are present at the *Exposition internationale*, they stand next to their works, and are eager to discuss with whoever approaches them. The Biennale moreover lodges them in the same hotel in order to create the best conditions for interaction. 'This is a fantastic experience! We stay together in the same hotel, we look at each other's work, we visit together exhibitions, we discuss our respective practices …' an artist told me. It is a special atmosphere that establishes the Biennale as a real space of encounter, as Barkinado Bocoum explains:

> When I was selected in 2010, the Biennale told us local artists that we should stay in our homes, that there were enough possibilities to interact with our peers. I said no, I wanted to stay in the hotel with the other artists. This would enable me an in-depth interaction, and the Biennale agreed. This is was what we are looking for!

In Youma Fall's survey the high number of schools is of special interest. In every edition I attended, I was astonished by the large number of school children of all ages who could be seen in the premises of the Biennale's exhibitions from the end of the first week on. On several occasions I observed teachers discussing with pupils what artists are, what they are doing, what a curator is. I observed how they explained specific works of art, how they encouraged pupils to express their experiences, how they attracted their attention to particular characteristics of an artwork. I also observed older school children with pencils and writing pads, walking around in the international exhibition and taking notes here and there. One day in early May 2014 I discussed this with the third secretary general, Babacar Mbaye Diop, in charge of the eleventh edition in 2014.

> This is most important to us! We need to develop art education in schools, in order to raise the interest in contemporary art of the youth. It is our initiative. The Biennale makes appointments with the schools, and we are using our budget for hiring the buses to bring them here.

For former Secretary General Rémi Sagna, the focus on youth is mandatory, albeit a long-term endeavour (Vincent 2007: 134). In several public debates, as well as in personal conversations with local art world members, this initiative was often addressed as the need for learning 'to read a contemporary artwork'. This strategy of the Biennale clearly focuses on the upcoming young generations to develop a sensibility for contemporary art, and it affects local school curricula.

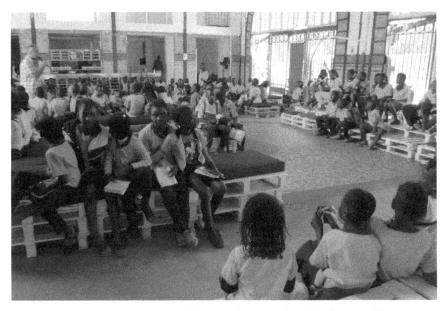

Figure 6.1 School children, Village de la Biennale, 2016. Photo by Thomas Fillitz.

In Search of the General Public

Youma Fall's (2009) presentation of the survey of 2008 indeed demonstrates the role of the Biennale to consolidate Dakar as a major cultural node for contemporary African visual arts. The cyclical cluster of Dak'Art confirms the success of the overall orientation of the mega-event, of the selections of artists and their artworks, and of the invitation policy for the development of an international audience.

Nonetheless, Secretary General Marième Bâ (2018) places her intervention in the press release for the thirteenth edition, under the title *Elargir l'audience de la Biennale* (widening the audience of the Biennale):

> That is why we shall intensify the work to widen the audience of the Biennale. To widen it, first, to youth; it constitutes the very large basis of a pyramid which bears all the promises. Furthermore to other worlds, that were so far held at the margins.
>
> Ba 2018: 7[8]

Reflecting on his curatorial work for the Senegalese Pavilion for the 2018 edition, Viyé Diba identifies the problem that frequently the public does not understand the artistic practices. That is why he chose the title *La Brèche* (the breach), a search for restructuring the relationship between artists and society. In a more general perspective, artists should treat subjects which their neighbourhoods are living and experiencing (Bob 2018: 11; see as well Diba, Chapter 3). Konaté (2009)

ascertains that the success of the Biennale of Dakar depends on its appropriation by African populations (ibid.: 75).

Issues of local public attendance were raised in many conversations with artists, art world members and functionaries. Yes, the Biennale brings in people from global art world networks, but it insufficiently serves Senegal's citizens. One idea was to extend the Biennale beyond Grand Dakar, and to cover the whole Senegalese territory with art activities, in order to better attract the local population. As the late Amadou Sow told me a few years ago: 'Dakar is successful regarding its international attendance, now we need to go a step further, we need to go to the people and to include other sites within Senegal!'

Cultural Citizenship, Art World Members and the Prestigious Site

Three aspects are at stake in these audience-related discourses: the nature of the local (or general) public, the sites chosen for the Biennale's exhibitions, and the international audience. As mentioned previously, both state functionaries and artists focus on the general public. For the state, the objective is citizenry. In this context, Konaté reports a conversation he had as general curator of the seventh edition (2006) with a personality of the Ministry of Culture. The latter asked him what to respond to a citizen who questions why funds are allocated to organize a Biennale for the privileged few while the houses of many poor people are flooded by the heavy rains (2009: 35). As mentioned earlier, many inhabitants of Dakar know the Biennale and are proud of this mega-event, although they would not visit any of the official sites. But now, this experience of Konaté brings into focus the state's responsibility vis-à-vis its citizens and the cultural institution.

David Chaney (2002) proposes the notion of 'cultural citizenship', in addition to civil, social and political citizenships. Cultural citizenship relates to the role of the state as facilitator and mediator in providing cultural facilities, while meeting the needs of its citizens (ibid.: 169). Hence, the goals of the Biennale of Dakar appear as sociocultural obligations, such as the professionalization of artistic practices, of art criticism, and the development of the art market (see Fall 2009, 2010; Fillitz 2012).

The state's claim to bring a general public into the Biennale, then, may be understood following Chaney: 'If cultural appreciation is highly socially stratified, should general public resources be used to support the tastes of privileged groups?' (ibid. 168). The subject is tricky, insofar as the Biennale meets the appreciation of particular segments of Senegal's populations: art professionals, and art amateurs – a notion uniting a common interest of different professional groups. The 2018 survey, moreover, demonstrates high indirect returns, and proves that the Biennale is an appropriate institution for development in the field of leisure industries. Hence, other economic fields and more social strata of Senegal's citizens benefit from this cultural institution.[9] From this line of argument, cultural citizenship, and general public as well, are encompassing notions which hide social diversity and stratification of the state's population.

Artists I talked to, moreover, view another idea when they envision the general public. Their objective is an enlarging of art amateurs, of potential collectors, and

an adequate social status. Viyé Diba's reconciliation between artists and society, for instance, connects to the former's roles in society, of their artworks as being inserted in its contexts. For art professionals and art-interested people, the question of the general public rather relates to the development of the local art world. Indeed, the overall Biennale cycle shows two movements: first, of stepping out of the prestigious exhibition sites (museum) with the *Exposition internationale*; and second, of moving into Dakar's districts with particular official programme lines.

The curatorial team of the eleventh edition (2014) – Abdelkader Damani, Elise Atangana and Ugochukwu-Smooth C. Nzewi – took a radical decision for the Biennale's *Exposition internationale*. They transferred the main venue away from Musée Théodore Monod d'art africain in the city centre to a multi-functional space in an industrial area on the route de Rufisque.[10] This latter was definitely far from any resemblance to a museum or gallery. Local artists I had conversations with considered Musée Théodore Monod as not ideal for an expanding exhibition, for the requirements and demands of artistic creations. Some of them, nevertheless, did not savour this location: 'This is not a place worthy of hosting art, this is an industrial zone, it has nothing to do with art', as one of them argued.

Simon Njami, artistic director of the twelfth and thirteenth editions (2016, 2018), shifted the centre of gravity of the Biennale to the Ancien Palais de Justice, at Cap Manuel. Whether artists, art critics, or the art public I talked to, all were delighted with this location. Many also envisioned this place as site for a museum of contemporary art. Notwithstanding the possibilities of the building, in particular on the ground floor with its large courtyard and spacious halls, Njami created with this selection an imaginary bridge to Senghor's *Premier Festival Mondial de l'Art Nègre* (1966), insofar as this building then hosted the modern art show *Tendances et Confrontations* (curator Iba Ndiaye). It was again chosen in the *Expositions individuelles* programme line by Bruno Cora in 2002, and by Hans Ulrich Obrist in 2004. At these times, however, the site was considered undignified for art: the building fabric was evaluated as unstable, and waste was scattered all around the place.

These reflections, and comments about the site of the *Exposition internationale*, relate to efforts to decrease emotional thresholds to enter a contemporary art mega-event, besides the validation of an artwork as contemporary art, or a place's capacities to host artistic projects. In a global perspective, biennials have replaced art museums for the negotiation and validation of contemporary art: 'art during the contemporary period has been indelibly marked by the biennials that were held around the globe', as Charles Green and Anthony Gardner contend (2016: 7). Further, quantitative selections of artworks, the diversity of artistic media and on-site artistic projects are other reasons for stepping out of the colonial-style museum building. The curatorial concepts of the Biennale's editions of 2014, 2016 and 2018 and some of the displayed art would not have been possible in the older museum premises. Further, museums are a major tool for the production of the category 'fine art', and they cultivate art's elevation into realms of prestigious, aesthetic appreciation. Inserting art into society – the call of the state of Senegal for the Biennale's general public, the vision of artists like Viyé Diba, and the concepts of

biennial curators – also requires to think about where to locate this mega-event. Indeed, the discourses in Dakar's art world about the reputation of buildings, about dignified or undignified places for the exhibition of contemporary art, correspond as much to visions of who the Biennale's diverse publics are and will be.

In order to attract a general public, the Biennale also conceptualized a movement into Dakar's districts. The Village de la Biennale shifted to Gare Ferroviaire, next to Marché Malien in 2010, 2012 and 2016. In 2014 Secretary General Babacar Mbaye Diop initiated the exhibit *Dak'Art au Campus* (of Université Cheikh Anta Diop), curated by Ndeye Rokahaya Gueye. For the editions of 2016 and 2018 Simon Njami conceptualized a specific programme line, *URBI*, for an intensified transit of the Biennale into Dakar's more popular districts. In 2018 *Mon Super Kilomètre* was one of these projects, a collaboration between the French group UY077 and Espace Médina: artworks mingled with the permanent stalls of tradespeople along a red ribbon that stretched from Avenue Canal de la Gueule Tapée into Médina. In fact, there were protests to the district's mayor, with vendors arguing that artworks and visitors would impede their sales.

With this insertion of art projects into Dakar's neighbourhoods, the Biennale's official programme connected with the informal Dak'Art–Off. Born out of individual initiatives of local artists to counter the Biennale's exclusivity on artists of Africa and its diaspora and its selection mechanisms, the Off is represented as the popular side of the Biennale (see Grabski, Chapter 10). Howsoever, its present patterns share some similarities with the official spaces. If there are many alternative exhibition sites in popular districts, there are exclusive ones also, such as art

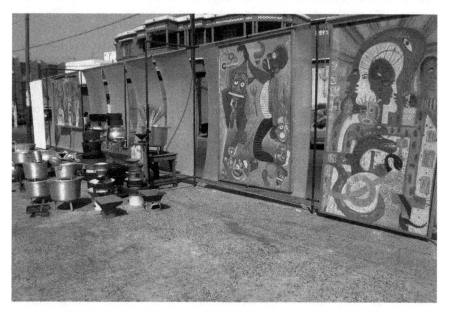

Figure 6.2 *URBI: Mon Super Kilomètre*, Canal de la Gueule Tapée, Dak'Art 2018. Photo by Thomas Fillitz.

galleries, the exhibition areas of national cultural institutes, hotel lobbies, etc. Depending on the site's character, one can indeed observe changing audiences. Art-dedicated spaces, or those of prestigious institutions – for example, the British Council, or Eiffage's headquarters – rather welcome international public and art-interested locals. Artistic projects in a neighbourhood's alternative sites may instead raise the curiosity of nearby residents.

The exhibition *Soré/Diégué* (Wolof: so far, so near) illustrates this connection between the prestige of the space and audience. In 2016, artist Mauro Petroni curated it with the collaboration of Khalifa Dieng: artworks of thirty-five artists from Dakar's suburbs were shown in the halls of Radio-TV-Sénégal (RTS), the national broadcasting company, with sponsorship from Eiffage Sénégal[11] and RTS. These were artists from popular neighbourhoods, marginalized from the high-profile art spaces in Dakar's central areas; nonetheless, the show would not attract a 'general' public. Although a non-art space, the RTS headquarters is prestigious in the field of communication, and its demarcation from popular social spaces is accentuated by the security service that controls access to the buildings.

The lack of a general public may also be viewed in connection with a further aspect: contemporary art is elitist. Konaté recognizes this fact, 'in the sense that it concerns only a culturally motivated part of the social pyramid' (2019: 77).[12] Viyé Diba's consideration of the detachment between artist and society fits with this argument (Bob 2018: 11; Diba, Chapter 3). This also explains the Biennale's success in respect of the international dimension of its public, well documented in its survey of 2008, whereas the orientation survey of 2010 collected by myself and my students clearly demonstrates the link between education and appreciation of contemporary art.

In his reflection on influences of biennials on artistic practices in Asia, John Clark (2010) raises questions about the audience for artworks created in far-away art worlds, which are then presented by a curator at a locally specific mega-event on the other side of the world. 'Is this new, particular audience the site of a dynamic that is quite different from that of the production of an artwork for a national art salon . . . or thematic exhibition previously confined to one art culture?' (ibid.: 178). From this vantage, what art for which public is at stake, but also the mediation between particular publics and the Biennale exhibition as encompassing entity, respectively its specific artworks. Indeed, for the first time, the thirteenth edition (2018) included accompanying services for adults, young people and children in the *Exposition internationale*: guided tours and an *espace éveil* (awakening space), a room for the mediation between art and children – both for free.[13]

From a more radical perspective, one needs to acknowledge that the *Exposition internationale* has to be prestigious, because this is the space for validating the latest trends in contemporary African art. Further, this exhibition constitutes the core element for the international evaluation of an edition's performance. It requires to be international in the scope of the selected works, thus reaching out to those art worlds where artists of African citizenship or descent are living and working. For Clark, the transnational and global character of art biennials also counts for their audiences, in particular for their appreciation of contemporary art.

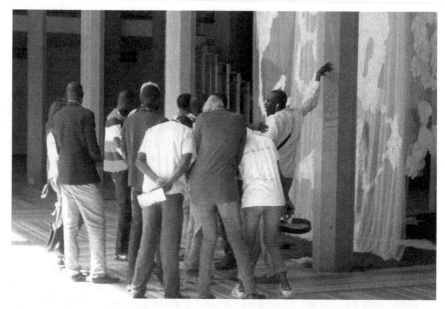

Figure 6.3 Guided tour at *Exposition internationale: The Red Hour. A New Humanity.*
Ancien Palais de Justice, Dak'Art, 2018. Photo by Thomas Fillitz.

His ideas incite to reconsider the divide of the Biennale's public into an international
and a general-local one, and to move beyond it, to envision its contribution to an
interconnected, local, transnational and global public. The point worth reflecting is
the further potential of the Biennale in respect to its reaching out to other mega-
events of Africa by means of the formation of its public. Dak'Art indeed has
realized its uniqueness within the global biennials network. In a ranking of 2014,
Artnet News classifies this mega-event as fourteenth among the 'World's Top 20
Biennials, Triennials, and Miscellenials' (ibid.).

But what about the Biennale's interconnections with other cultural institutions
in Africa, and the development of its transnational African audience? Simon
Sheikh (2010) argues for valuing the potential of art mega-events, such as biennials,
to 'create new public formations that are not bound to the nation-state or the
[local] art world' (ibid.: 157). In this conceptualization of a biennial's public, Sheikh
shifts the attention from an event's uniqueness to its interconnectedness (ibid.:
157–8). Our orientation survey, for instance, shows the high interest in
contemporary African art of visitors, whereas two-thirds of the interviewees
would not travel to another biennial, and among those who do so, only the
Rencontres de Bamako is mentioned for Africa.

Of course, one can argue that the overall objective of Biennale of Dakar is to
promote in Dakar the encounter of African artists, art world professionals and
gallerists. Even so, and in this perspective, the widening of the institution's overall
public may be subject to an intensification of continental networks. Such strategies
have been developed in 2006 in Asia, in Europe with the so-marketed 'Grand Tour'

of mega-events in 2007,[14] and other biennials follow this strategy of collaborative branding (see Tang 2007). According to Jeannine Tang, not competition but collaboration is the objective of such regional network productions, 'securing territorial power via interdependence' (ibid.: 248). Dak'Art's programme *Carte Blanche* may be understood as a first step towards reaching out to other African art institutions. Simon Njami introduced it in 2016, and invited Doual'art (Douala, Cameroon; see Pensa, Chapter 11) to portray itself at Maison des Anciens Combattants. In 2018 the invitation went to the Cairo-based contemporary art centre Darb 1718.

Conclusion

The public is another central aspect in the constitution of an art biennial as 'field-configuring event' (Lampel and Meyer 2008). This chapter therefore investigated how artists, curators, art specialists, and an art audience with highly different geographical backgrounds are brought together in face-to-face interactions. From its inception, the Biennale applied diverse strategies for the formation of this public, in particular with a clear intention to become acknowledged internationally as the showcase for contemporary African art. As a cultural institution that the state founded, and still closely controls its status, it faces the mandate to attract an under-represented general public to the official exhibitions, in particular the *Exposition internationale*.

The Biennale's survey of 2008 and the orientation survey elaborated by students from the University of Vienna and myself in 2010 demonstrate the success of Dak'Art in attracting artists from Africa and its diaspora, art world professionals and an international audience. Further, visitors are rather young and educated, the vast majority having a university training. The 2018 survey of Agence Nationale de la Statistique et de la Démographie (unfortunately no information regarding the visitors' structures is available) pinpoints the Biennale's success in the production of indirect returns.

Hence, the overall problem with the Biennale's public is clearly identified as the local one, labelled as 'insignificant' in the survey of 2008 (Fall 2009: 4), although the situation has improved a lot since then. Albeit, one needs to wonder what is meant by this call for a general public: the state argues with cultural citizenship; by contrast, artists envision their insertion into society; and, finally, one requires to question whether a prestigious site (for some art-educated and interest social strata) is adequate to operate as egalitarian space for a mass public.

Cultural citizenship positions the state on the one hand as facilitator of the Biennale, whether by the institution's inclusion into governmental structures or by means of its financial impact. But it also allows the state to formulate some goals or obligations the institution has to fulfil, among others to attract a general Senegalese citizenry. For the art world, the emphasis on a general audience is a vision to reconnect artistic practices and society, as expressed by Viyé Diba. This implies to revalue artists as important agents in national cultural discourses, as was

the case in the 1960s under Senghor, but also to strengthen the market segment in acquiring new potential collectors. Thirdly, this search for a general public is also a matter of the prestige of exhibition sites. Another strategy of the Biennale may be observed: for the latest editions, the official Biennale moved some of its programmes (e.g. *URBI* in 2016 and 2018) into more popular districts of Dakar. In doing so, it actually copied what artists have been doing successfully for some time in the informal Dak'Art–Off, by looking for alternative spaces.

Even so, the Biennale's core venue, the *Exposition internationale*, is special in all respects. It needs to be prestigious to comply with a central purpose: the validation of artworks as contemporary African art. Stepping away from the old Musée Théodore Monod at Place Soweto and the search for another location in 2014, and the relocation at Ancien Palais de Justice in 2016 and 2018, rather have to do with requirements to conceive a large exhibition, and with qualitative demands of artistic projects. It is the site of visibility of artistic pan-Africanism at Dak'Art; the artworks on display need to come from artists of African citizenship or origin who live and work in different, international art worlds. Instead of emphasizing the 'local sedimentation', these requirements for a successful *Exposition internationale* encourage to turn the focus on the capacities of the Biennale to fashion an audience that is grounded on intensified transnational interconnections with other cultural institutions on the continent. As a field-configuring event, Dak'Art thus positions itself both as a primary centre for contemporary African art within the global biennials network, and potentially as a key institution for strengthening regional networks – Dakar as cultural node that extends its interconnections.

Chapter 7

THE BIENNALE OF DAKAR AND THE STATE OF SENEGAL

Sylvain Sankalé

The Biennale of Dakar (Dak'Art) is the result of a double paternity, of the artistic community and of the state of Senegal. It was born out of collective initiatives of artists formulated in the wake of the structural adjustment programmes in 1980 and 1989. The state's tutelage is manifest with a permanent structure: the Secretariat General of the Biennale, which is tied to the Ministry of Culture and destined to continue to direct the organization of the event. As a creation of the state of Senegal, the Biennale is completely under the latter's authority and, consequently, is often subjected to its agendas. However, after the adjustment and refocusing of the first editions, the Biennale maintains two characteristics: it is reserved for the fine arts, and it is a space for the legitimization and promotion of contemporary African – not just Senegalese – creativity.

Since its 'stabilization' in 1996, the Biennale of Dakar has been seeking the best formula for both its organizational structures and its processes for selecting artists and their works of art. As part of these efforts, the Biennale has tried to obtain autonomy from the Senegalese state, but to no avail. It remains an organ of the state despite contestations and criticisms that the current situation both limits and constrains the Biennale. Nonetheless, some of the Biennale's organizational structures have evolved. The *Comité National*, for example, was replaced in 1996 by the *Conseil scientifique*, which in turn became the *Comité d'orientation* in 2006. However, these are *sui generis* amendments; they do not follow from a structured reflection and thereby restrain efficiency in the short term and any form of prospective regarding their role and field of action. Indeed, in order to guarantee its credibility at national and international levels, the Biennale must not only exhibit works of art of the highest calibre but also have a structure that is transparent and efficient.

The lack of sustainable developmental framework for the near and long term and of the professionalization of personnel precludes the resolution of the Biennale's artistic problems. The Biennale is still inconsistent in its relational representation of various art media in the exhibitions, its stance regarding the citizenships or places of residence of the artists, and its relationship with the

diasporas. Each edition introduces novelties or regressions with regard to each of these questions, depending on the sensibilities of the different involved parties, without any overarching logic from one edition to the next. No doubt, this damages both the artistic credibility and the legitimacy of the Biennale.

The absence of coherence is also apparent in the choices of exhibition models adopted and artistic categories represented [textile and tapestry, *sous-verres* (glass painting), digital art, etc.]. The logic behind the choice of any particular mode of display is rarely apparent and is never explained. Yet the immediate consequences of these decisions are huge, as they often cause organizational difficulties and are tough to implement because the format changes from one edition to the next, and no one really knows why.

The undertaking of different exhibition strategies and designs, as determined by the curator/s and specific financing of any given edition, is partially intended to make the Biennale correspond with the diversity and adaptation of artistic changes throughout the world. However, most visitors regard the variation from edition to edition as a demonstration of incoherence and disorganization. Variations with respect to the choice of exhibition spaces and their locations, and to the format, content and technical quality of the catalogue, for example, are too dissimilar from one edition to the next.

Hesitation and heterogeneity seem to characterize the Biennale of Dakar's evolution. The successive personnel responsible for the Biennale have certainly put in thorough efforts to give the institution identity and meaning. They have also assured its sustainability, in spite of moments of challenge and tenuousness. Yet there is an absence of vision that prevents an amelioration of the situation, and the frequent changes both of the holders of the ministerial posts in charge of cultural affairs and of their teams do not facilitate visionary activities.

Assessments indicate that, paradoxically, no concrete and pragmatic decisions were ever made by the governmental authority. Senegalese authorities and principal sponsors of the Biennale have initiated most of these assessments, which have been undertaken repeatedly over the past twenty years in the form of analyses, expert input, reports and seminars. The state seems to welcome an evolution of the Biennale towards its autonomy and yet, at the same time, continues to maintain direct and sterilizing control without analysing the situation or recognizing that granting the event autonomy does not mean loss of control. The transition towards professionalization, which necessarily requires a certain degree of autonomy, is nevertheless crucial to assuring the credibility and thus the sustainability of this institution.

The first part of this chapter outlines the means by which the strengths as well as the weaknesses of the Biennale of Dakar can be evaluated. The second part then extends beyond the state of the art to address questions about the necessity of reforming this cultural institution. While there are many smaller problems, which will be formulated, the overarching issue is the need for a change in the Biennale's legal status and for a balance between autonomy from the state's supervision without losing the financial support and commitment of the government.

The Biennale of Dakar – The State of the Art

The Strengths

The Biennale is generally viewed as a cultural institution that serves and is tied to the Senegalese state. The state's control over the Biennale comes from not only its responsibility for creating the institution but also the fact that for a long time, Dak'Art was the only artistic manifestation on the continent that was created out of a national political will and, thereafter, conceptualized and managed by an African state. Other notable cultural institutions in Africa with a similar mission, in contrast, had been created by international cultural organizations such as the Agence Intergouvernementale de la Francophonie,[1] or Afrique en Créations,[2] which was founded by the French development agency.

As a state biennial, the Biennale of Dakar is inseparable from the cultural history of Senegal. Indeed, the state of Senegal invested early in the fields of culture and the arts and institutionalized original and fruitful cultural politics. The Biennale is one of multiple institutions that were created by the state with the intention of internationally proclaiming Senegal's status as pioneer in the realm of contemporary artistic practices. This position was initially asserted with the creation of the School of Fine Arts in Dakar, which took place immediately following Senegal's attainment of independence in 1960, and the organization of the famous *Premier Festival Mondial des Arts Nègres* (First World Festival of Black Arts) in Dakar in 1966 (see Mbaye, Chapter 2).

Beyond this critical political dimension, which cannot be ignored, other positive aspects of the Biennale deserve to be mentioned, despite their instability and insufficiency. Paradoxically, the format of the Biennale as it stands following its reinvention with the edition of 1996 – that is, as *Bienniale de l'art contemporain africain* – is one of the institution's strengths, although it is equally one of its weaknesses. Undoubtedly, the Biennale provides African artists with a platform through which they can integrate themselves into and promote themselves within the international art world. The Biennale indeed constitutes the unique international cultural event in Africa that is fundamentally dedicated to visual arts of the whole continent and, despite its weaknesses, has a longevity that is greatly admired throughout the continent.

Its persistence and its inscription in the continental and global calendar of major cultural events is due to the regularity of its organization at the envisaged date. Its consistent occurrence has endured the transition of three successive presidents of the republic since its foundation. This regularity is undoubtedly one of the institution's fundamental advantages.

To date, more than 500 artists from three-quarters of the countries in Africa have participated at the main venue: the *Exposition internationale* of the Biennale of Dakar. Some of these artists have participated several times. In addition, a comparable number of artists have exhibited in the Off space (see Grabski, Chapter 10). The number of artists who submit applications to the calls of the Biennale is constantly rising, and the applicants come from more and diverse countries. Even

if the circulation of the calls for applications is still insufficient, the information is increasingly subject to the most up-to-date information technologies, and this is definitely a gauge of the reach of the mega-event.

The extraordinary and spontaneous expansion of Dak'Art–Off is also a capital index of the recognition and the vitality of the Biennale. Freed from any constraints of status or modalities of selection, the Off opens itself more and more to the world, although some critical voices reproach this liberty for not always being in line with the quality of the presented works of art. Even so, whereas contemporary art is often considered elitist and hermetically closed to a general public, the Off is a fantastic means by which such objects can be integrated into quotidian life, as the whole city and many regions of the country now participate in it and thus contribute to the advent of artistic talents. It is vital to neither think about constricting the Off, nor to direct or orient it. It is a formidable act of popular liberty and absolutely must remain so.

Other satisfactory aspects of the Biennale which require acknowledgement are the augmentation of the duration of the principal exhibitions in the environment of the Biennale, the multiple visits of students from particular schools, and the increase in the number of visitors (including of the travelling foreign public) and in the presence of invited specialists (e.g. museum and freelance curators, artists and critics). Furthermore, the Biennale triggers a cascade of direct and indirect positive repercussions for the artists, their satellite professions (from the framer to the gallerist), and the city of Dakar, its infrastructures and its touristic institutions.

While these achievements should be recognized and valued, they should not belie the Biennale's underlying problem or that the state of Senegal should be satisfied with the status quo. With the global blossoming of African art, the proliferation of other cultural manifestations on the continent or in other regions of the world do not challenge the Biennale's leadership position or star power in Africa. However, the Biennale can uphold its lead and supremacy on the continent and at the international scale only at the price of conceptual and organizational rigour and inventiveness. Certainly sporadic efforts have been made to reorganize particular aspects of the mega-event, and the flamboyant character of the artistic director of the last two editions (2016, 2018) has partially hidden some of the insufficiencies. These inadequacies nevertheless persist, and the Biennale's few successes cannot mask its numerous challenges that otherwise could be easily fixed.

The Weaknesses

Several editions ago, the Biennale reached a critical point, principally because of a certain short-sightedness in the transitions from one edition to the next and from one director to another, whether this be the president of the *Comité d'orientation* (advisory council), the secretary general or the minister of culture. The success of each edition largely rests upon the nature of the relationships between these constituents. Even if this is inevitable to a certain degree, it is nevertheless inadmissible considering the important issues at stake. Such a situation is a given

and persists because the Biennale maintains, voluntarily or by negligence, a structural deficit that has become increasingly evident.

One of the major challenges is maintaining effective communication between the different organizational structures of the Biennale, between partners and collaborators, with the participating artists and other art world professionals, and with the general public. Overcoming this challenge starts with making the individuals responsible for the Biennale accessible and accountable, for basic things such as correcting wall texts and exhibition signage, and general public presentation of the various exhibits. Ineffectual communication during both the event itself and the inter-Biennale period – a period during which the public and specialists alike have the impression that nothing happens – affects both the internal preparation and the external perception of the Biennale. Furthermore, publications produced by the Biennale, including the magazine *Afrik'Art*, when it appears, and the catalogue of the Biennale, should have a proper mechanism of distribution in Senegal and overseas.

The lack of communication is aggravated by the feeling that the organizers are purposefully hiding information and deliberately not being transparent with the different phases of preparing the Biennale, from the opaque selection process of the curator or artistic director, to the dates of nominating the members of the *Comité d'orientation* (advisory council) and other structures that organize the Biennale. The general belatedness of rolling out public announcements of appointments or dates greatly harms the credibility, visibility and viability of Dak'Art.

Serious organizational difficulties compound these communication-related issues. All sorts of delays and approximations that affect both the artists and the general public are recurrent from one edition to the next, regardless of the good intentions proclaimed by the organizers. These issues result directly from the deficits in the organizational structure of the Biennale apparent in the perpetual lateness in organizing its events and programmes. These organizational problems also concern difficulties related to the works of art themselves. The later the selection and, therefore, transportation of the works takes place, the more things are done with imprecision and under huge time pressure. Some of the works of art do not arrive in time, preventing them from being exhibited and from being considered by the jury for the awards, thus resulting in frustration for all parties concerned. Works that arrive damaged, possibly as a result of bad packaging, although a problem not created by the Biennale, present another issue, in that they are sometimes displayed in their damaged state. The late return of works to their artists is another recurrent problem. If criticisms of these ineptitudes are aired via present-day communication media, and if the institution has no adequate tool for counterbalancing or correcting this information, such criticisms will cultivate a negative image of the Biennale.

Furthermore, there is an overall negligence fostered by the unprofessionalism of the Biennale's organizers. The office spaces of the Secretariat General, for example, are decrepit, inaccessible to people with reduced mobility, and in no way representative of the entity's commitment to aesthetics. The sites of exhibition are also badly managed, with inaccurate text labels, dysfunctional exhibition materials

(videos and other media often break), and uninformed guides who are unable to orient visitors in the exhibition premises.

The Need for Reform

Why Elevate the Standard of the Biennale?

Pioneering and legitimate on the continent, and an instrument of the cultural diplomacy of the Republic of Senegal at the international level, particularly in the domain of culture, the Biennale of Dakar must maintain a high level in order to be a showcase of modernity, as its founders claim. Furthermore, its role as space of encounter and exchange – as an epicentre of the network that unites artists of the African continent and connects them with the rest of the world – is fundamental and justifies that the Biennale is both an object of research for scholars throughout the world and participates in the infatuation with our continent and with contemporary African art, which, until recently, was not even mentioned in art publications.

It appears that the Biennale maintains its position in order to prevent the collapse of all the hopes that were invested in it. The stakes concern not only the art and artists but also the political and strategic influence of our country by means of an affirmation and valorization of its artistic capacities. In this spirit, President Macky Sall inaugurated the two most recent editions of 2016 and 2018 and reaffirmed the bonds between the state and the Biennale. Most notably, he fulfilled his promise to raise the institution's budget.

It is, however, paramount that the Biennale of Dakar reaches and maintains the level of similar mega-events in the global art world. This, however, requires a comparative study that would allow the clear establishment of the institution's limits, its points of tension and its challenges. Such a study would, above all, help formulate an effective remedy. Actually, these critical pointers were identified long ago and have been discussed by experts for twenty years. It would be easy to resolve some of the fundamental issues that were treated in the most recent evaluative report, such as the criteria for selecting artists, the internationalization of the artists and teams selected, and the exhibition design.

In order to codify consistent and coherent criteria for selecting participating artists, it is imperative that the Biennale's organizers determine its intended mission. What goals does the Biennale want to achieve? Should the Biennale be a space for the discovery of new artists or for the consolidation of the careers of already established artists? Once it is determined, the Biennale's mission must be taken at face value and not depend on the caprices of each edition's specific curator or curatorial team. For the 2010 Biennale, for instance, the selection committee (of which I was a member)[3] anonymously agreed to exclusively select artists whose work had never been on display before. The resulting experience was very interesting and launched the careers of several artists who have since become internationally renowned, even if it unsettled several art world members at the time. Hence, the mission of the Biennale needs to be determined by a group of

international experts who take into account both the objectives of other mega-events and the necessity to bestow the Biennale of Dakar with a strong and unique identity. The Biennale cannot consider the ever-changing trends of contemporary art haphazardly. These tendencies must be subject to aesthetic and theoretical analysis, as must the art's medium and genre.

Once the organizers of the Biennale have clarified and endorsed the institution's position, its course should not be changed gradually according to personalities or opportunities. The curator or curatorial team of each edition must use the Biennale's overarching mission as a roadmap and must always use all necessary and available means in order to realize this mission. This cannot be accomplished in a few weeks.

Internationalization of the Teams: In order to raise the standard of the Dak'Art Biennale, it is also paramount to internationalize the group of individuals responsible for selecting the participating artists and the group of selected artists themselves. Curators, artistic directors and members of the jury[4] should not be exclusively Senegalese. Moreover, they should have proven experience in these fields, not only at the local level but also on a larger scale. The credibility of the whole mega-event depends partly upon this, and if one accepts the idea that it is easier to destroy than to reconstruct, a discredited edition has widespread and long-lasting repercussions.

Internationalization of Artists: As for diversifying the group of selected artists, the organizers of the Biennale are caught between two constituencies. On one hand are the Senegalese artists and their public, who complain that they are not sufficiently represented. They forget that the Biennale is not and never was a biennial of Senegalese art, even though the state of Senegal institutionalized it. On the other hand are foreign artists, international art specialists and the international public, who continuously critique the excessive amount of space accorded to the Senegalese. However, the selection statistics of the various Biennale editions show that this criticism does not unequivocally apply. While at some editions up to 25 per cent of the selected artists have been Senegalese while Senegalese artists have been prioritized regarding the awards (one was even awarded the grand prize twice[5]), at many editions, artists from other countries and Senegalese artists have been equally represented. That said, the physical proximity of Senegalese artists to the Biennale grants them better access to information, including solicitations, and makes it easier for organizers to meet them on site and to see and transport the work(s) of art.

Exhibition Design: This is the Achilles' heel of the Biennale. The best intentions and ideas can hardly overcome inappropriate exhibition spaces, the late arrival of certain works of art, and technically deficient materials or installations. In addition, exhibition design is never given appropriate attention or importance, even though it is upon this that the whole public perception of both individual works of art and the whole event depends. Can one imagine a theatre play without a director? The appointment of the exhibition designer(s) should be based upon an international bid. The same is true for the other 'peripheral' aspects of the Biennale, particularly communication and mediation, which are no less fundamental for the encounter between the art and the public, both amateurs and specialists.

How to Raise the Quality of the Biennale

The three problems outlined above all arise from the same underlying source: the organization of the Biennale. As a matter of fact, the regulations once established and still valid nowadays are those quoted in the decree of the Ministry of Culture, where the Biennale is evoked in the following way:

> The Secretary General of the Biennale of Art is charged with the preparation, organization, and follow-up of the Biennale of Art on an international dimension in order to:
>
> – assure the promotion of the Senegalese artists, in particular, and African artists, in general, to strengthen and grow the diffusion of African productions in the international art market;
> – to deepen the capacity of professionals of contemporary African art, and finally to make Dakar an African capital of the arts. (République du Sénégal Primature: 2008)[6]

This mention of the Biennale is brief. It is, in addition, erroneous, as the official title of the Biennale is *Biennale de l'art africain contemporain* (Biennale of Contemporary African Art). But the primary difficulty posed by this statement is the ambiguity of the Biennale's purpose: is its objective to promote African art or 'Senegalese artists, in particular'? Regardless, the absence of any supplementary rules or definitions allows the specific organizers of each edition to develop the event as they would like without any set parameters, resulting in many random changes and nominations.

The most crucial question is the legal status of the Biennale. All the involved parties agree that the organization of the Biennale must allow for flexibility, administrative and financial autonomy, adaptability to or acceptance of the socio-economic environment, the development of partnerships, communication capacities, and lightness of the structure. As the state of Senegal conceives, organizes and finances the Biennale in response to the preoccupations and aspirations of the community of Senegalese artists, it seems legitimate to leave to the state the continuing care of this project that it has overseen for nearly thirty years.

At the same time, however, a framework of autonomy should be applied in order to liberate the Biennale from various institutional and political hazards. The Biennale is non-commercial by definition and unable to survive without receiving the state's subsidies, either directly or indirectly, by means of bilateral or multilateral cooperation. It has also been a major axis of the cultural politics of the Senegalese government for more than two decades. Thus, it has fulfilled its mission of public service and, unless its structure is to be completely changed, it seems logical to recognize and bolster this mission.

If one enumerates the various possible statuses that the Biennale could adopt in Senegalese positive law, it is easy to identify each one's advantages and disadvantages and, ultimately, to eliminate nearly all of them, as few would resolve all of the institution's current issues. The only two options that remain under consideration are the legal statuses of the not-for-profit cultural association and the foundation.

The Not-for-Profit Cultural Organization

Some experts who have addressed the status of the Biennale believe it should operate as a cultural association. They consider this status the easiest to be institutionalized. If the Biennale held this legal status, the supervising ministry would nominate the secretary general, and the administrative counsel or board would include representatives of the ministry but as the minor party. The association would have to define the fundamental missions of the Biennale, a role currently played by the *Comité d'orientation* (advisory council). The secretary general, nominated by the minister and selected from among the state's civil servants, would receive a permanent contract from and be paid by the association, and would act as chief executive officer of the Biennale. This legal solution would be the most convenient, but its drawback is the strong privatization. The state would be merely a partner like any other, and the Biennale could escape its control. This solution might raise an additional problem regarding the acquisition of funds through bilateral or multilateral agreements.

The Foundation

The status of the foundation results from the allocation of resources towards the accomplishment of general interest. A foundation is not composed of members and therefore does not levy any subscriptions. It is created under conditions defined by the law and acknowledged of public utility by decree upon consultation of the state council. The founder(s) of a foundation can be physical individuals or moral people of private law or public law who have the juridical capacity to undertake a liberality. The objective of a foundation must be the realization of non-profit work of public interest that is clearly and precisely defined and that is achieved through the allocation of goods, rights or resources. The state of Senegal could certainly set up a foundation.

The founder(s) must bring into the foundation an initial endowment (in kind or in cash) that allows it to fulfil its mission, assures its functioning and independence, and guarantees its sustainability. This endowment may be either exclusively private or a mixture of private and public. The amount of the initial endowment cannot be less than 30 per cent of the sums necessary for the financing of its short-, mid- and long-term programme, which is attached to the file of request of authorization. Besides the initial endowment, resources of the foundation may stem from manual donations (i.e. donations and bequests from any individual), donations from public collections which are authorized by the appropriate administrative authority, transfers carried out by individuals and corporations, revenues made from the management of the initial endowment, subventions of the state or other public authorities, private grants from other national or foreign foundations, and donations from assimilated organizations and diverse sponsors that can control their utilization.

The statutes chosen at the time of a foundation's creation determine the structure of its administration. It can have either a council and an administrative

committee, or a council and an individual administrator. In both cases, the foundation must institutionalize a system of internal control. The council must be composed of at least six members, the first of whom are nominated by the founders and can be drawn either from the group of founders themselves or from the outside. Those nominated are chosen for their expertise in the particular field of the foundation's activities and because of their availability to perform the duties assigned to them. If the task of the foundation, its location and the nature of its activities demand it, the state can nominate one or several representatives who have seats on the foundation's council with voting rights.

There are two other important types of position within the foundation's organizational structure: the management committee and the general administrator. The management committee, whose task is the administration and handling of the foundation's patrimony and activities, is composed of three members of the foundation's council, individually nominated by the council members. The general administrator (should there be one) assists with the duties of the president of the council. S/he is recruited through an international bid solicited by the foundation's council. The position may be held by one of its members or an external individual. Regardless, it is revocable at any moment and the person holding the position must be physically present.

I have long been convinced that adopting the legal status and organizational structure of a foundation is the best option for the Biennale, and the state of Senegal has already created foundations in situations similar to that of the Biennale of Dakar. Making the Biennale a foundation would enable the state to legitimately maintain control over the event, and yet the mechanisms of a foundation's function would allow the Biennale to carry on its activities independent of the hazards of politics, changes in leadership, and various other pressures. Moreover, as a foundation, the Biennale would secure the investments of the state and gain credibility that would allow it to cultivate other sponsors. The foundation is the only legal structure that offers such comforts.

Furthermore, complementary arrangements depend on the state's goodwill, particularly the 'recognition of public utility' – a tax incentive to the benefit of those people and companies that wish to participate in the financing of the Biennale. One may add Senegal's adoption of legislation favouring patronage that is inexistent to date. Finally, a simplification of customs regulations and procedures could facilitate the import and export of works of art destined for cultural events such as the Biennale.

Conclusion

The Biennale of Contemporary African Art is an institution of the state of Senegal. It is the first and probably the only one of its kind on the continent, having been created by the unique will of an African state. There is no reason to change this particularity. Nevertheless, the dysfunctions that have been observed since the time of its inception incite reflections on how the institution's organization might

be improved. The suggested improvements primarily concern the structure of the Biennale. It seems reasonable to confer a legal status that would allow a certain autonomy. I suggest that of a foundation. The creation of a legally favourable environment should supplement this restructuring, particularly by simplifying some procedures and formulating legislative texts. Once professionalism is established at all levels of the Biennale, all other issues will resolve themselves and the Biennale will reaffirm its place as a pioneer and leader for contemporary African art.

Chapter 8

REIMAGINING THE BIENNALE OF DAKAR

Koyo Kouoh and Eva Barois De Caevel

Introduction

When tasked with reimagining the Dakar Biennale in the run-up to its eleventh edition in 2014, we were confronted with an event which, despite a considerable track record of achievements in showcasing and developing African contemporary art, appeared to be in a state of atrophy. Established in 1996 in the Senegalese capital, the Biennale of Dakar, or Dak'Art, was at the time widely acknowledged as the foremost international cultural event in Africa dedicated to the visual arts of the continent and its diaspora. Notable, unlike many other African cultural events, in having been created and organized by an African state, the Biennale had become a recognized avenue for African artists to establish themselves and promote their work. Its durable format and reliable biennial slot allowed Dak'Art to become recognized in international professional circles, and its particular open-call format had attracted ever-increasing numbers of submissions. Up to that point, 300 artists and more than fifty designers from thirty-five African countries had featured in the Biennale. It had also developed a lively programme of fringe events complementing the official selection in the form of Dak'Art–Off, which in 2012 featured more than 300 artists from places of origin as diverse as Senegal, Denmark, Cuba, Togo and Morocco. Closer to home, the Biennale had registered positively with the local art community of Dakar, who noted higher levels of sales during editions of the event. On a continental level, it had encouraged the growth of an embryonic market of private and institutional collections of African contemporary artworks, including by recently established private art foundations such as the Fondation Zinsou in Cotonou in Benin, which opened its doors in 2005 and already boasted a significant number of works which had featured in the Biennale.

Yet, a range of serious issues, including a lack of a coherent aesthetic identity, internal structural problems, unprofessional day-to-day operational delivery and inadequate levels of community engagement, threatened these hard-won but fragile gains. In order to consolidate the Biennale's existing achievements, strengthen Dak'Art's place at the centre of African contemporary art production, and advance its founding vision of staking an ever-larger place for the cultural

production of the continent and its diaspora within the broader contemporary art world, we identified four main ways in which the Biennale should be reimagined: aesthetically, structurally, operationally, and in terms of social engagement.

Defining an Aesthetic Vision

While Dak'Art unambiguously conceived of itself as an African biennial for African contemporary art, beyond this limited definition the Biennale had been hampered by a lack of a consistent curatorial line and a clear aesthetic vision. Exhibition categories shifted haphazardly between options such as design, textile and tapestry, *sous-verre* painting, young artists and digital art. Curatorial choices tended to be excessively broad and showed a consequent lack of specific focus or interest. Even the 'Africanness' of the Biennale was somewhat ill-defined; no clear and coherent line had been adopted on what proportion of African, diaspora and international artists should feature in the selection, or whether quotas could be useful in maintaining this balance. There was also no clear consensus on what ways the event felt it should engage with the African diaspora, or whether it even saw the diaspora as a viable concept that the Biennale should make use of.

One clear change that appeared essential to us was the introduction of a dedicated prospective element to the Biennale's selection process. As well as exhibiting well-known artists, we felt that the Biennale should be conceived of as a hive for young talents who had not yet attained international recognition. To locate and present such artists, a qualified curatorial team of specialists of the African contemporary art scene would need to be constituted. We also proposed decoupling the selection criteria of the international selection from those of an individual selection, which would be retained as a dedicated space for artists already established on an international level. We no longer saw it as viable for Dak'Art to observe and follow trends in contemporary art in an erratic manner, and therefore advocated a serious process of aesthetic and theoretical reflection. Other as yet unresolved questions, such as which artistic media should be prioritized and what thematic categories should be used for each edition, would be dealt with by a team composed entirely of independent qualified professionals, working within the context of an autonomous and well-resourced Biennale. When addressing these issues, this team would draw inspiration from other successful contemporary art biennials throughout the world.

Creating a Durable Structure

At the time of our review, the Biennale had not at any stage of its development possessed an independent status, having been structurally integrated into the Ministry of Culture of Senegal since its foundation. The legal and financial implications of the Biennale's lack of autonomy had been considerable. This situation had significantly limited the capacity of management and organizational structures to evolve, and constrained management's room to manoeuvre when

prospecting for new financial partners and identifying ways to self-finance. Lack of autonomy had also directly affected the quality of the Biennale's artistic direction. For instance, on at least one occasion the head curator of the Biennale had been appointed in an arbitrary manner by the ministry, without consulting with either the governing body or the board of management. Such incidents had caused lasting damage to the image of the Biennale and had been unanimously criticized by those involved in the event. The lack of an autonomous status had also contributed to difficulties formally defining a conceptual mission, and developing a long-term strategy linking the event to wider society. A key first step in any reform of the Biennale would be to acquire an independent status that would allow the event to become a secure and distinct entity. Operating autonomously, the Biennale would be better able to formalize selection processes of staff, participating artists and jury members, and ensure that all these roles would be consistently filled by competent and experienced professionals.

In the context of a structural revamp, we argued that it would also be essential to ensure that Dak'Art lived up to its claim to be an international event, covering the fifty-four countries of Africa and the African diaspora. Artists, the public and specialists had regularly expressed concerns regarding the over-representation of Senegalese artists in the Biennale. They pointed to the 2002 edition, when a quarter of the artists picked by the international selection process were Senegalese; the 2008 edition, when the *Grand Prix du Chef de l'État* was awarded to two Senegalese artists; and a subsequent edition, when two Senegalese artists were selected as guests of honour, despite the fact that neither had the profile or the quality of work to merit such a distinction. As an international African biennial, we felt that no region or country – not even the host country – should benefit from any privileges in terms of representation. The event would need to move past nationalist and identitarian priorities, and enlarge collaboration with high-level international artists and professionals. These steps would be essential to improving the quality and increasing the contemporary relevance of the Biennale.

Meeting International Standards of Delivery

Looking back at previous editions of the Biennale, we found failures at all organizational levels to meet the standards of a high-profile contemporary art event. Communications, both during and surrounding the event, had been consistently lacking. The call for applications had not been adequately disseminated, the public and contributors had expressed confusion about whether the event would be taking place on the designated dates, and during the festival, participants had not been sufficiently informed about the day-to-day scheduling of events. In the aftermath of each edition, the texts that had been produced, such as the magazine *Afrik'Art* and the catalogue, had not been widely distributed. Imprecise communications had resulted in multiple organizational problems, including last-minute invitations, problems booking flights and hotels, failure to compensate expenses, and changes in the dates and times of openings.

Other recurring issues included problems transporting works. Complicated by the late date at which selections were finalized, shipping regularly had to take place in a hurried manner. On multiple occasions, works had not arrived on time, preventing them from being exhibited and consequently ruling them out of contention for prizes. Other works had been damaged and exhibited in a damaged state, then returned in the same condition, without any team member having noticed. Even more seriously, some artists had complained of not receiving their works back at all. On top of this, financial constraints or simple negligence had resulted in other problems: exhibition spaces not being sufficiently clean or tidy, videos and other technical installations not working, staff in exhibition spaces being unable to respond to basic visitor queries. All of these incidents seriously discredited the Biennale's management team and made the event as a whole appear unprofessional. As part of any restructuring process, we saw it as imperative to engage in a communicational and logistical overhaul at all levels of organization. This would ensure that the event met the professional standards befitting a high-profile international biennial.

Encouraging Lasting Social Engagement

The fourth serious issue facing the Biennale of Dakar was a sustained lack of social engagement. By its very nature, the Biennale appeared to provide an invaluable opportunity to bring people together and encourage social exchange. In the Biennale, we saw the potential to promote justice and social dialogue, and to further struggles for emancipation and collective well-being. Dak'Art constituted a prime opportunity to improve the general public's understanding of African history and cultural heritage, and its failure to do so called into question the event's relevance on both a national and an international level. To establish a firm rooting among the inhabitants of Dakar, we suggested developing a dedicated programme of activities during the Biennale, complemented by projects aimed at sustaining public attention on contemporary art between editions. These would include:

– Discussions between artists and curators.
– Conference cycles with a broad variety of formats (round tables, presentations, etc.).
– Guided tours, led by trained docents and adapted to different kinds of audiences, for example, children, the general public, specialists, young artists.
– Tours organized in partnership with educational establishments, from preschools to universities.
– Workshops aimed at children and young artists.
– Educational screenings, for example, documentaries on artists, art movements, art scenes.
– Radio and television programmes, recorded live with public audiences in the flagship spaces of the Biennale.
– Performance pieces.

A well-organized programme of events would allow the Biennale to anchor itself in the city, without compromising on its commitment to contemporary art. We envisioned that these activities would be planned and organized by skilled professionals, and executed by trained docents and cultural outreach officers. Once constituted, an informed and aware local public would be the best possible interlocutor for the artists, galleries, museums and other cultural institutions involved in the event. We believed that the Biennale should strive to make art accessible to the largest possible number of people, and dispel the entrenched idea that contemporary art is a good solely destined for an informed elite. Rather than infantilizing or underestimating the local public, we recommended that the Biennale fully involve Dakar and its inhabitants in its projects, in order to best realize its considerable potential.

Conclusion

Reimagining the Biennale of Dakar as an African biennial for African contemporary art meant taking into account the political, artistic, educational and social elements of the project. Politically, properly targeted state involvement has the potential to bear witness to the Senegalese state's commitment to cultural policy, good governance, and its ambition, thus increasing its prestige and soft power. Artistically, Dak'Art could assert its status as the most prominent event dedicated to the visual arts of the African continent and its diaspora. Educationally, the Biennale constitutes an opportunity for forming industry professionals for the future, as well as helping to conserve a collective African past through its pedagogical dimensions. Socially, the event could be a tool for social cohesion, facilitating new connections between the different kinds of audiences it addressed itself to.

To bring about these diverse and ambitious goals, we drew on the comments of previous directors, consultations with international professionals, and above all our own expertise in the world of international contemporary art, to identify a number of key strategic approaches to be put into place. Seeing potential in the unique spirit and vitality of Dak'Art, yet disappointed by its current state of atrophy, an urgent process of renewal seems necessary to prevent lasting damage being done to the Biennale's reputation. A profound process of reform would allow the Biennale of Dakar to embody a progressive pan-African spirit of collaboration and exchange, develop to match its considerable ambition and, thus, establish a truly global footprint.

Part III

CONTEMPORARY AFRICAN ART AT DAK'ART

Chapter 9

THE MAKING OF A CANON: HISTORICIZING CONTEMPORARY AFRICAN ART AT DAK'ART

Ugochukwu-Smooth C. Nzewi

Introduction

Dak'Art affords one the opportunity to analyse the changes in the topography of contemporary art in Africa through a biennial that was created specifically for that purpose. Works at Dak'Art reflect gradual formal and conceptual shifts in the art of African artists since 1992. They demonstrate the tenor of change in aesthetic orientations and ideological agendas that once informed modernist artistic practices in Africa. The most apparent is the departure from the decolonizing legacies of easily identifiable African tropes and leitmotifs. Arguably, modernist practice was aligned with the politics of nation building though at times mirroring the ferments of international art movements from about the mid-twentieth century onward (Enwezor et al. 2016; Okeke-Agulu 2015; Harney 2004; Hess 2006). Conversely, contemporary artists at Dak'Art address their postcolonial reality subjectively without any impetus for governing ideologies such as *Négritude* or pan-Africanism or collective actions quite unlike their modernist predecessors.

Dak'Art's exhibitions since 1992 provide a vehicle to trace the shift from the formal and ideological questions that preoccupied African modernists early on to the subjective gestures and cosmopolitan sentiments that began to outline artistic contemporaneity in Africa from the late 1990s to the present. In the first decade of its existence, the Biennale featured mainly paintings and sculptures. The impact of new technologies of communication on visual practices, neoliberal ideas with regard to the market values of art objects, and processes of globalization catalysed artistic trends and new art forms such as video, performance, installations and photography, all appearing at the Biennale for the first time in 1998, and became firmly entrenched from the 2000s onward. I suggest that works featured in successive Dak'Art exhibitions offer compelling insight into the modalities of contemporary artistic production in and about Africa in the last three decades. As such, in analysing these works and the artistic practices that underpin them, I argue that the canon of contemporary African art begins to emerge at a venue

created expressly for that purpose. But before launching into the works, a quick note on modern and contemporary, two normative art historical categories that are otherwise conflated in the scholarship of African art.

Modern and Contemporary African Art

The boundaries of modern and contemporary in African art require more rigorous analysis. The two terms are, to a large extent, used interchangeably as the best way of dealing with African art that does not fit within the historical canon, meaning works that were once described as tribal or attributed to cultural groups. The conflation of the two terms first appeared in Evelyn Brown's *Africa's Contemporary Art and Artists* (1966) and Ulli Beier's *Contemporary Art in Africa* (1968), in reference to emergent styles and art forms in the late colonial and early postcolonial periods. For the most part, hybridity is posited as the defining element of modern and contemporary art in Africa since the end of European colonization (Kasfir 1999). This consideration stems from an attempt to distinguish an imagined authentic past and an altered present, which, inadvertently, dismisses the *longue durée* of appropriations across cultures in Africa, and between African cultures and alien cultures.[1]

More recently, scholars have suggested that modern and contemporary now imply different theoretical approaches in writing about African art since the formal end of colonialism (Kasfir 2013: 437–56). For example, studies by Elizabeth Harney (2004), Chika Okeke-Agulu (2015) and Holiday Power (2018) explore the distinctive modernist practices in Senegal, Nigeria and Morocco, respectively, addressing aesthetic patterns and ideological positions that were in response to social, cultural, political and economic developments in these countries in the few decades following political independence. In *Contemporary African Art Since 1980* (2009), Okwui Enwezor and Okeke-Agulu create a timeline for the contemporary in African art that departs from the hitherto dating that positioned both modern and contemporary to coincide with the emergence of political independence in Africa from the late 1950s (ibid.). Enwezor and Okeke-Agulu's new timeline considers conceptual and formal differences between artistic practices in Africa from the 1980s and what came before. They also highlighted a number of historical markers such as military incursions in governance, economic collapse in many African countries, shift from social welfarism to liberalism, rise of civil society, globalization, and increased mobility, all of which helped to catalyse a new kind of cultural production in Africa especially from the 1990s. Along these lines, non-Africanist art historians such as Alexander Alberro (2009), Terry Smith (2010) and Miguel I. Rojas-Sotelo (2011) observe that the 1990s marked the decline of the formalist agenda that once underpinned art modernism and began a new phase of contemporary art.

This current phase is distinctive in the ways in which it constitutes and addresses viewers and is aligned with contemporary hegemonic configurations such as globalization and neoliberalism. Arguably, contemporary art today is at once

underpinned by globality and coevalness, be it in Africa or elsewhere (Fillitz 2009). Yet, as it is the case, the landscape of artistic practices in Africa suggests the commingling of temporalities. While some artists continue to create in historical styles, others embrace new forms, ideas and practices. Yet others locate their work within international trends. Not all works that are currently being produced can be labelled as 'contemporary' in the art world sense, although this begs a larger question of who and what frames the definition. My focus, however, is on art that circulates within international circuits and their enabling institutions and platforms such as museums, art biennials and art fairs. By looking at a variety of works since the inception of Dak'Art, I map the ways in which the Biennale as a venue has engendered a specific understanding of contemporary African art, one that is part of what is now referred to as global contemporary.[2]

Dak'Art in the 1990s

On 12 December 1990, the maiden edition of Dak'Art opened at Place de l'Obélisque, the grand parade ground in Dakar, as a literary festival in line with the original plan to alternate the Biennale between literature and visual arts. It was graced by such literary greats as the Nigerian Nobel Prize winner Wole Soyinka and former President Senghor, an accomplished poet, whom the inaugural Biennale celebrated. However, the event did not have the international impact the government of Senegal hoped for. Consequently, the state decided to convert literary Dak'Art to an annual national salon of literature and letters.[3] But the decision to dedicate Dak'Art exclusively to visual arts would be concretized after the second iteration in 1992. This was the direct result of intense lobbying by artists and recommendations of an international team of experts sponsored by the European Union and the Senegalese government.

Dak'Art 1992's international exhibition titled *Regards croisés sur l'Afrique* was modelled after the old Venice and São Paulo Biennales, which invited national participations from the continents of Africa, Europe, Asia and the Americas.[4] It featured 110 artists whose works were displayed at the then newly constructed temporary exhibition gallery in the grounds of the Musée de l'Institut Fondamental d'Afrique Noire (IFAN).[5] Due to space constraint, I will focus on some of the African artists' works in the exhibition. Gambian modernist Chuckley Vincent Secka's masterly *Retrouvailles* (1992), a painting on batik, and Senegalese modernist Fodé Camara's expressive *La Magie des Noirs* (1992), an acrylic painting on canvas, allude to formal strategies of postcolonial modernism of reefing canonical forms and traditions. Secka creates stylized human forms with mask-like visage. On the other hand, Fodé Camara combines ram mask and face mask forms respectively attributed to the Bobo peoples of Burkina Faso and Mali and Baule people of Côte d'Ivoire, and naturalistically rendered human face in profile. Both artists deploy brilliant brushstrokes, breaking the picture surface, behind the imposing anthropomorphic forms, into large and tiny colourful planes to produce abstract effects.

Figure 9.1 Fodé Camara, *La Magie des Noirs*, 1992, acrylic on canvas. Courtesy of the artist and *Secrétariat Général de la Biennale de l'art africain contemporain*.

Two works by Senegalese sculptor Moustapha Dimé and Ethiopian painter Zerihun Yetmgeta appear to have captured the prevalent avant-garde trends in Africa, or at least in their individual countries, in the late 1980s and early 1990s in more compelling ways. Dimé's *La Dame à la culotte* (about 1991–2) is a schematized body of a woman with her pants outlined in deep brown paint. The woman's exposed breasts are carved in a pronounced fashion, and her head is attached to the body via a long spike. The sculpture is made from driftwood in the recuperation technique. *Récupération* involves salvaging items found around the urban environment as media. Until his death in 1998, Dimé was considered one of Senegal's most successful proponents of *récupération*.

Similarly, Yetmgeta's *When the Sun Gets the Moon* (1991) appears to draw upon the technique of using found material. The artist creates his own painting surface using bamboo strips repurposed from weaving looms, over which he stretches and glues leather skin to create a two-dimensional surface. Working with acrylic, Yetmgeta covers the painterly surface in colourful geometric symbols and icons, some of which are invented and others derived from scrolls of the Ethiopian Orthodox Church and popular African masks. Yetmgeta deviates from the social realism style that was officially promoted by the communist military dictatorship of Mengistu Haile Mariam, who presided over Ethiopia from 1974 to 1991. Dimé's

Figure 9.2 Moustapha Dimé, *La Dame à la culotte*, about 1991–2, driftwood. Courtesy of the artist's estate and Secrétariat Général de la Biennale de l'art africain contemporain.

and Yetmgeta's works are outstanding on formal and conceptual levels, which is perhaps the reason why the artists were joint winners of the *Grand Prix Léopold Sédar Senghor*, Dak'Art's top prize, in 1992.

In June 1993 the Ministry of Culture and the Biennale Secretariat organized a week-long evaluation panel sponsored by the European Union to address the issues and criticisms that had arisen at Dak'Art 1990 and Dak'Art 1992.[6] It was already agreed that alternating the biennial between literary and visual arts was no longer feasible. It was also noted that African and African diaspora artists had little visibility at the international level. Thus, the decision was made to transform Dak'Art into a pan-African biennial dedicated to contemporary African and African diaspora arts. In clearly outlining a new direction for Dak'Art, the evaluation panel expected that the Biennale would become the foremost international venue for contemporary African art and artists. With the new pan-African identity, Dak'Art would distinguish itself from other biennials that had more financial strength and international recognition. Dak'Art did not take place

Figure 9.3 Zehirun Yetmgeta, *When the Sun Gets the Moon*, 1991, acrylic on bamboo.
Courtesy of Secrétariat Général de la Biennale de l'art africain contemporain.

in 1994 due to the reorganization. (The changes in institutional identity and internal structures of Dak'Art are addressed in detail in Chapter 4.) However, this transformation of Dak'Art into a pan-African Biennale has had important ramifications in positioning it as arguably the most significant venue to encounter contemporary African art from 1996 until the present day.

On 9 May 1996, Dak'Art became formally known as the Biennale of Contemporary African Art at the opening ceremony of Dak'Art 1996, held in the Daniel Sorano Theatre. Most works in the international selection were paintings and sculptures, eclectic in their formal offerings and aesthetic strategies, but following a pattern established at Dak'Art 1992. However, there was an increase in the number of installations at Dak'Art 1996. The most impressive of the installations was the mixed-media *Hommage aux chasseurs du Mandé* (1994) by Malian artist Abdoulaye Konaté, who had also exhibited at Dak'Art 1992. *Hommage aux chasseurs du Mandé* is a large-scale mud-coloured textile installation, composed of multiple horizontal rolls of neatly sewn and arranged multicoloured strings, some

Figure 9.4 Abdoulaye Konaté, *Hommage aux chasseurs du Mandé*, mixed-media. Image: Courtesy of the artist and Musée des Civilisations Noires, Dakar. Photo credit: Anna Karima Wane.

bearing tiny traditional medicinal amulets and other objects, including cowries, bits of ivory and driftwood, and wooden troughs laden with similar found material, arranged at the base of the hanging textile. Konaté's aesthetic vocabulary is refreshingly familiar – simultaneously traditional and contemporary. The installation, which was awarded the *Grand Prix Léopold Sédar Senghor* at Dak'Art 1996, draws upon the sophisticated Malian craft tradition, the Bògòlan technique of dyeing textile in rich mud, and the folkloric mystic world of Malinke and Bamana hunters.

The individual exhibitions of five established and mid-career artists, who stood in for the five sub-regions of Africa, were an important curatorial development at Dak'Art 1996. The artists were Mohamed Kacimi (Morocco), representing North Africa; Ezrom Lagae (South Africa), representing Southern Africa; Pascale Marthine Tayou (Cameroon), representing Central Africa; Zerihun Yetmgeta (Ethiopia), representing East Africa; and Moustapha Dimé (Senegal), representing West Africa. The exhibitions provided a context to explore the dimensions of artistic modernism in Africa in greater depth, addressing the figments of linguistic and cultural boundaries. A pioneer Moroccan modernist, Mohamed Kacimi's paintings, which covered the walls of the IFAN Museum's main building, presented a critical lens into the artist's pictorial strivings to find the depth and meanings of reality. In the large-scale haunting paintings, Kacimi pushes the boundaries of form, oscillating between abstraction and figuration, shifting from thick exuberant coloration to softer pastel effect, and creating a dialogue with Islamic calligraphic tradition and Western modernism, particularly French abstract art.[7] The powerful

oeuvre of South African Ezrom Legae was displayed at the IFAN Museum's main building in the exhibition titled *I think more with my eyes than with my mind*. Works in the exhibition, such as *Dying Beast* (1993), capture the mood of political transition from Apartheid to democracy in South Africa in the early 1990s. *Dying Beast*, a bronze work, depicts a headless zoomorphic figure resting on its back with outstretched legs. Legae's bronze sculptures, as well as ink drawings, are grotesque as containers filled with horrific memory but very beautiful as aesthetic objects. Their formal qualities attest to Legae's technical proficiency in bronze and his impeccable skills as a draughtsman. Until his death in 1999, Legae was a celebrated pioneer black modernist in South Africa whose works portrayed the harsh social condition in South Africa during Apartheid.

Pascale Marthine Tayou, who was then still an emerging artist, displayed a body of installations in an exhibition titled *Neither Primitive, Nor Wild* at the Goethe Institute in Dakar. Consisting of five installations made mostly from detritus (dolls, plastic cosmetic containers, plastic bags, socks, wood, etc.) sourced from the immediate environment, the exhibition demonstrated Tayou's penchant for connecting his personal experiences to common social issues such as the HIV/ AIDS pandemic, which he variously explored between 1994 and 1996. Zerihun Yetmgeta's (co-winner of Dak'Art 1992's top prize) exhibition titled *A Spiritual Art* at Galerie Quatres Vents in Dakar presented twenty-five works in the artist's signature style of painting on dried animal skin stretched over strips of bamboo, held together with strings. The works depict the artist's preoccupation with symbolic and subliminal aesthetic vocabulary that combines Ge'ez scripts of the Ethiopian Orthodox tradition and the iconography of African masks. Completing the monographic exhibitions was the late Moustapha Dimé *From the Long Search for a Shadow* at Galerie 39 and in the garden of Centre Culturel Français. The exhibition included free-standing slender figures made from driftwood and wall-hung sculptures made of wood boards and steel. Inscribed on the boards were Arabic scripts.

Whereas the large percentage of works exhibited at Dak'Art in the 1990s were paintings and sculptures, Dak'Art 1998 marked a shift from the modernism that defined much of post-independence African art to the more conceptually driven and politically charged contemporary African art. One clear example was Cameroonian artist Barthélémy Toguo's *Carte de Séjour*, a performance. Toguo, who lives in Paris and Bandjoun in Cameroon, enacts the joy of an African immigrant upon obtaining the French residential permit, which would allow him to find legal employment and begin to live his European dream, so to speak.

In the performance Toguo cajoles, caresses and holds tightly a large *carte de séjour* residence permit, carved from wood, contorting and embracing his body in act of relieving personal experience of expatriation – existential for most African immigrants, but also universal. The aesthetic language of engaging themes or issues that affect people at local and global levels employed by Toguo was enhanced in Dak'Art exhibitions in the succeeding decades.

Figure 9.5 Barthélémy Toguo, *Carte de Séjour*, performance, Dak'Art 1998. Courtesy of the artist.

Reading the Contemporary: Dak'Art since the 2000s

In *Red, Yellow, and Brown: Face to Face* (2000), exhibited at Dak'Art 2000, South African artist Berni Searle, one of the finest of her generation, utilizes her body as a site of historical interrogation. The photographic installation reflects a new artistic strategy to employ the artist's individual image or body as visual reference. This opens up a range of conceptual possibilities, allowing artists to address history, identity and cultural roots. It is the image or body of the artist which drives both the creative process and meaning. The photographic installation consists of eighteen large-size digital colour prints on vellum drafting paper of a nude Searle, who is lying down horizontally and covered in either red, yellow, or brown spices. In some of the prints, the outline of the artist's absent body is traced in the same spices. At the base of the sheets with outlines of Searle's absent body, there is a mound of the particular spice that matches the colour of the spice in the individual prints. *Red, Yellow, and Brown: Face to Face* belongs to a body of work, the *Color Me* series, in which Searle examines her personal history and inserts it into the broader histories of South Africa's social, economic and political evolution. Searle's story of South Africa's complex identity politics is revealed in her own cultural roots, which are a mixture of several racial groups and ethnic identities. She is of European, Asian and African ancestry and also has Muslim and Roman Catholic roots.

Figure 9.6 Berni Searle, *Red, Yellow, and Brown: Face to Face*, 2000, photography, variable installation. Courtesy of the artist.

Like Searle, Durban-born Tracey Rose uses her own body to open up conversations on South Africa's social history, addressing similar issues around the female body, identity and gender. Her nude body is the visual reference and conceptual point of departure in *Span II* (1997), a video and object installation exhibited as part of Dak'Art 2000's international selection. *Span II* was initially exhibited as a performance and video installation in GRAFT, curated by Colin Richards at the Iziko South African National Gallery (ISANG) as part of the Second Johannesburg Biennale in 1997. In the ISANG installation, a nude Rose sits in a reclining pose on top of an overturned television which shows a looped video of Rose's naked body. Both Rose and the television are in a massive glass cabinet. Rose's head is shaven and tilted downward as she knits with some of her cut hair placed on her lap. The rest of her hair lies at her feet in the right-hand corner of the vitrine. She intentionally presents a passive image of domesticity, exhibiting herself as a woman who is oblivious to her surroundings and apparently lacks agency over her displayed body, which is on full view for the spectators' consumption. In *Span II*, Rose makes several allusions to her personal biography as a 'coloured' South African. She is of German and indigenous Khoisan ancestry, and a Roman Catholic. She also explores the history of the ethnographic display of the black woman's body, postcolonial thought, the fiction

of racial constructs, and predatory colonial and male gazes that have objectified the female body.

It is easy to view Searle's and Rose's work as addressing the specific South African context. Indeed, both works belong to a late 1970s and 1980s conceptual strategy in South African art history, where female artists focused on the female body as a 'symbolic gesture to politicize the personal' (Van Der Watt 2004: 74). Yet contemporary African art since the 2000s shows a pattern wherein artists address postcolonial identities and postcolonial subjectivities in Africa. Several works at Dak'Art have presented the intersection of self-imagining, beauty and history in addressing the female body. Artists such as Cameroonian Angèle Etoundi Essamba, Egyptian Amal El Kenawy, Tunisian Fatma Charfi and Kenyan Ingrid Mwangi have explored women's experiences from multiple perspectives using photography, video, performance and installation.

The Nigerian photographer Mfon Essien provides a personal and intimate account of her body, but with a poignant universal message, in a series of photographs entitled *The Amazon's New Clothes* (1999). Exhibited at Dak'Art 2000, the black-and-white photographs are of the artist's post-mastectomy body, addressing the possibility of the heroic female nude. The visually impressive and sensual photographs capture a woman facing bodily change and infirmity bravely and with dignity. They are inspiring photographic self-portraits of Essien, who rejects being scarred by an experience that would later claim her. By shielding her face from the picture frame, she insists on her body as both object and subject of visual expression, and more importantly, a symbol of universal courage. Although Essien does not address an African context specifically, her work certainly fits within the autobiographical body as a mode of address, so evident in the works of Searle and Rose.

Interests in the nude also extend to the male artist's body. Congolese Moridja Kitenge Banza offers a personal take on African history and postcolonial subjectivity using his body in the video installation *Hymne à Nous* (2008), which was awarded Dak'Art 2010's *Grand Prix Léopold Sédar Senghor*. In the video, Banza's nude body is multiplied, such that the *doppelgängers* stand in for a band of choristers singing Beethoven's *Ode an die Freude*. Banza, however, composed his own lyrics, which are a fusion of the Congolese, Belgian and French national anthems. The nude body and combined anthem are unstable, multivalent signifiers, standing as metaphors for Banza's Luba ethnicity, Congolese nationality, Belgian colonial legacy, expatriation in France, and professional status as an artist-nomad.

Like Searle and Rose, Banza, who was born in Kinshasa in 1980 and currently lives in Montreal, Canada, addresses identity as a loaded construct shaped by political, historical, cultural and social processes. Banza's focus on identity escapes the racial discourse that once plagued ideologies of cultural nationalism and African modernism, such as *Négritude*. The multiple identities signalled in his work reflect what philosopher Kwame Anthony Appiah describes as rooted cosmopolitanism (2007). It is the idea that an individual can belong to or engage with several overlapping communities or contexts, as forms and processes of identification.

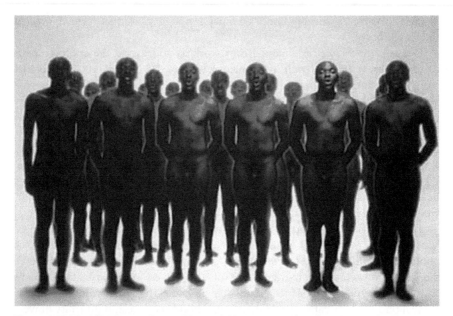

Figure 9.7 Moridja Kitenge Banza, *Hymne à Nous*, 2008, video, duration: 1min, 20sec.
Courtesy of the artist.

Most African artists reflect the cosmopolitan ethos given the legacy of
colonialism in Africa which makes them amenable to cultural experiences from
elsewhere, including those who have never been outside of their immediate
communities. The works featured in Dak'Art's exhibitions since 2000 show
the interesting dialectic of the local and the global, a defining element of the
contemporary. In *Malgré tout* (2000) and *G8 promène son chien* (2001), the
Beninese Dominique Zinkpè addresses Africa's relationship with the Western
world. Both installations were exhibited at Dak'Art 2000. *Malgré tout* is composed
of a body made of flexible wire, rags and fibrous rope, bound to a hospital bed. The
body represents a severely sick patient being fed by multiple intravenous drips
from several plastic containers hanging above the patient and surrounding the
bed. The containers of intravenous fluid are labelled with the names and acronyms
of several international humanitarian agencies and donor institutions, such as
USAID, UNICEF and the IMF. *Malgré tout* provides a brutally honest comment
on the effects of Africa's continued dependence on external aid, which prevents the
continent from asserting itself on the global stage and to taking control of its
destiny. The installation also offers a biting criticism of the white-saviour complex
that undergirds what the economist Dambisa Moyo refers to 'as the self-
perpetuating aid industry' (2009).[8]

The Senegalese Babacar Niang explores the links between globalization and
illegal immigration in *Émigration Clandestine: Le Grand Débat* (2008), featured in
Dak'Art 2008. A significant number of Senegalese and West Africans are known to

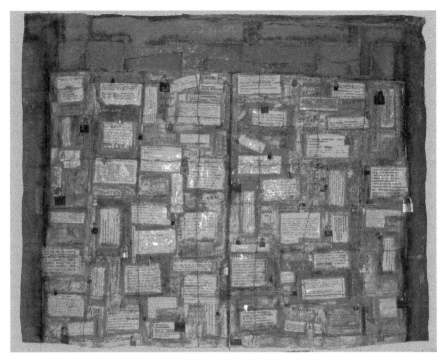

Figure 9.8 Babacar Niang, *Émigration Clandestine: Le Grand Débat*, 2008, collage and installation. Courtesy of the artist.

have attempted the treacherous trip to Europe via the Sahara Desert without surviving the experience. Niang sees globalization as an economic process that opens borders to allow the flow of goods and services that further the interests of big businesses, but shuts them to impoverished economic migrants from the so-called developing world, specifically Africa.

Combining painting, collage and installation, Niang follows a formal approach of layering recycled and repurposed materials to generate cumulative meaning on the subject of illegal immigration. The work includes several graphic inscriptions and newspaper clippings on the subject of illegal immigration, difficulties of international mobility and access for African immigrants, and some of the tragic accounts of the fate of African illegal immigrants. These items are written and glued to the picture surface, which is broken into planes of rusty brown, orange and lemon-green colours. Transparent plastic covers the newspaper clippings to safeguard them. Cutting across the newspaper clippings and writings are barbed wires and several padlocks with their key attached, numbering about sixty. Each padlock is placed close to a newspaper clipping. Taken together, the padlocks symbolize barriers and hurdles faced by illegal immigrants as they attempt to breach the unwelcoming and closed immigration borders of the so-called developed world.

Similarly, Kuwait-born Egyptian-American artist Ibrahim Ahmed addresses the politics and economics of migration in the twenty-first century in the visually arresting and astute *Only A Dreamer Leaves* (2016). Featured in Dak'Art 2018's *Exposition internationale* titled *The Red Hour: A New Humanity,* the installation comprises several sails created from weighty and permeable textiles used for labour and domestic work. The textiles are embroidered with gold patterns that suggest baroque and arabesque iron gates, which are seen as symbols of wealth and status in Cairo. The artist suggests that the gates are a metaphor for political and economic exclusion and segregation which compel people to seek socio-economic mobility elsewhere, mostly outside of Egypt. It is a work rich in visual flourish yet poignant and timely in content.

In the 4min, 4sec video work titled *Consomania* (2007) exhibited at Dak'Art 2008, Senegalese Samba Fall focuses on consumerism as the most visible characteristic of economic globalization. A well-made animation, *Consomania* depicts alien-like depersonalized human forms with motorized faces holding barcoded signposts that read 'Who am I' across their chests. These human forms, some of which are black silhouettes while others are composed of excerpted newspaper clippings, are clones of each other. These figures are placed against a blood-red background, and organized in ways that suggest that they are felons having their mug shots taken. It is most probable that they are prisoners of excessive consumption whose identities are reduced to barcodes. Surrounding the figures, in the background, are tiny shells emitting black and white smoke. In another scene, a human form lies in profile, recumbent on massive white barcodes. The skeleton can be seen through the human form which is dripping red blood through the barcodes. Both the human form and barcodes are placed against a black background. Fall's intervention is playful, yet the gravity of his subject matter is not lost. His visual language is astute in conveying the dangers of consumerism for humanity and the environment.

Jointly awarded the top prize of Dak'Art 2008 after winning it previously in 2002, Ndary Lo's *La Muraille Verte* (2006/2007) tackles environmental issues. The installation was inspired by Nigeria's former President Olusegun Obasanjo, who, while on an official state visit to Senegal to attend the New Partnership for Africa's Development (NEPAD) meeting, called for a concerted effort to tackle desertification and ocean surge in Africa through public sensitization campaigns and the planting of trees. *La Muraille Verte* consists of several trees fashioned out of rebar and painted green, arranged on a pile of austere beach sand. Stripped of leaves to denote a lack of foliage, the impoverished branches of the trees are shaped into wiry, elongated and contorted human forms, possibly to remind us of the role of human activities as a principal vector of environmental degradation.

Several works of Dak'Art have addressed the existential conditions of contemporary Africa. Artists including Ivorian Robert Jems Koko Bi and Congolese Freddy Tsimba and Aimé Mpane engage the harsher vicissitudes of Africa's recent history and contemporary social conditions from individual and collective perspectives. For example, in *Darfur* (2007), created from burnt wood, exhibited at Dak'Art 2008, Koko Bi extrapolates from the recent genocide in Darfur, Sudan, to

address past instances of civil war in post-independence Africa. Koko Bi's life-size installation consists of three nude figurative sculptures of a standing man, a kneeling woman and a child with nondescript faces huddled in a heap, carved in wood and in the artist's conventional but realist style. The male figure's stomach is hollowed out, legs are spread apart, and hands are held behind with fists clenched. His face is contorted, indicating frustration and anguish, and he gazes upward, possibly beseeching the heavens. Like the man, the kneeling woman's visage shows tremendous anguish and she also gazes to the heavens. She gestures forward with her hands clasping her chest. Her stomach is also hollowed out. In between the man and the woman is the lifeless and kwashiorkor-ridden body of the child. It appears as if the couple is appealing to the heavens to rescue and revive their child, while knowing that it is a lost cause. The child's twisted head, exposed rib cage and mangled limbs tell of the fate of children in Africa's theatres of war.

Aimé Mpane's *Congo, Shadow of the Shadow* (2005), exhibited at Dak'Art 2006, connects historical memory to extant memory as it relates to the civil war in the

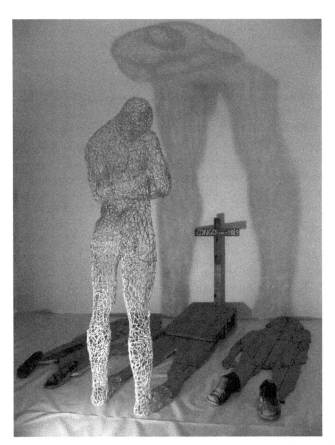

Figure 9.9 Aimé Mpane, *Congo, Shadow of the Shadow*, 2005, matchsticks, wooden boards hewn from alder and fir, sculpture installation, variable. Courtesy of the artist.

Democratic Republic of Congo (DRC). The main element of the installation is a life-size transparent male figure created from 4,652 matchsticks whose combustible heads were carefully removed before being assembled and glued together. Mpane's visual vocabulary is sophisticated and laborious, but also very successful in conveying the fragility of existential reality in the DRC. The human figure stands with his arms folded across his chest and his head and neck hunched over in a meditative stance before three human shadows made of wood placed flat on the ground. The shadow in the middle is headless with the torso slightly elevated, and a cross with the inscription 'Congo 1885' is implanted firmly as a tombstone where the neck would have been. The engraving and date refer to the Berlin Conference, in which the Congo area became a personal property of Belgium's King Léopold.

The anti-government protests that shook North Africa and the Middle East from late 2010 to 2012 are the subject of Algerian Katia Kameli's *Untitled* (2011), a 2min 30sec video piece, featured in Dak'Art 2012's *Exposition internationale*, and Tunisian Nidhal Chamekh' *De quoi rêvent les martyrs* (comprising eighteen seminal drawings), featured in Dak'Art 2014's official exhibition. Filmed in the months of the mass revolution, Kameli's video opens with the camera canvassing the sidewalk of a street, possibly in Algiers. The sidewalk is littered with cardboard used by homeless people to construct sheds in which to sleep. The artist emerges from one of the sleeping sheds and constructs a placard out of a piece of cardboard lying nearby. The placard is blank. She walks into the street and is joined by a group of women of different ages, some dressed traditionally, others in modern clothes. All the women, however, bear grave countenances as they walk silently on the street with their raised blank placards. In the affective set of drawings, Chamekh presents a chronicle of the events of the so-called Arab Spring in Tunisia, beginning with the self-immolation of the street vendor Mohammed Bouazizi to the gory avalanche of deaths as security forces mowed down protesters on the streets of Tunis. The work, created between 2011 and 2013, consists of anatomical/scientific sketches of human body parts, image transfers, combined with Arabic scripts, animal heads on human forms, guns, police batons, among other elements.

Tunisian Faten Rouissi tackles post-revolution Tunisia in *Le fantôme de la liberté (Malla Ghassra)* (2012), a large-scale installation consisting of seventeen ceramic toilet water closets painted in gold colour, arranged to evoke a sitting arena for public conversation. One of the outstanding works featured in Dak'Art 2014's *Exposition internationale* titled *Producing the Common*, the installation comes to grips with the mirage of political revolutions and the hypocrisy of the political class. Drawing on the specific context of Tunisia, the work embodies the sense of despair that has since enveloped peoples in Egypt, Libya and other parts of Africa and the Arab world where the revolution once held promises of a seismic change in the political order.

It can be surmised that the works of contemporary African artists at Dak'Art engage the dialectics of the local and the global through recurring themes, including identity – see for example Ethiopian Aïda Muluneh's *Local Understanding, The World is Nine* series (2016) and Moroccan M'barek Bouchichi's *Cimetière* (2016), featured in 2016 and 2018 respectively; globalization and its effect on local

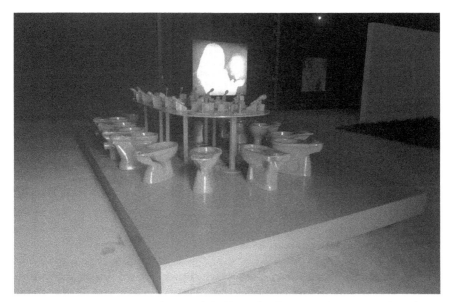

Figure 9.10 Faten Rouissi, *Le fantôme de la liberté (Malla Ghassra)*, 2012, mixed-media installation. Courtesy of the artist.

economies – see Nigerian Olu Amoda's *Sunflower* (2012), featured in 2014; global consumerist culture – see for instance Kenyan Wangechi Mutu's *The End of Eating Everything* (2013), featured in 2014; the legacies of modernism and national modernization agendas – see for instance Algerian Kader Attia's *Indépendance Tchao* (2014) and Amina Menia's *Un Album de Famille bien Particulier* (2012), both featured in 2014; spirituality and memory – see for example Rehema Chagache's *Nankondo Part III* (2017), featured in 2018; postcolonial politics and history – see for example DR Congolese Michèle Magema's *Oye Oye* (2002); and urbanization and quotidian life – see for example Emeka Ogboh's *LOSatlantic* (2014) and Sammy Baloji's *Ouakam Fractals* (2015), featured in 2014 and 2016 respectively. Themes of historical import such as the *Middle Passage* and its aftermath as relationship to the diasporic imagination continue to be a hot button – see for instance British Keith Piper's *The Space of the Raft* (2006) and American Radcliffe Bailey's *Storm at Sea* (2007–14), featured in 2006 and 2014 respectively.

With narratives and dialogues, Dak'Art artists engage reality in its most direct form, offering responses to historical, political, psychological and sociological issues that confront them in their social spaces in Africa and the diaspora. They address issues that are humanistic, universal and at times with activist or propagandistic bent. Angolan Kiluanji Kia Henda and British-Kenyan Sam Hopkins, for example, confront the industry of non-governmental organizations (NGOs), of which more than a proportional number are found in Africa, in their respective works *As God Wants and the Devil Likes It* (*O.R.G.A.S.M Congress,*

2011–13) and *Logos of Non-Profit Organisations working in Kenya some of which are imaginary* (2010–ongoing). Henda's wall-like installation is populated with manipulated portraits of the artist, images of his friends, and leaders of the European Union. Painted blue overall, on its other side, a map of Africa painted in gold is surrounded by the twelve-gold-star emblem of the European Union in the middle of the wall. Laden with satire and irony, Henda imagines an African NGO that provides aid and grants to the West, reversing assumptions and expectations about needy and helpless Africa and drawing attention to the power dynamics that undergird the thriving industry of Western NGOs in Africa, something addressed by Hopkins.[9]

Focusing attention on Kenya, seen as the hotbed of NGOs on the continent, Hopkins explores the country's assortment and the various missions of these NGOs by looking at their logo designs. He assembles several recognizable and imaginary logos, blurring the line between real and fake, as a commentary on the many purported activities and roles of NGOs in Africa.

Works at Dak'Art reflect a consciousness rather than a collective identity because participating artists engage with contemporary and historical experiences of Africa. Yet, despite Dak'Art's pan-African orientation, the works cannot be so labelled from an aesthetic point of view. Artists whose works have been exhibited at Dak'Art no longer seek an aesthetic return to 'Africanness', as arguably did the modernists early on. Yet they are well aware of their cultural, ethnic or national ties as forms of social identification, hence their participation at Dak'Art. They engage their identities, be it Luba, South African or African as a given, without allowing them to dictate their aesthetic approaches. These identities become one of the

Figure 9.11 Kiluanji Kia Henda, *As God Wants and the Devil Likes It* (O.R.G.A.S.M Congress), 2011–13, photography printed on wallpaper, dimension variable. Courtesy of the artist.

Figure 9.12 Sam Hopkins, *Logos of Non-Profit Organisations working in Kenya some of which are imaginary,* 2010–ongoing, silk-screen print. Courtesy of the artist.

many windows through which Dak'Art artists see their immediate and cosmopolitan worlds. As the sociologist Stuart Hall once said, 'we speak from a particular history, out of a particular experience, a particular culture, without being constrained by the position of "ethnic artists"' (Hall 1992: 258). Africa is the immediate cultural experience or point of departure for most of the artists at Dak'Art.

Cultural theorist Nikos Papastergiadis suggests that 'the coda for the contemporary artist is defined by the desire to be in the contemporary, rather than to produce a belated or elevated response to the everyday' (2008: 363). This coda, Papastergiadis suggests, 'recognizes the dual right of artists to both maintain an active presence in a local context and participate in transnational dialogues' (ibid.: 363–4). Contemporary African artists' realities are no different; they address the everyday through personal, collective, existential and historical experiences in and of Africa. On a similar note, Ousseynou Wade, former Secretary General of the Biennale of Dakar (2000–13), suggests that contemporary African art mirrors the multifaceted dimensions of African postcolonial experiences and subjectivities in the era of cultural globalization.[10]

Finally, it is important to emphasize that the works discussed are a snapshot or rather subset of contemporary African art. They are neither the entirety of what has been exhibited at Dak'Art in the last few years nor the contemporary cultural production in Africa writ large. In addition, I have focused mostly on works featured in official exhibitions otherwise known as the 'In'. Dak'Art does not

provide a complete picture of contemporary cultural production in Africa and does not claim to do so. However, it has exhibited a much greater number of African artists practising today and a wider range of contemporary art forms than any other biennial or exhibition in Africa and internationally. By the last iteration of Dak'Art in 2018, works of more than 500 artists have been exhibited in its official exhibitions. If one is to include the works in the 'Off' exhibitions, over 5,000 artists (a conservative estimate) would have participated in the Biennale since 1992. In this regard, and without any shadow of doubt, it is apparent that Dak'Art has been a catalyst or at least central to the formation of what may well be a canon of contemporary African since the 1990s.

Chapter 10

ALL THE CITY IS AN EXHIBITION:
THE DAK'ART-OFF IN THE BIENNALE AND
IN DAKAR'S ART WORLD CITY

Joanna Grabski

During the buzz of the Dak'Art Biennale's opening week in 2018, many conversations revolved around Dak'Art's 'Off' exhibitions – their multitude, the array of artistic propositions, their *vernissages*, and the challenge of getting from one venue to the next. Art world travellers attending the Dak'Art Biennale have typically focused their visits on the curated *Exposition internationale*, the event's centrepiece and raison d'être, along with the other 'In' sites organized under the auspices of Senegal's Ministry of Culture. With its objective of representing the contemporary arts of Africa and its longevity, Dak'Art is unique to the international biennial circuit. For much of Dak'Art's history, biennial goers viewed the Off exhibitions as secondary destinations to the *Exposition internationale* and the official Dak'Art–In sites more generally. They were, at best, exhibitions to see if time permitted and based on recommendations from colleagues or friends in the know.

The Off exhibitions, once connoted by the marginality implied in their name, have become integral to Dak'Art's programme, purpose and presence in the roster of international art biennials. In numbers alone, the Off exhibitions dominate Dak'Art. Whereas the In sites usually encompass a handful of exhibitions and additional related programming, the Off sites numbered more than 300 in the 2018 Biennale.[1] Not only are the Off events more numerous than the *Exposition internationale* and the other In sites, they are also more profoundly associated with Dakar-based artists and Dakar itself. As I have asserted in my book, *Art World City* (2017), the Off events are what make the Biennale a collectively mobilized urban project (ibid.: 57). Expanding on this contention, this chapter addresses the relationship of the Off exhibitions to the Dak'Art Biennale as a whole and to Dakar's art world city. The examination of two interwoven questions runs through this chapter: what do the Off sites reveal about the dynamics of Dakar's art world city, and what do the Off sites contribute to Dak'Art as a totality and distinctive art world event?

Figure 10.1 Biennale visitor viewing the Off exhibition at Atelier Céramiques Almadies during Dak'Art 2018. Photo courtesy of Forrest Solis.

Reframing the off Sites

Art World City argues for the need to interpret artists and artistic propositions in Dakar on their own terms (ibid.). This is also true for the Biennale of Dakar. The peripheral status signalled by the rubric 'Off sites' flattens our understanding of their impacts and glosses over their significance. Describing them as collateral or satellite sites derives from the paradigm of other international art biennials, the most celebrated of which is the Biennale di Venezia, where the Arsenale and Giardini exhibitions are surrounded by smaller and less prominent shows. In the case of Dak'Art, the relationship between the Off sites and the juried *Exposition internationale* is much more complex than the analogy of satellites pulled by the orbit of a larger and more captivating body. Like in Dakar, the collateral exhibitions in Venice encompass a range of individual and group shows scattered across the city.[2] However, Dak'Art–Off exhibitions differ from collateral shows in other art biennials such as Venice in a couple ways.[3] First, Dak'Art–Off exhibitions are associated primarily with arts stakeholders in Dakar. Secondly, the Off exhibitions are embedded in the exhibition practices of Dakar's art world city rather than those of global biennial culture or the top-down mega-event production of contemporary festivals (Haferburg and Steinbrink 2017).

Instead of framing the Off sites as peripheral to the *Exposition internationale* and the In sites more generally, I propose that we read them as emergent from and embedded within Dakar's art world city. The Off sites are articulations of the exhibition practices that characterize Dakar's art world city: the opportunism and improvisation that allow art to be exhibited and sold wherever it can be, as well as the multiscalar networks that enable connections to form across cities and art world sites (Grabski 2017: Introduction and Chapter 2). As for the Off sites' contributions to the Biennale's totality, they give Dak'Art its configuration and character. Furthermore, they are critical to the Biennale's particularity as an art world event. They animate the city and give art world travellers access to the city's art scene, making Dakar integral to the experience of Dak'Art. As much as Dak'Art's dedicated focus on the contemporary arts of Africa defines its purpose, the Off exhibitions are what give Dak'Art its specificity.

The Off Sites in Relation to National Cultural Politics and Urban Space

This history of the Off exhibitions reveals their deep embedment in and emergence from the history and dynamics of Dakar's art world city. What are now termed Off exhibitions were initiated by arts stakeholders in Dakar to coincide with the Biennale's first edition devoted to contemporary African art in 1996.[4] The Off began at the grass roots as events held in conjunction with the Biennale. Several motivations prompted their emergence: to join Dak'Art's momentum and opportunities, to extend the programming associated with the event, and to challenge the Biennale's governmental imprint and power to represent artists.

From a historical vantage point, artists' organization of events alongside the Biennale was a means to ensure their participation in a high-profile international art platform overseen by the Ministry of Culture. Given the state's history of sponsoring exhibitions during Senghor's presidency (1960–80) and the decline in state funding for the arts in the post-Senghorian years, artists in Dakar were uncertain as to whether they would be represented officially in the Biennale. This uncertainty was further complicated by the Biennale's shift in focus from international contemporary art in 1992 to the contemporary arts of Africa in 1996. The shift in focus from the 1992 to 1996 editions meant that the Biennale was to be inclusive and representative of artists from across the continent. Senegalese artists would not have the same opportunity to represent the continent as in a biennial dedicated to contemporary art. Comparing the presence of Senegalese artists in the first few Biennale editions is illustrative. Although the first edition of the Dakar Biennale in 1992 included forty-two Senegalese artists of the 110 artists featured, subsequent editions in 1996 and 1998 saw their presence diminished. The 1996 edition, the first to focus on contemporary African art, included ten Senegalese of forty-two African artists featured and the 1998 edition included six Senegalese of thirty-seven African artists featured. The dwindling number of Senegalese artists represented in the Biennale was construable as another example of decreasing

state support for contemporary art compared to the era of Senghorian state funding for the arts.

The artist-led Tenq workshop in 1996 is one of the earliest events to have been held in conjunction with the Biennale. Artist El Hadji Sy, who led the workshop, described it not as an 'Off site' but as a 'pôle d'extension' that would enlarge the event's impacts for artists in Dakar and artists visiting from abroad. In this case, the workshop capitalized on Dak'Art 1996 by inviting international visiting artists to participate in a residency and exhibition at the Campement Chinois, a group of abandoned buildings ideally suited for artists' studios. The artists in residence activated the space which later became the new Village des Arts, replacing the former Village des Arts that was razed by governmental troops in 1983.[5] As this example suggests, the Off events have the potential to challenge the association of the arts with national politics and to refocus attention on artistic projects organized independently from the state. Since then, the Village des Arts has been a consistent site for Off events.

In the context of Senegal's art history, the Off sites allowed artists to contest the Biennale's association with the state, and especially the relatively meagre government support for the arts compared to the heyday of Senghorian funding. Art and culture in Senegal are still associated with the history of government funding due to the precedent set by the nation's post-independence President Léopold Sédar Senghor in making the arts a state project. While a number of state-run institutions, such as the École des Arts, Galerie Nationale, Musée Théodore Monod and, of course, the Biennale itself, still anchor Dakar's art world, struggles between artists and the state, so fundamental to Dakar's art history in the immediate post-Senghorian years, have also played out at several editions of Dak'Art. For some artists, especially those who began their careers in the 1980s, participation in Off venues has been a means to oppose the politics surrounding the In exhibitions, to assert autonomy from the state, and to call attention to the lack of funding for the arts compared to the time of Senghor's cultural politics. The topics of opposition are typically the selection for the juried *Exposition internationale*, the Biennale's organizational issues, or the government's investment in the Biennale rather than other arts infrastructure such as the art school. Over the years, several high-profile Senegalese artists, including Ndary Lo, Joe Ouakam, Ousmane Sow and El Hadji Sy, have boycotted the Biennale's In sites as a form of protest. Because the Off sites are independent exhibitions framed within a larger exhibition project, they offer a way to challenge Dak'Art's structure, propositions and agenda from within while maintaining some degree of autonomy.

The venues for the Dak'Art–Off and Dak'Art–In sites emblematize two very different relationships to national politics and to the city's institutional, geographical and social spaces. Associated with the state's resources, the In exhibitions, including the juried *Exposition internationale*, are organized by individuals invited by Senegal's Ministry of Culture, under whose administration Dak'Art operates.[6] They are held in buildings associated with the Senegalese government, many of which are located in downtown Dakar or adjacent neighbourhoods. These include the Ancien Palais de Justice, Centre International du Commerce Extérieur du

Sénégal (CICES), Galerie Nationale d'Art, Maison des Anciens Combattants, Maison de la Culture Douta Seck, Musée Théodore Monod and Village de la Biennale.

The vast majority of Off events take place between and beyond sites associated with the state. This is also true of the preponderance of contemporary artistic initiatives in Dakar more generally. When the Biennale is not taking place, artists might occasionally rent exhibition space in the Galerie Nationale d'Art and Musée Théodore Monod. More often, however, artists exhibit and sell their works in a variety of other locations in Dakar and elsewhere. As I have elaborated in *Art World City*, too much weight has been placed on the formal infrastructure of galleries, museums and auction houses as requisite for art's exhibition and sale. Rather, in Dakar's art world city, platforms for the display and sale of art take shape where possibilities for visibility, social relationships and financial transaction coalesce. Were we to map where artists exhibit and sell their works, we would see that Dakar has no single dedicated gallery district or studio visit destination.[7] The implications are that the activities of artistic life, including the exhibition and sale of art, occur across the city in expected and unexpected locations.

Thus, like art exhibitions occurring year-round in Dakar, the Off sites emerge authentically from the city's resources and possibilities, especially its social networks and built environment. Many of the Off sites are venues artists use when the Biennale is not happening, while other sites are deployed opportunistically in order to join the Biennale's momentum. The Off sites transform public and private space into the space for art. They constellate the city's diverse neighbourhoods, from Medina to Mermoz and Yoff to Plateau.[8] Some take place in art galleries or other expected venues for art, but the majority take place in alternative private spaces, such as banks, bookstores, car dealerships, the Catholic cathedral, clinics, dance clubs, hairdressing salons, homes, hotels, gas stations, restaurants, schools, and outdoor public spaces such as traffic circles and building facades.

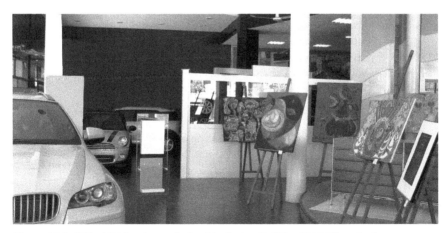

Figure 10.2 Off exhibition in car dealership during Dak'Art 2012. Photo by Joanna Grabski.

The range of private and public locations that are activated as Off venues underlines the extent to which Off events emerge from the city's possibilities. They further indicate the fluidity with which city sites transform into art world sites, exemplifying the opportunism and improvisation that characterize Dakar's art world city. The range of Off sites also highlights the overlay of Dakar's creative economy and urban space while demonstrating the propensity of individuals and groups as cosmopolitan as Dakar itself to forge opportunity in the art world city.

Given their propensity to spring up in city spaces not designated exclusively for art, the Off exhibitions have the capacity to engage city residents in a way the *Exposition internationale* could not. Since the Off sites rely largely on spaces beyond those formally associated with art such as galleries and museums, they actualize the potential for the city's alternative spaces to display art. In this, the Off sites are more visually prominent in urban space and to urbanites than the In sites. They have the power to entice art world travellers and the urban populace as their audience. Various off exhibitions provide rich examples, from Béninois artist Dominique Zinkpè's outdoor installation at Colobane's traffic circle, *Taxis-Zinkpè*, exhibited during Dak'Art–Off 2002, to Laboratoire Agit'Art's performance, *La cloche des fourmis,* near the old Malian market in Plateau during Dak'Art 2018.[9] Not only do the venues and locations indicate the extent to which diverse city spaces are deployed for the display of art during the Biennale, they also demonstrate that the Off exhibitions are embedded in Dakar's urban space.

In contrast to the In sites which are organized by individuals invited by or associated with the Ministry of Culture, the Off venues are activated by artists, gallerists and other *animateurs d'art*. Most of these individuals are active in the city's art scene during non-Biennale months. The Off sites in any given Biennale edition reflect their individual and collective resolve to engage in the processes of *animation artistique*, to create exhibitions, and to make visible the art scene's players and propositions. With the Biennale as the catalyst, the practices of exhibition culture and *animation artistique* that characterize Dakar's art world city also drive the articulation of Off sites. Many Off projects are artist-led because exhibition making in Dakar is largely artist-led. More exhibitions are organized by artists than by other art world *animateurs* such as gallerists or curators. Given that so many Off site exhibitions are organized by Dakar-based artists, it is unsurprising that Dakar-based artists and their artistic propositions are far more visible in Dak'Art–Off than the In-site exhibitions.

Dakar-based and International Propositions in Dak'Art–Off

As an entity, the Dak'Art–Off programme represents the diversity of propositions and art world figures active in Dakar. The Off sites call attention away from the *Exposition internationale's* connotations of governmental, official or continental by bringing our imagination back to the individuals who animate the art scene and make the city vibrant all year long and not just during the Biennale. The projects featured in the Off sites encompass solo and group exhibitions as well as

collaborative workshops, performances and open studios. Because they emerge from the art world city's dynamics, the Off sites are better positioned to elaborate the issues, themes and concerns of Dakar-based artists. In this sense, the Off exhibitions exemplify the many dimensions of art practice in Dakar. They also demonstrate the initiatives that Dakar-based artists care to undertake, including exhibitions dealing with issues at the heart of local social experience as well as exhibitions paying homage to deceased colleagues. An example is the exhibition of the late Souleymane Keïta's work at Galerie Kemboury during Dak'Art–Off 2018.

The fact that so many of Dakar's artists participate in Off projects further emphasizes that those who make the scene in Dakar's art world city also have a hand in shaping the experience of Dak'Art. The Off exhibitions are representative of the diversity of art practice and range of motivations for making art in Dakar. Most of the artists I have worked with participate in at least one Off site per Biennale edition. They participate in the Off events for all the reasons they participate in Dakar's art scene when Dak'Art is not happening: to show their work, to see and be seen, to be part of the scene, and to make connections that may grow their networks or lead to other opportunities. Some participate in the Off sites to join the momentum of an art event that animates the city and because these offer more creative freedom or allow autonomy from the Biennale's official, governmental structure. Given Dak'Art's international profile, the Off events also provide the opportunity for Dakar-based artists to invite their international colleagues to collaborate in exhibitions, workshops and performances. Collaborative initiatives between Dakar-based artists and colleagues from other parts of the world are plentiful during the Biennale because the international audience drawn in by the event makes this possible. Such collaborations are opportunities to exchange ideas and grow professional contacts. They are also, as I propose elsewhere, crucial to composing the networks that connect Dakar's artists to other art world sites and experiences (Grabski 2017: Chapter 3).

In addition to representing the projects of Dakar-based artists, the Off events also render visible the role of international organizations in Dakar's art world city. Many foreign cultural centres, embassies, non-profit organizations and corporations host Off exhibitions and workshops during the Biennale and during non-Biennale seasons. These institutions have also played a significant role in funding the Biennale's exhibitions, catalogues and prizes. Among the most active are British Council, Institut Français and Goethe Institute. The company Eiffage Sénégal is a major sponsor of Dak'Art–Off, the Biennale more generally, and artists' exhibitions throughout the year.

Eiffage Sénégal's activity in Dakar's art world city is represented on its website which features a link to its art collections and exhibitions.[10] Along with private businesses, cultural centres and embassies are also in the strategic position to liaise with international sponsors and secure subvention for the Biennale. The range of international organizations contributing to Dak'Art's financial base is evidenced in the event's publicity materials.[11]

The international organizations active in Dakar and which sponsor Off initiatives are critical nodes that link artists from Dakar to global art world

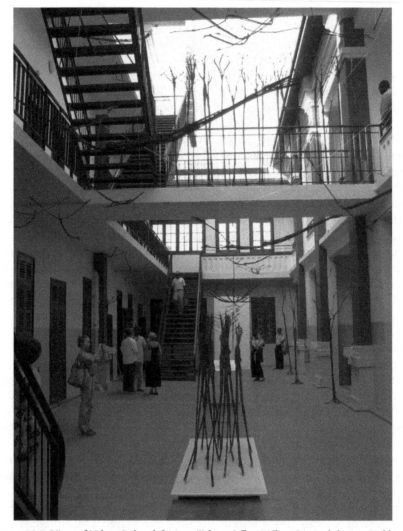

Figure 10.3 View of Ndary Lô's exhibition, *Taking Off*, at Eiffage Sénégal during Dak'Art 2010. Photo by Joanna Grabski.

platforms. They facilitate connections and passage between home site and host site (Grabski 2017: Chapter 3). These institutions further embed Dakar's art scene in international circuitry, visualizing international presence as integral to Dakar's art world city.[12] Off projects sponsored by embassies or hosted by their cultural centres signify the city's cosmopolitan environment as well as the institution's ambassadorial intention.

Many initiatives, including exhibitions and workshops, are collaborative in spirit. They feature the work of Senegalese or African artists alongside nationals from their

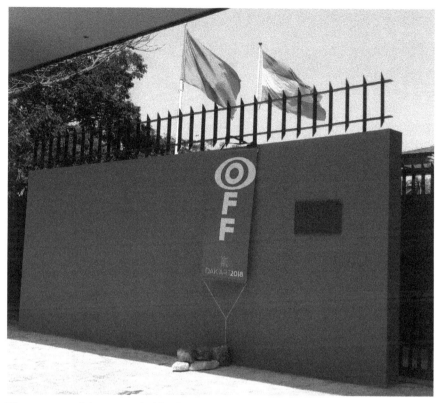

Figure 10.4 Exhibition marked by the OFF flag at the residence of the Netherlands Ambassador during Dak'Art 2018. Photo courtesy of Ashley Czajkowski.

home country in characteristic diplomatic fashion.[13] While the participation of international organizations in Dak'Art is incorporated in the Dak'Art–Off Guide, in the 2008 edition of Dak'Art, international presence in the Off exhibitions was illustrated by a separate brochure published by the European Union. The brochure listed the Off venues featuring projects with French, German, British, Spanish, Austrian, Dutch and Polish artists.

Analysis of the Dak'Art–Off 2018 venues and participants reveals the expanded presence of curators and event producers from Dakar and abroad as exhibition makers. Nearly twenty curated platforms were featured in the 2018 Dak'Art–Off Guide. Among them were the group exhibition presented by Salimata Diop at Bridge–Villa Rouge in Fann Hock; the group exhibition *The Matter* presented by Thomas Cazenave and Bénédicte Samson at the Immeuble Grey on Corniche des Almadies; *Le Rêve africain* at the residence of the Netherlands Ambassador organized by Rosalie van Deursen; and *The View from Here: Contemporary Perspectives from Senegal* curated by Joseph Underwood at Waru Studio in Mermoz.

Figure 10.5 *The View from Here: Contemporary Perspectives from Senegal* curated by Joseph Underwood at Waru Studio during Dak'Art 2018. Photo courtesy of Joseph Underwood.

In previous editions of Dak'Art, such platforms were quite rare. However, the increase in curated platforms among the Off events is not unexpected in light of the plentiful opportunities for curatorial projects presented by Dak'Art–Off. The emergent and flexible character of the Off sites makes them relatively accessible for exhibition makers seeking to participate in the Biennale. The increase in projects organized by curators is also responsive to their role in contemporary exhibition culture more globally and Dak'Art's draw as an art world event. For exhibition makers, as with artists, the Off platforms enable participation in a larger event. They are an entrée to professional opportunities and networks just as they situate participants in the spaces of art world belonging. Because the Off sites emerge from Dakar's possibilities and networks, they represent a potentially unbounded

number of possible platforms for participation, from an ambassador's residence to an artist's studio. To this end, the Off exhibitions have been critical to the Biennale's expansion throughout Dakar, its suburbs, and other cities in Senegal.

The Off's Centrality to Dak'Art

Since the inception of the Off events, each of the Biennale editions demonstrates the impressive, if not seemingly unbridled, growth of the Off venues. The Off exhibitions have increased more than tenfold in the span of two decades, from twenty-nine in 1998 to 150 in 2012 and 300 in 2018. Art world travellers who come to Dakar for Dak'Art's *Exposition internationale* require several days to see a mere selection of Off events. Just as the Off exhibitions have increased in number, they have also become increasingly formalized as part of the Biennale's programme. The Off sites are now referred to collectively as Dak'Art–Off, an acknowledgement of their centrality to the Biennale. Their integrality to the whole of Dak'Art was recognized formally in 2000 when the Biennale programme map incorporated the Off exhibitions for the first time. In 2002, Dakar-based artist and art world figure Mauro Petroni began to coordinate the Off exhibitions and by the 2010 edition, the Off and In exhibitions were listed together in a multi-paged, spiral-bound guide. Also indicative of their place in the Biennale is the declaration, '*Le OFF appartient à tous*' (The OFF belongs to all of us) in the 2014 Biennale's Off and In exhibition guide (Off Guide 2014: 5).

For the past several editions, the Off exhibitions have been compiled in the rectangular format Dak'Art–Off Guide. Organized by neighbourhood, the guide lists the exhibitions and indicates their location on a map with street names. The Dak'Art–Off shows all the markers of a curated and coordinated programme. In addition to the compilation of venues in the Dak'Art–Off Guide, the *vernissages* are often scheduled strategically so as to maximize attendance and minimize the complexities of getting from one neighbourhood to another. Participants who register their exhibitions as part of the Dak'Art–Off programme in advance are included in the guide and can obtain a brightly coloured flag emblazoned with the word OFF, to signal the event's location to Biennale visitors and passers-by. In keeping with the improvisation and inclusion typical of Dakar's art world city, those late to the process of registering their exhibitions can still participate in the event by handing out invitations to their exhibitions at other art events and displaying homemade OFF signs advertising their venue as an Off site.

The formal naming of the Off sites as Dak'Art–Off and their incorporation in the Dak'Art Biennale advances a couple of critical objectives. In addition to serving Dak'Art's purpose by enlarging the vantage point on what constitutes contemporary art from Africa, the Off exhibitions are critical to Dak'Art's objective of creating a pluralistic and diverse view on the contemporary art of the continent. In contrast to the *Exposition internationale*, Dak'Art–Off is liberated from the pressures and expectations of a curated show deemed to represent the contemporary arts of Africa in a single venue. The multiplicity of Off exhibitions conveys the breadth

and diversity of contemporary art in Dakar and from beyond Senegal. In their number and in their diversity, the Off sites reinforce a pluralism of practice. The pluralism these sites evince challenges assumptions that visitors might experience a one-dimensional or unified exhibition in which contemporary African art is easily defined.

The Off exhibitions also expand the Biennale's spatial claim to the city. Because the Off sites are located throughout Dakar's neighbourhoods, they give the Biennale a far-reaching, protean shape. The neighbourhood maps published in the Dak'Art–Off Guide visualize the extent to which off exhibitions pervade city space. The Off exhibitions constellate the topography of Dakar's neighbourhoods and suburbs. So plentiful and pervasive are the Off exhibitions that, as one journalist observes, all of Dakar seems to become a space for exhibition (BBC 2019). Of the eight neighbourhood maps in the 2018 Dak'Art–Off Guide, only three neighbourhoods include both In and Off sites; the other five neighbourhoods only feature Off exhibitions. The map of the Plateau is unique in its concentration of In sites: it depicts six In exhibitions alongside fifty-eight Off exhibitions. Thus, read as the sum of its parts, the Biennale's expanding urban presence is due mainly to the proliferation of Off sites. Without the Off sites, the Biennale would not be a collective urban project emergent from the dynamics of the art world city. It would consist of a handful of somewhat coordinated exhibitions associated with a governmental initiative.

Comparing the In and Off programmes over the course of Dak'Art's editions points out that the In exhibitions appear to have appropriated strategies associated with the Off exhibitions. These include the distribution of venues across neighbourhoods as well as the use of city spaces and non-governmental sites as exhibition venues. An excellent example is offered by the project *Mon Super Kilomètre*, one of Dak'Art 2018's In exhibitions. Taking the form of a public artwork in the popular neighbourhood of Gueule Tapée, the project is characteristic of an Off exhibition in its embeddedness in public urban space and capacity to engage the city's residents as well as art world visitors to the Biennale. Two additional In programme venues from Dak'Art 2018 also reveal alignment with the Off sites' characteristics. Held in a gallery active throughout the year, the exhibition *Bois Céleste* at Galerie le Manège was an In venue in 2018. In previous Biennale editions, exhibitions at Galerie le Manège were Off venues which featured the work of Abdoulaye Konaté in 2014 and Serge Alain Nitegeka in 2012. Likewise, the Maison Ousmane Sow, the late artist's former home in Yoff which now functions as a museum, was featured as a Dak'Art 2018 In site. Private homes and private museums are typically associated with Off venues.

These examples demonstrate an increasing fluidity between the Off sites and In sites. This fluidity is traceable to the 2006 Biennale, which capitalized on the decentralization and mobility that accompanies the experience of Dak'Art–Off's venues. Namely, the *Exposition internationale* has been installed for much of the Biennale's history at a single venue, including CICES, the large commercial fairgrounds; the Village de la Biennale, located on the Route de Rufisque in Dakar's industrial zone; and the Ancien Palais de Justice. A shift in the spatial configuration

of venues and thus exhibition experience occurred during the 2006 edition, when the *Exposition internationale* was distributed among a cluster of venues including the Musée Théodore Monod, Galerie Nationale, Maison de la Culture Douta Seck and Maison des Anciens Combattants. While these venues are marked by their association with the state, that the latter among them is not necessarily connected to Dakar's art world suggests that Dak'Art's official structure drew upon the strategies of both the Off events and the art world city by incorporating multiple sites for an exhibition and integrating urban spaces not associated exclusively with art into the larger Biennale project.

In addition to shaping the overall experience of Dak'Art, the Off venues make experiencing Dakar part of experiencing Dak'Art. Exhibition-goers are required to move through the city to see the Off exhibitions and experience the Biennale as a whole. Although movement is required to experience Dak'Art, Dakar's streets and neighbourhoods are challenging to navigate by foot or by vehicle. Even with the Dak'Art Guide, maps and OFF flags indicating venues, even the most seasoned exhibition-goers remark with frustration and amusement on the difficulty of navigating such a wide terrain of events, losing their way on unmarked streets, communicating with taxi drivers, and avoiding hustlers on their way to view exhibitions of uneven quality (Van Rensburg 2006).[14] Because of the Off's embedment in Dakar, art world travellers visiting the Off exhibitions will also be immersed in the city's visual, historical and social landscapes.

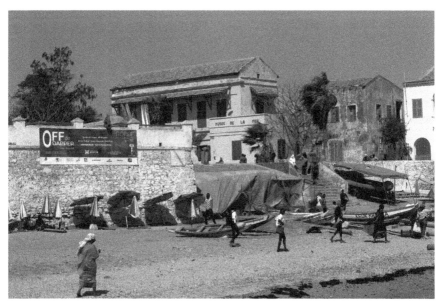

Figure 10.6 Arriving on Gorée Island to visit Off exhibitions during Dak'Art 2018. Photo courtesy of Ashley Czajkowski.

The immersion in Dakar that accompanies experiencing the Off exhibitions has become definitive to the Biennale's particularity. Not only are the Off exhibitions a striking change from the centralized or campus-like configuration of other art exhibitions, they also reveal the imbrication of artistic expression and urban life. The Off exhibitions give the Biennale of Dakar its specificity because they allow for the commingling of Dak'Art, Dakar, and the routine workings of its art world city. Dak'Art's increasing integration – and some might say co-optation – of the Off sites over the years not only signals increased recognition of the Off exhibitions as platforms in the Biennale, it also illustrates that the Biennale has become increasingly conceptualized as a dynamic, integrative project that emerges fundamentally from the logic of the urban creative economy. The Off exhibitions represent the scaling up of city's art world practices that happen year-round. They make Dak'Art an event like no other. The extent to which the Off exhibitions are embedded in the city and emerge from the city distinguishes Dak'Art from other art world events including biennials with collateral shows. Aside from its objective of representing the continent, the specificity of the Dak'Art Biennale lies in the Off exhibitions – their emergence from the dynamics of Dakar's art world and their engagement with their city.

Chapter 11

DAK'ART'S ECOSYSTEM: IN AND OUT OF SENEGAL

Iolanda Pensa

Introduction

The Biennale of Dakar has been influencing the establishment of new events in Africa: it is a meeting point capable of triggering new ideas and collaborations and a platform that increases the reputation of artists and curators who participate in it. This essay observes the relationship between Dak'Art and SUD–Salon Urbain de Douala, a triennial event dedicated to public art, promoted since 2007 by the cultural association Doual'art founded in 1991 in Cameroon. This comparison allows us to highlight some of the elements that characterize the two events, such as the different relationship with the city and the territory and the discordant strategy in the selection of the artists and in the production of the artworks.

In and Out of Senegal

I have always thought that the most effective way to represent the Biennale of Dakar is not the catalogue but a group photo: the image of all the people who meet every two years in Dakar or who come for the first time to set foot on a new continent, some of them with the expression of someone looking for Zion. For the professionals who exhibit, present and sell art, the exhibitions and the catalogue are simply a teaser to decide which artists to meet. And from this point of view the Biennale has worked very effectively, regardless of the quality of its exhibits and the consistency of its artist selections. Indeed, the very variety of proposals – exhibited both in the official programme (Dak'Art–In) and in the side programme (Dak'Art–Off) – offers something valuable to many different sectors of culture.

The Biennale has been most attractive for three main reasons: it is a biennial, it is an event dedicated specifically to contemporary African art, and it is a cultural institution that activates the cultural landscape of the city of Dakar in Senegal. From the point of view of the art world, the event can be framed in the broader debate about large-scale international events and, being the most resilient of the

African biennials, it is analysed in debates, it feeds them, and it is an excellent destination for curators and international experts.

The attention of Dak'Art to contemporary African art – triggered in particular by the European Commission in 1996 – has allowed the event to focus on African and African diaspora artists and to give them visibility inside an international network.[1] The African focus of the Biennale also addresses professionals who operate in the fields of cultural cooperation and cooperation for development. For artists from Africa taking part in the Biennale, it is a consecration; thanks to Dak'Art, they position themselves in an international network and their reputation grows in their home countries.[2] Besides, Dak'Art is also a perfect opportunity to visit Dakar and to explore the city through the activities and events offered in the Dak'Art–Off programme, which is independent of the Biennale's official ambit. Many foreigners describe the experience as their first opportunity to 'visit Africa.'

At Dak'Art there are artists, curators, critics, operators of international cooperation, journalists, students and tourists. The Secretary General of Dak'Art (1993–2000), Rémi Sagna explained that the Biennale of Dakar has made hospitality its distinctive trait (Pensa and Federici 2006). The Biennale pays for both travel and accommodation of the invited artists, curators involved and scholars and professionals who take part in the conference programme. Those not officially invited cover their own cost. Some of the most important people in the art world have attended the Biennale, such as the artistic directors of the Biennale di Venezia and documenta, Kassel, museum directors and international gallery owners. Over the years, the presence of international art world actors and collaborators has steadily increased, engendered by a slew of professionals, such as international curator and cultural producer N'Goné Fall. Fall, for example, was central to the participation of the international programme of art residencies *res artis network* in 2004. This was hugely important in amplifying the presence of international institutions at Dak'Art and offered the possibility for participating artists to build their network and to enter the international system of artist residencies. Another example is the curator Olabisi Silva (1962–2019), who brought her roaming Asìkò Art School to Dakar during the Biennale's edition of 2014. The late Silva had been a regular attendee since the 1990s, and under Yacouba Konaté's general curatorship of Dak'Art 2006, she was curator for West Africa.

Artistic direction Simon Njami (2016, 2018) has furthermore included a selection of independent initiatives within the official programme, such as the *AfroPixel* Festival organized by Kër Thiossane. In 2002 the Egyptian artist Moataz Nasr was selected for the *Exposition internationale* of Dak'Art. In fact, Moataz Nasr did not want to go to the Biennale of Dakar because he could not understand how a biennial in Africa could be relevant to his career,[3] but Dakar proved to be an excellent platform. He then began exhibiting with Simon Njami and formally established in Cairo the art centre Darb 1718 in 2008. The initiatives of the centre were presented at Dak'Art 2018 within the programme *Carte Blanche*. Nasr himself confirms the decisive role that participating in the Biennale has played in his career. Furthermore, with his word of mouth, the artist and cultural producer has

been fundamental in expanding the network of the Biennale to Egypt and North Africa in general.

Doual'Art and Dak'Art

In this section, I want to focus attention on Doual'art, an independent initiative in Douala, Cameroon, and to explore it comparatively with Dak'Art. The two founders of Doual'art – the couple Marilyn Douala Manga Bell (president of Doual'art) and Didier Schaub (artistic director) – have participated regularly in the Biennale of Dakar within the official In and Dak'Art–Off programmes.[4] They have also supported the participation of Cameroonian artists in Dak'Art, helping them to prepare their applications and artists portfolios. In addition, Didier Schaub (1952– 2014) was a member of the selection committee of Dak'Art 2004. Dak'Art and Doual'art undoubtedly share at least this connection. One of the first distinctive features of both events is this territorial positioning by inserting the name of the city in their own name, but in reality, the two events have a very different relationship with their city and territory. Furthermore, the two events have a dissimilar strategy in the selection of the artists and in the production of the artworks.

In 1991, the art centre Doual'art was founded in Douala and it immediately began producing public art. Douala is one of those cities that does not know the number of its inhabitants – maybe 1.5 million or maybe 4 million, many of them concentrated in shabby and overcrowded neighbourhoods. Unlike Dakar, Douala is far from being a tourist destination: it is a chaotic and decadent city, where people live as if they were always passing through, even if they have lived there for twenty years (Simone 2008). For Doual'art, the idea of producing artworks in Douala has always been meant to transform the city, to participate in the construction of a shared identity, a sense of belonging (Babina and Douala Bell 2008, Pensa 2017a). For the founders of Doual'art – Marilyn Douala Manga Bell, trained in economics, and Didier Schaub, trained in art history – the intervention on space is a political and ideological statement, the starting point of their work and not a possible side effect (Nzewi 2015). Unlike the Biennale of Dakar, Doual'art's approach is profoundly urban, rather than national; the real focus is on a city, Douala, which historically represents the place of greatest political turmoil.

The Biennale of Dakar allows attendees to enlarge their network, to collaborate and discuss; its context stimulates ideas and it facilitates the creation of new projects, as it did with Doual'art and the SUD–Salon Urbain de Douala. In 2007 Doual'art initiated the SUD–Salon Urbain de Douala, a three-year public art event focused on urban transformations; numerous artists exhibited both within the Biennale and the SUD[5] and several curators contributed to both.[6] SUD–Salon Urbain de Douala was presented in Dakar, both in the Off programme in an exhibition in the art space Raw Material Company in 2012, and in the In programme Carte Blanche in 2016.

The Biennale of Dakar was established to promote the international visibility of contemporary African artists in general and Senegalese in particular, and their

success on the art market. The Senegalese government has a central role in supporting and maintaining the Biennale of Dakar while fundraising with sponsors, agencies of cultural cooperation, the European Commission and international partners. Further, it uses the Biennale to affirm its centrality for the cultural promotion of Africa. In addition, Dak'Art-Off encompasses a wide network of events, allowing local and international artists and curators to take part in the Biennale by being included in its time frame, by guiding its visitors to different locations and by animating an extensive territory. But the Dak'Art-Off programme has essentially a temporary nature and it is not meant to transform the city.

In contrast, the production of site-specific permanent works and urban transformation lies at the heart of the SUD–Salon Urbain de Douala. The SUD is deeply rooted in Douala and its focus is precisely Douala. The event is organized by an independent art centre and non-profit organization. The cultural institution SUD is largely financed by international agencies focused on cultural cooperation and cooperation for development (Pensa 2011, 2013). In 2003, Dutch funds supported in Cameroon the *Bessengue City* project promoted by the artist Goddy Leye (1965–2011). Leye was able to obtain this support thanks to the *RAIN Artists' Initiatives* that allowed students of the Rijksakademie in Amsterdam to access small grants to organize cultural initiatives in their countries of origin (Odijk and Flentge 2001).[7] The support of The Netherlands for cultural projects in Douala increased with the creation in 2005 of the iStrike Foundation in Rotterdam, of which I was the promoter, an organization that operated as a Dutch interface to fundraise for the SUD. Following the closure of iStrike, the organization ICU art projects was created by the co-founder of the iStrike Foundation Kamiel Verschuren, who has continued to support the SUD and to contribute to its productions.

The collaboration and work offered by the Doual'art network both nationally and internationally is a central element to understand the sustainability of the event. One must keep in mind that the monetary budget – in the case of cultural initiatives in particular – does not represent all the activated resources. Doual'art has also involved the Cameroonian government in the SUD, both for the necessary authorizations and to guarantee the maintenance of the artworks, even if they have not been made with Cameroonian public funds. Doual'art offers the works it produces as a gift to the city, asking in exchange that the city takes care of them; the signing of these agreements has been a great success for Doual'art. Needless to say, the lack of direct support by the Cameroonian government for the artistic production also means freedom for artists and cultural operators.

Another element in which Dak'Art and Doual'art differ is the selection of artists and the production of artworks. With the aim of specifically promoting contemporary African art, the Biennale of Dakar has provided a much bigger venue to showcase contemporary African art, for new artists to be discovered, and has continued to expand its network because of its viability. This approach characterizes many other international exhibitions of contemporary African art between 1966 and 2005 which presented new artists instead of reinforcing the

presence and the selection of a curated group (Pensa and Federici 2006). The selection of artists for the SUD–Salon Urbain de Douala has always been open, without any geographical restriction.

Despite the many connections between Doual'art and Dak'Art, the extremely small Senegalese presence within the SUD–Salon Urbain de Douala and its related events is surprising. Doual'art involved the architect Jean-Charles Tall and the curator with an architectural background N'Goné Fall, but no Senegalese artist has ever been invited by Doual'art to produce works in Cameroon, as if the networks remained parallel with contact points, but separated, confirming that there is not a single art world (Pensa 2017b). The selection by Doual'art is meant to generate new views on the city and to nurture a dynamic and continuous dialogue and exchange. Within the SUD–Salon Urbain de Douala, international artists are invited to produce artworks in the city of Douala after two residencies. The first residency is meant to explore the city, to identify a location and an approach; Doual'art then starts working with the community to prepare the production of the work and to negotiate its location. During the second residency the artists produce their work. Artists based in Douala are involved in longer projects, often in collaboration with schools or the specific neighbourhoods where the artists already live.

Doual'art has been producing public artworks since 1991, and the city embraces them through a process of construction and destruction that must continually be nourished by new energies, negotiations, resources, arguments and discussions. It is with these premises that the SUD–Salon Urbain de Douala was created, designed with a three-year period of production (which includes the creation of new site-specific artworks and maintenance of the current works) and a festive event which presents the artworks to local and international audiences and animates the city with *vernissages*, conferences, performances and concerts. I have participated in the planning of the project. There is, of course, the desire to gain visibility, to produce a large-scale event and to place Douala and Doual'art and its promoters on the map of the international art system. But there is also the profound will to intervene in the city and to use the festival as a production, management and maintenance tool for the artworks, a specific strategy that is different from the Biennale of Dakar, which is more closely focused on the event itself.

Conclusion

In 2002 the artist Fernando Alvim participated in the fifth edition of the Biennale of Dakar. I can see him moving across the large spaces of the CICES exhibition centre, while with his brilliant and conspiratorial way he meets artists, introduces himself to curators and plans the new world order: a presence of a network of art centres with the acronym CCASA, TACCA, CCAEA, CACAO in Dakar, Nairobi, Johannesburg, Luanda; an invasion of the continent showing the world how Africa produces African antennas capable of supporting cultural production and influencing it, in the same way foreign cultural centres settled in Africa.

Fernando Alvim's project would only develop partially, but Dak'Art 2002 offered an effective portrait of how the Biennale feeds debates, consciously and unconsciously through formal events, but also through meetings between colleagues and professionals, lively discussions in cafés and late-night chats. In fact, Dak'Art, in addition to inviting and welcoming a large number of art professionals, has a significant disorganization on its side, which turns out to be an effective social aggregator: artists without their artworks, technicians dispersed in the markets in search of hard-to-find materials, and people who simply cannot take a taxi lost, in search of advice and open to new encounters. Fernando Alvim is an appropriate point of reference for this galling disfunction. Previously, the artist participated in Dak'Art 1998 but without his artwork, which never arrived at the port of Dakar. 'They say that it should be off the coast of Saudi Arabia', the artist told me with resignation and humour, and in my mind that work became a legend. Even today, when I think of the impact of the Biennale of Dakar in the world, I think of Fernando Alvim's work, which wanders, infects oceans, fights against pirates, and brings with it what we try to define as the ecosystem of Dak'Art.

Acknowledgements

This article is based on personal research carried out at the Biennale of Dakar in 1998, 2000, 2002, 2004, 2006, 2010, 2012, 2014, 2016, 2018 and in Douala in 2003, 2005, 2007, 2010, 2013, 2017 and on the results of the research project 'Culture and Safety in Africa. Documenting and assessing the impact of cultural events and public art on urban safety' supported by SNIS and SNF Agora Programme. All the documentation produced during research and articles is released under the CC by-sa licence.

Epilogue

GLOBAL BIENNIAL DISCOURSES: A CRITICAL VIEW FROM DAK'ART

Thomas Fillitz and Ugochukwu-Smooth C. Nzewi

A continuing preoccupation of Dak'Art is its position within the global biennials network. Indeed, the founding of the Biennale of Dakar as mega-event of contemporary African art occurred some years after the founding of the Bienal de La Habana in 1984 as a biennial dedicated to the so-called 'Third World'. The cementing of Dak'Art's international reputation and its transformation into a biennial of contemporary African art happened in between the first instalment of *Recontres de Bamako – Biennale Africaine de la Photographie* (Bamako Encounters of Photography) in 1994 and the two iterations of the Johannesburg Biennial, in 1995 and 1997, and before the exponential growth in the number of biennials and triennials[1] on an unprecedented global scale.

Research on the influence of a specific institution within the worldwide spread of biennials is generally linked to the history of this art world phenomenon. It all started with the Biennale di Venezia in 1895, which scholars consider the 'ur-biennial' (Jones 2010: 69), the *'grande dame'* (Lee 2012: 12), or the 'primogenitor of all biennials' (Smith 2012: 88). The historically linear account would continue with the Bienal Internacional de Arte de São Paolo, Brazil (1951), documenta in Kassel, Germany (1955), and the Biennale of Sydney, Australia (1978). Within this theme of biennial research, scholars today rather structure the history of biennials in periodic waves. Sabine Vogel (2010), for instance, recognizes two phases: the 'Age of Modernity' – from Venice until the 1980s (Cairo, La Habana, Istanbul) – and the 'Age of Globalization' – from the 1990s until the present (from Dak'Art, Johannesburg, Sharjah or Gwangju to Moscow and Singapore) (ibid.: 4–5). Vogel's narration, however, already identifies a major problem with this approach: the massive proliferation of biennials can only be conceived as linear historical continuity when applying the foundational dates as exclusive criterion.

Another approach operates with models of biennials. Caroline Jones (2010) argues for the universalist model of the Biennale di Venezia as valid for all biennials around the globe: 'all such events form themselves against the backdrop of the ur-biennial' (Jones 2010: 69). Jones conceives her model as a 'biennial culture': historical continuity, cyclical recurrence, artists as representatives of nation states,

an international (global) dimension on artists and artworks on display, a promotion of cultural tourism, finally urban development and city branding (ibid.). In opposition to Jones' model, Rafal Niemojewski (2010) argues for a model of the 'contemporary biennial' that is valid for the second and specifically third wave of biennial foundations. It originates in the Bienal de La Habana with its second (1986) and third (1989) editions. While Niemojewski acknowledges the complexity and diversity of contemporary biennials, he nevertheless aims at enunciating dominant features that characterize the encompassing dimension of his model of 'the contemporary biennial': 'a strong will to negotiate its peripheral condition, to represent the ambitions of its host city, and to form infrastructures for contemporary art and the public sphere' (ibid.: 91). Yet, both models recall early twentieth-century diffusionist theories. Jones' model of the proliferation of biennials corresponds to an export from a dominant cultural region to the peripheries (Ferguson and Hoegsberg 2010: 363; Sheikh 2010: 152) – an overt Eurocentric perspective. Conversely, Niemojewski places the Bienal de La Habana at the centre of a difussionism that is a South–South flow.

Within the scope of model production, two further typologies are worthy of mention. Charlotte Bydler (2004) proposes a three models typology: a) the capitalist–philanthropic projects – Venice before the Second World War, São Paolo, Sydney; b) events that originated in the post-war era – documenta, post-war Venice, Havana, Dak'Art, Ljubljana; and c) the 'flexible production- and event-oriented variety of the 1990s and 2000s' – Istanbul, Gwangju, Manifesta (ibid.: 151). René Block, a high-profile biennials curator, differentiates between four models of biennials: a) the Venice model – autonomous national pavilions; b) the Sydney model – curatorial themes, invited artists, but dependent on financial participation of other countries; c) the Gwangju model – independent of foreign support, themes and invited curators, selected artists independent of national representation; d) the Manifesta model – changing location, favouring curatorial teams, and rejecting the artistic director structure (Glaser 2000; Block 2013).

Anthony Gardner and Charles Green (2013) articulate a radical critique of such narratives of the biennials' histories:

> the histories of biennials as they currently stand remain resolutely *Northern* histories – written predominantly by analysts of the North and reinforcing, even in their self-reflexive critique, a lineage of influence within and from the North – despite their claims to globality.
>
> ibid.: 443; italics in original

Gardner and Green hence propose a different approach – a Southern perspective – and describe as second wave the foundation of Southern biennials such as Alexandria, Egypt (founded in 1955), Bandung, Indonesia (1955), Biennale of Ljubljana, Slovenia (1955), Bienal de Coltejer, Medellín, Colombia (1968), India Triennale of Contemporary World Art, New Delhi, India (1968), Bienal Internacional de Arte, Valparaiso, Chile (1973), or the Arab Art Biennial, Baghdad, Iraq (1974).

The development of biennials as form, and from there their influence on the production of global contemporary art, is the subject of Gardner and Green's *Biennials, Triennials, and documenta* (2016). Relying on their 'South as Method' approach (Gardner and Green 2013, 2015), the authors clearly emphasize the study of biennials of international art in their interconnection with globalization. 'Landmark biennials offer clear, provocative insights into the structure and changes underlying the development of contemporary art and globalization since the second World War' (Gardner and Green 2016: 9).

A change of perspective is also proposed by scholars who consider particular biennials of the South as 'biennials of resistance' (Hoskote 2010; Marchart 2014), or as emancipatory cultural institutions (Oren 2014). These are biennials that 'articulate what we may term the emergence of a global South, a network of sites of cultural production sharing common questions, themes, and, indeed, a common precariousness' (Hoskote 2010: 312). These cultural institutions are conceived against any universal constructions from the Biennale di Venezia. For Ranjit Hoskote, two concepts are paramount for such a history–narration: their 'will to globality' and their potential for a 'critical transregionality' (ibid.), that is, movements between global histories and regional ones. Hoskote also formulates an interesting vision with this idea of the biennial of resistance:

> Perhaps it is time for us to address our global present in this spirit of critical transregionality, to configure new continents of affinity that correspond more genuinely to our desires and aspirations . . . Perhaps, also, we may reflect on how a large exhibition of international art might propose such new continents of affinity.
>
> ibid.: 314

Apart from such studies of the history of the proliferation of biennials and the importance of this exhibition format for the development of global contemporary art, there are few scholarly publications on particular biennials. Without any claim to completeness, we would like to mention Yacouba Konaté's (2009) monograph on the Biennale of Dakar, the edited volume by Rachel Weiss and colleagues (2011) on the Bienal de La Habana, Enzo Di Martino's (2005) history of the Biennale di Venezia, some small publications on documenta (e.g. Schwarze 2007), and John Clark's analyses of Asian biennials and their influence on Asian contemporary art (e.g. 2010, 2015). Panos Kompatsiaris' (2017) comparative study of the third Biennial of Athens (2011) and the seventh Biennial of Berlin (2012) connects to those scholarly views of biennials as tools of neoliberal capitalism. Both are examples of counter-strategies that rather challenge neoliberal regimes, insofar as their respective curatorial teams radicalize these mega-events by emphasizing the political in its relationship to artistic practices. In particular the exhibition making of the Berlin Biennial appears as stage of political activism, to the point that art critics wondered whether one could still speak of an art exhibition (Kompatsiaris 2017: 100).

There is a curious phenomenon in the reflection of the genealogies of biennials: at the time of the huge wave of worldwide biennial foundations, large conferences

were organized that questioned the relevance of such cultural institutions for the making of contemporary art (cf. Gardner and Green 2015: 28). In 2000, within the frame of the exhibition *Das Lied von der Erde/The Song of the Earth*, René Block initiated the conference *Biennials in Dialogue* at documenta-Halle in Kassel, and invited presentations from Havana, Istanbul, Johannesburg, Gwangju, Lyon, Pittsburgh, São Paulo and Sydney (Block 2000).[2] In 2012, the Amsterdam-based Biennial Foundation[3] and the Gwangju Biennale Foundation organized *Shifting Gravity*, the First World Biennial Forum in Gwangju (see Meta-Bauer and Hanru 2013). This was followed by the Second World Biennial Forum in 2014, organized by the Biennial Foundation together with Fundação Bienal de São Paulo and ICCo–Instituto de Cultura Contemporânea, *Making Biennials in Contemporary Times* (see Bilat et al. 2015), which took place within the framework of the Biennale of São Paolo.

However, the most important of these conferences was in Bergen in 2008 and 2009 (see Filipovic, van Hall, Øvstebø 2010). It started by scrutinizing whether the creation of a biennial in Bergen would be meaningful, and raised major issues that had begun to bother curators and art theorists from different regions of the world. What about this multitude of biennials, are they still most important for determining contemporary art? What about the canonization of contemporary art on a global scale? Some of the major topics of critical assessments included the production of 'biennial art' (Verwoert 2010), a global canon of contemporary art, and the ensuing presence of 'biennial fatigue' (Ferguson and Hoegsberg 2010: 363; Meta-Bauer and Hanru 2013: 18) due to the mass of biennials that one can no more visit, overlook or reflect upon. Terry Smith views this as an 'overproduction' (2012: 92) of such mega-art events which present similar pressing issues of the globe with similar art. Peter Osborne interprets this massification with its cyclicality as 'overcoded' biennials rhythm (2015: 26), where the contemporary gets inflationary and biennials end up as 'varying *articulations* of the temporal logic of capital accumulation – although not reducible to it' (ibid.; italics in original).

Dak'Art

At the First World Biennial Forum, Mauro Petroni (2013), artist and member of the Biennale's orientation committee since 2002, resolutely declined any universality of a biennial model: 'a biennial model does not exist' (ibid.: 146). Regarding the Biennale of Dakar, he added: 'this Biennial has had an exceptional role in developing the African artistic scene, imposing the continent's contemporary art to the appreciation of the entire world (ibid.: 146–7). Hence, the Biennale of Dakar fulfils the field-configuring objective in relation to artistic practices in the art worlds of the African continent. For Petroni, the Biennale is moreover successful in positioning itself within the global biennials network with its geo-culturally specific transregional contemporary art. It negotiates the complexity of being an international exhibition platform in the West-controlled biennale system while mobilizing an African art world still struggling to find its feet on the global stage.

Its version of internationalism that privileges African and African diaspora artists can be viewed as a postcolonial institutional critique of the dominant Western modalities of the art biennial, which prior to 1990 was not very inclusive of non-Western artists. A prime example of a geographically and ethnically delimited venue, Dak'Art might illustrate Monika Szewczyk's (2010) observation that in moving from the universal towards a critical regionalism, some art biennials filter global pressures and affirm local and regional identities.[4] Yet, the Biennale shares certain common attributes with other international biennials, 'such as globally acting curators, nomadic artists, intercultural curatorial boards, and traveling elite or cosmopolitan audiences' (Fillitz 2009: 125).

Simon Sheikh's (2007) notion of oppositional and relational politics in critical exhibition making that draws upon Michael Warner's notion of 'counterpublics' (a parallel configuration of publics (and genealogies of discourse and practice acting in opposition or in relation to dominant publics), describes Dak'Art's interfacing with hegemonic discourses of the global mainstream (Warner 2002). This is particularly salient in understanding how it aligns with and distinguishes itself within the global biennial system. For Sheikh:

> All exhibition making is the making of a public, the imagination of a world. It is therefore not a question of art for art's sake or art for society, of poetics or politics, but rather a matter of understanding the politics of aesthetics and the aesthetic dimension of politics. Or, put it another way, it is the mode of address that produces the public, and if one tries to imagine different publics, different notions of stranger relationality, one must also (re)consider the mode of address, or, if you will, the formats of exhibition making.
>
> 2007: 182

Dak'Art exhibitions are a tool of articulating and communicating the African perspective on global contemporary art. Through the exhibitions, the Biennale imagines a pan-African art world public for its critical exhibition making, produces a politics that resonates with the imagined public, then creates a world that is defined by that politics – a pan-African world within the global art world.

Such pan-African identity, which is arguably parochial, would seem to clash with the Biennale's global aspirations. Notwithstanding, Dak'Art's pan-African identity legitimizes its will to create a kind of geopolitical integration based on sociocultural solidarities and interstate networks that sidesteps the territorial boundaries of Senegal. This approach adheres to Cynthia Lucas Hewitt's articulation of pan-Africanism as a 'form of nationalism where the "nation" is writ large – the continent of Africa and its entire scattered people (in Africa and the diaspora) – in comparison to the nationalisms of defined states, which are considered micronationalism' (2007: 24). In this regard, the Biennale might thus be addressed as a supranational institution, following what Achille Mbembe (2001) recognizes as new forms of territoriality and locality which provide alternative ways of imagining confined sovereign spaces as transnational and beyond the state structure (ibid.: 25).

Any experience of a Dak'Art edition, however, confronts the visitor not only with selections of contemporary African art, but also with political decisions that interfere with the exhibition making. The cultural institution is subsumed under the Ministry of Culture, and permanently dependent on the goodwill of the state's presidents. As Ugochukwu-Smooth Nzewi (2013) asserts, 'I consider Dak'Art as a product of Senegal's long-standing state policy on cultural politics' (ibid.: 19). Various chapters of the present volume (in particular Nzewi, Chapter 1; Mbaye, Chapter 2; and Part 2 as a whole) deal with this aspect. In other words, the state is not only the principal sponsor of the Biennale, it marginally controls its activities, lays down objectives of specific editions, and Dak'Art is the major tool for the state's international cultural politics.

Nonetheless, there are other discourses that inform the Biennale of Dakar, such as those of local artists, art world professionals, the public, and those of the institution itself – an interconnection between the general secretariat, the orientation committee and the selection committee. In this epilogue, we reflect on these latter ones in relation to debates of biennial research as outlined earlier.

As Gardner and Green (2013) assert, biennial research is strongly informed by '*Northern* histories' (ibid.: 443; italics in original) – studies that mostly focus on those biennials which are considered as relevant for global art discourses. Financially powerful, these institutions are platforms of international superstar curators and globally acknowledged artists, they deal with subjects that are considered paramount for the world (climate change, migration, neoliberalism, etc.), and they are leaders for the definition of preponderant art forms.

Several structural aspects are widely assumed in these global biennials' discourses, in particular the centre–periphery divide. This latter is justified by the focus of these institutions: global contemporary art for the leading biennials, and regional contemporary art for the marginal ones. Biennials in the periphery are financially weak, and face a permanent existential threat.[5] To these arguments, we add the perception of a biennial problem at the moment of vast, independent worldwide foundations of such cultural institutions: the creation of a uniform global contemporary art, many topics in the same structural presentation, etc. In the following section, we examine the Biennale of Dakar in relationship to this centre–periphery hierarchy, and the widely unquestioned subject of the claim to the globality of contemporary art representation in connection with the rising 'biennial fatigue'.

Against the Centre – Periphery Hierarchy

Prior to the 1990s, international cultural exchange mirrored the flow of global capitalism sketched by Wallerstein. The anthropologist Ulf Hannerz (1991) notes that cultural interrelatedness between the centre and periphery was a function of the transnational flows of labour and cultural commodities. The centre controls the periphery completely by creating and institutionalizing the frameworks through which transnational cultural processes flow. In drawing attention to the unequal distribution of global capital, Hannerz outlines a Western cultural

imperialism that creates a psychology of dependence and associated sense of inferiority in the non-Western world. The discourse of global visual culture flows through controlled channels that highlight the perpetuation of a centre and peripheries. Non-Western biennials are perceived as junior partners in the global biennial system and still need the validation and affirmation of the key art world institutions (the global market, coterie of museums, cultural NGOs) located in Western Europe and the United States. Nevertheless, there is an important positive outcome in the expansion and de-centring of the global cultural landscape since the 1990s. Subsequent emergent biennials such as Dak'Art share a strong emphasis on a counter-narration of contemporary art from their own regional and local perspectives. Okwui Enwezor (2002) also highlights such a production of a 'counter-hegemonic/counter-normative gaze' as a search for new relations of power and cultural translations.

With its foundation in 1989, and in particular with the first edition as Biennale of international contemporary arts in 1992, the Biennale of Dakar takes a peripheral stance in relation to the global biennials network. It is conceived as a platform for the encounter of Senegalese artists with their international peers, and the juxtaposition of their artworks with those from other regions of the world within a common space should stimulate the advancement of artistic practices in Senegal. With the reorientation as Biennale of Contemporary African Art, this self-positioning as periphery becomes even more obvious with the state's definition of the institution's objective. As cited by Sylvain Sankalé (Chapter 7), the decree of the Ministry of Culture clearly expresses the promotion of Senegalese artists in particular, and African artists in general.

The so-defined trajectory of the Biennale appears as well inscribed in Senghor's concepts of *enracinement et ouverture* (rootedness and openness). These latter ones were formative in the arts far beyond Senghor's presidency, as some contributors show (Mbaye, Chapter 2; Diba, Chapter 3; Ndiaye, Chapter 5). These concepts informed the invitation policy of the Biennale, of artists and their artworks, of experts into committees and to the forum *Rencontres–échanges*. This approach reaches its zenith and best expression in 2006 under Yacouba Konaté's general curatorship. His exhibition making seeks a balance between an art history of modern African art and newest trends in contemporary African art (see Nzewi and Fillitz, Chapter 4).

As a matter of fact, while Konaté insists on making a true African Biennale, one must recognize that this exhibition is conceptualized from an African aesthetic centrism: the history of modern and contemporary African art that cannot be written from the gaze of European and North American art history, therefore also the title *Africa – Agreements, Allusions and Misunderstandings*. This assertion, an explicit *enracinement*, also influences Dak'Art's peripheral self-restriction. In contrast, Konaté's seventh edition of Dak'Art is a self-conscious affirmation within the global biennials network as the pan-African biennial. Hence the early history of the Biennale of Dakar is one of self-relocation within the global biennials network, from a (marginal) biennial of the periphery to *the* Biennale of Contemporary African Art with equal aesthetic value: 'it embraces its marginality

or geopolitical focus to carve out a space for itself in the global circuit of biennials as a pan-African, postcolonial, and non-Western biennial' (Nzewi 2013: 6).

Another trajectory commenced and took form from the fourth edition (2000) onwards, at once enlarging the meaning of Dakar as a crossroad of cultures and Dak'Art as a site of validating and negotiating contemporary African art. The inclusion of artists of Africa's diaspora comes with the rising mobility of African artists, as Nzewi highlights (2013: 2). As David Elliott, president of the selection committee, notes in his introduction to the 2000 edition, 'leading artists from both inside and outside Africa are being invited' (2000: 15). Regarding art forms, this approach implies an emphasis of installation, video and photography (see Nzewi, Chapter 9), and that 'the generation of artists showing here have much in common with their contemporaries elsewhere' (ibid.: 16). In 2000, however, Elliott still identified this process as emergent. For now, the Biennale of Dakar remains marginal in relation to those others that dominate global discourses on the exhibition form and on contemporary art.

Nevertheless, these curatorial decisions have an impact on the conceptual characteristic of rootedness and openness. The ideological claim of Dakar as cultural node now also connects to the intensified, multidirectional and transcultural interactions of art world professionals. This will inform the self-determination of the Biennale of Dakar within the global biennials network. Contemporary African art in the *Exposition internationale* visualizes the increasing movement and mobility of curators and artists who are working in and out of Africa (see Nzewi, Chapter 9). In this regard, Dak'Art 2010 appeared conceptually interesting, although it was thus far the most problematic edition (extreme time pressure, severe budgets cuts; see Nzewi and Fillitz, Chapter 4). The selection committee, for the first time exclusively African experts, agreed to formulate radical criteria for the *Exposition internationale*'s Perspectives. Instead of differentiating between artists of the diaspora and African artists, any artist with a passport from an African state was eligible, no matter where they lived and worked, thereby expanding the centrality of Africa as geospatial entity. Further, only young artists who had never participated in the Biennale previously – that is, a generation of artists imbricated in mobility – were selected for inclusion in the show. Finally, both occidental art history and any 'Africanness' of artworks were rejected as criteria. This approach was emphasized in succeeding editions, 2012 and 2014, reaching a climax in 2016 and 2018 with an artistic director who largely relied on invitations of artists for the *Exposition internationale*. From 2014 onwards this trend was complemented by an intensification of bringing non-African artists into Dak'Art–In, in 2014 with the exhibition *Diversité Culturelle* at Musée Théodore Monod (curator Massamba Mbaye), and in 2016 and 2018 with exhibition projects of internationally active curators invited by artistic director Simon Njami.

Following this line of reflections confronting contemporary African art, the Biennale of Dakar 'moves' towards Achille Mbembe's concept of Afropolitanism (2010): a cultural, historical and aesthetic sensibility, an imbrication of the worlds (ibid.: 229). The Biennale of Dakar may be recognized as a transcultural space which correlates with Mbembe's notions of *Esprit du Large* (ibid.: 233; Spirit of the

Wide), and an *esthétique de l'entrelacement* (ibid.: 228; aesthetic of interweaving). They refer to the preponderance of movements, to mixing as a process of cultural vernacularization. El Hadji Malick Ndiaye (Chapter 5) refers to similar thoughts regarding the forum *Rencontres-échanges* for Dak'Art 2016, which highlighted as its central theme the transformations of the normative intellectual frames in the context of contemporary African arts (ibid.). Indeed, the Biennale of Dakar thereby may be conceived as cultural space that consists of passages, of blazing trajectories which are reaching in and out. These consist of combinations of artistic practices from multiple art worlds with experiences from a diversity of art worlds. In such a consideration, the statistics of the many artists who have been exhibited so far, and their many countries of origin, are meaningful if viewed as circular movements that constitute the space of the Biennale.

In relation to the 2006 edition, this is another self-positioning of Dak'Art within the global biennials network, one which is characterized by Mbembe's aesthetic of interweaving, and which we find in thinking about the meanings of contemporary African art as present in the various fields (Dak'Art–In and Dak'Art–Off) of the Biennale (see Part 3). It has, albeit, little if anything to do with discourses structured according to centre–periphery hierarchies. This differentiation has its tradition in the categories of World Systems Theory, which are structuring world–market connections into centre–semi-periphery–periphery models. In present-day discourses of global art phenomena, these categories are fundamental for hegemonic discourses to classify global contemporary art creation and its exhibition, and to withhold their equal aesthetic values.

Globalism and Canon Building?

According to European/North American viewpoints, documenta and the Biennale di Venezia compete in the field of biennials for the most influential position regarding global contemporary art. Nonetheless, these exhibitions' globalism lacks concretization: do they truly cover contemporary artistic creations of the innumerable art worlds of the globe, or does this global reach rather strive after geo-cultural multitude that is attuned to other similar aesthetically judged mega-events? Catherine David, general curator of *documenta X* (1997), acknowledges the limitations of such an endeavour, not to say the impossibility of matching the objective of an encompassing global perspective (O'Neill 2007: 79). Peter Osborne (2015) speaks of a '*collective fantasy* ... the fantasy of providing comprehensive artistic coverage of the globe, through something like a world system of art (ibid.: 16; italics in original).

Hence, global contemporary art develops as a specific canon out of the exhibitions of a few powerful biennials which are accompanied by related globalized art discourses. This production of dominant art forms and interrelated exhibitions – Verwoert's (2010) 'biennial art'; Smith's (2012) 'overproduction' – is further supported by the conceptualization of either a unilinear history of *the* biennial (in the singular) or the diffusion of a few models as variants of this very same, singular exhibition form. One needs to recall that the global proliferation

of biennials is neither authoritatively decided, organized nor mediated in a centre.

From the vantage of the Biennale of Dakar, such discourses hardly comply with the intentions of this cultural institution – whether it belongs to those institutions that replicate what is produced elsewhere (Verwoert 2010; Smith 2012), or whether it belongs to the category of emancipatory biennials (Marchart 2014; Oren 2014). From the start it has been inscribed in Senghorian *Négritude* concepts of rootedness and openness, and of symbiosis as a method for cultural vernacularization. *Symbioses* was indeed the title of the forum *Rencontres–échanges* in 2016 (see Ndiaye, Chapter 5), and it has been central for the preoccupations of Senegalese artists (see Nzewi, Chapter 9). Indeed, the Biennale might be approached as a site of translation, where the local determines how it responds to or uses the protocols of the global. The local is the initial context from which biennials such as Dak'Art make sense of the contemporary world and then seek to address that world through contemporary art. Dak'Art mediates local concerns and also serves as an important conduit through which events and discourses from the international art world are examined and translated for local audiences.

The recent iterations of the Biennale of Dakar manifestly prove that the reflection of globalism of contemporary art is a different task compared to those other discourses: it deals with aesthetics of interweaving in the creation of contemporary African art. This is the topic of Part 3, and the chapters of Nzewi (9), Joanna Grabski (10) and Iolanda Pensa (11) deal with the subject from different angles: Nzewi from a continental and pan-African perspective, Grabski in relation to the impact on local artistic practices (Dak'Art–In and Dak'Art–Off), and Pensa by comparing the Biennale with the regional impact of a local, non-governmental art institution in Cameroon, Doual'art.

Describing the Biennale's impact on artistic practices, we need to acknowledge Abdou Sylla's (2008) insights about influences on the conceptualization of installations in Senegal, and in particular the work with new information and communication technology materials (see also Ndiaye, Chapter 5). Also, Petroni's observation of a certain lack of turnover of artists (Petroni 2013: 147) requires to be recognized.

Canonization of contemporary African art, nevertheless, cannot be the main objective of Dak'Art. Nzewi's examinations (Chapter 9) show the complex interplay of artists from nearby and distant, transcontinental art worlds. Even on a continental scale, South African curator Marilyn Martin, president of the selection committee of 2010, underpinned the diverse art languages. Grabski (Chapter 10) elaborates on the artistically heterogeneous field of Dak'Art–Off, which extended to Saint-Louis in 2002 and currently reaches cities throughout Senegal. In her comparative analysis, Pensa (Chapter 11) argues that artistic collaborations within neighbourhoods are creating the most important impacts on each other's artistic practices, echoing Elvira Dyangani Ose's (2015) observation that 'it is in local initiatives led by artist collectives – against cultural narratives and policies proposed by national institutions – that one can find the genesis for change and experimentation within the arts' (ibid.: 105). Furthermore, in conversations with

artists at diverse editions of the Biennale, we realized that the question of canon building is not their primary preoccupation. They all emphasized encounters with peers and art world professionals as most important as an exchange of ideas regarding art and society, artistic practices and the development of joint projects, not to mention artistic techniques, the inclusion of other support for artworks, and other materials (see also Diba, Chapter 3).

Indeed, to conceive the Biennale of Dakar as a field-configuring event is less a matter of canon building, rather it is how the institution strives for its global perspectives from an African stance (see Nzewi and Fillitz, Chapter 4). Here, we see a connection with Hoskote's reflections for future large exhibitions, to elaborate on such spaces on the basis of critical transregionality (2010: 314). As Dyangani Ose (2015) restates, 'pan-African cross-cultural conversations' (ibid.: 105) have been ongoing for a long time. But the Biennale's new dimensions, its future visions and trajectories that emerged with the editions of 2014, 2016 and 2018, reach out towards imaging this *Esprit du Large* (Spirit of the Wide, Mbembe 2010). For the *Exposition internationale*, the flagship exhibition of the Biennale, the task then becomes to strengthen the curatorial work beyond sole selection mechanisms towards valuing art's potential to engage the world in diverse ways, to imagine social, cultural or political issues differently (see Martinon 2015). This challenge, however, summons all cultural agents involved, curatorial teams, artists, art world professionals and visitors. Setting aside political constraints and restrictions, the Biennale of Dakar today represents the means to intensify geo-cultural affinities beyond boundaries, linking the local, the international, and diasporas.

NOTES

Introduction

1 'Et puis, vint ce livre. Il est africain, et il est en dialogue.'
2 'comment le besoin d'une grande manifestation culturelle comme la biennale de Dakar, élabore une forme d'art de masse, tout en résistant à l'aveuglement, à la standardisation.'
3 'Le temps des biennales est donc . . . celui d'une exigence générale des libertés.'
4 'Sous le couvert de l'art contemporain, la Dak'Art ne doit pas ouvrir sans modération ni discernement la porte à "n'importe quoi". Les œuvres exposées doivent être d'abord des œuvres d'art, c'est-à-dire des créations.'
5 'En premier lieu c'est un projet parce que, à partir de sa nouvelle formulation de 1996, la biennale se structure en "objectifs, activités et résultats mesurables" et cette nouvelle structure comporte un effet évident sur son fonctionnement.'
6 'le projet insiste sur le développement économique, qui relève également de la formation et de la participation des communautés locales.'
7 'Dak'Art n'a pas produit d'œuvres nouvelles, elle n'a pas inventé des manières d'exposer innovatrices . . . et elle n'a pas facilité l'émergence d'institutions culturelles actives et stables à Dakar.'
8 '. . . où l'exigence aujourd'hui est de sortir d'une « africanité » qui pouvait être nécessaire au début, mais qui demande aujourd'hui à être dépassée.'
9 'ce sera une rencontre beaucoup plus intéressante pour le brassage des cultures.'

Chapter 1

1 Diop's appeal to progressives from all walks of life to help introduce Africa into a modern world, as pejorative as that might sound, must be understood within its time, which was at the height of European colonialism.
2 Author's interview with Lamine Sall, former Secretary General (1 February 2012, tape recording, Dakar).
3 Massamba Mbaye (journalist), interview by author and Hélène Tissières (17 May 2010); Viyé Diba (artist), interview by author (29 May 2010); Abdou Sylla (art historian), interview by author (25 May 2010).
4 'Borrowed personality' is the term used by Lilyan Kesteloot to describe the effects of the policy of assimilation on Senghor and his cohorts (Kesteloot in Kennedy 1974: xvi).
5 Ellen Conroy Kennedy suggests that the quest by proponents of *Négritude* to recuperate cultural origins was inspired by the Parisian modernists' admiration of African art for its originality and social values. She also argues, and rightly, that the African American brand of cultural nationalism with Africa as an ideological anchor was in circulation in black Paris through exposure to the work of New Negro authors, visits by Harlem Renaissance literati to Paris, and transatlantic relationships forged between individuals such as Alaine Locke and Jane Nardal, who was a very influential figure among the black

Parisian elite, and was a critical model. Although valid, Kennedy's analysis is not complete. Without dismissing the cross-currents of influences that may have inspired *Négritude*, a more probable catalyst for the final shape *Négritude* took was the hypocrisy of the French policy of assimilation, which, while divesting black Parisians of their so-called barbaric cultures, was co-opting the same primitive cultures for their so-called magical qualities to reinvigorate a Western modernism undergoing a crisis. This hypocrisy would have been obvious to the *Négritude* circle (Kennedy 1974: xvii).

6 Senegal, which was one of the first countries to obtain financial support under the structural adjustment programmes, received its first standby loan of US$10.5 million from the IMF under the Medium-term Economic and Financial Recovery Plan in 1979. In 1980, it worked out an Extended Fund Facility (EFF) agreement for US$184.8 million to be spread out over a three-year period with the IMF and World Bank (Chowdhry and Beeman 1994: 154).

7 The first annual exhibition of the reconstituted *Association Nationale des Artistes Plasticiens Sénégalais* (ANAPS) was a collaborative venture with the Musée Dynamique in 1985. The exhibition, which was held in the main hall of the Théâtre Sorano, focused on children's drawings, selected from several schools in Dakar. The exhibition, which was also co-organized with the UNICEF office in Dakar, was part of a campaign and social mobilization for the survival and welfare of the child.

8 The artists included Magdalena Abakanowicz (Poland), Gavin Jantjes (South Africa), Iba Ndiaye (Senegal), Skunder Boghossian (Ethiopia), Robert Rauschenberg (USA), Twins Seven Seven (Nigeria), Sol LeWitt (USA), Julio Le Parc (Argentina), Patrick Betaudier (Trinidad and Tobago), Wau-ki Zao (China), Jesus-Raphael Soto (Venezuela), Mario Gruber (Brazil), Wilfredo Lam (Cuba), Valente Ngwenya Malangatana (Mozambique),Titina Maselli (Italy), Roberto Matta (Chile) and Jean-Michel Meurice (France), among others (see www.mayibuyearchives.org.)

9 *Art contemporain du Sénégal: 18 septembre–28 octobre 1990 à La Grande Arche de la Fraternité* (Paris): ADEC, (1990); Marie-Hélène de Toffol (1991); Françoise Balogun (1991).

10 Author's interview with Youma Fall, co-curator of Dak'Art 2006 and former director of National Theatre (27 April 2012, tape recording, Dakar, Senegal).

11 Author's interview with Clémentine Deliss (31 October 2012, tape recording, Frankfurt/Main, Germany).

12 Ibid.

13 Author's interview with Lamine Sall, former Secretary General, 1990–93 (1 February 2012, tape recording, Dakar).

14 Ibid.

15 This insistence in dictating the direction of the Biennale by the European Union was also confirmed by Sall's successor, Rémi Sagna, who, however, said that Minister Thiam did not want to work with Sall, in part because he did not manage the finances of Dak'Art 1992 well. At the end of Dak'Art 1992, there was a mountain of debt arising from unpaid expenses for services rendered such as hotel accommodation for artists and international experts, meals, and other logistics. Sall was also owed some of his salary. Sagna liquidated the old debt before the next Biennale in 1996 (Rémi Sagna, former Secretary General of Dak'Art 1993–2000, interview by author, 9 May 2012, digital recording, Dakar, Senegal).

16 Ibid.

17 Dak'Art '92: *Exploitation des Fiches d'Evaluation*. Documentation centre, Dak'Art Secretariat, Dakar.

18 Ibid.
19 Sagna (interview by author, 9 May 2012, digital recording, Dakar, Senegal).
20 The major problem that plagued the Biennale between 1992 and 1996 was the liquidation of old debts arising from Dak'Art 1992. After that was resolved, Minister Thiam sought to oversee the financial expenditures of the next Dak'Art (ibid.).
21 Sagna stated that with the exception of Moustapha Ka, who was instrumental in the creation of the Biennale in 1989, and Abdoulaye Kane, who replaced Madame Thiam in 1995, successive ministers of culture in Senegal had lacked an understanding of the objectives of Dak'Art and its historical significance.
22 This is no longer the case as the Biennale has since grown into its own event from the 2000s on.

Chapter 2

1 By visual reactions, I mean an aesthetic positioning of connivance, of mistrust, of opportunity, and of authenticity.
2 '*Un rare don d'émotion, une ontologie existentielle et unitaire aboutissant, par un surréalisme mystique, à un art engagé et fonctionnel, collectif et actuel, dont le style se caractérise par l'image analogique et la parallélisme asymétrique.*'
3 '*Ma Négritude est truelle à la main, est lance au poing.*'
4 '*Le peuple juif a apporté le message de la Bible, le peuple arabe, le message du Coran. Quant à nous, Noirs, le message de l'Art Nègre.*'
5 It consisted of Senegal and French Sudan (present-day Mali).
6 In 1966, the Manufacture des arts décoratifs was transferred to Thiès, some 70 km to the East of Dakar, and Papa Ibra Tall became its director.
7 '*Pour lui, il est choquant de réduire le créateur nègre à la spontanéité, à l'instinct et l'onirique. Le dispensant de toute forme de réflexion. L'histoire avait déjà établi que les techniques picturales existent et qu'elles s'apprennent. Et c'est parce qu'elles sont bien maîtrisées qu'on parvient, par la suite, à rendre en couleurs et formes tout ce qui peuple nos univers physique et mental.*'
8 '*La tradition de mécénat d'Etat initiée par Senghor n'a pas été interrompue ou abandonnée par son successeur; au contraire, outre le maintien des formes traditionnelles, ce mécénat s'est diversifié par des initiatives nouvelles et s'est approfondi par la recherche et l'exploitation de nouveaux créneaux.*

 Ainsi, dès 1982, Abdou Diouf Chef de l'Etat, décide de faire élaborer une Charte culturelle nationale, dont la conception a bénéficié de la collaboration de toutes les compétences nationales concernées. Après plusieurs années de travaux, cette commission a déposé en 1989 ses conclusions, destinées en priorité à lutter contre les formes modernes d'aliénation culturelle, à réinsérer les faits culturels nationaux dynamiques dans la quotidienneté des citoyens et à constituer un bréviaire de valeurs et de normes à prendre en compte dans le système éducatif moderne et à enseigner.

 Cette Charte inspire, tout en intégrant les deux axes initiaux, la politique culturelle appliquée depuis lors.'
9 '*Parallèlement à la réduction drastique des budgets et des possibilités de financement de l'Etat, une réorientation de la politique culturelle est opérée à partir de 1990. Cette réorientation s'est traduite, dès 1992, par l'organisation des Journées du Partenariat, lors de la Biennale de Dakar et dont les objectifs majeurs consistaient, entre autres, à*

rechercher des possibilités nouvelles et des sources de financement des projets culturels et à inciter les artistes à initier des projets d'industries culturelles.'

10 *'L'actuel Ministre de la Culture . . . a perçu, semble-t-il, l'importance et les enjeux de la dynamique nouvelle; et prenant en compte les contraintes majeures de l'Etat, il redéfinit de manière réaliste, dans une interview au Sud-Quotidien (n°s 706 et 707 des 16 et 17 Août 1995), les axes de la nouvelle politique culturelle de l'Etat: réaffirmation et ancrage dans les fondements originels de la politique culturelle du pays (enracinement et ouverture), appui et soutien à la créativité et à l'innovation artistique et culturelles, restructuration de certaines institutions, privatisations d'autres structures, recherche de financement de projets culturels et artistiques, création d'une Fondation de Développement des Industries Culturelles (FODIC), mise en place, en partenariat avec l'Union Européenne, du Projet de Soutien aux Initiatives culturelles (PSIC), avec un financement initial de 300 millions de Francs CFA, etc.'*

11 *'Des fonctionnaires en bois brut remplacèrent progressivement les créateurs. Le paysage culturel sénégalais commença à prendre du vert de gris puis à se fossiliser, faute de fertilisants. La culture au sens conceptuel du terme commença à se transformer en «loisirisation» de la culture.'*

12 *'L'affectation, toute provisoire, au demeurant, du Musée Dynamique à la Cour Suprême n'aura aucune incidence négative. . .'*

13 Officially, the sculpture is attributed to the plans of Senegalese architect Pierre Goudiabry.

14 *'Ce que nous venons de vivre n'a pas de prix mais il est légitime de s'interroger sur les retombées. Parlons-en. Des dizaines de milliards de revenus distribués aux artistes, à leurs orchestres, leurs danseurs et leurs collaborateurs, aux intellectuels qui ont perçu des per diem, aux hôteliers et leurs fournisseurs, aux nombreuses sociétés qui ont réalisé les villages et effectué les rénovations des salles de spectacles et d'exposition, aux sociétés avec leurs milliers de travailleurs de toutes catégories . . . et derrière ceux-ci, les marchands de denrées alimentaires, de viandes et légumes . . . pour fournir 6 .000 personnes pendant trois semaines !'*

15 *'Dans le domaine de la culture, il s'agit de valoriser les potentialités et de stimuler la créativité et le talent des artistes pour accroître le volume et la qualité de la production culturelle et artistique. À cet égard, pour promouvoir les industries créatives performantes et mieux diffuser les produits culturels au plan national et international, des infrastructures et des plateformes culturelles seront réalisées pour accompagner le développement du secteur./ Concernant les pré requis, l'accent devra être mis sur: l'amélioration de l'accès au crédit pour les porteurs de projets culturels, la promotion de la formation artistique, le renforcement de l'implication des privés dans la promotion culturelle, et la promotion du statut des artistes, des droits de la propriété intellectuelle et artistique et la lutte contre la piraterie.'*

16 *'Ce moment est historique. Il fait partie des repères qui, nous reliant à notre passé, résistent à l'usure du temps, se bonifient avec l'âge et nous projettent vers le futur, en gardant nos pieds fermes sur le socle de notre histoire. Enracinement et ouverture, dirait le Président Senghor.*

L'acte que nous posons aujourd'hui n'est pas une singularité isolée dans son temps et dans son contexte. Il s'inscrit dans la continuité de l'histoire.

Le Musée des Civilisations noires rejoint, en effet, une dynamique au long cours; dynamique de confluences et de symphonies entre africains et afro-descendants unis dans l'affirmation de leurs valeurs de culture et de civilisation; valeurs à l'historicité tant de fois niée, valeurs à l'historicité tant de fois avérée!'

17 'En soutien à notre patrimoine culturel, le gouvernement a consenti d'importants efforts,
 avec: la réhabilitation d'édifices religieux et lieux de mémoire; la création de la Sénégalaise
 du droit d'auteur et des droits voisins; la contribution à la mise en place de la Mutuelle
 nationale de santé des acteurs culturels, au titre de la Couverture Maladie universelle; le
 doublement du budget de la Biennale de l'art africain contemporain, porté désormais à
 500 millions de francs CFA; la rénovation de l'ancien Palais de Justice et sa
 transformation en Palais des Arts; et le lancement prochain des chantiers de l'Ecole
 nationale des Arts et Métiers de la Culture, et de la Bibliothèque nationale.'
18 *Femme signare* designates African women from the northern coastal areas of Senegal
 who were living with Europeans until the mid-nineteenth century, and who acquired
 high economic and social status.
19 'Le propos de Boilat ne se limite cependant pas à l'édification de cette somme érudite et,
 par conséquent, à une description statique du Sénégal à un moment de son histoire. Tout
 au long de son ouvrage, en effet, l'auteur se montre préoccupé de situer les faits observés
 en fonction du devenir du pays.'

Chapter 3

1 When André Malraux, then Minister of Culture in France, visited the First World
 Festival of Black Arts in Dakar, 1966.
2 ANAPS organized the annual exhibitions of its artist members.
3 Under Amadou Mahar M'Bow's direction, the report *Many Voices, One World* was
 published by UNESCO in 1980. It presented recommendations for a fairer global
 order in the fields of information and communication.
4 See in particular 'Dakar Sénégal', *Revue Noire* 7, December 1992–January/February 1993.

Chapter 4

1 Ousmane Sow Huchard was, among others, chief curator of the Musée Dynamique
 (1983–8); he later founded and directed the private cultural engineering firm
 'CIWARA'. On behalf of BCEAO, he organized an exhibition of the bank's collection
 of modern African art at AFRICUS 1995, and presided over the Biennale's
 international jury for the prize awards.
2 Ousseynou Wade was Secretary General from the 2002 edition until 2012.
3 Another interesting development at Dak'Art 2006 was that it had a separate
 international jury who selected winners of the different prizes awarded at the Biennial.
 In several editions of Dak'Art, members of the jury have doubled as the curators of the
 official exhibitions. In addition to the *Grand Prix Léopold Sédar Senghor*, Dak'Art's top
 award, these prizes are the Minister of Culture and Tourism Prize, the City of Dakar
 Prize, the International Organization for Francophonie Prize, the Economic and
 Monetary Union of West Africa Prize, and the European Union Prize for the best work
 by a young artist in the Off. They are long-standing and can be considered as
 traditional prizes. Other wards, which are in the form of artists' residency programmes,
 are more recent and inconsistent. They include the Blachère Foundation Prize, the
 Vives Voix Foundation Prize, ResArtis Prize, Deveron Arts Prize, the Thami Mnyele
 Foundation Prize, Thamgidi Studio Foundation Prize, and the Centre Soleil d'Afrique.

4 This was the first and only time funds to organize Dak'Art were released on time. Konaté was also able to attract more international partners through his own network. In addition to the generous support of the Senegalese government and traditional partners, including the European Union, the Organisation International de la Francophonie, Afrique en Créations and UNESCO, support also came from new partners such as the Fondation Blachère, Africalia Belgium, Belgian Development Cooperation, the Prince Claus Fund and Resartis.

5 President Wade's daughter, Sindjely Wade, who had neither organizational background in the field of culture nor knowledge of the art world, was put in charge of the visual arts section, with disastrous consequences. Due to the incompetence of her organizing committee, the visual arts section was badly managed. At the end of the FESMAN, artworks submitted by over one hundred artists were not returned. In September 2011, South African artist Johann van der Schijff created an online petition to force the organizers to return the works to the artists. While some, mostly from the diaspora, were returned by May 2012, the rest are yet to be returned.

6 Ousseynou Wade invited all former living winners of the *Grand Prix du Chef de l'État* to each display one new work in the 'Retrospective' space.

Chapter 5

1 Egypt was the first African country to institutionalize its national pavilion from the second Biennale on, and participated permanently from 1948 (Malbert 2006, vol. 2: 549). In 1990, an initiative of Grace Stanislaus of Studio Museum Harlem enabled the exhibition *Five Contemporary African Artists* at the Biennale di Venezia, featuring El Anatsui, Tapfuma Gutza, Nicholas Mukomberanwa, Henri Munyaradzi and Bruce Onobrakpeya. In 1993 this was followed by *Fusion: West African Artists at the Venice Biennale*, curated by Susan Vogel, Museum for African Art, New York.

2 '*la motivation principale de Dak'Art reposait sur la volonté du Gouvernement du Sénégal de faire re-naître le prestige culturel du Festival Mondial des Arts Nègres de Dakar et de faire ainsi de la capitale sénégalaise une plaque tournante culturelle dans la contemporanéité.*'

3 '*Sa spécificité, donc, tient à cette exigence endogène, contrairement, par exemple, à la Biennale de Bamako, née de volontés politiques françaises.*'

4 '*A cet égard, les colloques internationaux, l'expérience l'a montré, débouchent souvent sur la formulation de propositions et recommandations frappées du sceau de l'expertise locale, dans un contexte d'ouverture aux idées constructives venues d'ailleurs.*'

5 Three panels lasting two days each were: permanence and aesthetic mutations; materials of recuperation and artistic creation; reception and distribution of African art.

6 '*Le rapport général issu des trois journées qu'a duré le colloque international dresse un bilan global de l'itinéraire de l'art africain, depuis le Festival mondial des Arts nègres de 1966 ainsi que de sa place dans le monde.*'

7 '*L'identification de la grande majorité des participants, toutes catégories confondues, est passée par le biais des réseaux occidentaux. A la recherche d'artistes africains, la biennale a choisi ceux de la diaspora déjà intégrées dans ces réseaux. Elle a envoyé le plus grand nombre de ses invitations aux critiques et marchands occidentaux.*'

8 '*entre les artistes et les spécialistes, sur la vie des artistes et leurs démarches artistiques, aussi bien sur les mécanismes et stratégies de pénétration des marchés.*'

9 Iba Ndiaye Diadji directed the forum until 2002, thereafter Aminata Diaw Cissé until 2017.

10 '*par la volonté du Conseil scientifique de Dak'Art de mieux poser les arts d'Afrique dans le débat actuel sur la contemporanéité artistique et de faire de Dakar, une place forte dans le marché mondial des arts plastiques.*'

11 '*l'art africain n'avait de compte à rendre qu'aux lois implacables du marché de l'art mondial.*'

12 '*lors des quatre dernières éditions de cette Dak'Art (2000, 2002, 2004 et 2006), les œuvres en installation, en vidéo et en TIC sont de loin les plus nombreuses; en 2004, elles sont 65 sur 91 œuvres présentées; en 2006, elles sont 44 sur 122 œuvres au total.*'

13 '*La problématique du contemporain s'impose en même temps qu'émergent de grandes expositions comme la biennale de Dakar et celle de Johannesburg. Il y a une contiguïté de fait entre l'art contemporain et la biennale en tant que forme d'exposition spécifique. La biennale comme instance et institution est un élément du système de l'art contemporain avec la communauté agissante des directeurs de galeries, des conservateurs de musées, des critiques, des commissaires.*'

14 '*l'idée du ré-enchantement et de la renaissance d'une esthétique de l'art contemporain africain consciente de ses missions de transcripteur d'une Afrique dynamique, en mutation, et de pont jeté sur les autres manières de voir et de penser le monde.*'

15 '*Cependant, renégocier notre place dans le monde passe par la révision des concepts qui nous gouvernent. Or, les débats sur les enjeux de l'heure sont profondément ancrés dans la réflexion artistique et l'art contemporain. Que nous apprend cette pensée sur nos rapports quotidiens avec la globalité, façonnée par les flux d'idées, par la circulation des biens culturels et par la frénésie des réseaux d'acteurs interactifs et interdépendants?*'

16 The author of this chapter directed the commission. Members of the commission were: Thérèse Tupin Diatta (director of Galerie Kemboury), Ibrahima Lo (Ministry of Culture), Sokhna Sane (Université Cheikh Anta Diop of Dakar), Felwine Sarr (Université Gaston Berger of Saint-Louis) and Maguèye Touré (Ministry of African Integration).

17 Besides the opening day, when there is only one workshop, two are scheduled per day.

Chapter 6

1 See also the regulations regarding the edition of 2018, specifically articles 1 and 2 (2017).

2 Interestingly, access to exhibitions of documenta 14 (2017) in Athens was free, with many art activities in public spaces. While documenta published the figure of over 339,000 visitors for Athens, critics highlight the problems of a reliable count under the circumstances.

3 '*[L]'œuvre d'art à deux dimensions et l'art conceptual ont du mal à s'imposer auprès de la population locale africaine du fait d'une longue tradition des sculptures et des masques.*'

4 Most international visitors are present during the first week after the opening.

5 Either we interviewed visitors, or interlocutors themselves filled out the questionnaire. Several interviewees did not answer all questions, and around fifty questionnaires had to be dismissed for lack of reliability.

6 Regarding visits to other biennials, the Biennale di Venezia was most mentioned, followed equally by documenta, Kassel, and the Rencontres de Bamako/Biennale africaine de la photographie.

7 The administration economist Gerd-Michael Hellstern, University of Kassel, and his team investigated this survey.

8 '*C'est pourquoi, nous travaillerons à élargir davantage, l'audience de la Biennale. A l'élargir, d'abord, à la jeunesse qui constitue la base très large d'une pyramide porteuse de toutes les promesses, ensuite à d'autres mondes, tenus jusque là à la périphérie.*'

9 Massamba Mbaye argues that Abdoulaye Wade was keen to propagate this indirect return argument, in particular when he presented the overall benefits of his project of FESMAN (see Mbaye, Chapter 2).

10 'Building B' of Musée Théodore Monod was constructed in 1991–2 specifically for the Biennale. Spaces of the Dakar fair (CICES) were rented for the editions of 2002 and 2004. Yacouba Konaté, however, favoured the museum building in the city centre, and re-transferred the mega-event for the 2006 edition (see Konaté 2009: 102–3). In 2014, its premises were dedicated to the exhibit *Diversité culturelle* (curator Massamba Mbaye). In 2016 and 2018, it hosted the projects of the invited international curators.

11 Eiffage Sénégal is a large construction corporation for infrastructure (highways, bridges, edifices, the port of Dakar, etc.). It is a primary sponsor of visual arts in Senegal, and owns a significant collection of modern and contemporary African art.

12 '. . . *en ce sens qu'il ne concerne qu'une partie culturellement motivée de la pyramide sociale.*'

13 Having visited this exhibition on a daily basis during the first two weeks, one critique, however, is that the signage for the guided tour service was quite non-existent at Ancien Palais de Justice.

14 In Asia 2006: the biennials of Singapure, Gwangju and Shanghai, to be expanded to the Biennale of Sydney in 2008; the European Grand Tour of 2007: Biennale di Venezia, documenta, Skulptur-Münster and Art Basel (Tang 2007: 248).

Chapter 7

1 The Agence de coopération culturelle et technique was first founded in 1970. In 1998, it was renamed the Agence Intergouvernementale de la Francophonie, and in 2005 it became the Organisation internationale de la Francophonie.

2 Afrique en Créations was founded in 1990. Its objective is to promote contemporary African creations in cultural markets in France and Europe.

3 Marylin Martin (South Africa) was the committee's president; the other members were Rachida Triki (Tunisia), Kunle Filani (Nigeria) and Marème Malong Samb (Cameroon).

4 The jury decides the major prizes that the Biennale awards.

5 The *Grand Prix du Chef de l'État* has been awarded as follows: 1992, Moustapha Dimé; 1998, Viyé Diba; 2002, Ndary Lo; and in 2008 again Ndary Lo together with Mansour Ciss Kanakassy (Senegal).

6 '*Le secrétariat général de la Biennale des Arts est chargé de la préparation, de l'organisation et du suivi de la Biennale des arts d'une dimension internationale, afin:*

– *d'assurer la promotion des artistes sénégalais en particulier et africains en général, de renforcer et d'élargir la diffusion des productions africaines dans le marché international des arts;*
– *de renforcer la capacité des professionnels de l'art contemporain africain et enfin de faire de Dakar une capitale africaine des arts.*'

7 It appears that in 1998 at least one artist tried to illegally introduce some audio-visual equipment by hiding it among the works of art.

Chapter 9

1 One great example is the ancient Benin court art, particularly the bronze plaques and carved ivories, which reflect the cross-cultural relationship between the palace and the Portuguese.
2 For an in-depth discussion of global contemporary, see Belting et al. (2013).
3 Author's interview with Youma Fall, co-curator of Dak'Art 2006 and former director of National Theatre, Dakar (27 April 2012, tape recording, Dakar).
4 Such model has since been abandoned by biennials in general. Artists are invited on an individual basis, although the Biennale di Venezia still retains the national pavilions format.
5 The new temporary exhibition space was a gift from the North Korean government, which has maintained a constant presence in the cultural landscape of Senegal. It supported the First World Festival of Black Arts in 1966, and most recently, produced and donated the monumental bronze sculpture *Renaissance Africaine*, a tourist attraction, in Ouakam suburb of Dakar.
6 Dak'Art '92: *Exploitation des Fiches d'Evaluation*. Documentation centre, Secrétariat Général, Dakar.
7 In the mid-1950s, a young Kacimi frequented the painting workshops organized by French interlocutor Jacqueline Brodskis in Casablanca (see Irbouh 2005).
8 In *Dead Aid* (2009), the Zambian-born international economist Dambisa Moyo addresses the encumbering effects of humanitarian and charity aid on African economies and the collective psyche of African peoples, arguing that it encourages corruption and economic indolence and suggesting instead that African governments should be made accountable to the domestic population.
9 The Nigerian-American writer Teju Cole's well-written essay 'The White-Savior Industrial Complex' (2012) offers a trenchant assessment of the duplicitous and paternalistic approach of the NGO industry in Africa.
10 Author's interview with Ousseynou Wade, former Secretary General of Dak'Art (1 February 2012, tape recording, Dakar). Wade's perspective on African art was either reaffirmed or reinforced in many interviews conducted in Dakar or during the biennial in 2010 and 2012, with the following: Ibrahima Niang (artist), interview by author (22 March 2012, tape recording); Ndary Lo (artist), interview by author (24 May 2010, 18 April 2012, tape recording); Sofiane Zouggar (artist), interview by author (13 May 2012, tape recording); Hervé Youmbi (artist), interview by author (28 May 2010, tape recording); Moridja Kitenge Banza (artist), interview by author (24 May 2010, tape recording); Moataz Nasr (artist), interview by author (14 May 2012, tape recording); Chika Modum (artist), interview by author (12 May 2012, tape recording); Abdou Sylla (art historian), interview by author (28 May 2010, tape recording); N'Goné Fall (curator), interview by author (9 June 2010, 17 May 2012, tape recording); Simon Njami (critic and curator), interview by author (19 January 2012, 12 May 2012); Marion Louisgrande-Sylla (curator), interview by author (21 April 2012); Raison Naidoo (co-curator of Dak'Art 2012), interview by author (9 May 2012, tape recording); Yacouba Konaté (philosopher, and curator), interview by author (13 May 2012, tape recording); and Achille Mbembe (philosopher and public intellectual), interview by author (12 May 2012, tape recording).

Chapter 10

1 The 2018 edition lists twelve venues as Dak'Art–In sites. These include exhibitions, concerts, the Biennale office, and the theatre where the Biennale held its opening ceremony. Previous editions included fewer In sites.

2 See https://www.labiennale.org/en/art/2019/collateral-events

3 The majority of collateral shows in Venice are not associated with artists and art world animateurs based in Venice.

4 The 1990 Biennale of Dakar focused on literature, Dak'Art 1992 focused on international visual art and Dak'Art 1996 focused on contemporary African art. No biennale took place in 1994.

5 For more on the Village des Arts, see Harney (2004) and Grabski (2017).

6 See Diop (2014: 17). There has been much discussion of the need to make Dak'Art independent from the government (see Sankalé, Chapter 7; Kouoh and De Caevel, Chapter 8). In the 2014 edition, the Secretary General suggested this in his introduction to the Dak'Art catalogue.

7 A similar case is presented for Tokyo (see Christian Morgner 2019).

8 The Off exhibitions have expanded in recent editions to Dakar's suburbs as well as the city of Saint-Louis.

9 This event was organized with EUNIC (Instituts culturels nationaux de l'Union européenne).

10 http://senegal.eiffage.sn/index.php/evenements-culturels

11 For more on the Biennale's funding, see Iolanda Pensa (2011).

12 Exhibitions and projects at Galerie Le Manège, the gallery of the Institut Français, are developed in consultation with an advisory board and often capitalize on related venues and networks in Africa and France.

13 An example drawn from my own participation in Dak'Art–Off 2010 is the collaborative Senegalese–US American printmaking workshop. My collaborative documentary film, *Market Imaginary*, premiered as a Dak'Art–Off site in 2012. Both the premiere and the workshop were sponsored by the US American Embassy's Cultural Affairs Office and the Public Affairs Section.

14 In his review of Dak'Art's 2006 edition, art writer and curator Storm Janse Van Rensburg includes a vivid account of his experience attempting to navigate Dak'Art–Off.

Chapter 11

1 In 1991 the magazine *Revue Noire* was founded. This publication played an enormously important part in surveying the state of contemporary cultural production in all the nations of the African continent and it shaped a new sophisticated style of portraying Africa. *Revue Noire* organized the exhibition *Les Artistes africains et le Sida* during Dak'Art 1996 and its team actively contributed to the debates and the evaluation of the event: Jean-Loup Pivin was a member of the selection committee of Dak'Art 1996, N'Goné Fall in 2002, and Simon Njami in 2000, and artistic director of the event in 2016 and 2018. *Revue Noire* has played a major role in inviting artists to apply to Dak'Art, and in communicating the Biennale. Likewise *Revue Noire* dedicated its thirteenth issue to Cameroon in 1994 and in 2010 it developed the project _trans- in

collaboration with Doual'art. In 2005 N'Goné Fall participated with the Senegalese architect Jean-Charles Tall in the *Ars & Urbis* symposium in Douala, a conference which represented the first step for the creation and design of SUD–Salon Urbain de Douala (Pensa 2005), and Simon Njami was artistic director of SUD in 2010.

2 Consideration and fame for artists tend to grow in their home countries after they have attended the Biennale of Dakar and in general after relevant international experiences. In the case of Cameroon, it appears clearly in the relationship of local artists such as Goddy Leye (1965–2011), Hervé Yamguen, Hervé Youmbi, or Salifou Lindou.

3 I know that Moataz Nasr did not want to go to the Biennale of Dakar because I wrote his application form in 2001 and made him propose his candidature, convinced as I was that it would be most significant for the Biennale and for his career.

4 Among the events involving Doual'art at the Biennale of Dakar was a presentation in 2006 organized by the Prince Claus Fund and the Mondrian Foundation to a Dutch group of visitors.

5 Artists who exhibited both in the Biennale of Dakar and in the SUD–Salon Urbain de Douala include Michèle Magema, Younés Rahmoun, Ato Malinda, Kader Attia, Tracey Rose, Faouzi Laatiris, Bili Bidjocka, Pascale Marthine Tayou, Salifou Lindou, Joseph-Francis Sumégné, Hervé Yamguen, Hervé Youmbi, Danièle Diwouta-Kotto, Sandrine Dole and Trinity Session involved in the *AfroPixel* Festival organized by Kër Thiossane.

6 Among the curators who contributed to both the Biennale of Dakar and the SUD in the official programme and in Dak'Art–Off are Cameroonian curator Koyo Kouoh, who created RAW Material Company art centre in Dakar, Elvira Dyangani Ose, Abdellah Karroum, N'Goné Fall and Simon Njami, as well as intellectuals such as the Cameroonian scholar Achille Mbembe, who lives in South Africa, and Ntone Edjabe, the Cameroonian founder of the South African magazine *Chimurenga*.

7 RAIN Artists' Initiatives is a brilliant initiative by Gertrude Flentge, who subsequently created among the best programmes of international cultural cooperation.

Epilogue

1 In the following, we use the term 'biennial' for the exhibition format.

2 Former Secretary General Rémi Sagna is listed as participant.

3 It was legally established as a private institution in November 2009. Its overall objectives are the interaction and communication between art biennials worldwide, and the promotion of the knowledge on biennials.

4 Szewczyk uses the term 'biennial bending' (2010: 30–1) to describe such a phenomenon.

5 A special form of this marginalization is the perspective of 'hope' these biennials could assume, to liberate from the neoliberal appropriation of the biennials system. Gardner and Green (2015) consider this 'to romanticise the South as a Deus ex machina from neoliberalised conditions' (ibid.: 34).

REFERENCES

Introduction

Altshuler, Bruce. (2013), *Biennials and Beyond: Exhibitions that Made Art History: 1962–2002*, London and New York: Phaedon Press.

Appadurai, Arjun. (1996), *Modernity at Large: Cultural Dimensions of Globalization*, Minneapolis and London: University of Minnesota Press.

Bajorek, Jennifer and Erin Haney. (2009), *Beyond the Biennial: Bamako at 15* years, London: Autograph ABP.

Born, Georgina. (2010), 'The Social and the Aesthetic: For a Post-Bourdieuian Theory of Cultural Production'. *Cultural Sociology*, 4 (2): 171–208.

Diop, Babacar Mbaye. (2018), *Critique de la notion d'art africain*, Paris: Hermann Éditeurs.

Elkins, James, Zhivka Valiavicharska and Alice Kim (eds) (2010), *Art and Globalization*, The Stone Art Theory Institutes vol. 1, Pennsylvania: The Penn State University Press.

Fillitz, Thomas. (2016), 'The Biennial of Dakar and South-South Circulations'. *ARTL@S Bulletin*, 5 (2): 57–69. Available online: http://docs.lib.purdue.edu/artlas/vol5/iss2/6/ (accessed 3 December 2016).

Gersovitz, Mark and John Waterbury (eds) (1987), *The Political Economy of Risk and Choice in Senegal*, London and New Jersey: Frank Cass and Co. Ltd.

Grabski, Joanna. (2017), *Art World City. The Creative Economy of Artists and Urban Life in Dakar*, Bloomington, Indiana: Indiana University Press.

Green, Charles and Anthony Gardner. (2016), *Biennials, Triennials, and documenta. The Exhibitions that Created Contemporary Art*, Malden, MA and Oxford: Wiley Blackwell.

Konaté, Yacouba. (2009), *La Biennale de Dakar. Pour une esthétique de la création africaine contemporaine – tête à tête avec Adorno*, Paris: L'Harmattan, La Bibliothèque d'Africultures.

Konaté, Yacouba. (2010), 'The Invention of the Dakar Biennial', in *The Biennial Reader*, Elena Filipovic, Marieke van Hal and Solveig Øvstebø (eds), 106–29. Bergen and Ostfildern: Bergen Kunsthall and Hatje Cantz.

Lampel, Joseph and Alan D. Meyer. (2008), 'Guest Editors' Introduction. Field-Configuring Events as Structuring Mechanisms: How Conferences, Ceremonies, and Trade Shows Constitute New Technologies, Industries, and Markets'. *Journal of Management Studies*, 45 (6): 1025–35.

Leivestad, Hege Høyer and Anette Nyqvist (eds) (2017), *Ethnographies of Conferences and Trade Fairs*, Cham, Switzerland: Palgrave Macmillan.

Mauchan, Fiona. (2009), *The African Biennale: Envisioning 'Authentic' African Contemporaneity*, Stellenbosch: MA thesis Stellenbosch University. Available online: http://scholar.sun.ac.za/handle/10019.1/2596 (accessed 15 May 2016).

Moeran, Brian and Jesper Strandgaard Pedersen (eds) (2011), *Negotaiting Values in the Creative Industries. Fairs, Festivals and Competitive Events*, Cambridge, UK: Cambridge University Press.

Mudimbe, Valentin Y. (2009), 'Préface de Valentin Y. Mudimbe', in *La Biennale de Dakar. Pour une esthétique de la création africaine contemporaine – tête à tête avec Adorno*, Yacouba Konaté, 7–12, Paris: L'Harmattan, La Bibliothèque d'Africultures.

Nyqvist, Anette, Hege Høyer Leivestad and Hans Tunestad. (2017), 'Individuals and Industries: Large-Scale Professional Gatherings as Ethnographic Fields', in *Ethnographies of Conferences and Trade Fairs*, Hege Høyer Leivestad and Anette Nyqvist (eds), 1–21, Cham, Switzerland: Palgrave Macmillan.

Nzewi, Ugochukwu-Smooth C. (2013), *The Dak'Art Biennial in the Making of Contemporary African Art, 1992–Present*, Atlanta: PhD-thesis Emory University. Available online: https://legacy-etd.library.emory.edu/view/record/pid/emory:f3rxn (accessed 25 May 2014).

Pensa, Iolanda. (2011), *La Biennale de Dakar comme projet de coopération et de développement,* Paris and Milan: PhD-thesis, École des Hautes Études en Sciences Sociales and Politecnico di Milano.

Power, Dominic and Johan Jansson. (2008), 'Cyclical Clusters in Global Circuits: Overlapping Spaces in Furniture Trade Fairs'. *Economic Geography*, 84 (4): 423–49.

Rodatus, Verena. (2015), *Postkoloniale Positionen? Die Biennale Dak'Art im Kontext des internationalen Kunstbetriebs,* transpekte/transpects vol. 8, Frankfurt/Main: PL Academic Research-Peter Lang.

Rojas-Sotelo, Miguel I. (2009), *Cultural Maps, Networks and Flows: The History and Impact of the Havana Biennale*, Pittsburgh: PhD-thesis, University of Pittsburgh.

Smith, Terry. (2009), *What is Contemporary Art?* Chicago and London: The University of Chicago Press.

Chapter 1

Chowdhry, Geeta and Mark Beeman. (1994), 'Senegal', in *The Political Economy of Foreign Policy in ECOWAS*, Timothy M. Shaw and Julius Emeka Okolo (eds), 147–72, New York: St. Martin's Press.

Deliss, Clémentine. (1993), 'The Dakar Biennale '92: Where Internationalism Falls Apart'. *Third Text,* 7 (23): 136–41.

Diop, Alioune. (1947), 'Niam n'goura ou les raisons d'être de Présence Africaine'. *Présence Africaine*, 1: 7–14.

Diop, Alioune. (1956), 'La Culture Moderne et Notre Destin'. *Présence Africaine*, 8/10: 3–6. Available online: http://www.jstor.org/stable/24346884 (accessed 15 May 2019).

Diouf, Abdou. (1992), 'Inaugural address at the Biennale Internationale des Arts de Dakar', in Fraternité, métissage, dialogue des cultures, *Le Soleil*, December 15: 10.

Diouf, Abdou. (1990), 'Message de son Excellence Monsieur Abdou Diouf, Président de la République du Sénégal', in *Biennale de Dakar 1990*, exhibition catalogue, 3, Dakar: Ministère de la Culture et de la Communication.

Diouf, Abdou. (1995), 'Art against Apartheid (Inauguration address, Dakar, 1986)', in *Seven Stories about Modern Art in Africa: An Exhibition*, Clementine Deliss (ed.), exhibition catalogue, 236, New York: Flammarion.

Ebong, Ima. (1991), 'Negritude: Between Mask and Flag – Senegalese Cultural Ideology and the Ecole de Dakar', in *Africa Explores: 20th Century African Art*, Susan Vogel (ed.), 198–209, New York and Munich: The Center for African Art and Prestel.

Easterly, William. (2005), 'What did structural adjustment adjust? The association of policies and growth with repeated IMF and World Bank adjustment loans'. *Journal of Development Economics,* 76: 1–22.

Harney, Elizabeth. (2004), *In Senghor's Shadow: Art, Politics and the Avant-garde in Senegal, 1960-1995*, Durham and London: Duke University Press.

Hooker, J.R. (1974), 'The Pan-African Conference 1900'. *Transition*, 46: 20–4.

Huchard, Ousmane Sow. (1989), 'The Salons of the Senegalese Artists', in *Bildende Kunst der Gegenwart in Senegal/ Senegal/Anthologie des Arts Plastiques Contemporains au Sénégal/ Anthopology of Contemporary Fine Arts in Senegal*, Friedrich Axt and El Hadji Moussa Babacar Sy (eds), 77–8, Frankfort/Main: Museum für Völkerkunde.

Ka, Moustapha. (1990), 'Message du Ministre de la Culture et de la Communication', in *Biennale de Dakar 1990*, exhibition catalogue, 5, Dakar: Ministère de la Culture et de la Communication.

Ka, Moustapha. (1992), 'Préface', in *Dakar 1992: Biennnale Internationale des Arts*, Secrétariat Général (ed.), exhibition catalogue, 2, Dakar and Paris: Beaux Arts.

Kennedy, Ellen C. (1974), 'Translator's Introduction', in *Black Writers in French: A Literary History of Negritude*, Lilyan Kesteloot, trans. Ellen Conroy Kennedy, xiii, Philadelphia: Temple University Press.

Konaté, Yacouba. (2010), 'The Invention of the Dakar Biennial', in *The Biennial Reader*, Elena Filipovic, Marieke Van Hal and Solveig Øvstebø (eds), 104–21, Bergen: Kunsthall and Ostfildern: Hatje Cantz.

Langley, Ayodele. (1979), *Ideologies of Liberation in Black Africa*, London: Rex Collings.

Markovitz, Leonard I. (1969), *Léopold Sédar Senghor and the Politics of Négritude,* New York: Atheneum.

McCarthy, Cameron and Dimitridas, Greg. (2000), 'Art and the Postcolonial Imagination: Rethinking the Institutionalization of Third World Aesthetics and Theory'. *ARIEL*, 31 (1–2): 233–53.

M'Bengue, Mamadou Seyni. (1973), *Cultural Policy in Senegal*, Paris: UNESCO.

Musée du Quai Branly. (2010), *Présence Africaine: A Forum, a Movement, a Network* (Exhibition file, 10/11/2009–31/01/2010).

Niane, Djibril Tamsir. (1989), 'The Exhibitions of Senegalese Contemporary Art Abroad', in *Bildende Kunst der Gegenwart in Senegal/ Senegal/Anthologie des Arts Plastiques Contemporains au Sénégal/ Anthopology of Contemporary Fine Arts in Senegal*, Friedrich Axt and El Hadji Moussa Babacar Sy (eds), 83–4, Frankfort/Main: Museum für Völkerkunde.

Nzewi, Ugochukwu-Smooth C. (2012), 'Curating Africa, Curating the Contemporary: The Pan-African Model of Dak'Art Biennial'. *SAVVY: Journal of Contemporary African Art,* 4: 34–40.

Nzewi, Ugochukwu-Smooth C. (2013), 'The contemporary present and modernist past in postcolonial African art'. *World Art*, 3 (2): 211–34. DOI: 10.1080/21500894.2013.775899.

Martini, Vittoria. (2010), 'The Era of the Histories of Biennials has Begun. A review of the lectures "Historical Origins" by Caroline A. Jones and "The Global Art World" by Charlotte Bydler', in *The Biennial Reader*, Elena Filipovic, Marieke Van Hal and Solveig Øvstebø (eds), vol. 2, 9–13, Bergen: Kunsthall and Ostfildern: Hatje Cantz.

Sherwood, Marika. (2011), *Origins of Pan-Africanism: Henry Sylvester Williams, Africa, and the African Diaspora*, London and New York: Routledge.

Smith, Terry. (2009), *What is Contemporary Art?*, Chicago and London: The University of Chicago Press.

Smith, Terry. (2011), 'Currents of world-making in contemporary art'. *World Art*, 1 (2): 171-188. DOI: 10.1080/21500894.2011.602712.

Snipes, Tracy. (1998), *Art and Politics in Senegal, 1960-1996*, Trenton, NJ and Asmara: Africa World Press.

Sylla, Abdou. (1998), *Arts plastiques et état au Sénégal: Trente-cinq ans de mécénat au Sénégal*, Dakar: IFAN-CH.A. Diop, Université CH.A. Diop de Dakar.

Underwood, Joseph L. (2019), 'Tendances et Confrontations: an experimental space for defining art from Africa'. *World Art*, 9 (1): 43–65. DOI: 10.1080/21500894.2018.1450286.

Zaya, Octavia. (1993), 'On Dak'Art 92'. *Atlantica*, 5: 126–8.

Chapter 2

Aziza, Mohammed. (1980), *La Poésie de l'action*, Paris: Stock.

Boilat, David. ([1853] 1984), *Esquisses sénégalaises*, Paris: Khartala.

DakarActu. (2012), 'Intégralité du discours à la nation du président Abdoulaye Wade'. Available online: https://www.dakaractu. com/L-integralite-du-discours-a-la-nation-du-president-Abdoulaye-Wade_a9900.html (accessed 27 August 2018).

Diouf, Abdou. (1988), 'Vos œuvres incarnent l'espérance'. *Le Soleil*, 4–5 June.

Enwezor, Okwui and Franz W. Kaiser. (2002), *Vous avez dit primitif ? Iba Ndiaye, peintre entre continents*, Paris: Adam Biro.

Faye, Ibrahima Lissa (2010), 'Intégralité du discours à la nation du président Abdoulaye Wade', *PressAfrik*. Available online: https://www.pressafrik.com/Integralite-du-discours-a-la-nation-du-president-Abdoulaye-Wade_a46854.html (accessed 02 August 2018).

Gouvernement République du Sénégal. (2014), 'Plan Senegal Emergent'. Available online: https://www.sec.gouv.sn/sites/default/files/Plan%20Senegal%20Emergent_0.pdf, (accessed 04 December 2018).

Gouvernement République du Sénégal. (2017), 'Message à la Nation de son Excellence, Monsieur le Président Macky SALL, à l'occasion de la célébration du 57e anniversaire de l'Indépendance du Sénégal'. Available online: https://www.sec.gouv.sn/ actualit%C3%A9/message-%C3%A0-la-nation-de-son-excellence-monsieur-le-pr%C3%A9sident-macky-sall-%C3%A0-l%E2%80%99occasion-de-la, (accessed 10 November 2018).

Gouvernement République du Sénégal. (2018), 'Discours du Président de la République à l'occasion de l'inauguration du Musée des Civilisations Noires (MCN)'. Available online: https://www.sec.gouv.sn/actualit%C3%A9/discours-du-pr%C3%A9sident-de-la-r%C3%A9publique-%C3%A0-loccasion-de-linauguration-du-mus%C3%A9e-des (accessed 07 January 2019).

Mbaye, Massamba. (2009), 'Refuser le destin du mouton'. *Ethiopiques* 83. Available online: http://ethiopiques.refer.sn/spip.php?page=imprimer-article&id_article=1683 (accessed 14 Mai 2019).

Mouralis, Bernard. (1995), '"Les Esquisses sénégalaises" de l'abbé Boilat, ou le nationalisme sans la négritude', *Cahiers d'études africaines*. 140 (35): 819–37.

Premier Festival Mondial des Arts Nègres. (1966), exhibition catalogue, Dakar.

Revue Noire. (1998), *Anthologie de la photographie africaine, de l'Océan indien et de la Diaspora*, Paris: Éditions Revue Noire.

Sankhare Oumar et Alioune Badara Diane. (1999), *Notes sur Ethiopiques*, Saint-Louis: Xamal.

Seck, Sidy. (2003), 'L'École de Dakar : réalité historique ou escroquerie intellectuelle', *Ethiopiques* 70. Available online: http://ethiopiques.refer.sn/spip.php?page=imprimer-article&id_article=48 (accessed 06 January 2019).

Seck, Tom Amadou. (1998), 'Résistances de la société civile: Le Sénégal au défi de l'ajustement structurel'. *Le Monde Diplomatique,* October: 4–5.

Senghor, Léopold Sédar. (1964), *Liberté I, Négritude et humanisme,* Paris: Seuil.

Senghor, Léopold Sédar. (1966), Conférence prononcée à l'Université de Montréal, le 26 septembre.

Senghor, Léopold Sédar. (1969), *Élégies des Alizés,* Paris: Seuil.

Senghor, Léopold Sédar. (1977), *Liberté II, Négritude et Civilisation de l'Universel,* Paris: Seuil.

Senghor, Léopold Sédar. (1989), 'Introduction', in *Bildende Kunst der Gegenwart in Senegal/ Senegal/Anthologie des Arts Plastiques Contemporains au Sénégal/ Anthopology of Contemporary Fine Arts in Senegal,* Friedrich Axt and El Hadji Moussa Babacar Sy (eds), 10–20 Frankfurt/Main: Museum für Völkerkunde.

Snipe, Tracy D. (1998), *Arts and Politics in Senegal* (1960–1996), Trenton: Africa World Press.

Sy, Kalidou. (1992–3), 'Biennale de Dakar 92: confrontation?', *Revue Noire,* 7: 16.

Sylla, Abdou. (1997), 'Senghor 90, Salve Magister. Hommage au Président Léopold Sédar Senghor à l'occasion de son 90ème anniversaire', *Ethiopiques* 59. Available online: http://ethiopiques.refer.sn/spip.php?article368 (accessed 22 August 2018).

Sylla, Abdou. (1998), *Arts Plastiques et Etat au Sénégal: Trente Cinq Ans de Mécénat au Sénégal.* Dakar: IFAN-Ch. A. Diop.

Tchédji, Gilles A. (2010), '50 ans de politique culturelle au Sénégal: Du génie de Senghor au complexe de Wade', *lequotidien.sn,* 13 April. Available online : http://xalimasn.com/50-ans-de-politique-culturelle-au-senegal-du-genie-de-senghor-au-complexe-de-wade/ (accessed 10 December 2018).

Chapter 3

Harney, Elizabeth. (1996), '"Les Chers Enfants" sans Papa', *Oxford Art Journal,* 19 (1): 42–52.

Huchard, Ousmane Sow. (1994), *Viyé Diba: Plasticien de l'environnement,* Dakar: Sépia éditions–NEAS.

Chapter 4

Biennale de Dakar. (1998), 'Comité International de Sélection et Jury de Dak'Art 98', in *Biennale de l'art africain contemporain,* Secrétariat Général (ed.), n.p., exhibition catalogue, Dakar: Biennale des Arts de Dakar.

Buchholz, Larissa. (2016), 'What is a global field? Theorizing fields beyond the nation-state'. *The Sociological Review Monographs,* 64 (2): 31–60. DOI:10.1111/2059-7932.12001.

Diamond, Sara. (2004). 'Decision and Process: the International Selection Committee', in *Dak'Art 2004, 6ème Biennale de l'Art Africain Contemporain,* Secrétariat Général (ed.), 15, exhibition catalogue, Dakar: Biennale des Arts de Dakar.

Diba, Viyé. (2006), 'Dak'Art 2006: A View from the Inside', *African Arts,* 39 (4): 62–3.

Diop, Babacar Mbaye. (2018), *Critique de la notion d'art africain.* Paris: Hermann.

Eyene, Christine. (2008), 'Dak'Art 2008. Africa's Mirror or Distorted Refection?' *Third Text,* 22 (6): 790–3. Available online: https://doi.org/10.1080/09528820802652573 (accessed 14 February 2016).

Eyene, Christine. (2012), 'On the process', in *Dak'Art 2012, 10ème biennale de l'art africain contemporain*, Secrétariat Général (ed.), exhibition catalogue, 14–15, Dakar: La Rochette.

Filipovic, Elena, Marieke van Hal and Solveig Østebø. (2010), 'Biennalogy', in *The Biennial Reader*, Elena Filipovic, Marieke van Hal, Solveig Østebø (eds), 12–27, Bergen: Kunsthall and Ostfildern: Hatje Cantz.

García-Antón, Katya. (1998), 'Dak'Art 98'. *Third Text*, 12 (44): 87–92. Available online: http://dx.doi.org/10.1080/09528829808576754 (accessed 15 May 2004).

Green, Charles and Anthony Gardner. (2016), *Biennials, Triennials, and documenta: The Exhibitions that Created Contemporary Art*, Malden, MA and Oxford: Wiley Blackwell.

Groys, Boris. (2008), *Art Power*, Cambridge, MA and London: The MIT Press.

Huchard, Ousmane Sow. (2010), *La Culture, ses Objets-Témoins et l'Action Muséologique*, Dakar: Le Nègre International de Dakar.

Konaté, Yacouba. (2009), *La Biennale de Dakar. Pour une esthétique de la création africaine contemporaine – tête à tête avec Adorno.* Paris: L'Harmattan, La Bibliothèque d'Africultures.

Laggoune-Aklouche, Nadira. (2012), 'Dak'Art, an African specificity', in *Dak'Art 2012, 10ème biennale de l'art africain contemporain*, Secrétariat Général (ed.), exhibition catalogue, 18–19, Dakar: La Rochette.

Naidoo, Riason. (2012), 'Not by coincidence!', in *Dak'Art 2012, 10ème biennale de l'art africain contemporain*, Secrétariat Général (ed.), exhibition catalogue, 22–3, Dakar: La Rochette.

Njami, Simon. (2016), 'La puissance voyante / The Seeing Power', in *Réenchantements. La Cité dans le jour bleu / Reenchantments. The City in the Blue Daylight, Dak'Art 12*, Simon Njami (ed.), exhibition catalogue, 20–41, Bielefeld and New York: Kerber Verlag.

Pensa, Iolanda. (2011), *La Biennale de Dakar comme projet de cooperation et de développement,* Paris and Milan: PhD-thesis École des Hautes Études en Sciences Sociales and Politecnico di Milano.

Smith, Terry. (2012), *Thinking Contemporary Curating*, ICI Perspectives in Curating No. 1, New York: Independent Curators International.

Tang, Jeannine. (2011), 'Biennalization and its Discontent', in *Negotiating Values in the Creative Industries. Fairs, Festivals and Competitive Events,* Brian Moeran and Jesper Strandgaard Pedersen (eds), 73–93, Cambridge, UK: Cambridge University Press.

Vincent, Cédric. (2007), '"Le grand défi de Dak'Art, c'est l'élargissement de son public," entretien avec Rémi Sagna', in Festivals et biennales d'Afrique: machine ou utopie? *Africultures*, 73: 131–7.

Wade, Ousseynou. (2006), 'Dak'Art 2006, the stakes and broad outlines', in *Dak'Art 2006, 7ème biennale de l'art africain contemporain*, Secrétariat Général (ed.), 16–17, exhibition catalogue, Dakar: Biennale des Arts de Dakar.

Chapter 5

Aka, Jean-Philippe. (2014), *Africa Art Market Report 2014. Modern/Contemporary/Design.* Create Space Independent Publishing Platform.

Biennale of Dakar. (2014), *Rapport de la 11e édition de la Biennale de l'art africain contemporain. D'ak'Art 2014*, Dakar: Biennale des Arts de Dakar.

Biennale of Dakar. (2016), *Rapport de la 12ᵉ édition de la Biennale de l'art africain contemporain. Dak'Art 2016,* Dakar: Biennale des Arts de Dakar.

Bosman, Isabelle. (1992), *La Biennale internationale des arts plastiques de Dakar. 10–20 décembre 1992.* Rapport d'évaluation réalisé pour la Commission des Communautés Européennes. Document de travail.

Cissé, Aminata Diaw. (2004), 'Contemporary African Art in its quest for a centre of gravity: the globalisation challenge', in *6ᵉᵐᵉ Biennale de l'art africain contemporain,* Secrétariat Général (ed.), 172–5, Dakar: Biennale des Arts de Dakar.

Diadji, Iba Ndiaye. (2002), *L'impossible art africain,* Dakar: éditions Dêkkando.

Diadji, Iba Ndiaye. (2003), *Créer l'art des africains,* Dakar: Presses Universitaires de Dakar.

Diouf, Mamadou. (2012), '"What Senegalese artists are saying:" citizen art in contemporary Senegal', *Dak'Art 2012. 10ᵉᵐᵉ biennale de l'art africain contemporain,* Secrétariat Général (ed.), 162–8, Dakar: Biennale des Arts de Dakar.

Huchard, Ousmane Sow and Alioune Badiane. (no year), *Rapport d'orientation du Conseil Scientifique de la Biennale de Dakar, Préparation du Dak'Art 94.*

Konaté, Yacouba. (2009), *La Biennale de Dakar. Pour une esthétique de la création africaine contemporaine – tête à tête avec Adorno,* Paris: L'Harmattan.

Malbert, Marylène. (2006), *Les relations artistiques internationales à la Biennale de Venise: 1948-1968,* vol. 2., Paris: PhD thesis, Université Paris I.

Ministère de la culture. (no year), *Séminaire d'évaluation de la Biennale de Dakar. Quelle Biennale pour Dakar ? (Quelques axes pour une réflexion future),* résumé des observations de la Commission scientifique.

Ndiaye, El Hadji Malick. (2018), 'Transformations et émancipations', in *L'heure Rouge. Contours,* Simon Njami (ed.), vol. 2, 284–7, Dakar: La Biennale de l'art africain contemporain.

Roche, Maurice (2000), *Mega-events and modernity. Olympics and expos in the growth of global culture,* London and New York: Routledge.

Sagna, Rémi and N'Goné Fall. (2006), 'Dak'Art. Témoignages'. *Africa e Mediterraneo,* 55: 43–9.

Secrétariat de la Biennale. (no year), *Biennale internationale des Arts et lettres de Dakar. Dak'Art 92. Evaluation et bilan financier.*

Sylla Abdou. (2008). 'Les arts plastiques sénégalais contemporains'. *Ethiopiques,* 80. Available online: http://ethiopiques.refer.sn/spip.php?article1599 (accessed 01 February 2019).

Chapter 6

Artnet News. (2014), 'World's Top 20 Biennials, Triennials, and Miscellennials. The artnet News power ranking of biennials', May 19. Available online: https://news.artnet.com/exhibitions/worlds-top-20-biennials-triennials-and-miscellennials-18811 (accessed 22 January 2018).

Ba, Marième. (2018), 'Elargir l'audience de la Biennale', in *Dak'Art 2018. L'heure Rouge. Pour une nouvelle Humanité, Dossier de presse,* 7. Available online: http://biennaledakar.org/2018/wp-content/uploads/2018/04/DAKART-2018-dossier-presse-FR-V6.pdf (accessed 20 April 2018).

Birane. (2018), 'Le Dak'Art 2018 a généré 2,28 milliards de francs CFA, selon l'Ansd'. *XalimaNews,* 31 octobre. Available online: http://xalimasn.com/le-dakart-2018-a-genere-228-milliards-de-francs-cfa-selon-lansd/ (accessed 18 May 2019).

Bob, Bigué. (2018), 'Réconcilier les artistes et le public. Viyé Diba, commissaire du Pavillon Sénégal'. *Dak'Art Actu*, 6: 11.

Budney, Jen. (1998), 'Who's It For?'. *Third Text*, 12 (42): 88–94. DOI:10.1080/09528829808576723.

Chaney, David. (2002), 'Cosmopolitan Art and Cultural Citizenship'. *Theory, Culture & Society*, 19 (1–2): 157–74.

Clark, John. (2010), 'Biennials as Structures for the Writing of Art History: The Asian Perspective', in *The Biennial Reader*, Elena Filipovic, Marieke van Hal, Solveig Øvstebø (eds), 164–83, Bergen: Bergen Kunsthall and Ostfildern: Hatje Kantz.

Fall, Youma. (2009), '*La Biennale de Dakar: Impact social et culturel*', Conference held at the University of Erfurth (Germany). Available online: https://www.yumpu.com/fr/document/view/36075809/dr-youma-fall-confacrence-et-discussion-a-universitac-erfurt- (accessed 09 September 2015).

Fall, Youma. (2010), 'Dak'Art: Transplant or Adaptational Model?', in *Dak'Art 2010. 9ème Biennale de l'Art Africain Contemporain*. 182–6, exhibition catalogue, Dakar: Biennale des Arts de Dakar.

Fillitz, Thomas. (2012), 'The Mega-Event and the World Culture of Biennials: Dak'Art, the Biennale of Dakar', in The Event as a Privileged Medium in the Contemporary Art World. *Maska*, 147–8: 114–21. ('Megadogodek in Globalna Kultura Bienalov; Dak'Art, Dakarski Bienale', in Dogodek kot Priviegirani Meddij na Podrocju Sodobne Likovne Umetnosti. *Maska*, 147–8: 106–13.)

Green, Charles and Anthony Gardner. (2016), *Biennials, Triennials, and documenta. The Exhibitions that Created Contemporary Art*, Malden, MA and Oxford: Wiley Blackwell.

Konaté, Yacouba. (2009), *La Biennale de Dakar. Pour une esthétique de la création africaine contemporaine – tête à tête avec Adorno*. Paris: L'Harmattan, La Bibliothèque d'Africultures.

Ketterizsch, Peter. (2007), 'Kunstfans kommen wieder', *Hessische/Niedersächsische Allgemeine*. Kassel, May 18. Available online: https://de.wikipedia.org/wiki/Documenta (accessed 09 April 2016).

Lampel, Joseph and Alan D. Meyer. (2008), 'Guest Editors' Introduction. Field-Configuring Events as Structuring Mechanisms: How Conferences, Ceremonies, and Trade Shows Constitute New Technologies, Industries, and Markets'. *Journal of Management Studies*, 45 (6): 1025–35.

Ministère de la Culture et de la Communication du Sénégal. (2018), 'Remise du rapport de la biennale 2018: Le ministre salue les innovations du 13ème Dak'Art", 30 octobre. Available online: http://www.culture.gouv.sn/?q=remise-du-rapport-de-la-biennale-2018-le-ministre-salue-les-innovations-du-13eme-dakart (accessed 18 May 2019).

Secrétaire Générale. (2017), 'Règlement intérieur de la Treizième Edition de la Biennale de Dakar Mai 2018'. *Draft-Règement-intérieur-DakArt-2018-au-29-mars-2017*. Available online: http://biennaledakar.org/ (accessed 17 April 2018).

Sheikh, Simon. ([2009] 2010), 'Marks of Distinction, Vectors of Possibility: Questions for the Biennial', in *The Biennial Reader*, Elena Filipovic, Marieke van Hal, Solveig Øvstebø (eds), 150-163, Bergen: Bergen Kunsthall and Ostfildern: Hatje Kantz.

Tang, Jeannine. (2007), 'Of Biennials and Biennalists. Venice, Documenta, Münster'. *Theory, Culture & Society*, 24 (7–8): 247–60.

Vincent, Cédric. (2007), '"Le grand défi de Dak'Art, c'est l'élargissement de son public," entretien avec Rémi Sagna', in Festivals et biennales d'Afrique: machine ou utopie? *Africultures*, 73: 131–7.

Chapter 7

République du Sénégal Primature. (2008), 'Décret n° 2008–832 du 31 Juillet 2008. Article 7 – Le Secrétariat général de la Biennale des Arts'. *Journal Official*, 6443 du Samedi 20 décembre. Available online: http://www.jo.gouv.sn/spip.php?article7208 (accessed 07 June 2019).

Chapter 9

Alberro, Alexander. (2009), 'Periodising Contemporary Art', in *Crossing Cultures: Conflict, Migration, Convergence, Proceedings of the 32nd Congress of the International Committee for the History of Art*, Jaynie Anderson (ed.), 961–5, Melbourne: Melbourne University Press.

Appiah, Kwame Anthony. (2007), *Cosmopolitanism: Ethics in a World of Stranger*, London: Penguin.

Beier, Ulli. (1968), *Contemporary Art in Africa*, New York: Praeger Publishers.

Belting, Hans, Andrea Buddensieg and Peter Weibel (eds) (2013), *The Global Contemporary and the Rise of New Art Worlds*, Cambridge, MA and London: The MIT Press.

Brown, Evelyn. (1966), *Africa's Contemporary Art and Artists*, New York: Harmon Foundation.

Cole, Teju (2012), 'The White Savior Industrial Complex'. *The Atlantic*, March 21. Available online: http://www.theatlantic.com/international/archive/2012/03/the-white-savior-industrial-complex/254843/ (accessed 21 June 2019).

Enwezor, Okwui, Katy Siegel and Ulrich Wilmes (eds) (2016), *Postwar: Art Between the Pacific and the Atlantic, 1945-1965*, exhibition catalogue, Munich: Haus der Kunst.

Fillitz, Thomas. (2009), 'Contemporary Art of Africa: Coevalness in the Global World', in *The Global Art World: Audiences, Markets, and Museums*, Hans Belting and Andrea Buddensieg (eds), 116–135, Ostfildern: Hatje Cantz.

Hall, Stuart. (1992), 'New Ethnicities', in *Race, Culture and Difference*, James Donald and Ali Rattansi (eds), 441–9, London: Sage.

Hess, Janet (2006), 'Spectacular Nation: Nkrumahist Art and Resistance Iconography in the Independence Era'. *African Arts*, 39 (1): 16–25, 91–2.

Irbouh, Hamid. (2005), *Art in the service of colonialism: French art education in Morrocco, 1912-1956*, London: Tauris Acad. Studies.

Kasfir, Sidney Littlefield. (1999), *Contemporary African Art*, London: Thames and Hudson.

Kasfir, Sidney Littlefield. (2013), 'African Visual Culture', in *Oxford Handbook of Modern African History*, John Parker and Richard Reid (eds), 437–56, Oxford and London: Oxford University Press.

Moyo, Dambisa. (2009), *Dead Aid: Why Aid Is Not Working and How There Is a Better Way for Africa*, New York: Farrar, Straus and Giroux.

Okeke-Agulu, Chika. (2015), *Postcolonial Modernism: Art and Decolonization in Twentieth-Century Nigeria*, Durham and London: Duke University Press.

Papastergiadis, Nikos. (2008), 'Spatial Aesthetics: Rethinking the Contemporary', in *Antinomies of Art and Culture: Modernity, Postmodernism, Contemporaneity*, Terry Smith, Okwui Enwezor and Nancy Condee (eds), 363–82, Durham and London: Duke University Press.

Rojas-Sotelo, Miguel. (2011), 'The Other Network: The Havana Biennale and the Global South'. *The Global South*, 5 (1): 153–74. DOI 10.2979/globalsouth.5.1.153.

Smith, Terry. (2010), 'The State of Art History: Contemporary Art'. *The Art Bulletin*, 92 (4): 366–83. DOI.org/10.1080/00043079.2010.10786119.

Van Der Watt, Liese. (2004), 'Tracing: Berni Searle'. *African Arts*, 37 (4): 74–96. DOI. org/10.1162/afar.2004.37.4.74.

Chapter 10

BBC. (2019), 'How I Made Fathers in Senegal Carry Their Babies on their Backs', *BBC News*, 16 April. Available online: https://www.bbc.com/news/world-africa-47922717

Diop, Babacar Mbaye. (2014), 'Challenges', in *Dak'Art 2014; 11ème Biennale de l'art africain contemporain,* Secrétariat Général (ed.), 17, Dakar: La Rochette.

Grabski, Joanna. (2017), *Art World City: The Creative Economy of Artists and Urban Life in Dakar,* Bloomington, Indiana: Indiana University Press.

Haferburg, Christoph and Malte Steinbrink. (2017), 'Mega-Events in Emerging Nations and the Festivalization of the Urban Backstage: The Cases of Brazil and South Africa', in *The Sage Handbook of New Urban Studies*, John Hannigan and Greg Richards (eds), 267–90, London: Sage.

Harney, Elizabeth. (2004), *In Senghor's Shadow: Art, Politics, and the Avant-Garde in Senegal, 1960-1995*, Durham and London: Duke University Press.

Morgner, Christian. (2019), 'Spatial Barriers and the Formation of Global Art Cities'. *International Journal of Japanese Sociology*, 28: 183–208.

OFF Guide. (2014), *Guide et Programme IN & OFF*, Khalifa Dieng and Mauro Petroni (coordination), Dakar: La Rochette.

Pensa, Iolanda. (2011), *La Biennale de Dakar comme projet de coopération et de développement,* Paris and Milan: PhD-thesis, École des Hautes Études en Sciences Sociales and Politecnico di Milano.

Van Rensburg, Storm Janse. (2006), 'Art Routes: Negotiating Dak'Art'. *African Arts*, 39 (4): 66–7.

Chapter 11

Babina, Lucia and Marilyn Douala Bell (eds) (2008), *Douala in Translation: A View of the City and Its Creative Transformative Potentials*, Rotterdam: Episode Publishers.

Nzewi, Ugochukwu-Smooth C. (2015), 'Art and the Public Space – Doual'art Since 1991: A Conversation between Ugochukwu-Smooth C. Nzewi and Marilyn Douala Bell', in *New Spaces for Negotiating Art and Histories in Africa* Kerstin Pinther, Ugochukwu-Smooth Nzewi and Berit Fischer (eds), 6–21, Berlin: Lit Verlag.

Odijk, Els van and Gertrude Flentge. (2001), *Silent Zones: On Globalisation and Interaction*, Amsterdam: Rijksakademie van Beeldende Kunsten.

Pensa, Iolanda (ed.) (2005), *Ars & Urbis*, Special Issue, *Africa e Mediterraneo*, 50.

Pensa, Iolanda and Sandra Federici (eds) (2006). *Sulla storia dell'arte contemporanea africana*, Special Issue, *Africa e Mediterraneo*, 55.

Pensa, Iolanda. (2011), *La Biennale de Dakar comme projet de coopération et de développement,* Paris and Milan: PhD-thesis, École des Hautes Études en Sciences Sociales and Politecnico di Milano.

Pensa, Iolanda. (2013), 'I'll have a project. How international grants and cultural cooperation have shaped contemporary African art into a project made of objectives, activities and expected results'. *Seismopolite Journal of Art and Politics*, 5.

Pensa, Iolanda (ed.) (2017a), *Public Art in Africa. Art et transformations urbaines à Douala /// Art and Urban Transformations in Douala,* Geneva: MetisPresses.

Pensa, Iolanda. (2017b), 'System Error. Art as a space to produce what we would never have thought we needed', in *Contemporary Perspectives in Art and International Development*, Polly Stupples and Katerina Teaiwa (eds), 104–17, London and New York: Routledge.

Simone, Abdoumaliq. (2008), 'Practices of Convertibility in Inner City Douala and Johannesburg', in *Gendering Urban Space in the Middle East, South Asia and Africa*, Kamran Asdar Ali and Martina Rieker (eds), 135–68, London: Palgrave Macmillan.

Epilogue

Bilat, Galit, Nuria Enguita Mayo, Charles Esche, Pablo Lafuente, Luiza Proença, Oren Sagiv and Benjamin Seoussi (eds) (2015), *Making Biennials in Contemporary Times. Essays from the World Biennial Forum no.2 São Paolo, 2014*, Amsterdam and São Paolo: Biennial Foundation–Fundação Bienal de São Paulo; ICCo–Instituto de Cultura Contemporânea. Available online: https://issuu.com/iccoart/docs/wbf_book_r5_issuu (accessed 3 August 2017).

Block, René (ed.). (2000), *Das Lied von der Erde*, Kassel: Museum Fridericianum.

Block, René. (2013), 'We Hop On, We Hop Off: The Ever-faster Spinning Carousel of Biennials', in *Shifting Gravity. World Biennial Forum No. 1*, Ute Meta-Bauer and Hou Hanru, (eds), 104–9, Gwangju and Ostfildern: The Gwangju Biennial Foundation and Hatje Cantz.

Bydler, Charlotte. (2004), *The Global Art World Inc.: On the Globalization of Contemporary Art*, Stockholm: Acta Universitatis Upsaliensis. Figura Nova Series 32.

Clark, John. (2010), 'Biennials as Structures for the Writing of Art History: The Asian Perspective', in *The Biennial Reader*, Elena Filipovic, Marieke van Hal, Solveig Øvstebø (eds), 164–83, Bergen and Ostfildern: Bergen Kunsthall and Hatje Cantz.

Clark, John. (2015), 'Canon-Making and Curating in Recent Asian Art'. *Journal of Fine Arts*, 2 (2): 33–93.

Di Martino, Enzo. (2005), *The History of the Venice Biennale 1895–2005. Visual Arts-Architecture-Cinema-Dance-Music-Theatre,* Venice: Papiro Arte.

Dyangani Ose, Elvira. (2015), 'For Whom Are Biennials Organised?', in *Making Biennials in Contemporary Times. Essays from the World Biennial Forum no.2 São Paolo,* Galit Bilat, Nuria Enguita Mayo, Charles Esche, Pablo Lafuente, Luiza Proença, Oren Sagiv and Benjamin Seoussi (eds), 103–9, Amsterdam and São Paolo: Biennial Foundation–Fundação Bienal de São Paulo; ICCo–Instituto de Cultura Contemporânea. Available online: https://issuu.com/iccoart/docs/wbf_book_r5_issuu (accessed 3 August 2017).

Elliott, David. (2000), 'Dakar: Real Action', in *Dak'Art 2000. Biennale de l'art africain contemporain*, Secrétariat Général (ed.) 14–16, Dakar: Biennale des Arts de Dakar.

Enwezor, Okwui. (2002), *Großausstellungen und die Antinomien einer transnationalen globalen Form*, Berliner Thyssen-Vorlesung zur Ikonologie der Gegenwart 1, Gottfried Boehm and Horst Bredekamp (eds), Munich: Fink.

Ferguson, Bruce W. and Milena M. Hoegsberg. (2010), 'Talking and Thinking about Biennials: The Potential for Discursivity', in *The Biennial Reader*, Elena Filipovic, Marieke van Hal, Solveig Øvstebø (eds), 360–75, Bergen and Ostfildern: Bergen Kunsthall and Hatje Cantz.

Filipovic, Elena, Marieke van Hal, Solveig Øvstebø (eds) (2010), *The Biennial Reader*, Bergen and Ostfildern: Bergen Kunsthall and Hatje Cantz.

Fillitz, Thomas. (2009), 'Contemporary Art in Africa: Coevalness in the Global World', in *The Global Art World. Audiences, Markets, and* Museums, Hans Belting and Andrea Buddensieg (eds), 116–34, Ostfildern: Hatje Cantz.

Gardner, Anthony and Charles Green. (2013), 'Biennials of the South on the Edges of the Global'. *Third Text*, 27 (4): 442–55. DOI: 10.1080/09528822.2013.810892.

Gardner, Anthony and Charles Green. (2015), 'South as Method? Biennials Past and Present', in *Making Biennials in Contemporary Times. Essays from the World Biennial Forum no.2 São Paolo*, Galit Bilat, Nuria Enguita Mayo, Charles Esche, Pablo Lafuente, Luiza Proença, Oren Sagiv and Benjamin Seoussi (eds), 28–36, Amsterdam and São Paolo: Biennial Foundation–Fundação Bienal de São Paulo; ICCo–Instituto de Cultura Contemporânea. Available online: https://issuu.com/iccoart/docs/wbf_book_r5_issuu (accessed 3 August 2017).

Glaser, Martin. (2000), 'Vorwort. Preface. Interview René Block', in *Das Lied von der Erde*, René Block (ed.), 4–11, Kassel: Museum Fridericianum.

Green, Charles and Anthony Gardner. (2016), *Biennials, Triennials, and documenta. The Exhibitions that Created Contemporary Art*, Malden, MA. and Oxford: Wiley Blackwell.

Hannerz Ulf. (1991), 'Scenario for peripheral cultures', in *Culture, Globalization and the World-System: Contemporary Conditions for the Representation of Identity*, Anthony B. King (ed.), 107–28. Houndmills and London: Macmillian and SUNY, Binghamton.

Hewitt, Cynthia Lucas. (2007), 'Pan-African Brain Circulation', in *African Brain Circulation: Beyond the Drain-Gain Debate*, Rubin Patterson (ed.), 15–38, Leyden and Boston: Brill.

Hoskote, Ranjit. (2010), 'Biennials of Resistance: Reflections on the Seventh Gwangju Biennial', in *The Biennial Reader*, Elena Filipovic, Marieke van Hal, Solveig Øvstebø (eds), 306–21, Bergen and Ostfildern: Bergen Kunsthall and Hatje Cantz.

Jones, Caroline A. (2010), 'Biennial Culture: A Longer History', in *The Biennial Reader*, Elena Filipovic, Marieke van Hal, Solveig Øvstebø (eds), 66–87, Bergen and Ostfildern: Bergen Kunsthall and Hatje Cantz.

Kompatsiaris, Panos. (2017), *The Politics of Contemporary Art Biennials, Spectacles of Critique, Theory and Art*, London and New York: Routledge.

Konaté, Yacouba. (2009), *La Biennale de Dakar. Pour une esthétique de la création africaine contemporaine – tête à tête avec Adorno.* Paris: L'Harmattan, La Bibliothèque d'Africultures.

Lee, Pamela M. (2012), *Forgetting the Art World*, Cambridge, MA and London: The MIT Press.

Marchart, Oliver. (2014), 'The globalization of art and the "Biennials of Resistance": a history of the biennials from the periphery'. *World Art*, 4 (2): 263–76. DOI:10.1080/21 500894.2014.961645.

Martinon, Jean-Paul (ed.) ([2013] 2015), *The Curatorial. A Philosophy of Curating*, London: Bloomsbury Academic.

Mbembe, Achille. (2001), 'At the Edge of the World: Boundaries, Territoriality, and Sovereignty in Africa', in *Globalization*, Arjun Appadurai (ed.), 22–51, Durham and London: Duke University Press.

Mbembe, Achille. (2010), *Sortir de la grande nuit. Essai sur l'Afrique décolonisée*, Paris: La Découverte.

Meta-Bauer, Ute and Hou Hanru (eds) (2013), *Shifting Gravity. World Biennial Forum No. 1*, Gwangju and Ostfildern: The Gwangju Biennial Foundation and Hatje Cantz.

Niemojewski, Rafal. (2010), 'Venice or Havana: A Polemic on the Genesis of the Contemporary Biennial', in *The Biennial Reader,* Elena Filipovic, Marieke van Hal, Solveig Øvstebø (eds), 88–103, Bergen and Ostfildern: Bergen Kunsthall and Hatje Cantz.

Nzewi, Ugochukwu-Smooth C. (2013), *The Dak'Art Biennial in the Making of Contemporary African Art, 1992-Present*, Atlanta: PhD-thesis Emory University. Available online: https://legacy-etd.library.emory.edu/view/record/pid/emory:f3rxn (accessed 25 May 2014).

O'Neill, Paul. (2007), *The Culture of Curating and the Curating of Culture(s): the Development of Contemporary Curatorial Discourse in Europe and North America since 1987*, London: PhD-thesis Middlesex University. Available online: http://eprints.mdx. ac.uk/10763/ (accessed 30 May 2017).

Oren, Michel. (2014), 'Biennials that promote an "emancipatory politics"'. *World Art*, 4 (2): 277–305, DOI: 10.1080/21500894.2014.961646.

Osborne, Peter. (2015), 'Every other Year Is Always This Year – Contemporaneity and the Biennial Form', in *Making Biennials in Contemporary Times. Essays from the World Biennial Forum no.2 São Paolo, 2014*, Galit Bilat, Nuria Enguita Mayo, Charles Esche, Pablo Lafuente, Luiza Proença, Oren Sagiv and Benjamin Seoussi (eds), 15–27, Amsterdam and São Paolo: Biennial Foundation–Fundação Bienal de São Paulo; ICCo–Instituto de Cultura Contemporânea. Available online: https://issuu.com/iccoart/docs/wbf_book_r5_issuu (accessed 3 August 2017).

Petroni, Mauro. (2013), 'No title', in *Shifting Gravity. World Biennial Forum No. 1*, Ute Meta-Bauer and Hou Hanru (eds), 146–7, Gwangju and Ostfildern: The Gwangju Biennial Foundation and Hatje Cantz.

Sheikh, Simon. (2007), 'Constitutive Effects: The Techniques of the Curator', in *Curating Subjects*, Paul O'Neill (ed.), 174–85, London: Open Editions.

Sheikh, Simon. ([2009] 2010), 'Marks of Distinction, Vectors of Possibility: Questions for the Biennial', in *The Biennial Reader*, Elena Filipovic, Marieke van Hal, Solveig Øvstebø (eds), 150–63, Bergen and Ostfildern: Bergen Kunsthall and Hatje Cantz.

Schwarze, Dirk. (2007), *Meilensteine: Die documenta 1 bis 12*, Berlin: B&S Siebenhaar.

Smith, Terry. (2012), *Thinking Contemporary Curating*, ICI Perspectives in Curating No. 1, New York: Independent Curators International.

Sylla, Abdou. (2008), 'Les Arts Plastiques Sénégalais Contemporains'. *Ethiopiques*, 80. Available online: http://ethiopiques.refer.sn/spip.php?page=imprimer-article&id_article=1599 (accessed 29 August, 2016).

Szewczyk, Monika. (2010), 'How to Run a Biennial (with an Eye to Critical Regionalism). A review of the workshop "How to Run a Biennial" by Yacouba Konaté, Mahita El Bacha Urieta, Per Gunnar Eeg-Tverbakk, Jonas Ekeberg, and Gerardo Mosquera', in *The Biennial Reader*, Elena Filipovic, Marieke van Hal and Solveig Øvstebø (eds), vol. 2, 27–32, Bergen and Ostfildern: Bergen Kunsthall and Hatje Cantz.

Verwoert, Jan. (2010), 'The Curious Case of Biennial Art', in *The Biennial Reader,* Elena Filipovic, Marieke van Hal, Solveig Øvstebø (eds), 184–97, Bergen and Ostfildern: Bergen Kunsthall and Hatje Cantz.

Vogel, Sabine B. (2010), *Biennials - Art on a Global Scale*, Vienna and New York: Springer, edition: 'Angewandte.

Warner, Michael. (2002), *Publics and Counterpublics*, New York: Zone Books.

Weiss, Rachel et al. (2011), *Making Art Global (Part 1). The Third Havana Biennial 1989*. London, Vienna, Eindhoven: Afterall Books in association with the Academy of Fine Arts Vienna and Van Abbemuseum.

INDEX